CARL F. GOULD

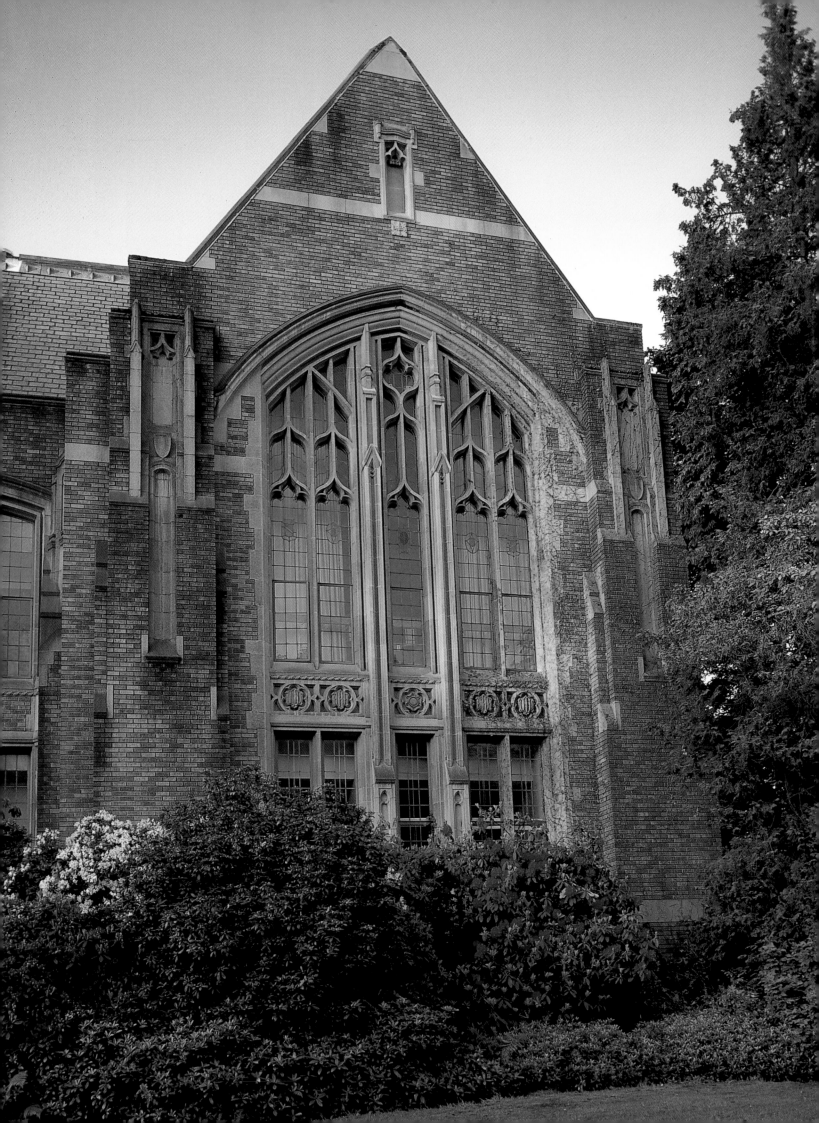

CARL F. GOULD

A Life in Architecture and the Arts

T. William Booth and William H. Wilson

UNIVERSITY OF WASHINGTON PRESS

Seattle & London

To Whitney S. Stoddard

Illustration facing title page: Bebb & Gould, detail of north elevation, Anderson Hall, University of Washington, Seattle, 1923–24. After Suzzallo Library, this is Gould's finest collegiate Gothic building. (T. William Booth)

Copyright © 1995 by the University of Washington Press
Printed in Korea

Library of Congress Cataloging-in-Publication Data

Booth, T. William.
 Carl F. Gould : a life in architecture and the arts / T. William
Booth and William H. Wilson
 p. cm.
 Includes bibliographical references (p.) and index.
 ISBN 0–295–97360–9 (alk. paper)
 1. Gould, Carl Freylinghuysen, 1873–1939. 2. Architects—
Washington (State)—Biography. 3. Civic leaders—Washington
(State)—Biography. 4. Eclecticism in architecture—Washington
(State) I. Wilson, William H. (William Henry), 1935–
II. Title.
NA737.G65B66 1994
720'.92—dc20
[B] 94–28501
 CIP

Contents

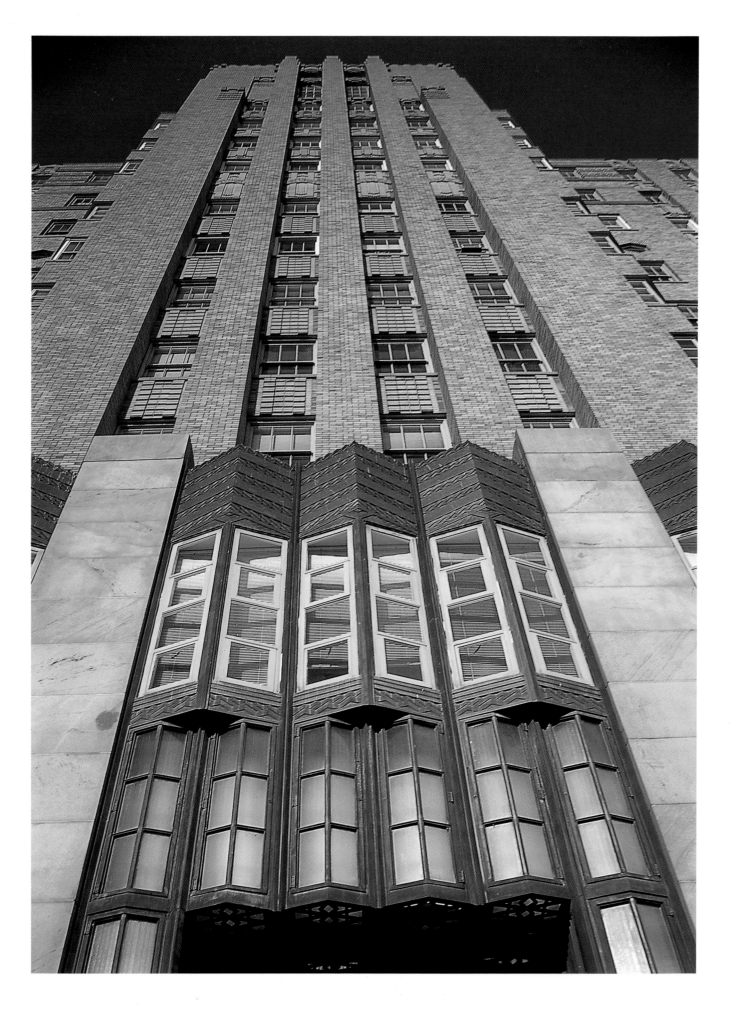

PREFACE

WE CAME TO APPRECIATE CARL F. GOULD BY DEGREES. BOOTH remembers flying above the San Juan Islands on a clear spring day, over tufts of green scattered through the sparkling blue of Puget Sound. After a while, the float plane touched the waters of Friday Harbor and taxied to the wharf at the Marine Biological Station. There five low, older buildings were seemingly set randomly along the shore. They appeared to be nothing remarkable, just sensible structures with stucco walls, hipped roofs, and simple windows.

Greater revelations awaited inside the dining hall. The design was modular, the timber frames of clear fir contrasting handsomely with the many small panes of glass infilling between the columns. The effect was strikingly modern, but the hall was more than, or different from, a modern building. Its apparently simple structure, overlaid by trim-boards and shingles, was in fact an elegant gesture to the rusticity and isolation of the site. That day, Booth knew who Gould was, but the range of his talent unfolded later, during Booth's walks around Seattle and especially on the University of Washington campus. Architectural critics and Whitney S. Stoddard sometimes went along on the campus walks. Without exception they marveled at Gould's Tudor-Gothic expressions and urged a full biographical examination of his work. Gould's campus buildings were traditional, they remarked, yet they also were modern because the architect effectively adapted them to contemporary uses. These observations encouraged the idea of less-restrictive definitions of the concept of architectural modernism.

Wilson remembers rounding a walkway turn on the University of Washington campus on another clear spring day, confronting the majestic cone of Mount Rainier poised beyond the end of Rainier Vista, then turning left to gaze upon Gould's magnificent Suzzallo Library. It was exhilarating to experience in sequence the sublimity of a natural form and the beauty of the collegiate Gothic building. The architect would have relished the emotional reaction. He argued for human-created beauty to complement the beauty of creation, and the swift appreciation of both would have tickled the imp inside his tall, spare frame.

As the weeks passed, there were all-too-brief glances out the bus window at Gould's fine Beaux-Arts expression, the Times Square Building, once the home of the *Seattle*

Bebb & Gould, U.S. Marine Hospital (Pacific Medical Center), Seattle, 1930–32. Its position on the northern brow of Beacon hill makes the hospital visible from many areas of Seattle. (T. William Booth)

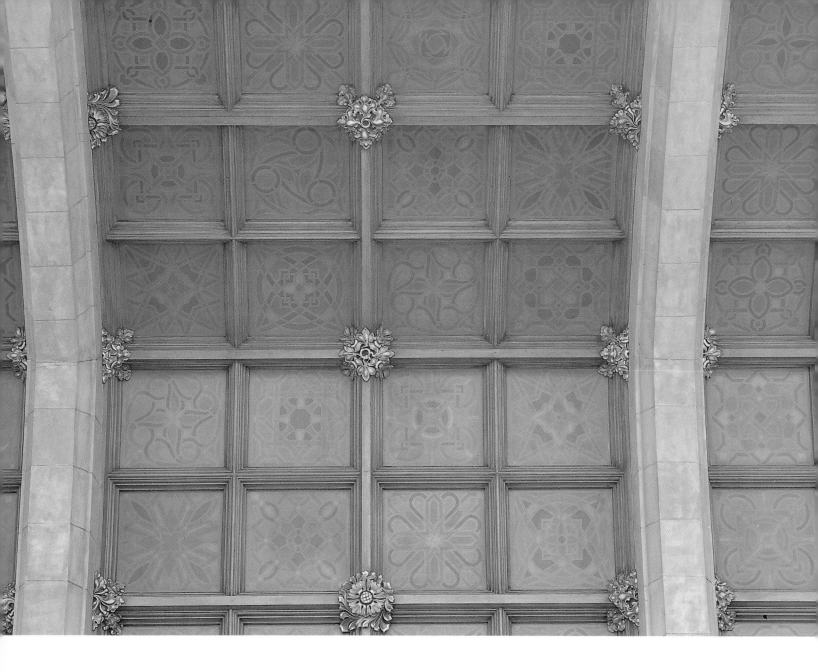

Times. Later there was the revelation of Gould's Seattle Art Museum, an Art Moderne diamond set in the emerald velvet of Volunteer Park. Through all these fine buildings, Gould was raising this question: does modernism really have all the answers in architecture? We had no quick or certain response, but there was little doubt that the question merited thoughtful attention.

As authors we owe our greatest debt to those architects and students of architectural history who, through their teaching, writings, or buildings, argued for the validity of various periods and styles. That a period or style was valid did not suggest to them that it was beyond criticism, but rather that its best examples were worthy of serious consideration. Decades ago such an idea appeared heretical to us; we were still committed to the notion of modernism's superior morality. In time, through Gould and others, we came to understand that morality in architecture consists of fidelity to a building's purpose and materials, and not to stylistic preconceptions. By this definition, Carl Gould was one of the most moral architects who ever lived.

Among many fine teachers of architecture we single out Whitney S. Stoddard, a scholar in the field of Gothic architecture and Booth's professor of architectural history at Williams College. He first informed Booth about America's European architec-

Bebb & Gould, vault over reading room, Suzzallo Library, University of Washington, Seattle, 1922–26. Gould took special care with the coloring of the medallions over this magnificent space. (T. William Booth)

Bebb & Gould, Pacific Telephone and Telegraph Company (U.S. West), Longview, 1928. With this building, Gould began his architecture in the Moderne Style. (T. William Booth)

tural heritage, and later opened to him the satisfying humanism of modern Nordic architecture. He suggested this biography. It is dedicated to Stoddard in recognition of his inspiration as a teacher and a mentor.

We are grateful for the help and encouragement of Carl Gould's children. During the 1980s they deposited their father's architectural drawings and a portion of his professional library in the Special Collections and Preservation Division of the University of Washington Libraries. Two children, Carl F. Gould, Jr., and Anne Gould Hauberg, donated portions of their father's and mother's papers, and of their own papers bearing on their parents' lives, to the university's Manuscripts and University Archives. Carl, Jr., opened his extensive collection of his father's papers and other materials to our investigation. Anne shared revealing reminiscences of her father. Both generously granted us the unrestricted use of all the sources in their care or under their control. This book would not have been possible without their active cooperation.

Our project began with Booth's volunteering to create a computer-based catalogue of the Gould drawings. Gary Menges, head of Special Collections and Preservation, and Richard H. Engeman, in charge of graphics for the division, cooperated in the task. David Brewster, editor of the *Seattle Weekly*, encouraged Booth to expand his

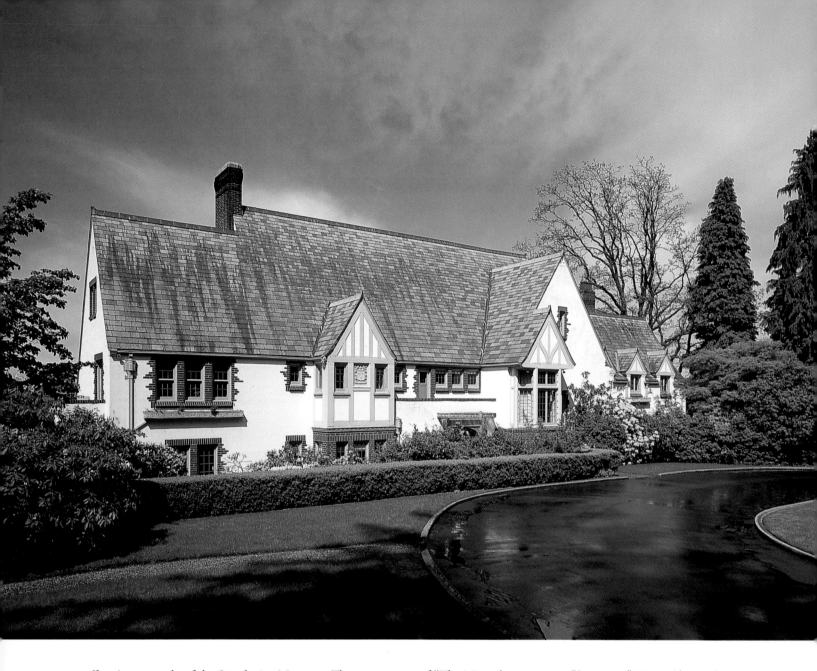

effort into a study of the Seattle Art Museum. The appearance of "The Man, the Moment, and the Museum" in November 1986 led to other explorations of Gould's work, chiefly in *Impressions of Imagination: Terra Cotta Seattle*, edited by Lydia Aldredge. Several people who knew Gould or his work submitted to interviews. We appreciate their patience, their knowledge, and their insights. The present owners of several Gould houses permitted us to enter and examine their homes, and we thank them for their forbearance. We selected most of the domestic projects presented in this book because they may be viewed from the public streets without trespass into private areas. The houses constructed in The Highlands and at The Country Club on Bainbridge Island are located in precincts that are open by invitation only. We ask our readers to respect every homeowner's right of privacy in house and lot, and thank them for their cooperation.

The staffs of Manuscripts and University Archives and of Special Collections rendered cheerful and informed assistance. Katharine Wilson was an acute compositor, editor, and critic. The faculty seminar of the Department of History at the University of North Texas dissected one chapter, substantially improving it. We acknowledge the kind grant of permission from the Johns Hopkins University Press to use, with adap-

"Sunnycrest," Hoge residence, The Highlands, Seattle, 1919–22. One of five major commissions in The Highlands, it retains all of Gould's fine interior design detailing. (Courtesy of William Howard)

Carl F. Gould and Bebb & Gould, U.S. Government (Hiram Chittenden) Locks, Seattle, 1914–17. (T. William Booth)

Overleaf: Carl F. Gould, paintings done in Europe: (top) view of Venice painted in 1903, at the end of Gould's post-student sojourn; (bottom left) view of Amiens painted in 1901(?) while Gould was on one of his many forays into the regions around Paris; (bottom right) sketch of stairway drawn and painted in 1900(?), as part of Gould's Ecole des Beaux-Arts studies of historic models of excellent designs. (All Gould Collection, CFG JR.)

tation, descriptions of Seattle and material about the Bogue plan from Wilson's *The City Beautiful Movement* (1989).

Jeffrey Karl Ochsner, Norman J. Johnston, and Dennis A. Andersen served as guides to sources. Those three, as well as Alice Copp Smith, read portions of the manuscript, or the entire manuscript, at different stages of its development. Their wise suggestions for improvement strengthened our study. At the University of Washington Press we thank Naomi Pascal, associate director and editor-in-chief; Julidta Tarver, managing editor; Lorna Price, copyeditor; and Audrey Meyer and Robert Hutchins, designers.

We acknowledge all this essential assistance, but recognize our ultimate account-ability for what follows. Our collaboration involved a division of labor that shifted with circumstances. Because both of us were at all times concerned with research, writing, revising, and checking, we assume equal responsibility for the result.

In conformity with current practice we have occasionally corrected quoted material without comment or brackets. Most of these corrections concern Gould's hastily written statements. The changes clarify his meaning and avoid slowing the reader. Gould's orthography was characteristic of the man. Wherever possible, we have preserved it without using *sic* or brackets to indicate that the departure from perfect spelling, punctuation, or grammar was his.

T. William Booth

William H. Wilson

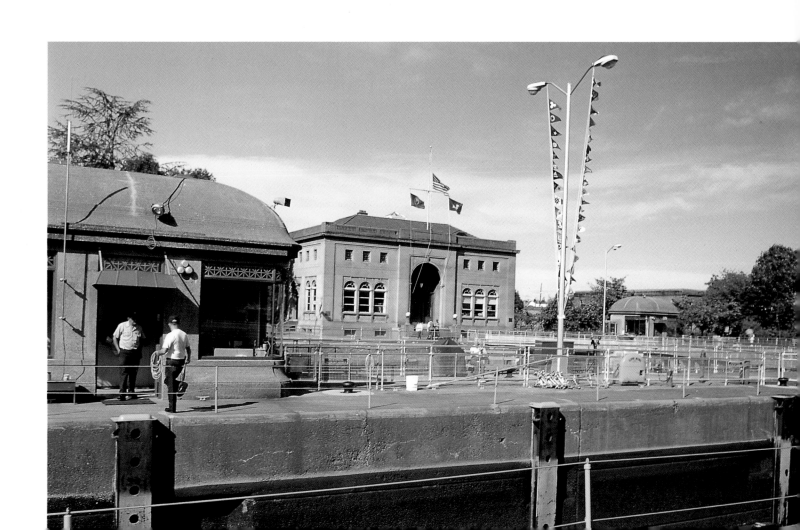

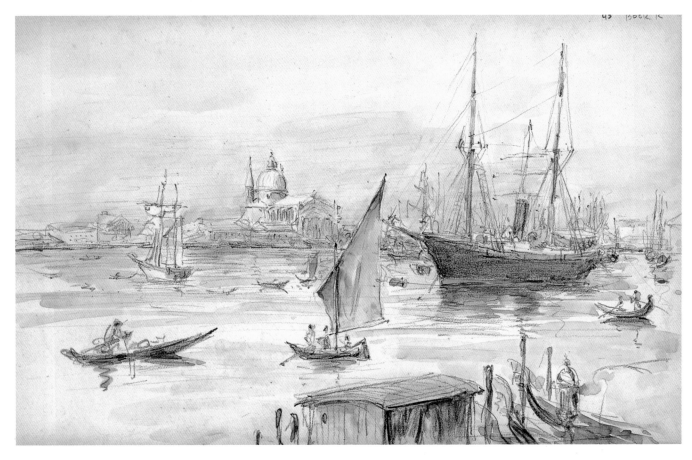

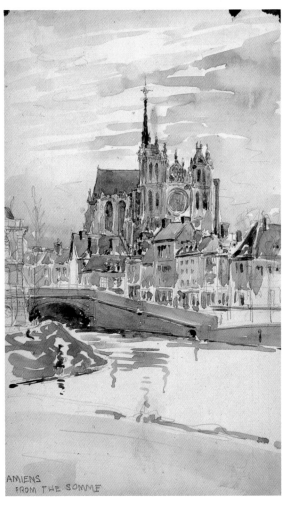

AMIENS
FROM THE SOMME

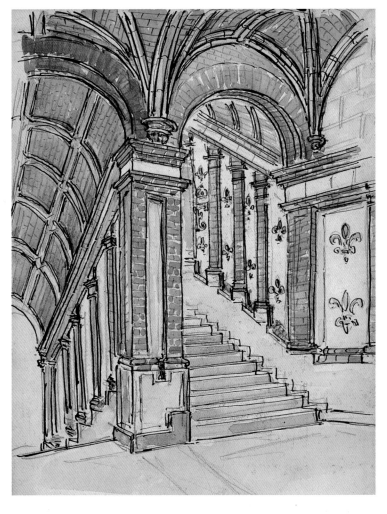

XII

CARL F. GOULD

1.1 Carl F. Gould (1873–1939) about age 50.

Art pays. Beauty is the best policy. . . . Be patient . . . and do not forget to develop the artistic life of your city.—OTTO KAHN, QUOTED BY CARL F. GOULD[1]

1 Architect and Civic Leader

CARL GOULD WAS TALL, HANDSOME, AND SUCCESSFUL. WHEN HE stepped from the office of Bebb & Gould, Associated Architects, to the streets of Seattle his lean frame was impeccably attired, and he moved at a racer's pace. A master architect, he looked the part in every one of his 76 inches (FIG. 1.1). He is best remembered for dozens of buildings and additions on the graceful campus of the University of Washington, but he designed many other structures, including more than fifty major houses.

Gould was a patrician. Born in New York to wealthy parents, he survived a difficult childhood under the watchful eye of his imperious mother, graduated from Harvard, then spent the better part of the next five years at the famed Ecole des Beaux-Arts in Paris. The Ecole offered the ultimate in architectural education at the turn of the twentieth century. Gould flourished in its relatively unstructured environment, learning principles of form and style that he practiced for the rest of his life.

In 1908, when Gould was almost thirty-five, he arrived in Seattle to begin a career based on his extensive education and previous apprenticeships with various firms, among them McKim, Mead & White, George B. Post, and D. H. Burnham & Company. Gould's enthusiastic dedication to beauty and its acquisition found expression in architectural practice, architectural education, the allied arts, and public service. He worked with tremendous concentration, but with great consideration for those around him. His determination and his courtly behavior inspired others to accept his leadership. So did his certitude, for he matured in a nineteenth-century family that knew what beauty was, and how, in architecture, it was rooted in the ancient styles. In his later years Gould became fascinated with the possibilities of a modernism that would be true to basic principles, yet lead the way toward a new vision of an ahistorical architecture.

Gould accepted modernism, but neither Louis Sullivan nor Frank Lloyd Wright influenced him, although he was far from ignorant of their work. His partner Charles Herbert Bebb had once worked for Adler & Sullivan in Chicago (see CHAPTER FOUR), and Bebb would have been acting out of character had he not regaled Gould with tales of Sullivan's skills and eccentricities. In 1938, probably not for the first time, Bebb

entertained Gould over drinks at Seattle's University Club with stories of his days in Chicago. Bebb mentioned Sullivan's "drinking," and the personality of the talented John Root, whom Bebb described as a "charming fellow." Gould's peer, the Seattle architect Walter R. B. Willcox (1869–1947), knew both Sullivan and Wright. Willcox, by then head of the innovative Department of Architecture at the University of Oregon, arranged Wright's 1931 exhibition and lecture tour of the Pacific Northwest. It is very likely that Gould met Wright during Wright's tour stop in Seattle, attended the Wright exhibit in the Gould-designed Henry Gallery, and listened to Wright's lecture on the University of Washington campus. A few years later he credited Wright and the European modernists with helping "to make the subject of archt. controversial which is very much to the good." Yet he refused any commitment to the particularistic nationalism of the picturesque successionists, or to the ahistoricism of the modernists. He adhered instead to the universalist principles of the Ecole des Beaux-Arts.[2]

Beaux-Arts students, whatever their shortcomings, could devise a program for a building type with relative ease. They understood that architecture involved the honing of technical skills such as drafting and shading, but that these skills should always be at the service of larger ends—a building's setting in space, its symbolism, and its historical references.[3]

Although Beaux-Arts trained, Gould was also part of a talented American generation that matured in exciting and contentious architectural times. Those born within five or six years of him included, in addition to Wright, John Russell Pope, Charles and Henry Greene, Paul Cret, Howard Van Doren Shaw, Bertram Goodhue, George Grant Elmslie, and Irving Gill. All these and many more distinguished themselves, however much they differed. Each was concerned with issues surrounding the development of a distinctly national architectural style, whether or not historically derived. Gould also was caught up in this concern, finally concluding in 1922 that although an American style was out of reach for the foreseeable future, a Pacific Northwest regional style was attainable. Such a style would incorporate, he thought, the verticality and broad, glazed elevations of traditional buildings in the higher latitudes.

Beauty would result from a style that succeeded in attaining a completely harmonious integration of its purpose and its environment. For Gould, beauty was achieved when the observer reacted with satisfaction and delight to the entire architectural composition, including any historical references. Beauty, then, was emotional and associational, not subject to precise intellectual parsing. Nor did Gould attempt to define beauty apart from the perfect realization of a style. Temperamentally he was agreeable and disinclined to argue, certainly not over the content of an ideal.

Gould designed in many styles. He was deft and sure in Gothic, Romanesque, neoclassical, modern, and rustic designs. A.D.F. Hamlin, editor of *Architectural Record*, wrote of architects that they could master one or at most two styles. Gould refuted Hamlin's statement because he depended not on the acquisition of drafting skills, but on the principles taught at the Ecole des Beaux-Arts. "The only way to approach a solution of any problem is of course to visualize all the factors involved," he wrote near the end of his life. "Such is the only way that creative work of permanent value is done. Over attention to rendered projects exclusive of solving the problem gets nowhere & is a misconception of the Beaux-Arts approach by those who have never really experienced it or understood it."[4]

1.2 Suzzallo Library, west front, University of Washington, Seattle, 1922–27.

With his design philosophy, Gould responded to the issue facing him: to employ contemporary methods in achieving a beautiful and practical result for his client. His philosophy was universal because it reached beyond mere incidents of design. Edward Larrabee Barnes appreciated that perspective when, in 1991, he spoke at the dedication of his extension of Gould's Gothic masterpiece, the Suzzallo Library at the University of Washington (FIG. 1.2). Barnes, weaned on modernism and living in an era far removed from Gould's time, nevertheless made a traditional statement. "In great architecture," Barnes remarked, "mass and form are primary, and details, no matter how elegant, are secondary." Carl Gould would have approved.[5]

Gould practiced in the era of the generalist, thus he was necessarily conversant with landscape architecture, building-site planning, interior decoration, and city planning. No mere aesthete, he created magnificent interior spaces and mastered the use of concrete and steel. He designed structures ranging from shelter cabins to a major hospital and an art museum. In 1911 and 1912 he supported the ill-fated Bogue plan for Seattle, a comprehensive scheme in the City Beautiful mode (see CHAPTER THREE), a plan that guided his thoughts on urban beauty despite the voters' rejection of it.

Gould chose Seattle well, for not only was it booming on the strength of lumbering, ocean commerce, and inland trade, but it was struggling out of its artistic swaddling clothes. He dominated several fledgling fine arts organizations for significant periods. He founded the Department of Architecture at the University of Washington

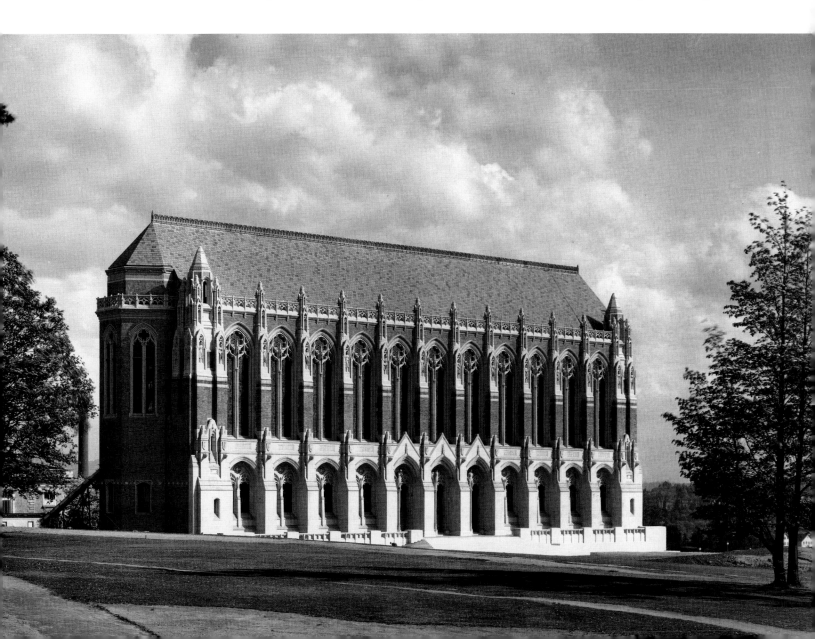

in 1914 and headed it until 1926. He nurtured the visual arts in a frontier city by serving as president of the Seattle Fine Arts Society and its successor the Art Institute of Seattle, predecessor organizations of the Seattle Art Museum. He was a two-term president of the Washington State Chapter (WSC) of the American Institute of Architects (AIA), and continuously active in that group. His community service included participation in the Chamber of Commerce and membership on Seattle's first planning commission.

Gould's warmth and love of life extended beyond his varied professional and civic concerns. Women responded to him, but he did not marry until he was forty-one years old. He adored his wife Dorothy Wheaton Fay, a member of a prominent Seattle family, and she returned his adoration in full measure. They had three children, two sons and a daughter, to whom Gould was absolutely devoted.

Gould was also a sportsman and club man, activities important to his garnering of commissions. He went horseback riding, sailing, skiing, and mountaineering with family and friends. He socialized intensely in clubs and organizations, believing that social activity was essential for group cohesiveness. He also sought more contemplative recreation in painting and sketching, alone or with a few close friends. He loved to travel. Almost every year he returned to the East Coast to keep up with old friends and new building types. He was a fluent speaker and writer of French; by 1923 he had made seven trips to Europe.[6]

The last twelve years of Gould's life were marked by several high achievements, including completion of the first art museum in the country built in the modern style (FIG. 1.3). His loss of the University of Washington design monopoly in 1926, and a general business decline shortly thereafter, held his career in check. The Great Depression further reduced the commissions of Bebb & Gould to as few as two or three a year. Before Gould died, his firm had begun the design for the Washington State Pavilion for the 1939 World's Fair at Flushing Meadows, New York. His expectation of international recognition was unfulfilled, and the pavilion was completed by others.[7]

During his lifetime Gould received regional and national recognition for some of his work. He unhesitatingly wrote about his institutional buildings, but many of his domestic designs remained relatively unknown because he respected the privacy of his clients. After his death he was remembered by modernists not as one of their own, but as an eclectic traditionalist who designed and taught in the old-fashioned, discredited Beaux-Arts manner. The tyranny of modernism is no better illustrated than in his daughter's comment: "In the late '30s my father's career was an embarrassment to me, simply because he had designed traditional buildings."[8]

In 1989 Washington State celebrated its centennial year. It was the fiftieth anniversary of Gould's death as well as the seventy-fifth anniversary of his founding of architectural education at the University of Washington. The man and his region matured together, so it is little wonder that Gould spoke out for a regional architecture. Years after his death, the shadow over his career began to lift, and now there is a better appreciation of his spacious, light-filled rooms, and his careful detailing of traditional exteriors. Gould was, however, more than a refined traditionalist. He was a gifted human being who left a significant heritage to the architecture, art, and civic life of Seattle and the Pacific Northwest.

1.3 Seattle Art Museum, west front,
Volunteer Park, 1931–33.

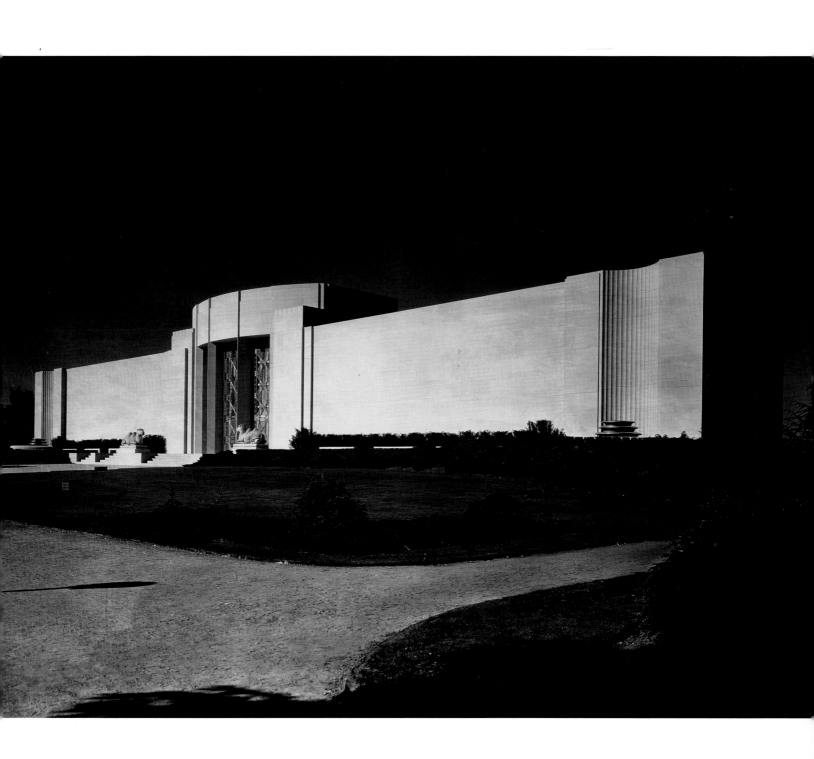

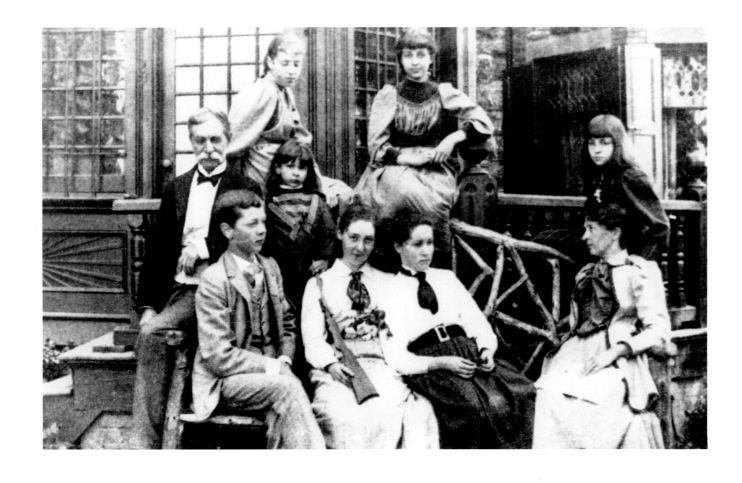

2.1 Charles Judson Gould family, ca. 1889. Standing: Charles, Edith, Aubrey, Ethel, Muriel; seated: Carl, Elsie, Rosalie, Annie.

One feels so frightfully misunderstood all one's life, but especially when young. — C A R L
F. G O U L D [1]

2 The Preparatory Years, 1873–1908

C A R L F R E L I N G H U Y S E N G O U L D W A S B O R N T O W E A L T H A N D P R I V I-
lege in New York City on 24 November 1873. He was the third of seven children, two
sons and five daughters, born to Charles Judson and Annie Westbrook Gould (FIG.
2.1). Annie's family traced its North American lineage through two generals of the
Revolutionary War and seven Dutch clergymen. The Gould name descended from an
English settler, John Gould, who arrived in the American colonies in 1664. Both of
Carl Gould's parents' ancestors had engaged in real estate and other enterprises in
New York and New Jersey for as long as two centuries. The land comprising the coun-
try retreat of Annie's ancestors in once-remote Harlem, though built over, remained
in the family for generations.[2]

Business acumen and inheritance assured Charles Gould's success as a tea mer-
chant and enabled him to retire in 1870 at age thirty-seven. Charles thereafter gave
himself over to the interests of a Victorian gentleman of leisure. Little is known of the
Goulds' family life, but it is probable that Charles devoted more time to his family
than Victorian stereotypes would suggest. Years later, Carl's mother-in-law asserted
that Carl inherited "from his father the energy and spaciousness of outlook which had
made possible his larger creative works."[3] The observation was plausible at the end of
Carl's life but his teen years were awkward. His social contacts were limited, he stut-
tered, and was mostly educated at home until age sixteen or seventeen.[4]

Annie influenced the withdrawn lad much more than Charles. She dedicated her
life to the acquisition and enjoyment of beauty. Good-looking, brilliant, energetic, an
avid collector, and an ardent bibliophile, she assembled a library of more than 2000
books on architecture, the arts, and letters. Annie was discerning as well as shrewd.
She hung the walls of the Gould townhouse and summer home with the works of
American artists, including George Wesley Bellows, Winslow Homer, and James
McNeill Whistler, acquired while their renown was modest. She probably encouraged
Carl to keep a sketchbook-journal during a family trip to the British Isles when Carl
was fifteen. The teenager returned with creditable sketches of buildings and land-
scapes and a life-long commitment to foreign travel, sketching, and journal-keeping.
"From his mother [Carl] inherited the perfect rectitude of taste which has always

distinguished him," wrote his mother-in-law, a firm believer in nature over nurture.[5]

Yet Carl was nurtured as well, and not only by his parents. New York during his childhood and adolescence was a polyglot city on a growth rampage. Its 1870 population neared a million (942,292), with more than 419,000 foreign born. Twenty years later the population exceeded 1,500,000. Carl was in that comparatively small cluster of 274,164 New Yorkers who claimed native, white parents. His circle was drawn even tighter among the elite who could boast of Knickerbocker ancestry. It is most unlikely that he knew any first- or second-generation Americans except as servants or tradespeople.[6]

What he could see and know was the headlong rush of building northward toward the pockets of miscellaneous construction around the Gould residence. Young Carl probably cared little for the infrastructure supporting the sweep up Manhattan Island, but the complex, interacting technology catalyzed his New York. Beginning in 1878, chuffing elevated trains leaped over the screeching cable cars. The Third and Sixth Avenue els opened huge tracts of the present Midtown and Upper East Side to low and middle income people crowded into the Lower East Side. As early as the 1880s relatively cheap houses went up on Ninety-second, far north and east of the Goulds, in a disorganized leapfrog development that was the despair of tidy minds. Thomas Edison began lighting the city electrically in 1882, and the els initiated their conversion to electricity in 1885. Water, as essential to growth as transportation and electricity, came in volume after 1890, with the completion of the Croton Aqueduct System. The system opened the city at last to a bounty of sweet, safe water.[7]

The elder Goulds' New York residences remained aloof from hurly-burly but were always in what is today the Midtown section. The Gould family dwellings advanced up the island with the press of population. Carl was born at 43 West Fiftieth Street, now just east of Radio City Music Hall in Rockefeller Center. The family's last apartment was on the eighth floor of 230 West Fifty-ninth Street, now Central Park South. Annie selected the location. "You looked right into the heart of the park," her daughter-in-law remembered. Annie "said it was the best lot in New York, and I think she was right."[8]

The New York that Carl saw outside his genteel apartments was filtered through his parents' notions of the proper city. No architect did more to shape the elite's architectural perceptions than the brilliant and aggressive Richard Morris Hunt. Hunt's spare Tenth Street Studio Building (1858), though much admired later, was almost certainly too bohemian for young Carl to have seen it or have been permitted to roam through its studios. It is more likely that he gazed upon the New York Tribune Building (1873–75), then an extraordinarily tall structure with a tower nearly matching the height of the Trinity Church spire. More likely still, he strolled, rode, and was driven past William K. Vanderbilt's High Victorian Gothic château (1879–82) on Fifth Avenue, as well as the later fantastic châteaux it inspired. The ranks of mansions marched up Fifth Avenue, reaching a climax of sorts with the Caroline Webster Schermerhorn Astor château (1893–95) at Sixty-fifth Street, an early herald of a residential building boom across from Central Park.[9]

The Goulds could hardly have escaped the excitement surrounding the arrival and erection of the Statue of Liberty. The noble monument, gift from the people of

France, stood frozen in stride atop a pedestal designed by the redoubtable Hunt. The Goulds may have forgone the official dedication on an increasingly rainy and foggy 28 October 1886. Later, however, Carl could scarcely have ignored the 305-foot statue and pedestal dominating the New York harbor.[10]

Reasonably close to Carl's home was the greatest Hunt building, the elegant Lenox Library (1870–77), with its forecourt in the French mode, its Beaux-Arts detailing, and its deep-set, arched windows forecasting the muscular style of Henry Hobson Richardson. The monumental limestone library stood on Fifth Avenue at Seventieth Street, across from Central Park. Annie may have held a card at the Lenox, for it was about a mile from the Gould home, and it contained rare editions of Shakespeare and Milton as well as paintings by Albert Bierstadt, Frederick Church, and Asher B. Durand, among many others.[11]

Other architects, including George B. Post, designed notable buildings. Of greater probable impact on Carl were some early contributions of the McKim, Mead & White firm, the Renaissance-style Villiard Houses (1882–85) on Madison Avenue between Fiftieth and Fifty-first streets, and the grand Italianate Metropolitan Club (1891–94) on Fifth Avenue near Sixtieth Street. By the time Madison Square Garden was finished in 1891, Carl probably was considered old enough to savor its more genteel entertainments.[12]

Central Park, Frederick Law Olmsted's and Calvert Vaux's brilliant design, was New York's great pleasure ground, where Charles Gould, an accomplished horseman, exercised his horse every day that he was in New York. Carl shared Charles's equestrian passion, learning horsemanship during frequent rides with his father. From the Goulds' front door the park stretched north to One-hundred-tenth Street between Fifth and Eighth avenues, 840 acres in all, and complete in its original incarnation when Carl was old enough to comprehend it. The park is acclaimed for its sophisticated naturalistic designs, its brilliant scheme of traffic separation, and the pathways and walkways that rise, fall, and bend to impart a sense of solitude and scenic variety in relatively confined, crowded spaces.[13]

Carl was seeing much more than scenery, however, for Central Park was an architectonic triumph. This was especially true of the south end, near the Gould home, where the stately Mall, the formal Terrace of Gothic-Romanesque design, and the magnificent Bethesda Fountain broke into the naturalistic landscape. Elsewhere a collection of rustic structures and such Victorian confections as Calvert Vaux's Mineral Spring Pavilion dotted the landscape. The bridges, much more visible to the slower-paced park travelers of the nineteenth century, displayed a great variety of good design. All this had a deep if unmeasurable influence on young Carl.

New York was so vivid and diverting that Carl would never be weaned from it emotionally. When he began his schooling away from home, however, the city was still the "old New York" of Manhattan Island; the five-borough consolidation would not come until 1898. Many of the architectural marvels later associated with the city were still unimagined. Pennsylvania Station (1904-1910), to which Gould would make a contribution, the Singer tower (completed 1908), the Metropolitan Life tower (1909), and other wonders rose only after his lengthy education was completed, or after his remove to Seattle. The New York that he experienced was, despite its comparative

immaturity, one of the great cities of the globe. If Carl saw more of the refined than the rambunctious, more of the genteel than the coarse or depraved, he nevertheless benefited from an extraordinary and rich experience.[14]

Carl knew the elegance of New York but he also knew the dignity and repose of "Suncliff," the family summer home completed in 1880 at Tarrytown (FIG. 2.2). Annie selected the site for its beautiful views toward the Ramapo Mountains and down the Hudson Palisades to New York. An old apple orchard and stands of oak and hickory graced the site on which she built a stone and timber English-style mansion. Formal gardens filled with specimen plants surrounded the manor. Here Annie entertained. Here Charles lived the life of a country squire, being "the dearest friend of his children," riding, boating, and hunting. A magnetic man, Charles "had friends wherever he stopped, whether it was to play golf with Mr. Rockefeller, or to chat with the inmates of the County Poor House," where he was an officer.[15]

At seventeen Carl entered the second form at Phillips Exeter Academy, the elite preparatory school in Exeter, New Hampshire. He enjoyed little success there, either in academics or athletics, although two masters remarked on his gentlemanly deportment. After three years he applied to Harvard College, to which his masters sent unenthusiastic letters of recommendation. One wrote that "his scholarship is not accurate," while the other commented on his willingness, lack of maturity, and "slight" speech impediment. The letters were pro forma. Carl's social standing assured him a place in the class of 1898, though a provisional one.[16]

2.2 Suncliff, Gould family home, Tarrytown, New York, 1880.

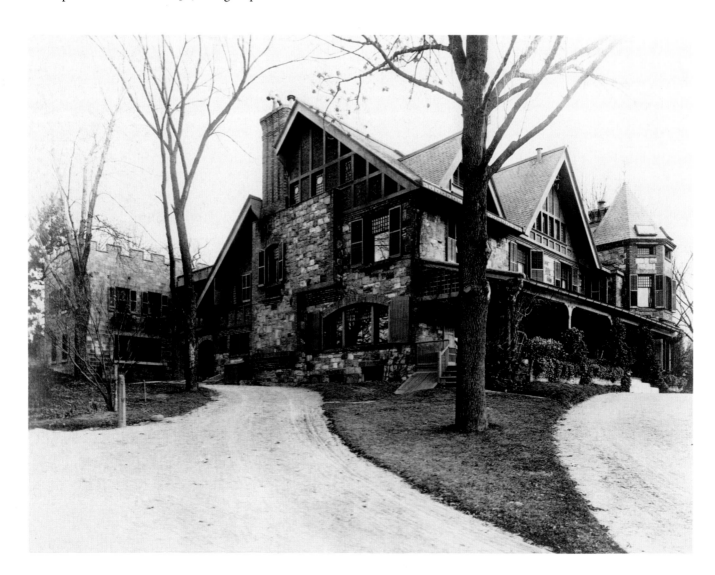

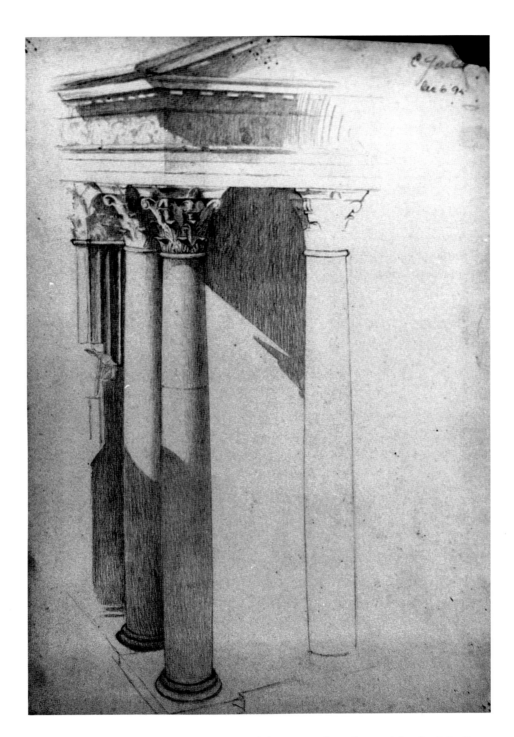

Harvard, so easy to enter, was stingy with honor grades. The gradebook of Carl's class reveals that the "gentlemen's C" was no embarrassment, and that Ds were ordinary. Carl fit the mold, though he fared better or worse in individual courses. In later life he was so fluent in French that he did not stutter when speaking it, yet his first attempt at French resulted in a D-minus grade. In studies engaging the visual or tactile senses—geology, fine arts, and economics—he did better, with Cs and Bs.[17]

But Harvard was critical to Carl's development, for the overprotected young man was emerging from his emotional cocoon. If he attempted to affiliate with an upper-crust social club, he was rebuffed, but there is no indication that he tried. He did join three clubs organized around his developing interests, the Pen and Brush, the Sketch (FIGS. 2.3, 2.4), and the Camera. His interest in photography dated from his Exeter days and was, in the mid-1890s, a hobby only recently simplified by the introduction

C.F.GOVLD

4

Helvellyn July 1878

14

of roll film and the box camera.[18] While at Harvard Gould painted several competent landscape watercolors.[19] His maturation embraced coursework, too. In his senior year he took the only course in architecture offered at the time. He did well enough overall to graduate in June 1898 with his entering class. After graduation he returned with his family to England, where he drew several charming landscape and figure sketches (FIG. 2.5).

But the vacation was no ordinary one, for Carl did not return home. Instead, he left England for Paris to enroll in the Ecole Nationale et Speciale des Beaux-Arts. It was an audacious decision, for the Ecole was simply the greatest school of architecture on earth, and he was wretchedly prepared for the grueling entrance examinations in mathematics, descriptive geometry, history, drawing, and architectural design. He was by no means poorly educated, but he had not drilled for the written and oral tests conducted in French by professors who looked askance at foreigners.[20]

Gould left no letters or reminiscences explaining his dramatic decision and arbitrary choice of a profession, but their sources are clear enough. Annie greatly influenced her children; two daughters were designers and three others married architects, while Carl was a skilled if not brilliant painter. Gould was twenty-four and had been indulged during a prolonged adolescence of irregular achievement, similar in some ways to the extended maturation of Daniel Hudson Burnham, the masterful architect and chief of construction of the World's Columbian Exposition (Chicago, 1893). He had been indulged, but he had not been spared. Annie was imperious. She showered gifts on her children when they excelled, but when they failed to meet her exacting standards, she flayed them with "scathing and constant criticism."[21]

Carl had other burdens to bear. As the eldest male sibling among seven children in a high Victorian household, in age widely separated from his brother, he had been treated as an only son, and had become imbued with a sense of his own importance. To Carl thus fell the duty of carrying forward the culture of a mother who had mastered Greek and a father who excelled in athletics. His stuttering was one result of the unremitting demands, an externalizing of intense familial pressures. Stuttering may have a psychological or neuromotor basis, or both, but in Carl's instance, the issue is clear: He stuttered only in his native English, not in French. He did not begin any serious study of French until he reached Harvard, far past the onset of stuttering. His freedom from the speech disorder in his second language disproves any neurological or physiological explanation for the affliction.[22]

Carl's turn to his life's profession had other bases besides Annie's emotional manipulations. He was, after all, talented. When he applied himself, as he did occasionally at Harvard, his talent shone, and he was rewarded. He possessed a working knowledge of French. He was physically impressive. Strikingly tall for his time, Carl stood six feet, four inches, was handsome, slender, and trained in fencing and polo. A photograph of the new Harvard graduate shows him standing in a rakish pose, right hand at the small of his back, left hand cocked in his trousers pocket, the beginnings of a quizzical smile on his lips, and with long, wavy hair slicked down over his high forehead (FIG. 2.6). A vest, high collar, key chain, and Prince Albert coat complete the picture of an American aristocrat. He did not lack money. Charles and Annie agreed to finance his stay in France, for while attendance at the Ecole was free, a student's living and traveling expenses could be high.[23]

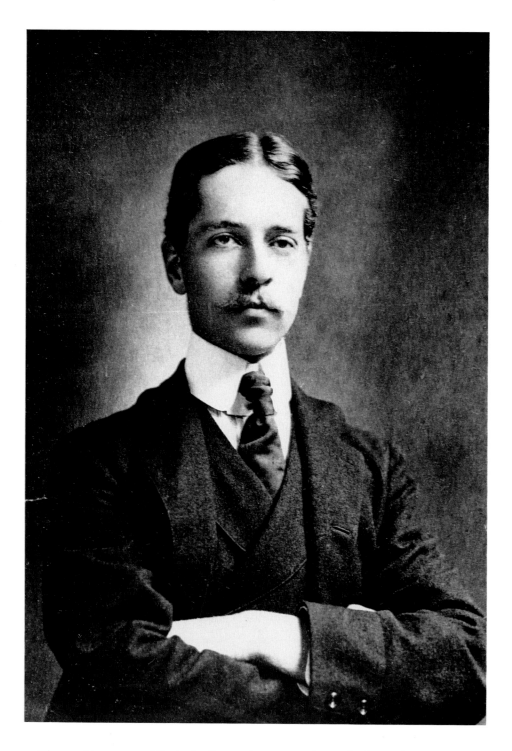

The world-renowned Ecole des Beaux-Arts was at the peak of its influence in the late nineteenth century. Beginning in 1846, with the admission of Richard Morris Hunt, the Ecole became the scholarly mecca for young Americans with career aspirations in architecture, including Henry Hobson Richardson, Charles F. McKim, Bernard Maybeck, and, briefly, the brilliant maverick Louis Sullivan. Ernest Flagg, another former student, wrote engaging descriptions of the Ecole which were published during 1894 in the *Architectural Record*, a series that Gould may have read.[24] Although students referred to the Ecole des Beaux-Arts as a school of architecture, they actually entered the Section d'Architecture, separate from the Section de Peinture et de Sculpture. The architecture section traced its origins to 1671 and the founding of the Royal Academy of Architecture. The Academy lost its "royal" appellation

2.6 Carl F. Gould about age 25.

16

with the Revolution of 1789, and generally suffered through lean times until it was reorganized under Napoleon Bonaparte in 1803. After the restoration of the monarchy, various royal orders of 1816 and 1819 organized the Ecole much as Gould would find it eighty years later, and placed it on the left bank of the Seine, opposite the Louvre. The Ecole expanded from its original site on the Rue Bonaparte until it comprised four buildings, their grounds, and their courtyards running south and west from the junction of the Rue Bonaparte and the Quai Malaquais.[25]

In 1823 the Ecole issued regulations defining the curriculum, regulations amended over the years, but continuing basically as Gould would find them in the days of the Third Republic. The enduring and consequential reforms broadened the curriculum and added a diploma, an award that had gained considerable stature by the time Gould arrived. The Ecole existed to train architects to play their role in making Paris and all of France more beautiful through private or public practice. The French students, especially the winners of the coveted Grand Prix de Rome, could look forward to government sinecures. The Ecole taught that for each problem there existed an ideal—a beautiful solution based on clarity of design and the proper application of proportion, order, symmetry, harmony, and a hierarchy of spaces. Its reigning style in Gould's day was neoclassical, but the students enjoyed some stylistic freedom. Their models included Classical Rome, the Italian Renaissance, the French Renaissance, and with the nineteenth century's growing archaeological knowledge, Classical Greece.[26]

Students at the Ecole followed a routine very different from the structured coursework and annual promotion to the next higher class that characterized United States colleges and universities. The Ecole controlled the entrance examinations, the competitions or *concours* through which students moved from the second to the first class, and the crowning competition for the diploma. It also provided lectures in such topics as architectural history and theory, descriptive geometry, construction, mathematics, and more specialized courses in the sciences, history, French architecture, and other subjects. The lectures were not compulsory and were poorly attended for the most part.[27]

To prepare for the exacting entrance examinations, the student found a master or *patron* of an atelier, a teaching studio. Students sometimes entered a preparatory atelier before, or about the same time that they selected a patron. In any event, a student enrolled at the Ecole as an *aspirant* after, in the case of foreigners, presenting a letter from his ambassador certifying his age and good character. Any male student over fifteen and under thirty years of age could enroll; the Ecole denied admission or continuing enrollment to those past thirty. The gender barrier fell in 1896, but only in October 1898 did the first woman pass the entrance examinations—the diminutive, determined, talented American, Julia Morgan.[28]

Once admitted to the second class, the student applied for the grueling architectural competitions, the concours. These were of two kinds, the *esquisses*, or sketches, and the *projets rendus*, the much more elaborate of the two. Each required the student to enter a cubicle at the Ecole, that is, to be *en loge* for up to twelve hours, and during that time to produce a careful sketch including all the basic design elements of, say, a small railroad station. The projets rendus required the student to leave the sketch behind and take a tracing to his atelier, where he developed finished designs with the help of the patron. These were often exquisitely proportioned and delicately

shaded works of art in themselves. Both concours were rigorously judged; points were awarded, to be accumulated toward admission to the first class, and then toward the diploma. Both the esquisses and the projets rendus forced the student to develop an idea and present it in a polished manner under the pressure of a deadline. There were other examinations in mathematics, descriptive geometry, perspective, and other subjects, the prerequisites for the construction concours, the most demanding of the second class competitions. A student could drop out at any time simply by failing to enter any of the numerous concours offered during a year. Most stayed on for several years, finishing the second class in two to four. The driven Julia Morgan, later the architect of William Randolph Hearst's sumptuous estate, San Simeon, went from admission to diploma in three-and-a-half years.[29]

Most teaching and learning occurred in the ateliers, which were roughly comparable to boisterous fraternities. Students usually chose patrons who had won the Grand Prix de Rome, who had active practices, and whose pupils in turn had won prizes or otherwise done well at the Ecole. Unlike the Ecole, all but a few of the ateliers were unconnected with the government. Most were simply large rooms with tall windows on Left Bank byways, rooms jammed with drafting boards. They could be charitably described as filthy. The students, not the patron, operated the atelier. They elected an experienced student to be the administrator, the *massier*, who collected fees from all to pay for the rent, stove coal, lamp oil or candles, and the patron's fee. The students divided into *anciens* and *nouveaux*. The new arrivals, the nouveaux, usually were subjected to a nonsensical initiation rite. They ran errands for the anciens and drew in the details of their drawings. The anciens helped the nouveaux with their early design efforts, honing their skills in drafting and shading, while urging them toward swift completion of the project. All this went on in an atmosphere of furious work punctuated by drinking, obstreperous singing, and horseplay. The patron appeared two or three times each week, at which moment the uproar ceased while he inspected and criticized each student's work.[30]

Gould plunged into his labors with no trace of diffidence. In October 1898, after only a few months in residence, he took the same examinations that gained Julia Morgan her entrance. It was a brash decision; he failed. Then, or perhaps later, he applied to a preparatory atelier but soon came down with an illness, possibly influenza or colitis, which he attributed to his bad housing. Such bouts of poor health, not mentioned as afflicting his childhood or adolescence, would recur throughout his adult life. Because the first of these illnesses roughly coincided with his radical change in work habits, it may have been induced by exhaustion. Gould's illnesses usually followed stretches of almost demonic labor and probably had some psychosomatic component.

Gould solved his housing problem with a move to 37 Rue Bonaparte, near the Ecole, where he shared rooms with four fellow-students of art or architecture. He formed a lifelong friendship with one housemate, J. Otis Post, son of George B. Post, the prominent New York architect. Gould's health improved, and he worked on through the winter. In March 1899 he left for a tour of southern France, Tuscany, and Rome, a respite almost as essential to Beaux-Arts development as his labors at the atelier and the Ecole. Travel to the sites of great Classical and Renaissance models "provided vocabularies of form and compositional themes from which the present

2.7 Carl F. Gould, park pavilion, design problem for admission to the Ecole des Beaux-Arts, 1899.

should learn."[31] Upon returning he threw himself into his work, and in the fall he again sat for the admission examinations. This time he passed, standing twenty-eighth overall and fourth among the foreigners (FIG. 2.7).[32]

Admittance gained, Gould applied to the masterful Victor Laloux, the patron most favored by Americans, a winner of the Grand Prix de Rome and architect of the magnificent Gare de Quai d'Orsay and the less renowned but marvelously functional railroad station at Tours. The Laloux atelier then included about fifty students. The young men responded differently to Laloux. Some admired his "creative genius," others his teaching, still others his worldly success. Though famous, the great architect had a playful side, as revealed in a mock-serious photograph made in 1890 or 1891 with his students in a courtyard of the Ecole. Laloux is seated front row center and nattily dressed, but with legs apart, a hand on each knee, and his walking stick held carelessly between his left thumb and forefinger. The students, some seventy of them, are arranged around and back of the master and are appropriately hatless. The students on the back rows pose on risers between two Classical statues, and it is here that their irreverence is most noticeable, for the discus-thrower to the right of the back rows has his lowered head piled high with hats, while the seated statue on their left is flanked by two students wearing hats, one of whom has linked arms with the statue.[33]

Laloux's atelier was distinguished from the others by its location in a great eighteenth-century house with beautiful woodwork and broad stairs having such gentle risers that "you sort of fell upstairs, it was so comfortable." Laloux dropped his playfulness and became all business when he visited the atelier to speak with each member about current projects. His belief "in rational change and progress in harmony with the needs of the epoch" informed these discussions, although he held just as firmly "for his profound convictions as to the essence of architectural design." His

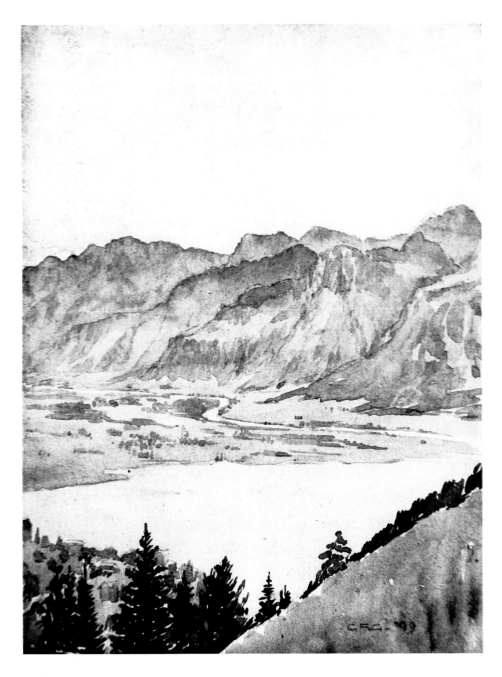

pupils trailed after him while "he went from table to table, giving his criticism to each student in turn; having made the rounds, he would bow, put on his silk hat and quietly leave the room, but no sooner was the door shut than pandemonium would break loose and a noisy discussion of what he had said [would] follow."[34]

Late in 1899 Gould left for a visit to New York. In the spring of 1900 he sailed to Italy, then made his way northward, painting as he traveled. His landscapes from that ramble are among his most charming (FIG. 2.8). He also is believed to have sketched buildings, a requisite activity for students at the Ecole, who were expected to develop a keener sense of proportion through sketching than they could by gazing at a structure or studying a photograph.[35]

By summer he was back in Paris, where misfortune overtook him once more. His sister Edith, his next-younger sibling, suffered an attack of appendicitis while visiting him and died after a brief illness. Edith and Carl almost certainly were each other's favorites; her visit, their birth order, and Carl's paroxysm of work as an anodyne to

2.8 Carl F. Gould, watercolor, valley of the Rhine, Switzerland, 1899.

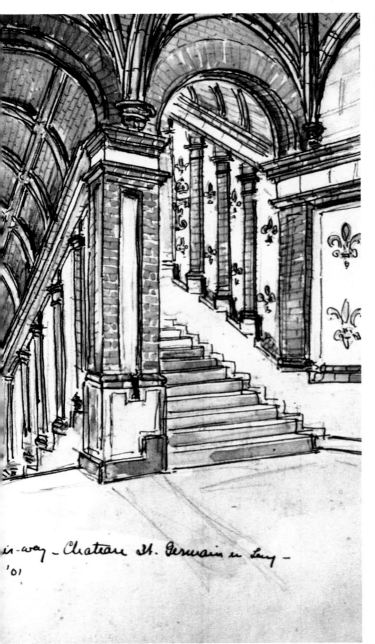

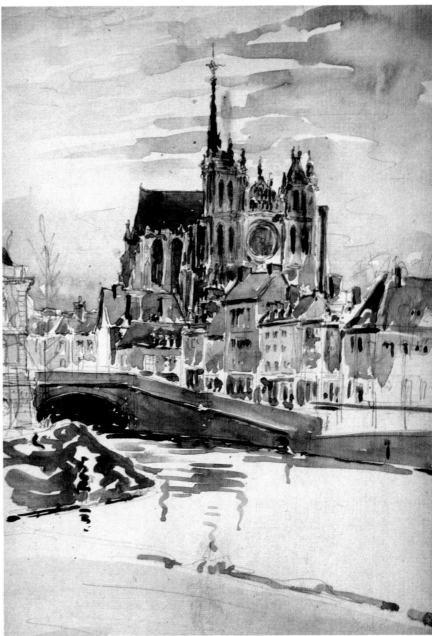

2.9 *Carl F. Gould, ink and watercolor, Château St.-Germain, France, 1901.*

2.10 *Carl F. Gould, watercolor, Amiens, France, 1902.*

grief all suggest that they were close. Gould worked at a furious pace through the winter, producing a rendered design in plan or elevation at the rate of one every four days. He broke his punishing routine in the spring of 1901 when he sailed across the Channel to England. While headquartered at Oxford he studied ecclesiastical Gothic architecture, the same Gothic derided at the Ecole for its exuberance and lack of discipline. During the summer and fall of 1901 and again in April 1902 he traveled to the Coucy-les-Châteaux region of Normandy and to Pas-de-Calais (FIGS. 2.9, 2.10).[36]

Gould's drawing, painting, and design matured during the years after 1900. His watercolors of French and English landscapes were exceptional, displaying a use of colors and whites recalling the best work of John Marin, a contemporary American painter. His drawings nicely captured architectural details, while his student work earned him many honors by 1902, including a second-place medal in decorative design (FIG. 2.12). Gould garnered a first mention for a concours entry, an alpine hostel (FIG. 2.13). The hostel rises above a rusticated stone base at once heavy and well-

proportioned, set on a promontory against a mountain backdrop. Drifted snow is piled about the base and its roadway approach. The hostel itself combines Romanesque, English, Italian, and Swiss elements in a manner both imposing and welcoming. It is a classic Beaux-Arts rendering that refutes the notion of Ecole dependency on Roman models.[37]

Despite these proofs of his ability, Gould never qualified for advancement to the first class because he could not pass the mathematics examination, a prerequisite for the construction concours, the ultimate second class competition. Possibly he could have cleared the mathematics hurdle by traveling less and focusing his considerable energies on studying. But for Gould, there was little point in doing so. He was weak in mathematics and disliked the subject intensely. Sketching, painting, collecting architecture books, and traveling were valuable experiences to be savored then and in later life, experiences much more pertinent to his future than passing a math exam. Besides, time was running out. He failed in April 1901, and faced months of cramming should he have elected to try again. He might or might not have passed before he turned thirty in November 1903, when he would be barred from further competitions, math or no math. In the early twentieth century it was enough for an American to have studied at the Ecole, whether or not the studies resulted in a diploma. Gould left the Ecole with no recorded regrets.[38]

2.11 Carl F. Gould, pen drawing, Coucy, France, 1901.

2.12 Carl F. Gould, model for composition décoratif, *Second Prize, Ecole des Beaux-Arts, 1902–1903.*

When Gould left the Ecole he also left Paris, the great city that had been his principal residence for five years. It is tempting to consider the Paris of 1898–1903 a mature city, elegant and sophisticated compared to the upstart New York; the urban center of an ancient civilization and the focus of French banking, finance, and manufacturing as well as the font of fresh artistic endeavor. All that was true, yet much of Paris was comparatively young, rapidly growing, and in a perpetual state of transformation. The city described a great oval defined by concentric-ring boulevards with major east-west and north-south crossings and broad axial streets. Napoleon III and his Prefect of the Seine, Georges Eugène Haussmann, had planned most of the broad boulevards beginning in the 1850s. A few were still under development in the late nineteenth century. Many of the 100,000 trees planted during the Second Empire were still growing to maturity. The famed Opera building was a mere twenty-three years old when Gould arrived. The Eiffel Tower, built for the 1889 exposition, was only beginning to outgrow the blasphemies heaped upon it and transmute into an accepted, even loved, fixture on the skyline. The famed parks, the Bois de Boulogne and the Bois de Vincennes, were only a few decades old in their public incarnations.[39]

The uniform heights of the buildings along the grand streets and boulevards still held, but the controlled facades were just giving way to innovative designs. Modified building regulations in the 1880s permitted some variety. From 1898, the year Gould arrived, to World War I, the municipal government awarded six prizes annually for creative facade treatments. Round-the-clock construction began on the Metro subway in 1898, choking the streets with earth and materials. The first section opened in 1900, in time for the latest exposition, but the heaps of debris and equipment were a staple of Parisian life for years. In 1899 Gould took an afternoon stroll through the

2.13 Carl Gould, Hostel in Alps, First Mention Award, Ecole des Beaux-Arts, 1900.

exposition grounds, finding "a city of construction, of details of architecture finished and unfinished," with "avenues of white walls" that "looked very impressive in the autumn mist."[40]

Yet much remained to be done. In 1900 the urbanized area in and around Paris held four million people, some living in vile slums. A cholera epidemic eight years earlier had claimed 906 lives. Tuberculosis was prevalent. The wide streets were fouled with horse excrement, the generous sidewalks cluttered with peddlers' carts and kiosks and littered with trash. A toilet in each dwelling unit was considered only as an ideal, and as late as 1906 a housing official declared that bathtubs and showers were "luxury devices."[41]

Gould had ample opportunity to experience both the elegance and the vulgarity of public life in a sprawling city still being formed. Alone or with his atelier companions, he gazed along the vistas, upon the monuments, boulevards, and great buildings, the masterpieces in the Louvre, and the demimonde of the Left Bank. Some of these scenes he did not report, at least not to his "Dearest Mama." In 1902, however, he wrote to her that he was awestruck by "the new vista that has been opened from the Champs Elysées to the [Hôtel des] Invalides," which he described as "the most strik-ing of the sort I have ever seen. The exhibition buildings being all torn down, that fine old building stands out in its full grandeure. Its stone is dark in color & in the distance looks very blue, its guilded dome rises up in the middle and illuminates the whole mass."[42]

Then there was the dense fabric of the city behind the boulevards; the grocers and butchers, the used-book dealers, and the small shopkeepers who supplied the middle class, as well as the eager students at the Ecole des Beaux-Arts. Gould haunted the bookstores, where he searched out more than sixty antique books. They supplied the foundation of a design library that eventually totaled about two hundred volumes. His collection of lavishly illustrated treatises included Jacques François Blondel's *Architecture Françoise*, Julien Gaudet's *Elements et Théorie de l'Architecture*, and P. M. Letarouilly's *Edifices de Rome Moderne*. The engraved plates in these volumes were important though not exclusive design sources for many projects of his later years. His later interest in city planning probably sprang from his experiences in this great city, a city planned but not closely controlled, a city dynamic but not desperately chaotic.[43]

Gould revealed his mature self in the five sketchbooks he kept during his last leisurely trip before returning home. While traveling from Sicily in March to Venice in June 1903, he recorded acute observations of form and color in architecture, interior decoration, and landscapes. He filled his notebooks with measured plans of monu-mental architecture, architectural details, color studies, and sketches of the beautiful faces of women seated at sidewalk cafes. In Venice (FIG. 2.14) he sketched objets d'art and noted their prices. He visited at least six famous Italian villas, among them the Villa Petraia near Florence, an ancient, fortresslike construction with a high parapet and central tower, and the Villa Gamberaia, a later Tuscan marvel. Renaissance Gam-beraia, with its unusual broad swath of turf, its formal water-garden with reflecting pools and topiaries, and its hazy view of Florence in the distance, is a designer's dream. Gould prepared sketches of the garden plans at Petraia and Gamberaia, as well as those at Conti, Corsini, Pamphili, and di Papa Guilo (FIG. 2.15). Everywhere he

2.14 *Carl F. Gould, watercolor, Venice, Italy, 1903.*

2.15 *Carl F. Gould, pencil sketch, Villa Conti, Italy, 1903.*

observed and noted buildings, artifacts, people, and gardens.[44] Gould's experiences during this tour, when blended with the knowledge he had already gained, created a deep well from which he drew later in his career.

When he left Europe, Gould retained the slender frame that so well displayed his impeccable dress. His hair was receding above his handsome, slightly ascetic face, and at the age of twenty-nine he was older than most fledgling architects. His maturity offered advantages. He had enjoyed the use of money, had assimilated a variety of experience, and did have a keen mind. His early tutoring and his schooling at Phillips Exeter, Harvard, and the Ecole were the privilege of only a few. The Ecole had taught him rapidly to reduce a problem to its essence, and to assemble the essentials in a quickly developed, expressive sketch. It was the essence that mattered. "An architect's training is very largely to see the thing in the big way, comprehend a place as a whole," he informed Annie in 1901. Several months later he wrote that the "'parti' or general scheme . . . is the first & important thing." Untrained people "do not understand this, and if a building or garden pleases or displeases them, it's rather the ornament" or other details that influence their judgment. Not that ornament was unimportant. When Gould enrolled in the "composition decoratif," he found it "most excellent . . . for seeing things in their . . . saliency." Knowledge of modeling, he thought, would help an architect in organizing his ornament "and in directing any sculptor he may employ."[45] The integrative bent of his Ecole training is best revealed in the careful ornament and symbolic sculpture of his buildings at the University of Washington.

Gould also gleaned much from his personal associations. No one could work five years, off and on, at a Paris atelier without learning how to survive in an environment at once keenly competitive and intensely supportive. Here he rounded and smoothed his notably friendly disposition. His close friends from the Laloux atelier included J.E.R. Carpenter, with whom he established a brief practice later in the decade. In 1903 he joined the Society of Beaux-Arts Architects and continued his membership after his later move to the West Coast. Yet Gould obviously preferred his own company; most of his travels in Italy and England were solitary, for his journals mention no one else, and he recalled only one companion on some of his trips through France. Such times were opportunities to reflect, and to assimilate his experiences as well as to study, observe, paint, and sketch.[46]

For a man of Gould's developed talent, patrician background, and elite education, the next eight years were frustrating. He endured a series of minor jobs with major firms, a brief and unrewarding partnership, and a bout of serious illness. Gould's Harvard class reunion report of 1913 asserts that upon his return to New York he joined McKim, Mead & White. New York's largest, most prestigious architectural firm was then at the height of its reputation, widely recognized for a breadth of design that included large-scale campus and transportation planning. It was also a model for office practice and the post-university training of young architects.

Though there is little doubt that he worked in some capacity for McKim, Mead & White, Gould's employment there cannot be verified. A supposedly comprehensive listing of employees in the firm does not include him, and in any case draftsmen were not important enough to sign drawings or to conduct correspondence. The probabilities are these: the list is incomplete; or Gould's work was sent to him on a fee basis; or he worked in the McKim, Mead & White offices while on loan from an obscure em-

ployer whom he preferred not to mention. Gould certainly exaggerated his role in the design of various early buildings and projects, but a spurious claim of employment would have become known among a wide circle of friends and acquaintances, and is therefore most unlikely.[47]

Whatever his relationship with the firm, he was set to work on the construction drawings for New York's Pennsylvania Station, a massive, magnificent neoclassical structure. He detailed the skylights above the concourse, a huge, starkly functional space of concrete and latticed steel contrasting with the Beaux-Arts flourishes and polished marble of the waiting room. The skylight experience stood him in good stead years later; his skylights for the School of Mines and the Henry Gallery on the University of Washington campus, and for the Seattle Art Museum in Volunteer Park, proved both durable and effective. He also was assigned to the new building for the Brooklyn Institute of Arts and Sciences (begun 1897), an ungainly Beaux-Arts structure from which his first sketches for the Seattle Art Museum derive. His role in the Brooklyn design was minor, as was his work with the Prison Ship Martyrs Memorial in Brooklyn. He claimed participation in three competitions: the Peace Palace at the Hague, an armory in Hartford, Connecticut, and a school in East Orange, New Jersey. Before or after McKim, Mead & White, or perhaps on loan from that office, he may have worked for Carrère & Hastings. There is no evidence that he undertook any important work for that firm.[48] The chance of handling a major design for any of these organizations was remote, and the opportunity for a partnership dim indeed.

Stated bluntly, Gould was going nowhere in New York. The West held more promise; therefore in 1904 or 1905, he probably appealed to his Beaux-Arts friend and classmate Edward H. Bennett (1874–1954) to find him a job on the staff of Daniel H. Burnham's new plan for San Francisco. Bennett, though a year younger than Gould, was already a valued member of the prestigious D. H. Burnham firm of Chicago. Burnham was well known for his leadership of the World's Columbian Exposition and his 1902 plans for Washington, D.C., and Cleveland. In 1904 he accepted the San Francisco commission from the Association for the Improvement and Adornment of San Francisco, a private, elite male group. By May 1905 Gould's participation had been arranged. "The work will be varied," Bennett assured him, adding that "all reasonable living expenses will be paid." Gould arrived in San Francisco on 4 June. He worked at the company bungalow on Twin Peaks under the direction of Bennett, and with Willis Polk (1867–1924), who would later, for a time, head a San Francisco office of D. H. Burnham & Company. At times "at least eight" planners worked at the bungalow, but only Bennett and Gould lived there permanently. Most evenings the others went home, leaving the two of them on Twin Peaks. Gould wrote to Annie, "It's pleasant to have the place to ourselves after the rather strenuous day."[49]

Gould profited from his San Francisco experience. He learned the aesthetic and practical values of City Beautiful planning of "public Plazas and parkways and terraced garden architecture," as Bennett put it. It was an approach to urban solutions that Gould later supported in Seattle. He saw the developing residential and commercial architecture of the Bay Area. He renewed his friendship with Bennett and developed one with Polk, friendships he maintained through the years. He worked on the presentation drawings for the association that sponsored the plan. It was a responsi-

ble task that maintained his skill in rendering. A number of sketches and renderings in the published San Francisco plan bear a close resemblance to Gould's known work (FIG. 2.16).[50]

2.16 Drawing from Report on San Francisco Plan, *D. H. Burnham with Edward Bennett, probably by Gould, 1905.*

Moreover, Gould's association with Bennett and Polk exposed him to the Burnham company's leadership in commercial architecture, even though there were few examples of Burnham's designs in San Francisco at the time. The exposure revealed Burnham's rejection of ponderous, lithic Romanesque in favor of lighter, more structurally expressive Neoclassical. The powerful turn-of-the-century reaction against Richardsonian Romanesque was not fully justified, but contemporaries, including Gould, applauded it. Several years later he praised Burnham's "courage" in leading the way toward a new architecture. "Great heavy reveals, circular headed windows encumbering the steel frame, gave way to . . . terra cotta; walls were turned into glass."[51]

Yet the San Francisco sojourn was not satisfying. Gould worked under Bennett, who was not only younger but secure in Burnham's esteem, and a coming talent in architecture and city planning. Gould was also practically if not organizationally subordinate to Polk, whose achievements rested on a genius and grit that overcame his rootless artisan background. Polk was a daily reminder to the elegant, highly educated Gould of his own modest attainments, even if Polk, as mercurial as he was sociable, never mentioned their profound differences in background. As for Burnham himself, Gould was beneath his recorded notice. Burnham's diary mentions lunches and consultations with Bennett and Polk, but not with Gould. Burnham was a kindly man who would have treated Gould courteously during his visits to San Francisco, but

Carl could not have escaped the realization that Burnham's favor fell on others.[52]

Worse, perhaps, was San Francisco's failure to be a viable alternative to New York. Gould's first impression was of "a more fertile country . . . than almost any I have ever seen." On 13 July he found the city itself to be not as "noisy" or "congested" as New York, but the pace of life was too relaxed for his taste. He wrote that "living suggests greater corruption in that there is less demanded of you." Riding and golf occupied some of his time, but there was "little going on" socially. He confessed, "I haven't yet felt any desire to stay out here." Six days later he had not changed his mind. "The fogs come in just the same and the winds rattle the bungalow," while "most all the extra moments are spent in discussion of the plan, and it has become a thoroughly absorbing subject." But it was the plan and not the city that kept him in San Francisco.[53]

Following his San Francisco sojourn, Gould had an illness portentous for his long-term future. In the fall of 1905, shortly before the presentation of the original plans and illustrations to their sponsors, he left for New York, taking a round-about trip through Seattle, perhaps intending to continue into Canada and view the scenery while traveling east. He left the train in Seattle suffering from appendicitis, or colitis masking as appendicitis. Friends from Harvard arranged for his hospitalization, secured a Harvard-trained specialist to treat him, and attended to his needs during a six-week recuperation. Illness aside, Gould's impressions of Seattle were favorable; he would stake his future on the city three years later.[54]

Once back in New York, Gould may have rested, or he may have returned briefly to McKim, Mead & White. From late March through July 1906 he was in the office of George B. Post & Sons, a berth probably secured through J. Otis Post. Gould later claimed that while at Post he "had charge of the Madison [Wisconsin] State Capitol competition won by that firm." The claim is exaggerated at best. He may have done some of the presentation drawings that so enchanted the competition commission and the Wisconsin public, but the Posts themselves kept a tight rein on their entry. The designs soon were modified under the senior Post's direction. Gould also claimed to have developed the plans for the armory of the Second New York Field Artillery Battery. It is more likely that the Post interlude was simply another experience with a large, illustrious firm to which Gould was called because of his skill at rendering. The friendship with J. Otis Post survived his brief association with the firm; Post later invited Gould to be his representative at the construction site of Seattle's Olympic Hotel (1923–24).[55]

In the summer of 1906 Gould shifted his sights to a partnership with Walter Blair, who had entered the Ecole des Beaux-Arts in 1898, ranking first among the foreigners and fourth overall. Blair was by then Gould's brother-in-law. The other partner was J.E.R. Carpenter, who had arrived at the Ecole in 1901 and joined the Laloux atelier. The trio designed some rather heavyhanded homes for the suburbs—stone, timber, and stucco piles that were common at the turn of the century. They submitted an unsuccessful proposal for a Confederate monument in Richmond, Virginia. Their most accomplished work was one in which Gould took the lead, their third award entry in the 1906 competition for the new campus of Union Theological Seminary, located northwest of Columbia University. Gould's primary authorship of the design rests on the fact that at the dissolution of the partnership, he received the original ink-

on-board drawings, even though he was away at the time, and it would have been an easy matter for either Carpenter or Blair to have retained them.[56]

The competition was important in New York and demonstrated how well Gould could apply his mature skills to the solution of a problem much like one he could have been handed during a projet rendu at the Ecole des Beaux-Arts. The seminary desired "a carefully studied general scheme only" for a completely equipped plant to be constructed as funds allowed on a rectangular site bounded by Broadway on the east, Claremont Avenue on the west, One-hundred-twentieth Street, and One-hundred-twenty-second Street.[57] Gould's entry was a deft amalgam of Beaux-Arts planning and the required Gothic styling. He wrapped the perimeter with buildings, leaving the interior free for a landscaped yard on the south, facing the museum-library, and a service yard at the north end behind the library stacks. His facade designs were late Gothic, with the cross gables on the roofs and the flatness of the surface, especially on the Broadway facade, suggesting the influence of the brilliant, reclusive Henry Vaughan (1845–1910). The general plan, however, is Beaux-Arts, especially the axial symmetry of the quadrangle, which served as a forecourt of the museum-library (FIG. 2.17).[58]

Gould was enormously proud of his design, for he later implied that it had won the competition. Yet it is evident why his hopes were frustrated. His walled entrance faced Claremont Avenue, in contrast to the open, inviting gallery of the winning Allen & Collens design. He may not have known of the concern within the seminary for buildings "substantial rather than ornate," for his library and museum did not at all appeal to it. The museum-library building stood in the center of his composition,

2.17 *Carpenter, Blair and Gould, ground plan, Union Theological Seminary Competition, 1906.*

organizationally ideal and functionally superb, for it expressed the nuclear role of the library at an educational institution and was easy of access. It was cheaper, however, to build the library into the east, or Broadway wall, as did the Allen & Collens entry. If all this were not enough, some of his elevations appeared to be hastily drawn in pencil, while the other entries were completed entirely in ink.[59]

After his consuming work on the Union Theological Seminary competition Gould again fell ill. This time the pressures of work and disappointment may have resulted in deep depression or some other sort of breakdown, or the diagnosis may have been the dreaded tuberculosis. In any event, he retired to a sanatorium at Saranac Lake, New York, in the beautiful Adirondacks, where he remained for fifteen months. There he spent long hours resting out of doors, imbibing a "spirit of friendliness," and, as always, observing the architecture, for the romantic buildings around Saranac may have influenced his later rustic designs in the Pacific Northwest.[60]

Gould's other relationships in New York are problematic. He may have learned the principles of landscape architecture from the work of the Olmsted Brothers, the premier landscape architects and designers of the Brooklyn Art Museum grounds, while he worked on the museum project. He may also have developed personal connections with members of the firm. It is almost certain that he knew Charles A. Platt, then a fashionable New York residential architect, professionally, socially, or on both levels of association. One of Gould's first projects in Seattle was to act as Platt's representative during the construction of the R. D. Merrill house (1909). In the unspecialized world of Seattle architecture, Gould would become a society architect, and his early designs would reveal an indebtedness to Platt's widely published plans and facades.

In the summer of 1908 Carl Gould made his momentous decision to go to Seattle and throw himself into the artistic life of the rough-hewn community he had visited three years earlier. The circumstances surrounding his choice were remarkably similar to those that had precipitated his decision ten years earlier to enroll in the Ecole des Beaux-Arts. He vacationed in England with his family, and while vacationing once more considered his future. His determination to go to Seattle at last ended what Erik Erikson has termed the "psychosocial moratorium," a prolonged adolescence conditioned by the actor's social situation and historical circumstances.[61] Gould's family had encouraged his delayed maturity when it endorsed extended and expensive study, so long as the education was directed to a definite end. His elite background assured him a continued "moratorium," a postgraduate education with prestigious firms at or near their peak of architectural influence. His partnership with Carpenter and Blair, an earlier effort to assume full adulthood, collapsed with the failure to win a coveted commission and was followed by illness. Gould's exaggerated memories of this phase of his life strongly suggest the denial of a lengthy and rather unproductive apprenticeship, and an effort to construct in its place a past of mature professional progress consistent with his family's expectations.

Gould's later comments about his decision reinforce that view. He said that on returning to New York, he found it "difficult to regain lost ground." The statement was as ingenuous as his declaration that he had "wandered out west by chance."[62] In truth, there was no lost ground to regain, and Carl Gould did little by chance. At thirty-four Carl, no longer youthful, had no reason to remain in New York, where his

talents had never been well rewarded. He knew the futility of beginning again with a large firm, working at odd jobs under the direction of men younger than himself. His effort to establish an independent office had collapsed with the failure to secure the Union Theological Seminary commission and the onset of a prolonged illness, events that did not augur well for another attempt at a partnership. The life of an educated, wealthy dilettante was open to him, but only at the risk of Annie's everlasting scorn. The prospect of a healthier life in a less urbanized place was a powerful incentive. Moreover, his assets were formidable: a well-honed talent, keenly developed architectural skills, parents who would underwrite another professional venture, a breadth of patrician experience including foreign residence and travel, a graceful, athletic carriage and good looks, an appealingly gregarious personality, and a driving ambition to rise from his status of unemployed journeyman architect. Carl Gould arrived in his adopted city about November 1908.

My own instinctive belief has led me to the common fact that architecture and art have a common source. — ALVAR AALTO[1]

3 Community Involvement and Residential Style, 1909–1914

UNKEMPT, BUMPTIOUS, AND REDOLENT OF THE FRONTIER, Seattle in 1908 seemed an unlikely place for a European-educated scion of Eastern wealth. Its downtown stepped back eastward from Elliott Bay along steep streets that extensive regrading made barely tolerable to healthy pedestrians. Except for a Richardsonian Romanesque ensemble around Pioneer Square, at the south edge of downtown, there was little impressive commercial architecture. Residential hills circled the central core in every landward direction except due south. A few brave northerly extensions aside, almost all the city's 237,000 residents lived within 5 miles of downtown. Modest houses were the norm; most of the relatively few big homes on the hilltops were capacious rather than elegant. Persistent winter rains turned unpaved or water-bound macadam streets to mud, so the city paved with planks, granite, sandstone, brick, and asphalt. It could not keep up with expansion, however, leaving many developers' streets to be graveled at best. Straggly firs or cedars, survivors of lumbering, sometimes formed the staples of neighborhood landscaping.[2]

Gould looked below these surface appearances to the fundamentals of topography, climate, population, and wealth. Seattle's site resembled a giant hourglass, pinched at its waist by intrusions from saltwater Puget Sound on the west and freshwater Lake Washington on the east. A series of bays and inlets as well as Lake Union between the Sound and Lake Washington, just north of the city's waist, created a richly varied pattern of land and water. Hills, plateaus, and ridges offered spectacular views of deep ravines, lakes, the Sound, the Olympic Mountains on the west, and the Cascade range to the east. Mount Rainier's near-perfect cone, visible to the southeast on a clear day, was the centerpiece of this visual delight.[3]

The climate was much milder than Seattle's latitude would suggest, for Puget Sound and the nearby Pacific Ocean moderated the temperature. The September-through-May rains supported a luxurious coniferous and deciduous vegetation. Cloudy and cool days, or mottled days varying from light rain and clouds to mostly clear conditions occurred, as did other more typically midcontinental periods of rain or sun. This meteorological mixture varied still more the visual experience of water and land.

Natural splendor was all very well, but there were other tangible benefits. Gould arrived near the end of a delirious decade, when Seattle's population had grown to 237,194, a net gain of 156,523, an increase of 194 per cent in ten years. The boom rested on ocean shipping, transcontinental railroads, lumbering, the coal trade, banking, and real estate. Commercial ties to Alaska had been especially strong since 1897, when the steamer *Portland* docked with a cargo of $800,000 in gold from Canada's Yukon Territory and stories of the fabulous wealth there to be had at the flip of a gold pan. By 1900, goods worth $20,000 moved through Seattle bound for Alaska, every day of the year. Shipping spawned the usual hard-bitten, tough customers and colorful characters found in port cities, but two factors limited the size of a casually employed underclass. There was little primary manufacturing in the city, and workers associated with lumbering or coal mining lived with their families in the surrounding coal and timber country.[4]

Furthermore, the wealthy in Seattle were beginning to assert themselves. A few of their homes in restricted subdivisions were grand, not just big; and more grand homes were coming. Several major downtown structures were being designed by Howells & Stokes of New York, the architects and planners of the Metropolitan Tract, comprising four blocks of the former University of Washington campus, a property whose income the state reserved for the university. They would in time include two stalwart essays in neoclassicism, the Cobb and the White-Henry-Stewart buildings. The tide of prosperity lifted building construction from $7,500,000 in 1905 to $19,000,000 in 1909. Activity fell off after Gould's first full year in Seattle, but nonetheless remained strong for several years. There would be plenty of work for an academically trained architect who made the right connections, especially since the wealthy were developing clubs and organizations bespeaking their interest in learning, culture, exclusivity, and in a citywide unity that transcended their scattered residential enclaves. Such an architect would be a rarity among the local practitioners, most of whom easily stepped over the then-permeable boundary between engineering and architecture, or who simply hung out their shingles after some experience as builders.[5]

The most visible emblem of boosterism, locally called the "Seattle Spirit," and of trade aspirations, was the developing site of the Alaska-Yukon-Pacific Exposition, a major regional "fair" on the still-new grounds of the University of Washington. The new campus sloped upward from Lake Washington's Union Bay and the projected waterway to be cut between Lake Washington and Lake Union. The exposition buildings rose under the supervision of John Galen Howard, a Beaux-Arts student and founder of the architecture department at the Berkeley campus of the University of California. John C. Olmsted, designer of the Seattle park system, and his assistant James F. Dawson represented Olmsted Brothers, the landscape architects of the exposition. The A-Y-P opened in 1909, site-oriented so that a breathtaking vista of Mount Rainier formed its backdrop. Its 3,750,000 visitors would see one of the last fairs modeled on the Worlds' Columbian Exposition of 1893.[6]

Gould immediately set about exploiting the vital interplay of environment, growth, city building, and commercial expansion in Seattle. His purpose was nothing less than to enter at once into the cultural and educational life of the elite, move quickly to the front rank in architectural practice, and to become involved in areas of civic activity, such as city planning, which would reinforce his other drives. Gould laid his ground-

work carefully, arriving with a letter of introduction from Edward H. Harriman. He moved into the University Club, where he quickly made close friends, among them Oliver H. P. LaFarge, son of the renowned painter John LaFarge; Valentine H. May, and Marshall Bond. All these men were well connected. Gould joined the newly formed Fine Arts Society and the Washington State Chapter of the American Institute of Architects (wsc), becoming active in both, and moving into leadership positions.[7] Later he joined the Monday Club, founded in 1906 by a group of cultured men committed to thoughtful discourse. The Monday Club, called the "Brains Club" by outsiders, met regularly for dinner to hear one of their number give a brief paper on some matter of intellectual substance, which was followed by discussion. Gould's presentations were superior. "We had only seven or eight present but a good paper and a good discussion," the club president wrote after one of his efforts. Gould rarely made rambling addresses to any forum. Although he was sometimes careless about details, his numerous corrections of articles and lectures show that usually he crafted his texts with care.[8] Meanwhile he was systematically extending his memberships in social and cultural organizations.

Gould's desire to exploit the relative openness and fluidity of Seattle's elite had a dimension beyond his ambition for success: his compelling desire to leave behind a career laden with potential but lackluster in performance, to end his "psychosocial moratorium." In 1929 he confessed to Annie that "in 1908 I was very much discouraged due largely to my inadequate health. I believe the new environment did much to give me new courage which would have been impossible if I had stayed in New York." Seattle was also a fresh field on which to deploy the dominant parental traits Gould long since had selected for himself. The senior Goulds' lengthy and powerful influence over him had led him to become his parents, in the sense that he blended the most distinctive psychological features of each, and used them reciprocally to advance himself. The traits he selected were, from Annie, her absolute commitment to the collection, enjoyment, and dissemination of beauty, and from Charles, his unfailing gregariousness.[9]

Gould undertook to do nothing less than lead his adopted raw boomtown toward the beautiful. His friendliness would facilitate his entrance into the right architectural firms, clubs, and associations, and, after a decent interval, assure him positions of leadership. But he could not reach his goal until he had achieved an inclusive organization. He strove throughout his life to create unifying and synthesizing organizations that would coordinate the artistic, educational, and cultural life of Seattle and the Pacific Northwest. His hopes for a unity that would overcome quarreling and divisiveness went unrealized, but he never surrendered them. His highest ambition was to achieve the beautiful while acting as the cordial, sympathetic leader of a holistic, organic group.

Gould did not often fully articulate his ideal of beauty, for it was safer to rely on a consensus arising from the cultured and genteel than to risk divisions by forcing the issue of definition. When he did express himself on the subject, he spoke without reference to any specific project, but instead identified beauty with two themes, the vital force of the architect's work, and the search for an American style of architecture. "We cannot easily describe the fervor or feeling of bringing into being something that the

world wants," he said, whether house, church, or bridge, but when "we add an element of what is recognized as beauty, the pleasure of creation is greatly intensified." Beauty, he insisted, "is the very soul of our profession."[10]

But what was beauty? It was a symbolic and expressive creation of culture and nationality evoking positive emotions. The pyramids of Egypt connoted the "spirit of universal man," while the Egyptians' court architecture "expressed the spirit of their race" in its stolid, planar forms "and somber interiors. Stability, endurance, finality are the feelings we have in the presence of these big hypostyle halls." Medieval architecture produces "a series of entirely different emotions" based on verticality. "The whole seems not borne by earth but something hung in the air. . . . A vibrant atmosphere grips us." The "emotional appeal" is in its "aspiring to infinity." Greek architecture could be appreciated "by the highest type of mind" through "the intellectual relationship of its parts and the exquisite refinement of all its elements." The Romans emphasized "sumptuousness of detail" and "a variety of forms . . . without which the monuments of the past could not have emotionalized the world down through the ages."[11]

Gould's Beaux-Arts training underlay his commitment to a soul-inspired search for an American style (see CHAPTER FOUR), for he consciously or unconsciously identified the realization of beauty with the perfect solution to the architect's problem. The Beaux-Arts taught that an architect had to consider the environment of a building in order to complete a beautiful project. The environment was not an easily comprehended surround of a structure, but rather a complex medium requiring systematic thinking, or more exactly, thinking in systems, to answer the questions it posed. What were the characteristics of the site in terms of its topography, climatic variations, prevailing winds, overall setting, and the sun's track above it? For what purpose did the client want the building, and how should that function be expressed? What system of window design would best meet the conditions of site on all sides of the building and at the same time contribute to the unity, harmony, and proportion of the completed construction? When all these questions and many more were successfully answered in the context of contemporary American conditions, then beauty, as well as an American style, would be achieved. It was a conception that Gould would later extend to regionalism and urban design.[12]

Gould faced the problem of an American style directly and spoke to it concretely when he was only four years into his Seattle practice. Walter R. B. Willcox, the president of the WSC, forced Gould's hand with a 1912 presidential address. Willcox's speech reflected his knowledge of modernist theory and his friendship with Frank Lloyd Wright. It presaged his rejection of Beaux-Arts methods when, ten years later, he became chairman of the Department of Architecture at the University of Oregon.[13]

Willcox criticized architects' reverent "attitude toward precedents which acts as an obstruction to the realization of our ideals as a separate people, a great nation." He asked if an adherence to "historical association" and the production of "synthetic archaeology" had diverted architects from developing a national style derived from the "conditions of our own climate, of our own social and business activities." Contemporary architects were, he claimed, criticizing "certain more adventurous souls" who were "searching new fields for ideals," while doing less well at developing an American architecture than did the vernacular builders of the Colonial era. He asked

whether attention to "the superficial endowments of architecture . . . has dulled our appreciation of its essential and inherent qualities, mass, proportion, silhouette, color, texture, scale and fitness?" Worse, the traditional architect did a disservice to the client and the public at large while taking refuge in security in ancient styles. The traditionalist "misdirects the client's attention and insidiously instills in his mind the notion that architecture is a sort of cloak to be thrown over structure, any one of the different styles of which is equally appropriate to any combination of conditions." The "more accurately" the historicist reproduces a past style, "the more certain he is to receive the commendation of the supposedly intellectual portion of the public, to escape, at least, violent criticism and to find himself in a position eminently safe if not altogether sane." Willcox disavowed issuing a "'Call of the Wild,'" but he did ask his listeners to free themselves from "intellectual bondage," to listen "to those wonderful harmonies which are infinite and eternal," and "far beyond our intellectual ken."[14]

Willcox stung Gould. In a paper which Gould intended to deliver to the wsc but probably, on reflection, did not, he praised Willcox for opening "various gateways for discussion which we are rather too apt to keep closed." He agreed with Willcox that Sullivan, Wright, and their adherents should not be discouraged or ignored, and that all architects "should be broad minded and not fear contamination." He acknowledged that "men such as the Chicago group have been able to stand opposition and branch out into what they consider creative independent work," and that their architecture was "an example of design independent of the clients' prejudices." He admitted that Wright and his coterie could "stimulate into vitality architectural expression which has grown mossy with age," and he tentatively agreed with Willcox that "the progress of architecture and the other arts" depended on sometimes outrageous creativity.[15]

Beyond these concessions Gould would not go. His Beaux-Arts training and his adaptiveness counseled a golden mean. "Between these extreme radical individualists," he wrote in reference to the Chicago and Prairie schools, "and the slavish copyist there are all degrees and variations. . . . Any Architect who takes his profession seriously and has somewhat studied along lines of adaptations of means to an end must bring into play some individual expression." He defended the associational psychology and cultural memory involved with the appreciation of ornament and form. He wondered "just how far it is possible to throw over the traditions of the past . . . the established relation and proportion." He asked if ornament "could exist or have any meaning unless it is evolved from some previous form. Architecture is almost entirely an abstraction," and its ornaments "are almost altogether abstractions of reality." Therefore an architectural form, whether or not from the hand of an innovator, "can only have an appeal in so far as it has been previously understood." Wright and the rest were bound by the ineluctable mechanism of the human mind, which "does not find interest in a form unless it has had previous cognizance of its existence."

Gould remained unreconciled to picturesque successionism. "We may dislike and probably do dislike the work produced by the group of Chicago architects." It was an unusually harsh judgment for the genial and accommodative Gould. He may have been temporarily angry with Willcox for his apparent dismissal of the Beaux-Arts absorption in the problem and its solution, or for his belief that the architect dictated style to the client and not the other way around. He may have seen himself unflatteringly reflected in the mirror held up to his professional gaze. Gould remained com-

mitted to innovation, but an innovation bounded by a national style appropriate to the problem and to the cultural heritage of the West.

A true American style, then, was still developing, but Gould's career could not wait for it. He began work as a draftsman with Everett & Baker. The only surviving study from his brief employment is a proposal for St. Mark's Episcopal Church at Broadway and Harvard Avenue, a well-proportioned sketch in the Gothic style. Soon he moved to the office of the established Daniel Huntington, where he became an associated architect, an arrangement forecasting his long relationship with Charles H. Bebb. Associated status, for all practical purposes a partnership, was a remarkable endorsement of Gould's ability and his prospective capacity to garner his own clients.[16]

Gould's first built project in Seattle, in association with Huntington, was what would later be called a multiple-use building (1909) (FIG. 3.1). A first story of slender, widely spaced, rough brick piers was designed for retail uses at the northwest corner of Thirteenth Avenue and Jefferson Street. Two apartment floors rose above, the second story carrying up the rough brick around conventional windows, the third finished in stucco. The building is a good example of its type but remarkable chiefly because of its autobiographical references. The bay windows at the corners and in the middle of the Thirteenth Avenue facade reflect a common element of San Francisco architecture at the time of Gould's work on the Burnham plan. The slightly projecting gables above the third floor bays and the parapet with its stylized battlements recall his award-winning Beaux-Arts design for the alpine hostel. He designed the building for Watson C. Squire, president of the Union Trust Company. Despite Squire's decision to give Gould's working drawings to another architect who would prepare plans and supervise construction for a lower commission, Squire's bank later became a steady client.[17]

Through early 1914, designing houses constituted the major part of Gould's work. Three themes run through his early residential work: careful site planning; a broad talent informed by experience and an extensive architectural library, with the books

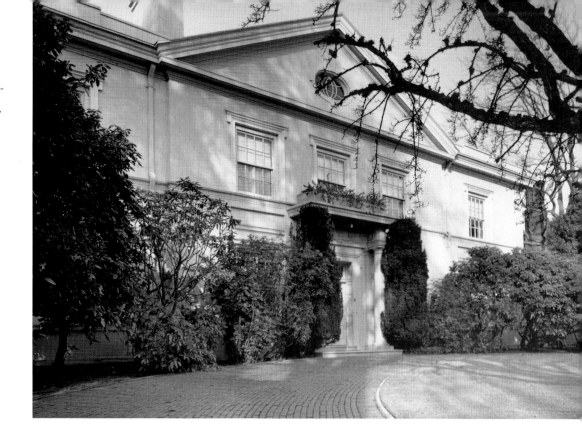

3.2 Charles A. Platt, Gould local repre-
sentative, Merrill residence, east front,
Seattle, 1909.

purchased during his Paris days at its core; and a commitment to modernism, that is, to examining problems in the light of contemporary conditions. The New York connection provided his first residential project (1909) in association with the well-known New York architect Charles A. Platt. Richard Dwight Merrill commissioned Platt to design a great house on Capitol Hill at 919 Harvard Avenue East. The Merrills controlled several firms, with the Merrill & Ring Lumber Company the most visible among them. Merrill's partner C. L. Ring had employed Platt six years before to design his grand home in Saginaw, Michigan.[18] Architects working at long distance commonly engaged a local representative to oversee construction, and Platt chose Gould to supervise his Seattle project.

The Merrill house (FIG. 3.2) epitomizes Platt's work. It is strongly axial in plan, simplified Georgian Colonial in style, and constructed of masonry and concrete overlaid with stucco. The interior walls are covered with rich wood and plaster detailing. Platt himself designed the grounds, for he had achieved prominence as a landscape designer before turning to architecture. He worked his customary garden magic on a site sloping more than 25 feet westward to Bellevue Avenue. Gould's role was to interpret the drawings for the contractor according to Platt's intentions, approving the materials used in construction and, probably, coordinating the materials and colors. The Merrill house was beautifully finished, a credit to Gould as well as to Platt. The association with Platt was important to Gould's stylistic development, while the relationship with Merrill resulted in the lumberman's commissioning Gould for later residential and commercial work.

While Gould was supervising the Merrill house, Francis H. Brownell, an attorney and building developer from Everett, commissioned him to design his family home on a site two blocks north of the Merrill house, at 1137 Harvard Avenue East. Gould's design (FIG. 3.3) displays a substantial similarity to Platt's Merrill house, but there are significant differences. An elliptical drive forms the approach to each. Platt designed a barely projecting portico, a feature typical of his work, but Gould endowed the

3.3 Carl F. Gould, Brownell residence, east front, 1137 Harvard Avenue East, Seattle, 1910.

Brownell house with a distinctive porte cochère to mark the entrance. Platt preferred stucco and simplified details derived from Italian villas; Gould opted for a shingle style with elaborate neocolonial details, reminiscent of the E. D. Morgan house by McKim, Mead & White and forecasting his definition of a Pacific Northwest regional style. The first-floor plans reveal Gould's debt to Platt: in both, a central hall leads straight into the living room, with the dining room to the right and the library to the left. In both houses the three rooms are ranged along the western, or view side. The major variation is the main staircase. Platt designed a gracefully curved stair, a hall-mark of his houses, while Gould set a straight flight of stairs in the Brownell house. Both houses are some 75 feet wide and 42½ feet deep, and open into gardens that are masterpieces of axial planning. The Merrill and Brownell projects, so beautifully executed, launched Gould's career as a residential architect in Seattle.

Gould's succeeding commissions demonstrate his continuing concerns for site and landscaping, contemporary analysis, and a style suggestive of the solution to the compound problem of client, building lot, and house plan. These themes unify his designs, whether modest or grand. Gould believed in serving all classes of clients, a belief driven in the early years by his psychic, if not actual need for some independent income, however slight. "A home should fit the condition of its owner," he told his University of Washington students in 1913. "It should not be a drain on his finances any more than on his health. It should correspond to his social condition in life. It should possess all the elements of convenience and beauty." Beauty emerged from the architect's study of the problem and not from the mere expenditure of money; therefore "an ugly house is not necessarily an inexpensive one, nor is a beautiful house

necessarily an expensive one." The statement about an owner's house fitting his social station suggests snobbery or condescension, but that was not Gould's intent, for the idea of a house corresponding to the owner's means is as old as Vitruvius. Gould meant that beauty depended on the symbiosis between owner and house as much as upon the quality of design. If the architect failed to integrate the client into his solution, and the client-as-owner was trapped in an inappropriate life style, then his unhappiness would mar the merely physical composition.[19]

When Gould plunged into residential work, the prevailing house designs were mostly influenced by Richard Norman Shaw at the custom end of the market, and by the bungalow style at the lower. The Shavian style is characterized by a massive granite first story, heavy timber-and-stucco second and third stories, gables, dormers, and asymmetrical floor plans (FIG. 3.4). Inexpensive bungalows exhibited a variety of floor plans, but they shared several features. Their common elements included ample entry porches usually bisecting the long axis of the dwelling but sometimes asymmetrically placed; roofs with low eaves and projecting gable ends; siding often of wood, rarely of stucco or brick, and walls designed as a continuum, with their windows banded together. Bungalow interiors lacked a space-consuming entry hall but often included beamed ceilings in living and dining rooms, which flowed into each other with the barest suggestion of separation; simple panel doors; ceramic-fronted fireplaces; built-in furniture, and unmolded paneling and casing boards.

Gould accepted elements of the Shavian and bungalow styles but rejected their rigid application. The bungalow style lacked references to historical models; nevertheless, Gould worried about what he termed "traditional" approaches. The bungalow style was a California development, the sort of style from which Gould later distanced himself. A California bungalow in the Pacific Northwest was one example of a failure to consider "each problem as it presents itself in the light of present day conditions," partly because of the interior-darkening effect of the eaves and gables, and perhaps because of the unimaginative lot development of many Seattle examples.[20]

3.5 *Gould & Huntington, Dovey residence, north elevation, 1017 East Blaine Street, Seattle, 1910.*

Gould's first opportunity to design more modest houses came with the opening of Federal Avenue East, developed simultaneously three blocks east of Harvard, but for less-affluent owners. In 1910, in association with Huntington, he prepared two designs that are transitional, both in terms of Gould's development and in the larger world of Seattle domestic architecture. The house at 1230 Federal Avenue East for Marshall Bond, a mining engineer, utilized brick instead of stone as the base material, but continued the use of timber and stucco above, although in a much simplified manner. The design may be Gould's weakest, for the house is poorly proportioned, and its plan is complicated by two stairwells in a rather small floor area. He did better with the other house, for J. Thomas Dovey, president of the Seattle Engineering Company, at 1017 East Blaine Street on the corner of Federal (FIGS. 3.5, 3.6). The design is derived from the late Georgian, with clapboard siding but with traditional columns and roof lines. The proportions in the projecting central element are unsettling—crowded and squat on the first floor, distended above—with a Palladian window in a front gable above the cornice line.

It is possible that Gould used the elevation of Charles Bulfinch's Elias Hasket Derby house (1795–99) in Salem, Massachusetts, as a model. The Derby house incorporates a slightly projecting entrance and balcony, with an arched window above, but the proportions are carefully drawn, the arch motif is maintained across the flat facade of the second story, and the cornice line is unbroken. Gould's Dovey house demonstrates that in his domestic architecture, the mastery of the smooth integration of elements essential to successful historical styling still eluded him. Unlike the Harvard Avenue

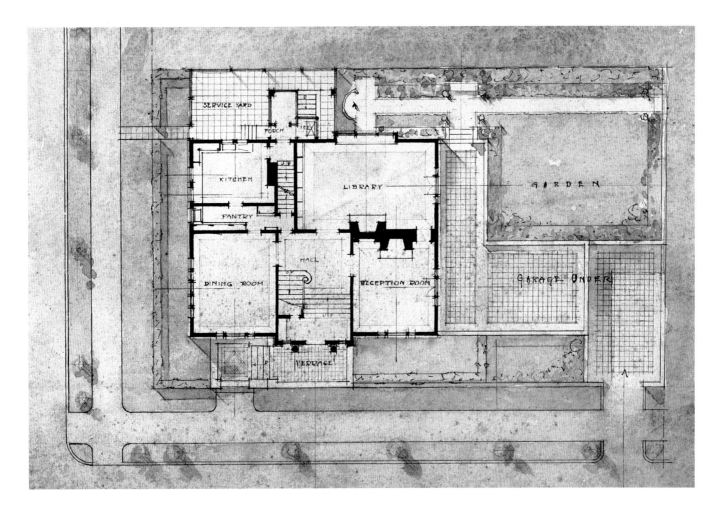

3.6 *Dovey residence, plan.*

houses, the Bond and Dovey houses occupy small lots that lack extensive gardens. Nevertheless, Gould took care with the design of the paths and the flower beds.[21]

The Arthur Glover house at 1206 Northeast Sixty-first Street (1913) illustrates Gould's interest in attractive and utilitarian lower-cost housing. Gould met the problem of inexpensive single-family housing with a skilled adaptation of the bungalow style. He designed at a time when the bungalow was popular in Seattle, so popular that the monthly *Bungalow Magazine* was published in the city from late 1912 through early 1918. Glover, a mineralogist and assayer, built the house as a speculative venture in the Cowen Park subdivision north of the University of Washington, near a new streetcar line. The house joins other modest bungalows along the street and shares their basic plan, a rectangle on a narrow lot. But there the similarities cease, and not only because the Glover house is brick-clad and the others are wooden-walled. Gould's design breaks up a potentially heavy porch line with a small gable that also marks the entrance. There are no projecting roof gables, and the well-proportioned eaves are narrow, allowing more interior light. The plan is asymmetrical, sacrificing a center hall in favor of stairways to the basement and unfinished attic. Two small bedrooms, a kitchen, and a bathroom complete the plan. The interior is unadorned, except for the display and entertainment area, the living and dining rooms across the front. Both rooms have heavily scaled, beamed ceilings (FIG. 3.7). The focal point, to the left of the front door, is the fireplace surrounded by handmade ceramic tiles. Bookcases flank the dining room entrance, forming a secondary focus. Gould concentrated those special touches where they could be enjoyed by the gathered family and

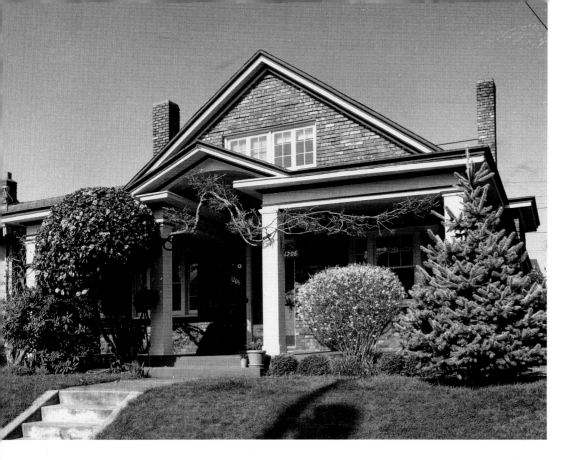

its guests. The Glover house signaled the beginning of Gould's involvement with the problem of well-designed but inexpensive housing.[22]

Gould was not Seattle's only budding regionalist. Better known for his regional adaptations is Ellsworth Storey (1879–1960), Gould's sometimes reclusive contemporary. Storey arrived in Seattle in 1903 and built two houses looking east across Lake Washington, in the Denny-Blaine area. Gracefully sited on sloping grounds, they are in part the very type of structure that Gould would praise almost twenty years later in a presidential address to the wsc. Although one house is reminiscent of the New England saltbox and the other of a Federal-era farmstead, both are free of direct historical references. They look vertical. Their pitched roofs and expanses of shingle siding contribute to the impression of verticality. An observer, standing at the lower portion of either steeply canted lot and looking up at the house, sees a towering structure, apparently three stories and an attic in height. But from Gould's perspective the houses do not fully realize his requirements. Their eaves are too wide, and the windows on their western exposures, the source of the most natural light, are curiously small. Banded windows on the south end of the saltbox house are partly defeated by an overhanging gable. The verdict on these early Storey houses is that they are ingenious but not fully indigenous.[23]

Storey was, however, as confirmed an eclectic as Gould. Had Storey refined and developed the themes of these maiden efforts in the fifty or more houses he subsequently designed or remodeled, his reputation might have burst its local-regional bounds. He designed in the Prairie style, the broad planar eaves of which work well in the sunny Midwest but block precious light in the Pacific Northwest. His chalet style houses suffer the same inadequacy, their sweeping overhangs on cantilevered beam ends shutting out some of the light entering through their small windows. Storey's bungalow-derived cottages that were built about the same time as Gould's Glover

bungalow echo the Prairie and stick styles. More charming than the Glover house, the simple cottages have beguiled a generation of Northwest architects. Nevertheless Storey's better interiors are found in his less innovative neoclassical houses.[24]

In fact Storey's superior regionalist work is nonresidential. His Tudor-Gothic Episcopal Church of the Epiphany is well proportioned and detailed. His Hoo Hoo House at the A-Y-P Exposition, a vaguely Elizabethan half-timbered, bungalow-style building, invited its owners, the International Concatenated Order of Hoo-Hoo, and other lumbermen, to enter and relax. His later log structures at Moran State Park on Orcas Island in the San Juan Island group are primitive in appearance but carefully detailed. There are several simple, open shelters, detailed with bracketed roof supports, wooden poles, and a fieldstone base. They epitomize Storey's concern for the proper exterior effect of indigenous materials and of a form that visually strengthens the site. But churches, exhibition halls, and most park buildings are not meant to be lived in. Storey's reputation for regionalism, then, rests more on the external appeal of his designs and less on their functional qualities. In Storey there was little of Gould's appreciation for the careful mating of the residential client with his needs and with his environment.[25]

Meanwhile, Gould depended upon acquiring larger commissions than the Glover bungalow could provide, so he turned to another significant source of income, building ample country places for the local elite. After arriving in Seattle, he cultivated new friends of means during the ascendency of the country place, a form of dwelling widely popular during the closing decades of the nineteenth century and beyond. The popularity of the country place depended upon increased wealth and a desire to emulate European exurban houses and grounds. It depended as well upon improved transportation beyond the available railroad: the interurban trolley, and later the private automobile, both of which opened vast acreages to the urban upper and middle classes. The country place may also be understood as the product of a reaction against urbanization, with its attendant smoke, noise, summer heat, small lots, and loss of wildlife. Those city residents who could afford it sought relief in the country.[26]

The country they sought was not the farm life of dawn-to-dusk labor, few or no luxuries, and isolation, but a middle landscape, a rural environment shorn of life's miseries while offering many of its pleasures. The country house "existed to serve a way of life that was instantly recognizable to the large numbers of people who either enjoyed it, aspired to it, or were appalled by it."[27] The New York elite whose great houses sprang up at Newport, Rhode Island, and along the coasts of Long Island and New Jersey enjoyed a social life less hectic than the social season in the city, and ready access to sports including golfing, riding, sailing, fishing, and shooting. Less affluent urban dwellers desired the same recreations, or a return to a less-demanding version of farmstead life, to a rustic retreat where they could reunite with the natural environment, or enjoy leisure in gardening on a small plot. The popular magazines of the time extolled all these interests.[28]

Many owners of country places commissioned architects to design them. The expensive "cottages" were elaborate, but with most houses the architects adapted current styles to achieve simplicity, informality, and ease of living. Many country-place projects enjoyed the advantages of beautiful sites. Their seasonal use implied a close

relationship between indoor and outdoor activity. The houses were not insulated and therefore were not intended to be comfortable in the winter. They were designed to entertain and house extended families and friends, and to be built with materials readily at hand, from designs that did not require especially skilled craftsmanship.

Seattle was no exception to the popular movement to country places, but in the Pacific Northwest there were very few great mansions. As Seattle society developed and its members emulated Eastern patterns, several families found seaside sites on the islands scattered throughout Puget Sound. A group of bankers and lumbermen began Seattle's country place era in earnest when, in 1891, they acquired Restoration Point, the southern tip of Bainbridge Island. In 1892 they incorporated The Country Club of Seattle to reserve the land for golfing and other recreational and social activities, as well as for summer houses restricted to members. Steam-powered, scheduled ferries operated frequently enough to move members' families to and from nearby Seattle. Gould's first project for The Country Club was a humble one, a cow barn to shelter the Club's herd of milk cows, but it served to introduce him to future clients. His design for the well-executed project (1911) drew on Victorian models, particularly in the attic-story window treatment (FIG. 3.8).[29]

3.8 Carl F. Gould, cow barn, southwest view, The Country Club, Bainbridge Island, 1911.

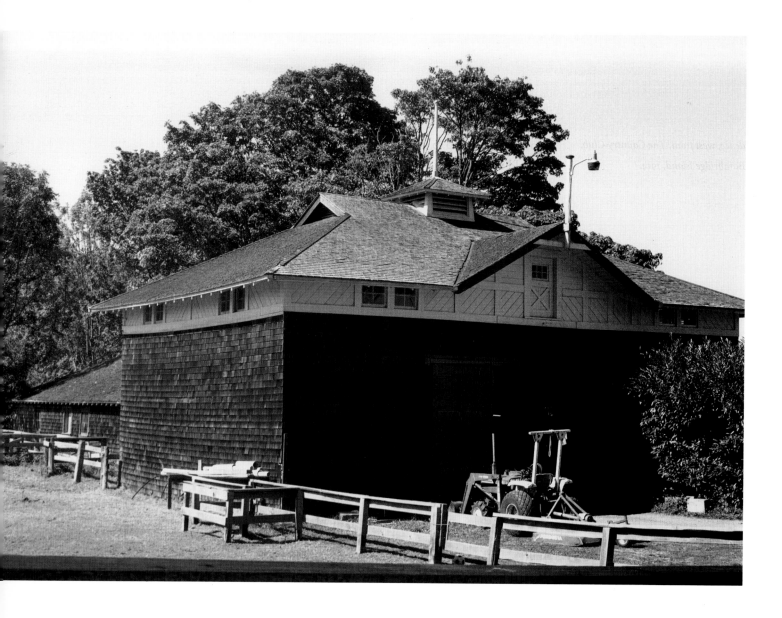

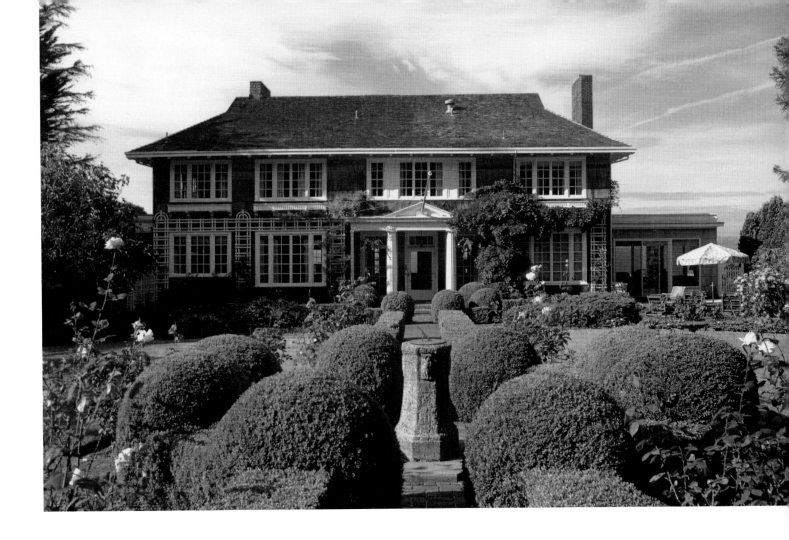

3.9 Carl F. Gould, Wm. McEwan residence, west front, The Country Club, Bainbridge Island, 1914.

Gould in 1914 received three commissions that redefined the Bainbridge Island country place. Up to that time the members' houses were modest-size cottages; now Gould designed large, shingle-style, neocolonial places. They were similar in basic plan but singular in their details. The brothers William and Alexander McEwan and Francis H. Brownell each asked Gould to design their summer retreats located on the steep bluff of Restoration Point, on lots facing east toward Seattle and south toward Mount Rainier. His planning began with siting, garden plans, and with garden furnishings typical of the era (FIG. 3.9). Taking his cue from Platt, Gould restated the lesson that "everywhere the garden should suggest the subdued artifice of humankind in accord with nature." He sited the houses to develop two distinct aspects: on the entry side, each house stands within a formally organized landscape, and on the water side, it "is placed in picturesque relationship to the natural site, but is . . . allowed to float free" above it.[30] Thus the facade of each confronts flat ground or a gentle slope, while at the rear the ground plunges toward the water. The main floors are more than 40 feet above the base of the bluff, at the level of the surrounding treetops. The outdoor living spaces on the water sides are decks thrust out over the bluff, enhancing the sense of standing or sitting in a tree house.

Entrances, clearly visible at the center of the garden-side elevations, are without vestibules (FIG. 3.10). They open directly into great living or drawing rooms about 20 feet deep by 40 feet wide, copies of the informal "living halls" of the Eastern Seaboard cottages. Doorways and windows across the great rooms frame sublime views, while the doors offer ready access to the decks and serve to blend indoor and outdoor living. Fireplaces at both ends of the living rooms, and one in every other major living

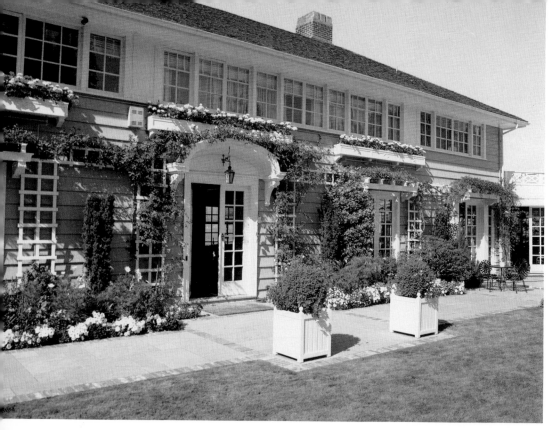

3.10 Carl F. Gould, Alex McEwan residence, west front, The Country Club, Bainbridge Island, 1914.

3.11 Wm. McEwan residence, interior.

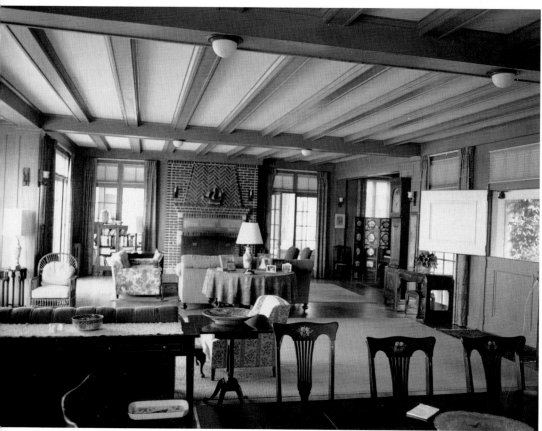

space, provide the only heating. Gould gave his fancy free play in the fireplace fronts, incorporating plaster casts in bas-relief, glazed tiles, and patterned brickwork in idiosyncratic designs. He beamed the ceilings to support the long spans across the living rooms (FIG. 3.11). Garden rooms and dining rooms flank these great halls. He placed the kitchens, intended to be staffed by servants, away from the view side, and quartered the servants in the basement.

3.12 Carl F. Gould and Bebb & Gould, Brownell residence, east front, The Country Club, Bainbridge Island, 1914–15.

In the McEwan houses, residents and their guests gained the upper floors by modest stairways originating in the living rooms. The numerous bedrooms and baths opening off central halls were designed for large families and their many guests. The horizontal banding of windows along the second floors suggests the uniformity of use behind them. Gould extensively employed wood trim in bands, moldings, and other details painted white, all offset by the natural cedar shingle walls. He also used trellises on the walls—as did Platt and others—to clothe the houses in floral decoration. All was contained under simple, sheltering hipped roof forms, reminiscent of neocolonial prototypes.[31]

In the Brownell house Gould elaborated some features of the McEwan designs. Here he used corner fireplaces to deny cross-axial formality in the rooms. He added sleeping porches to the main bedrooms, further enhancing the sense of healthful outdoor living. He disposed the second-floor plan on several levels, and designed two stairways to reach them. He covered the entire massing under one roof embellished with cross gables at the ends. The roof line ended with clipped rather than full hips. Gould contained his complex plan within uniformly simple and symmetrical elevations (FIG. 3.12).

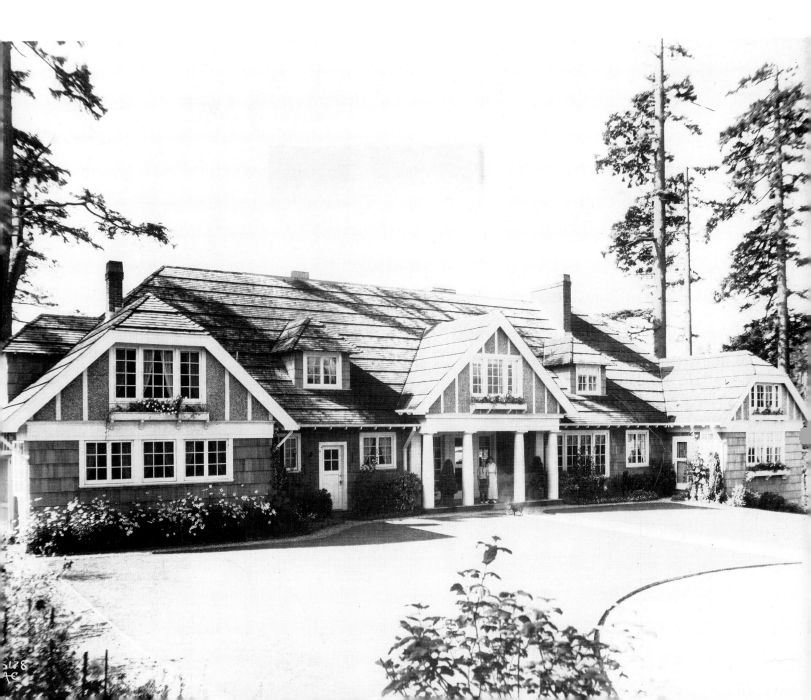

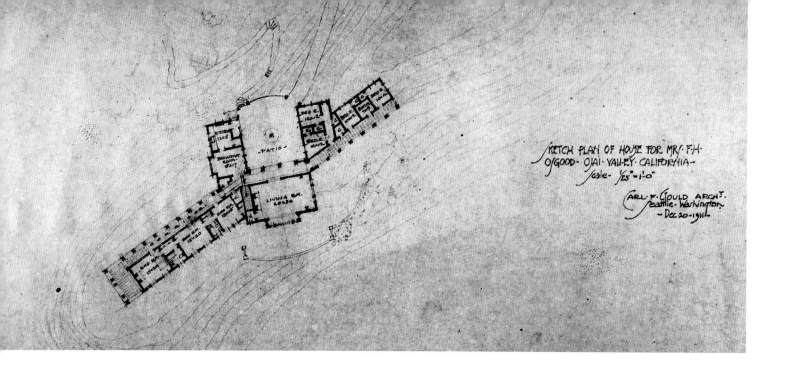

Sketch Plan of House for Mr. F.H. Osgood. Ojai. Valley. California. Scale ⅛" = 1'0"

Carl. F. Gould Arch't. Seattle. Washington — Dec 20·1911·

3.13 Carl F. Gould, Osgood residence plan, Ojai, CA, 1911.

During the next year, 1915, Gould designed a vacation house, "Eldoral" (demolished), for E. C. Potter on the Blackfoot River near Greenough, Montana. The house is significant for three reasons. First, its design epitomizes the rustic type, with forms derived from simple agrarian models having undecorated openings, rough and large timbers, wood detailing reminiscent of alpine architecture, and irregular stone or brickwork, all sheltered by vast, encompassing roofs. The rustic is distinguished from the romantic style, characterized by asymmetrical massing, fine detailing, and a sense of movement intended to surprise and delight the observer. Second, the house compares favorably with the Orrin W. Potter house (1914, demolished) in the same location, designed under the direction of Gould's partner Charles H. Bebb. The Orrin Potter house is a cumbersome log structure. Third, the E. C. Potter house was both derivation and precedent. It was inspired by the shaggy, boarded, heavy timber expression of the lodges around Saranac Lake, where Gould recuperated after losing the Union Theological Seminary competition. But it was so successful that he used the same design fundamentals for an unbuilt World War I project at Lake Pleasant (1918; see CHAPTER SIX), and the Weyerhaeuser Building (1923; see CHAPTER SIX) in Everett, north of Seattle. The Weyerhaeuser Building, a historic landmark, has survived two moves and now houses the Everett Chamber of Commerce.

None of these early plans were copies of others' work, although they were adaptations of traditional themes. The sketch plan of a country place from 1911 (FIG. 3.13) illustrates Gould's willingness to abandon tradition entirely and give full attention to a setting while utilizing the contemporary idiom. He created a scheme for an elegant villa in California's Ojai Valley for F. H. Osgood. Gould's plan features a great room and patio flanked by specialized rooms along an axis parallel to a ridge line. He may have been inspired in part by the Pratt house (1909) of Charles and Henry Greene. The Pratt residence is shaped like a lazy U, and is two stories high in its central section. Gould's one-level plan, in contrast, cants the servant and guest wing only slightly off the axis of the family bedrooms. This stunning, unbuilt project, oriented to landforms and views rather than to right angles, is insistently modern in its radical departure from convention. In that respect it forecasts a Bainbridge Island cottage of twenty years later (see CHAPTER SEVEN).[32]

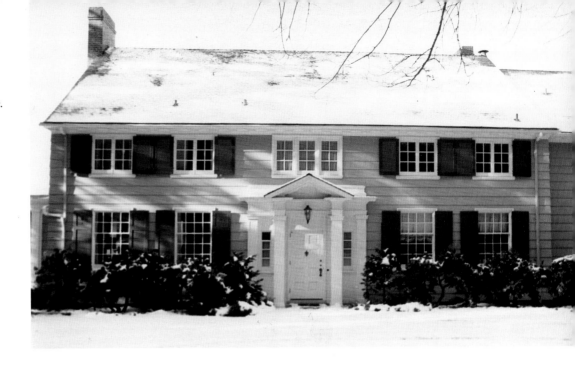

3.14 Carl F. Gould, White residence,
east front, The Highlands, Seattle, 1912.

Gould's first opportunity to carry an estate house to completion came in 1912, when Chester F. White, a prominent civil engineer, commissioned him to design a house of about 3700 square feet in The Highlands, an ultra-exclusive suburb immediately north of Seattle. The White house and other Highlands homes were designed for permanent residence and were therefore more formal, but were places in which guests and live-in servants would be expected. Communal social and recreational activity centered on golfing.

John C. Olmsted and his assistant James Dawson had laid out The Highlands' winding drives, bridle paths, and huge lots arranged for views and privacy during their several visits to Seattle. Olmsted Brothers, probably either or both Olmsted and Dawson, provided a site plan for Gould that included the retaining walls, gardens, drives, and even the disposition of the first-floor rooms. South of the house Olmsted Brothers planned a large formal garden retained by a wall and rail on the steeply sloping west side.

The White estate was a hit. It embodied gracious site planning, a costly house perfectly finished, and an eye-catching overall effect that helped lead Gould to thirteen more projects in The Highlands. The site of the Whites' home slopes sharply to the west, opening magnificent views of Puget Sound and the Olympic Mountains. The approach from the east unfolds the property to the visitors' view along a level, looping drive.[33]

In the White house Gould continued the traditional center hall arrangement, with the living room on the left (south) side, and the kitchen and dining room on the right. The center hall is 12 feet wide, providing a generous dimension in scale with the other first floor rooms. The second floor includes three bedrooms and two baths. Each room is correctly proportioned and not too large. All this is simply contained in a clapboard-covered building 35 by 53 feet. A central bay projects on the west (rear) side, allowing for sun rooms with views on both floors. A center doorway, richly detailed in the Colonial manner, is restrained in its scale and its projection beyond the facade. The house is calm and sedate, without fussiness or pretense (FIG. 3.14).

One other large house, although built after 1914, began with a project of that year. Gould designed a house in Bellingham, Washington, for C. X. Larrabee, a copper

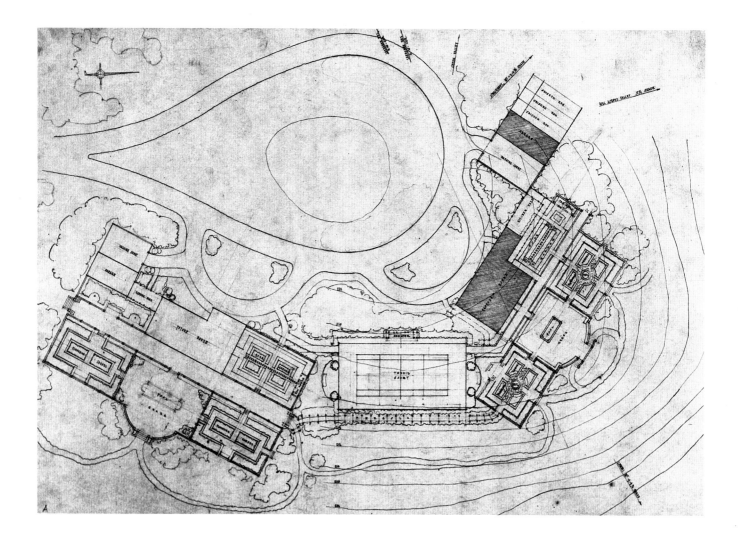

3.15 *Bebb & Gould, Larrabee residences, proposed site plan, Whatcom County, 1914–15.*

mining and timber magnate. The project, unbuilt because Larrabee died before construction began, demonstrates Gould's mastery of borrowed forms and his personal vocabulary of style. Platt's influence is apparent in the steep roof, the brick detailing, the doorways front and rear, the loggia at the southeast corner, and the expansive interior halls. Gould did not attempt absolute symmetry along the flanks of the doorway, as Platt might have done, but used the set-back servant's wing to fix the facade in balance. He drew the chimneys as tall, slender slabs, a departure from Platt's typical massing.

The garden plan (FIG. 3.15) relies on Italian formalism, which Gould had studied and the renowned novelist and avid gardener Edith Wharton had helped to popularize. The architect followed Wharton's admonition that "a piece of ground laid out and planted on the principles of the old garden-craft will be . . . *a garden as well adapted to its surroundings as were the models which inspired it.*"[34] He neatly set the main axis of the garden on the central bay of the living room. He directed the flanking garden paths toward the dining room doors and to the end of the entrance terrace. He banished the service court to the opposite end of the house, away from the most desirable view. Thus Gould achieved a unique composition, however much he may have been indebted to Platt for the general idea. After Larrabee's death his widow rejected Gould's plans and commissioned him to design an idiosyncratic structure on a different site (FIG. 3.16). In 1919 he designed a large house for her son Charles, in a Tudor

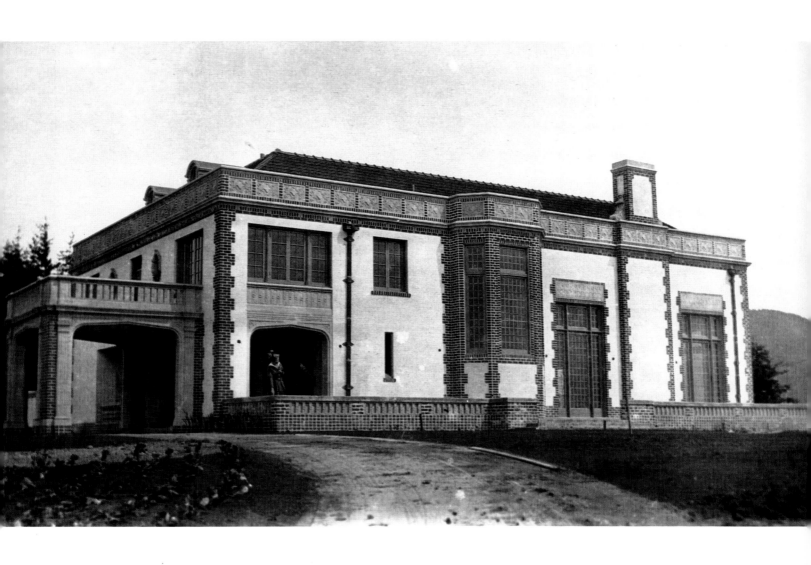

3.16 Bebb & Gould, Mrs. Larrabee residence, west front, 405 Fieldston Road, Bellingham, 1915.

mode incompatible with the widow's home. The son's house was not built, but offered a site problem that Gould solved in plan by connecting the two homes with paths through elaborate gardens laid out in the Italian manner. The result was a composition of landscaped spaces linking yet softening the buildings, and tying the entire composition to views and to the land.

Through early 1914 residences continued to be the mainstay of Gould's work. He planned nine in addition to those discussed here, while designing another commercial project, two bank remodeling jobs, and a public fountain. From 1911 he maintained an independent practice, first in office space shared with his erstwhile associate Huntington. Shortly after Huntington left to become the Seattle city architect, Gould moved from the Colman Building to the Boston Block on the northeast corner of Second and Columbia in 1912.[35]

Gould hired an able assistant, Frederick W. Elwell, who moved with him. By then Gould was relying on his Beaux-Arts training and natural talent to produce a sketched plan, and perhaps a careful rendering, from which the able Elwell would develop the working material. Elwell's name or initials appear on all Gould's construction drawings from 1912 to 1914. In addition to being chief draftsman, Elwell was the construction supervisor. Gould maintained his expanding practice and his increasing civic responsibilities by occasionally throwing the obligations of the job site on Elwell's willing shoulders. But he remained in control of his projects and meticu-

lously attentive to detail. When Chester White complained to him that "you come in such a hurry and remain only, all told, one hour," and only once a week, Gould was able to make a satisfactory reply. He admitted to appearing once a week and on "one or two occasions" being unable to remain long enough to "decide fully certain matters," but had been in touch by telephone almost every day and "sometimes several times during the day." He had given detailed orders to the tradesmen "in order that the work not only should be carried out properly," but also that "the different trades shall not interfere with each other." He promised in the future to be at the house twice each week, and to "attend to the details" then, while Elwell would continue to supervise at other times.[36]

With his accelerating activity, Gould found the energy to be involved with two government projects. In 1911 he submitted, with Huntington and other associates, an entry in the competition for the Washington State Capitol and its group plan. His previous experience with the Wisconsin Capitol design group may have helped his group garner fourth prize. Other Seattle architects also placed, or earned honorable mentions, but Wilder & White of New York won the commission.[37]

Gould fared better with a second government project, the commission for the buildings at the Hiram Chittenden Locks of the Lake Washington Ship Canal, about six miles northwest of downtown. A U.S. Army Corps of Engineers project, the canal was designed to open lakes Union and Washington to industrial shipping and to abate a flooding problem south of the city. His designs blended Roman and Renaissance styles in reinforced concrete, carefully smoothed and left exposed as the finish material. Unclad reinforced concrete was first employed in the late nineteenth century, but its use, except in a few industrial buildings, was unusual in the Pacific Northwest. Gould's structural solution was thoroughly modern, but he formed the administra-

3.17 Carl F. Gould and Bebb & Gould, administration building, south front, U.S. Government (Hiram Chittenden) Locks, Seattle, 1914–16.

3.18 Bebb & Gould, concrete structures, U.S. Government Locks, 1916.

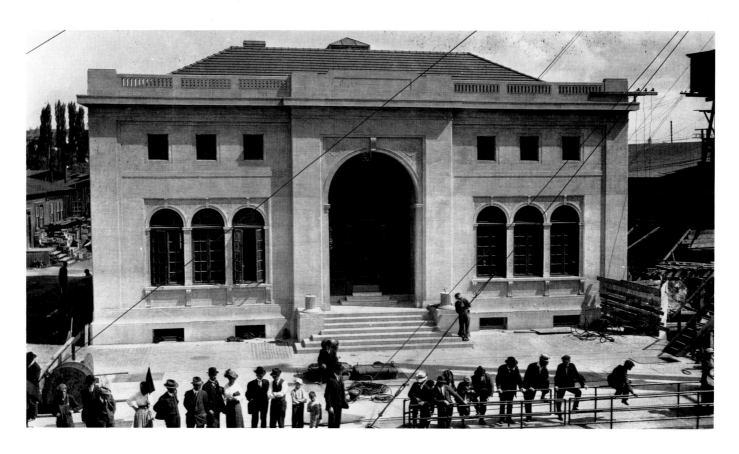

tion building (FIG. 3.17) with freely interpreted motifs borrowed from the past, to relieve the bleakness of the concrete. The massive Roman center arch leaves no doubt about the location of the entrance and forecasts the spacious interior hall. The central hall leads visitors between rows of two-story Ionic columns to a fine oculus-skylight made of stained glass.[38] Gould almost playfully mixed elements, such as the corbels supporting the first floor window sills. On the second story, the small, nearly square windows with deep reveals mimic many Renaissance-style buildings by McKim, Mead & White.

The ancillary buildings are simply decorated, with well-ordered arrangements of windows and doors. The lockmaster's houses (FIG. 3.18) show how well Gould could design small buildings. They are simple, with generous windows and restrained decoration. Yet their bases, and their roofs styled like mushroom caps, convey a sense of massiveness and of the essential operations conducted within. Gould designed each building "to serve its purpose without repair for as long as the locks themselves might endure," and all of them "to express in their architecture a homogeneity of effect." He continued his work on the ensemble until 1917, and the group still exists as he designed it. He was especially proud of this project, which established him as a large-scale planner and designer of nonresidential structures.[39]

Individual buildings or building groups could be beautiful but represented only one fine art, while designing them limited Gould's circle to his office force, clients, and whatever congenial company he could muster through his club contacts. Nor did those associations offer any way to advance the course of beauty city-wide. So Gould joined the Seattle Fine Arts Society, then the only local organization devoted to a range of artistic effort, including "municipal art, pictorial art, plastic art, art in architecture, interior decoration, ceramic art, applied design, landscape gardening and art in apparel." Organized in 1908, the Society grew from the earlier efforts of local artists to exhibit their work, augmented by a loosely organized group that from 1906 arranged for an occasional lecture or exhibit, and for monthly meetings, usually in a member's home. The forty-two founding members of the Society continued this program, offering an exhibition of Japanese prints in 1908 and of the work of John La Farge in 1909. La Farge's son Oliver arranged the 1909 exhibition. Society members were involved in the fine arts aspects of the Alaska-Yukon-Pacific Exposition.[40]

Gould, affable and determined, quickly rose to leadership in the Society. He urged an extension of its activity on several fronts. The organization had supported the Bogue plan of 1911, with Gould lecturing to the membership on "City Planning." He was elected president in 1912, serving two two-year terms to 1916. In 1915 he addressed the group, calling for a city art commission to pass on the design and placement of civic art, and for what would later be termed a magnet school, a public school specializing in art education. Under his leadership the membership increased substantially. When he moved to the Boston Block in 1912, so did the Society, probably at his urging.[41]

By 1915 the group had outgrown those quarters at Second Avenue and Columbia Street and followed downtown's northward trend to the showy neoclassical Baillargeon Building at Second and Spring. Under Gould's leadership the Society participated in the traveling exhibition of paintings done by artists commissioned to prepare

the mural decorations for San Francisco's Panama-Pacific International Exposition. The committee structure grew as the membership expanded, and in October 1912 the executive committee began regular meetings. Three developments bore Gould's stamp. In 1915 the weekly society sheet *Town Crier* became the official newspaper; a Fancy Dress Banquet that later became the annual spring Mardi Gras was inaugurated; and a series of popular Sunday winter afternoon teas began. Gould's emphasis on publicity and socializing was in part to bring Society members together to have a good time, but also to increase the Society's recognition among the elite, and raise it to a position of comprehensive leadership in the arts. Gould was equally concerned with better organizing the Society's activities, including "catching up with correspondence, etc."[42]

With equal fervor Gould plunged into the work of the Washington State Chapter of the American Institute of Architects (wsc). It was then an essentially Seattle-based organization, despite its inclusive name. Begun in 1895 on the foundation of a local group, the chapter was small—thirty-seven founding members—but zealous in its pursuit of professional goals, including involvement in the civic improvement of Seattle. By 1906 it was deeply if unofficially concerned with the planning of the Alaska-Yukon-Pacific Exposition. In 1907 it called for an independent building department, appointed a civic center committee, and listened to a member's paper on "Beautifying the City."[43]

All this activity dovetailed with the nationwide, if loosely organized City Beautiful movement. Sometimes criticized for its formalism, baroque city planning, indifference to urban realities and failure, the movement often enough resulted in definite urban improvements. The partially constructed Seattle park and boulevard system proposed by John C. Olmsted in 1903 was an instance. The era of the City Beautiful, from about 1899 to 1912, saw the first extensive comprehensive planning in the United States. City Beautiful plans incorporated few statistics or social science concepts, but they were pervasive, reaching into all or almost all parts of the city to confront a range of urban problems, and were, consequently, multifunctional. The movement, much more than an episode producing numerous plans and designs, often enjoyed some success. It was fundamentally a political movement, because the success of any plan depended on its advocates' ability to mobilize whatever backing was necessary to push it through the urban political process. City Beautiful supporters usually understood the indispensable political dimension even if their later critics did not.[44]

By the time "Karl," as he was entered in the minutes, attended his first wsc meeting in January 1909, the movement to launch city planning in Seattle was well under way. A. Warren Gould (no relation to Carl) and Charles H. Bebb, Gould's future partner, took the lead within the wsc and were prominent in the elite movement to secure a plan. The wsc itself organized a January 1909 meeting to create a Municipal Plans League (MPL). The MPL worked with the wsc, Seattle Chamber of Commerce, and the Commercial Club to formulate a charter amendment and submit it to the city council, which accepted it for the March 1910 general election ballot. The amendment created a broadly based Municipal Plans Commission to hire the planning experts and supervise their work, while it provided a tax levy for the experts' salary and expenses. The MPL and other groups propagandized for the amendment. It carried handily,

13,852 to 7311, "the largest majority ever cast for an amendment to the charter of the City of Seattle." The commission hired one expert, Virgil Bogue, a prominent civil engineer. Bogue completed his plan by the late summer of 1911. His scheme featured a civic center on the Denny regrade, just beyond the northern edge of downtown. After heavy campaigning for and against, on 5 March 1912 the voters of Seattle overwhelmingly rejected the plan, 24,966 to 14,506. They rejected it for two sensible reasons, the virtually mandatory provisions of the charter amendment and the enormous projected costs of realizing the plan.[45]

The defeat of the Bogue plan was a setback for the WSC, one of only two organizations that formally approved it. As a newcomer, Gould played a relatively minor role in the plan's promotion. He served as one of five WSC representatives on the conference committee that worked out the details of the plans commission. He wrote an editorial letter for the *Municipal League News*, the newspaper of the Seattle Municipal League. The league, an organization of reform-minded, middle-class businessmen and professionals to which he also belonged, was the other group endorsing the Bogue plan. The letter argued for the plan's acceptance on the grounds that without adoption it could not be carried through comprehensively, and that if the people did not like the plan they could change it by ballot. Gould's later letter to the *Seattle Times* was more boosterish, emphasizing the role of the Seattle plan in contemporary city planning, and how it held forth the possibility of success, in contrast to the stalled plan of San Francisco. Gould chose the best ground he could find, stressing the plan's importance, eliding the problems of the practically mandatory language, and ignoring the crushing costs involved. The plan's defeat was a blow to his hopes for a beautiful Seattle.[46]

But the Bogue plan survived as Gould's ideal. He was attracted to the aesthetic-functional expression of the City Beautiful and its promise of a cultural uplift compatible with commerce and industry. Early in 1913 he spoke at a church on "Town Planning," and its object, "a good and beautiful arrangement for a city." He argued for the need of a plan, "a vision of the completed ideal city." Such a plan would pay "not only in the current coin of commerce but in the refinement, the cheerfulness, the happiness, and the outlook on life of the poorest citizen." During the same year Gould developed a schematic design for a fountain in Seattle, a personal statement of his commitment to urban beauty. In 1925 a revision of his design was constructed as the Monsignor Prefontaine Memorial Fountain at Third Avenue and Yesler Way (FIG. 3.19).[47]

Meanwhile Gould continued to believe that something could be saved from the wreck of the Bogue plan. Hope remained high in the hearts of Bogue's partisans, partly because the site of the new King County courthouse was yet to be selected. If the county commissioners could be persuaded to locate the courthouse in the Denny regrade on the site of the failed Bogue civic center, then the county building would be the nucleus of a north end public building group. Soon after the March debacle, the former Bogue plan advocates organized the Seattle Civic Center Association to propagandize the benefits of the site at Fourth Avenue and Blanchard Street. The Municipal League entered the lists on the side of the northern location. The county commissioners, on the other hand, were intent on developing a county-owned block

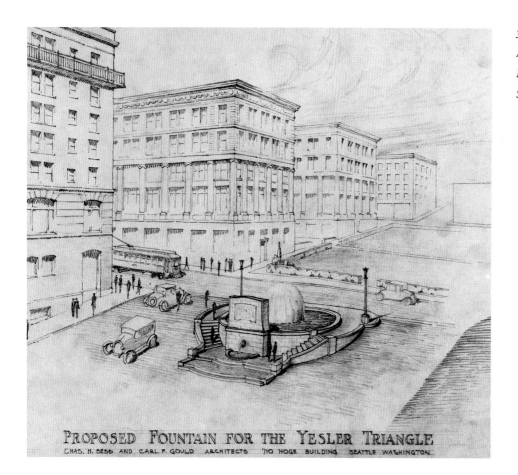

at Third Avenue and James Street on the south end of downtown. Should they waver, the south end property owners who had vigorously opposed the Bogue plan were on hand to firm up their resolve.

Gould's role was once more peripheral, but it demonstrated his firm allegiance to comprehensive planning. In April 1912, a month after the Bogue plan's rejection, he alerted the wsc to "a movement being inaugurated in the interests of the City Plan, particularly with reference to the Civic Center." That October he spoke in favor of the center at a wsc meeting and before a gathering at the Commercial Club. He sent letters to the *Seattle Times* and *Post-Intelligencer* endorsing the Bogue site for the court-house. If the voters rejected the north end site, he wrote, Seattle would lose its place in the van of forward-looking cities.[48] On 5 November King County voters rejected the site almost as decisively as Seattle voters had defeated the Bogue plan. The vote against the north end location was 31,206 to 18,123. Voters, in a separate proposition, favored the south end site 35,678 to 16,565.

Two issues remained to be resolved. The Municipal League sued the county commissioners, declaring that they had deceived the public about the type of building it was possible to construct on the south end site at a cost of $950,000. In December 1913 the Washington Supreme Court decided that the commissioners had committed no fraud, nor had they bound themselves to build a certain type of structure. The second issue involved Gould directly. The commissioners had retained the ubiquitous A. Warren Gould to design their new building, and he had campaigned vigorously for the site at Third and James. The Municipal League placed Carl Gould on a committee to arrive at a realistic cost for the south end building. When the committee released

figures considerably higher than those of the commissioners, A. Warren Gould attacked Carl and another architect as members of a "little ring" that "failed in their attempt to have the work taken from me."[49] Later the WSC recommended A. Warren Gould's expulsion from the American Institute of Architects because of his conduct during the campaign, but nothing salvaged the civic center dream. The Bogue plan and its descendant were beyond revival.

Gould's other WSC activities were more immediately rewarding. A member from June 1909, he was in October elected one of two delegates to the first convention of the Architectural League of the Pacific Coast. He continued his interest in unifying organizations and cooperative work, urging the WSC to recognize the assistance it received from others, including the Public Library. In 1911 he was selected as the WSC delegate to the national convention of the American Institute of Architects. On 5 June 1912 he told a WSC meeting attended by several members of the Pacific Northwest Society of Engineers that architects and engineers represented "in reality two branches of the same profession." He demonstrated an interest in professional concerns when in March 1910 he led a discussion on the limitation of the height of buildings. He probably inspired a June luncheon honoring his friend Bennett, who made a trip to Seattle while working on a plan for Portland, Oregon. He served as chairman of the exhibition committee, and in 1910 was elected to a three-year term on the executive council.[50]

By the end of 1914 Gould had achieved some of his personal goals in Seattle. His architectural practice was well established and covered a range of commissions that included commercial, residential, and governmental. Some of his work was remarkably modern. The use of concrete in the ship canal ensemble, the styling of the lockmasters' houses, and the project for the sprawling Osgood villa are free of rigid adherence to precedent without being idiosyncratic. At the same time, because of client preferences, monetary restraints, and personal inclination, he expressed the beauty of form and the organization of elements most often in buildings that were traditional but not slavishly so.

Gould's organizational achievements were impressive. In 1913, after some two years of work, a commission on which he was the Municipal League's representative completed a new building code, a code unanimously adopted by the Seattle city council.[51] In late 1914 he was beginning his second term as president of the Fine Arts Society, and while he had not advanced as far in the local chapter of the American Institute of Architects, he was a valuable member of that organization. Artistic unity in organizational and planning terms eluded him with the collapse of the Bogue plan and the failed drive for a north end courthouse site. But other avenues were opening. He was planning for the University of Washington, and establishing its Department of Architecture. Soon he would begin a distinguished career as campus architect. He had met his future wife. And he had formed an architectural association that would bring him regional fame and would last through the rest of his life.

The architect . . . determines the various movements of our heart and our understanding; it is then that we experience the sense of beauty. —LE CORBUSIER, QUOTED BY CARL F. GOULD[1]

4 Partnership and Marriage, 1914–1926

CARL GOULD ACHIEVED PROMINENCE DURING THE YEARS FROM 1914 THROUGH 1926. His partnership of 1914 with Charles Herbert Bebb (1856–1942) and his expanding role in professional and civic affairs brought him to the apex of his career. His marriage in 1915 to Dorothy Wheaton Fay united him with a family locally prominent in the law, mining, and real estate, and provided him with a lively, devoted family circle. Gould's new relationships reinforced each other, although the heavy professional demands often stole time from his wife and children.

The Bebb & Gould partnership flourished because their talents were complementary: Gould was artistically gifted, while Bebb was a consummate technician. Bebb brought the greater number of projects to the new firm and for a few years was responsible for about half the commissions. As Bebb's powers waned during and after the late teens, Gould increasingly shouldered the load of garnering and executing their contracts. Both men were charming and well-connected, Bebb with an older elite group, Gould with a younger one. They shared a good business sense, an ability to attract effective subordinates, a grasp of sound office practice, and a commitment to high standards in technical matters and design. Because their relationship produced bitterness between Bebb and Dorothy Gould after Gould's death, it is important to consider that as late as 1934 Carl wrote of Bebb: "A finer man never lived and during the 20 years we have been together not one serious controversial situation has arisen."[2]

When Gould arrived in Seattle, Charles Herbert Bebb was already a leading architect. Born on 10 April 1856 at Mortlake, Surrey, near London, of Anglo-Irish parents, Bebb enhanced his genteel background by pursuing education. After schooling in England and Switzerland, he left his studies in 1877 for a job in the engineering department of the South African government railroad. In 1882 he went to Chicago intending to work for the Illinois Central Railroad, but instead he took a job with a terra cotta company, soon becoming its construction engineer. There he mastered new techniques of fireproofing iron and steel framing with terra cotta cladding; he won the fireproofing contract for the Chicago Auditorium as well as other major buildings. After five years with the terra cotta business, he went to work for the prominent architectural firm of Adler & Sullivan as supervising architect, primarily

on the same Chicago Auditorium, one of Sullivan's pioneering buildings. He also gained invaluable experience in detailing Sullivan's ornamental designs.[3]

Bebb first came to Seattle in 1890 to supervise the construction of a theater and hotel or office building, but the project evaporated when its financing dissolved in a bank failure. After remaining to assist with another building, he went back to Chicago, but soon he returned to Seattle because of the declining fortunes of Adler & Sullivan. Bebb sought fresh ways to exploit the construction boom following Seattle's great fire of 1889, becoming in 1893 the architectural engineer for the Denny Clay Company, a terra cotta firm in the suburb of Renton. In 1898, in a move typical of the time, he declared himself an architect, and established his own practice. In 1901 he formed a partnership with Louis Leonard Mendel (d. 1940). Their earliest commercial project, the Corona Hotel (1903) at 608 Second Avenue, with its horizontally ordered facade and its sinuous floral ornamentation in unglazed terra cotta, exhibits Bebb's stylistic debt to Louis Sullivan, as does the frieze around the ballroom of the Stimson mansion (1905) at 415 West Highland Drive.[4]

Bebb & Mendel, with Mendel taking the design lead, produced some fine, large buildings that have aged well, including the Frye and Stander hotels, the Athletic Club (demolished), the Hoge Building (FIG. 4.1), the Schwabacher Building, the University Heights School, the Ballard fire station, and the First Church of Christ Scientist. The partners received awards for three buildings at the Alaska-Yukon-Pacific Exposition —the Washington State, the King County, and the Good Roads Association. Bebb & Mendel dominated the custom residential market along Minor Avenue East near the east shore of Lake Union, and on Queen Anne Hill. Leading families whose homes the partnership designed include Stimson, Green, Hyde, Walker, Ames, Kerry, Hefferman, Denny, Frye, Boeing, Fisher, Waterhouse, Cobb, and Hewitt. Among those houses, the Stimson, Green, Hyde, and Walker/Ames (now the president's house of the University of Washington) remain largely intact. In 1914 Bebb and Mendel separated, and Bebb lost his design rudder. Mendel's absence is apparent in the modern but stolid elevations and heavy windowsills of the great house for William Boeing at The Highlands, which Bebb completed. Bebb quickly found a new design partner in Gould, who was responsible for the interior finishing and furnishings of the Boeing residence.[5]

Gould probably was drawn to Bebb from the time the two men met, perhaps at the January 1909 meeting of the WSC. A founder of the WSC, Bebb would be named a fellow of the AIA in 1910. Bull-necked, balding, with piercing eyes and a moustache covering thin lips (FIG. 4.2), Bebb was superficially forbidding but actually gregarious and convivial, with a wide circle of friends. Charlie Bebb liked to joke. At the end of a December 1909 meeting of the WSC, Bebb, the outgoing president, "chided the new President for his failure to acquaint himself with the presence in the city of a newly arrived architect whose card he, Mr. Bebb, had received and which sets forth that said possible applicant for membership in the Chapter as not only an architect, but, as well, a contractor and builder, sign painter in colors, gold and silver leaf, wagon painter and electric wireman." Bebb, "to relieve the President from evident embarrassment" at overlooking such a broadly based talent, moved to adjourn the meeting.[6] Gould may have seen some of his father's good-humored friendliness in the older man.

There were other reasons for a close professional relationship. Both men were

4.1 Bebb & Mendel, Hoge Building, east front, 701 Second Avenue, Seattle, 1908.

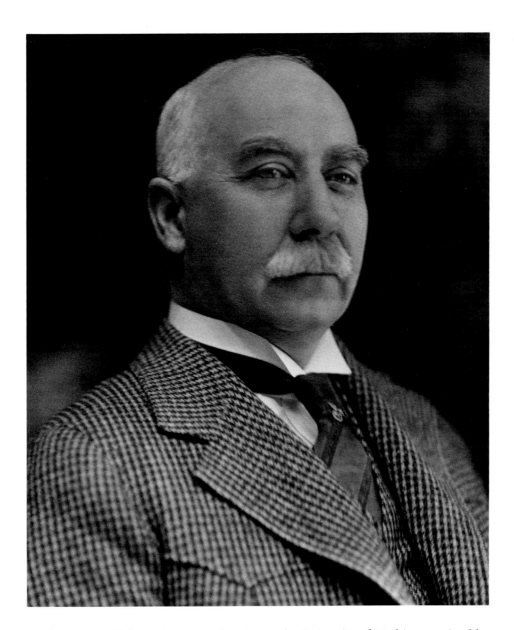

working to establish architectural education at the University of Washington. Gould was already teaching a course in "house planning" in the department of home economics, but soon he would establish the fledgling department of architecture. In 1913 Gould was appointed to a faculty committee to suggest fresh ideas for redesigning the campus, while Bebb was bending his ambition to capturing a plum commission, that of campus architect and planner (see CHAPTER FIVE). They nicely balanced relative youth and age—Bebb at sixty-one was eighteen years the elder—and relative length of time in Seattle. Both were energetic.

They joined forces in April in an agreement recognizing each other's strengths, Bebb's in engineering and technical concerns, Gould's in design. The document assigned percentages of the profits based on what the two believed were their individual specialties. Bebb was to receive 75 to 80 per cent of the net on warehouse work he brought in, and 65 to 70 per cent on the office and public work he garnered. Gould, conversely, would receive 60 per cent on the residential work whether he or Bebb attracted the client. If Gould brought in a warehouse job, however, Bebb would profit 60 per cent of the net. Similarly, if Gould landed any public or commercial work, 55 to 60 per cent would go to Bebb. The two men termed themselves associ-

ated architects, but they in fact operated as a partnership until Gould's death twenty-five years later.[7]

Neither man had direct experience in organizing an office for the large volume of work immediately at hand: Gould had seventeen projects under way and Bebb twenty-five. Gould's academic training did not include office practice, and they had no models to follow except for Gould's brief term at McKim, Mead & White and Bebb's engineering experiences in South Africa, Chicago, and Seattle. It is a credit to both men that they achieved a large output while meeting the highest professional standards. Both were among the early registrants under the state's licensing law of 1919.[8] They first established their office in the Securities Building at Third Avenue and Stewart Street, where it remained until February 1921, when it moved to the Hoge Building designed by Bebb & Mendel (1908) at Second Avenue and Cherry Street.

Bebb & Gould attracted an effective and devoted staff, not all of whom can be identified because their employees in the early years rarely signed or initialed their work. Some among the many who passed through the office remained long enough to make significant contributions to the practice, while others later led their own successful firms. The first category included Andrew "Sandy" N. Knox (1919–24), a Scotsman, and an extraordinary delineator in the Tudor and Gothic styles (FIG. 4.3); Paul F.

4.3 Bebb & Gould, A. N. (Sandy) Knox, delineator, University YMCA, 1435 Northeast Forty-third Street, Seattle, 1920.

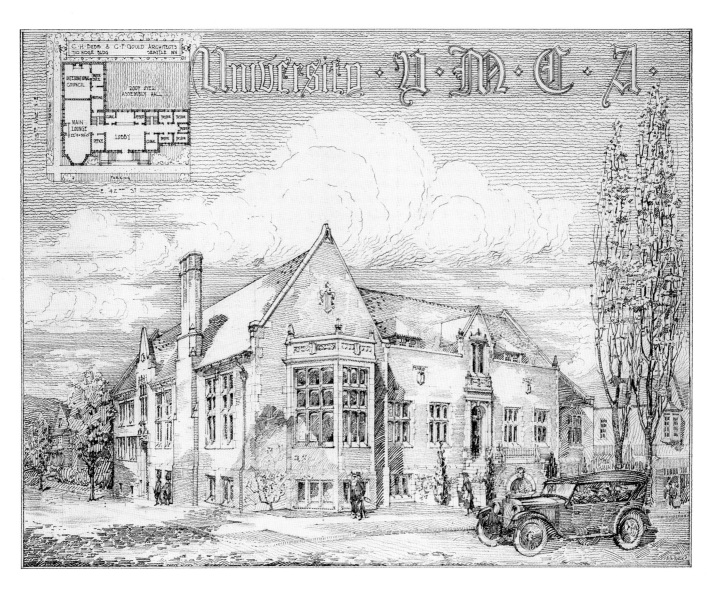

McAllister (1912–17), who had begun with Gould and continued in the new firm; and Frederick W. Elwell (1910–17), Gould's right-hand man, who later became superintendent of buildings and grounds at the University of Washington. Others who were important to Bebb & Gould were Walter G. Hemingway (1920–37), the steady hand at construction sites; Bert S. Waite (1917–23), a deft draftsman who was the office clerk at the Lake Pleasant project; Edgar G. "John" Park (1915–38), who handled specifications, estimating, and construction detailing; E. Arnold "Arne" Campbell (1932–39), office boy, draftsman, and supervisor; and the most enduring of all, John Paul Jones (1919–39), not an abundantly talented designer but a loyal lieutenant who shared in the profits after 1937.[9]

In the second group were those who went from Bebb & Gould to achieve distinction on their own. Howard O. Sexsmith (1914–17) was also Gould's first assistant at the university, and later taught at the University of California at Los Angeles. Walter C. Wurdeman (1930–32), who demonstrated his skills in Art Moderne design with the Seattle Art Museum and the unbuilt second Boeing house, went to Los Angeles to create the large post-World War II firm of Wurdeman & Becket. J. Lister Holmes (1928–30) took over the Washington State Building for the New York World's Fair (1939–40) after Gould became too ill to continue. John T. "Ted" Jacobsen (dates unknown) later was the design partner of John Graham, Sr. John S. Villesvik (1930–34), job captain for the Seattle Art Museum and the Everett Public Library, established his own practice in Yakima. Villesvik and Arne Campbell remembered how Gould inspired them. In drawing and conceptualization he was their model and mentor, while his gentle manner fostered loyalty and dedication to the work.[10]

The insistence on quality extended beyond the office to the best consultants in the city. In the early years Bebb probably was active in structural design, but Henry Bittman also provided structural analysis. Later Bebb & Gould retained Vernon Suchow and then M. O. Siliassen as consultants. In their University of Washington work they regularly employed Joshua Moore for electrical and mechanical expertise. Later, the complexities of the new, unfamiliar environmental controls for gallery spaces led Gould to retain Lincoln Bouillion for the Seattle Art Museum project. He was not afraid to retain young men of talent, for Bouillion was just beginning his career as an electrical and mechanical engineer. Gould relied upon Hemingway on the sites and on his job captains to coordinate the consultants' activities.[11]

Both Bebb and Gould worked hard in the early years to manage the flow of work through their office. Bebb undoubtedly exploited his club connections and wide associations to gain the commissions for the expansions and remodelings of the Rainier Club (1926, 1927, 1936), the Ellensburg General Hospital (1918), the Virginia Mason Clinic (1919, 1925), the Everett General Hospital (1922, 1924), Swedish Hospital (1917, 1933), Lakeside School (1931–34), the Times Printing Company (1913–15), and the mansions for William Boeing (1914), and Fred Greene (1930) in The Highlands. Bebb brought additional luster to the firm because he was the local architect of record at the Washington State Capitol project, a task that began in 1911 but continued into 1926.

Bebb tolerated and perhaps even encouraged Gould's absence from the office at the University of Washington for two days each week. After Gould began teaching and heading up the new Department of Architecture in the fall of 1914 (see CHAPTER

FIVE), Bebb expressed his support with a $100 scholastic prize in architecture. During the summer of 1916 Gould's headaches, insomnia, and depression reached such proportions that he retreated to a naturopathic sanatorium near Portland, Oregon for two months. Bebb took up the slack in Gould's fifteen or more projects.[12]

Over time, however, Bebb's contribution to the association diminished. By 1917 Gould was attracting about half the jobs. By 1918 the World War I curtailments had caught up with the firm; it was temporarily down to one draftsman, and Bebb was contributing little. Gould's wife Dorothy steadfastly believed that Bebb's sloth compelled her husband to compensate by overwork. She wrote in the spring of 1918 that Carl was "doing all the detail work which takes a lot of time, as Mr. Bebb the senior partner isn't a bit of good except at 'wangling' and just now there is nothing to wangle." Gould assumed the design responsibility even on those projects for which Bebb received the greater division of the net. The overall apportionment of profits did not immediately reflect Gould's lead because Bebb received the credit for repeat business from clients originally secured by him, and because a disproportionate profit accrued to Bebb from commercial and some public work. The two lost their biggest plum, architects to the University of Washington, in 1926. After 1927 Gould's share of the income exceeded Bebb's. The older man's dilatory habits eventually became a serious issue between them in the late 1930s (see CHAPTER NINE).[13]

Problems aside, Seattle in the later teens and for most of the 1920s was a good place for the partnership. It was growing from a population of 237,194 in 1910 to 315,685 in 1920, on its way to over 365,000 in 1930. Growth slowed both relatively and absolutely, and primary manufacturing declined, but too much should not be made of such developments. The families with whom Gould identified maintained their fortunes in mining, lumbering, transportation, real estate, and related activities. They continued to demand suitable residences in the developing areas east toward Lake Washington and north in The Highlands. They needed new structures for expanding businesses. They did not, of course, always turn to Bebb & Gould. The competition was heavy. John Graham, Sr., later Gould's collaborator on two federal projects, designed important downtown buildings including the Exchange and the Bon Marché. Graham carried the day with the Bon Marché department store even though Bebb or Gould designed the houses of the owners and managers, including those of Arthur Nordoff and Frank McDermott. In The Highlands and elsewhere, many houses went to firms headed by Arthur Loveless, David Myers, Kirtland Cutter, Andrew Willatsen, and Marbury Somervell. Nevertheless Bebb & Gould prospered through most of the period.[14]

A profound change in Gould's personal life followed his new professional arrangements, for on 22 June 1915 he married Dorothy Wheaton Fay (1890–1976) at Seattle's Trinity Episcopal Church. Dorothy was talented and well turned-out. A 1912 Vassar College graduate, she wrote a free-verse play, "The Thunder Bird," based on Northwest Native American legends and practices, which was performed that year as part of the commencement exercises. The predictable events in the life of a young upper-middle-class woman followed: a European tour and "coming out" at a debutante presentation ball. She was a handsome woman who described herself in 1915 as "tall" at 5 feet 6 inches, "ample in every direction," weighing "132½ pounds (gym weight)" but

"not at all pretty" with a nose having "a nice snub on the end of it," green eyes, and dark blonde hair. In public she was impeccably and stylishly dressed (FIG. 4.4).[15]

Dorothy met Carl at her debutante ball, but "his majesty merely settled his austere eyeglasses upon his nose and didn't see" the debs. Gould was, at thirty-nine, one of the most dashing bachelors in Seattle, tall, handsome, friendly, and witty, an excellent dancer and companion. "There were fifty thousand girls here," Dorothy remembered years later, "all very attractive girls, all had their eye on him." But "I don't think he gave a damn about girls," for he was involved with work and career, and had a reputation for being, despite his cleverness, forbiddingly cerebral. "His majesty did condescend" to notice Dorothy occasionally, she wrote after their engagement, "but I was perfectly terrified of his reputation for brains. . . . Our acquaintance was distinctly formal." Later, however, they danced at a masquerade, perhaps a Fine Arts Society party, "and we had a good time." Circumstances kept the acquaintance friendly but not close. The circumstances changed in 1914. In the fall of that year, Frederick Padelford, chairman of the English Department at the University of Wash-

ington, asked Dorothy to teach a composition class because of his heavy student load. She "couldn't resist the chance to try out this answer to the 'after-college-what' and 'why-are-we-here' questions, which gay society and charity and being a sunbeam in the home didn't seem to furnish."[16]

Dorothy's decision coincided with the beginning of Carl's teaching in the Department of Architecture. With some of her friends, she "used to go down and sit in the back row and listen to his lectures on what we call the 'Happy Home' course," his survey on architecture and the allied domestic arts. Carl noticed what the women enrolled in the course called "Newport Row" or the "immoral society girls," because they came to the campus in private cars. He began having lunch with them at the commons, along with "several other young professors." Then Dorothy asked him to speak to her class on the relationship between art and literature, partly to allow the class to hear the English language precisely articulated; Gould clearly had some control over his speech during lectures. Dorothy "sat up and took notice" of his "*nice, nice* talk," and of a man different from the lecturer who was "so highbrow and serious-minded" that "Newport Row" had irreverently nicknamed him "Gouldy." Carl was charmed by Dorothy, too, for he called the next evening. Soon they "had a talk after a party one night about some University plans. He was pretty discouraged, and I knew just what he was up against," because her father had resigned the presidency of the Board of Regents after "he got tired of trying to hammer a new idea into their heads." From then on it was a round of parties, walks on the beach, and an engagement with plans for a June wedding.[17]

In the meantime Carl was designing and building a house for his bride on Bainbridge Island, in Puget Sound near Seattle. He paid $50 for a lot on a rise of ground north of The Country Club on Upper Farms Road. He named the one-story residence "Topsfield." To build it inexpensively in what was then called "the country," he developed a precut modular system derived from the bungalow, a building style then in its Seattle heyday. He followed the bungalow arrangement of single-story wall, simple roof, veranda, and open interior plan. His system broke the wall into its components: supporting members, blank or closed elements, and openings, all devised to encourage easy communication between indoors and outdoors. The result has a distinctly Japanese flavor (FIGS. 4.5, 4.6).[18]

The upper part of each panel is composed of small glazed sash, fifteen panes in all, and the lower part is stuccoed. The panels reflect Gould's concurrent designs for the lavishly windowed buildings on the University of Washington campus. A formal garden on the north side provides an organized but intimate view from the kitchen (FIG. 4.7). The living and dining rooms face south, over the broad deck, the island, and down Puget Sound toward sublime Mount Rainier. Here Gould designed a different wall treatment to take advantage of the often-meager Pacific Northwest sunlight and the enchanting view. Four of the wall panels consist entirely of sash. Two of them flank each pair of French doors leading to the deck. The three-sided deck enhances the air of a country place, but Topsfield was intended for permanent residence. The roofs cover the casually arranged rooms beneath, sloping to narrow eaves which let in the light. The composition is disarmingly simple and without historical references, but sheltering and carefully oriented to views. Gould liked to relax on the deck by painting and sketching the scenery.[19]

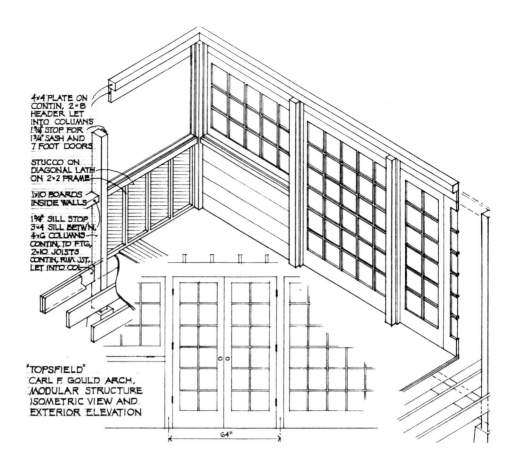

4.5 *Carl F. Gould, Topsfield, construction photo, 2380 Upper Farms Road Northeast, Bainbridge Island, 1914–15.*

4.6 *Topsfield, south view.*

4.7 *Topsfield, isometric view and south elevation.*

The structural organization of Topsfield allowed for its easy expansion. In 1916 the Goulds added a nursery at the north end of their island home and the dining room at the south. A "service wing" followed the next year. The house's studied informality encouraged its architect to indulge his humorous fancy by painting it yellow and black, colors prompting Dorothy to call it "Bumblee Cottage." As Dorothy's name suggested, the house was not quite a bumblebee, for Gould offset its hymenopterous hues with gutters of turquoise green and eaves of Chinese red.[20]

Topsfield is far more important than its deceptively casual, festive appearance suggests, for Gould's innovative adaptation of industrial construction assured its rapid and effective erection. He devised an economical system composed of posts on pre-cast footings uniformly spaced, with beams bolted to the posts. The floor and wall panels span the posts and beams. A rim beam over the posts supports ordinary roof rafters. He designed all these elements as precut modules to be manufactured in Seattle, numbered, then barged to a landing near the site. He used the same system in summer houses for Otto Hanson (1914, Bainbridge Island) and Broussais Beck (1918, location unknown); buildings for the Merrill & Ring Lumber Company at Pysht (1915–18); the project at Lake Pleasant (1918); and for the dining hall at the Friday Harbor Marine Station (1923). All these structures were, like Topsfield, to be built on remote sites where skilled labor and elaborate machinery were costly and scarce.

As he should have, Gould took full credit for this innovation when pressing his spirited if unsuccessful bid to design a military cantonment at American Lake (now Fort Lewis), south of Seattle. "It is a system I have worked out for a small cottage I have built for myself," he explained. The method worked superbly for "cook houses,

bunk houses, machine shops, cars for extension lumber operations, etc., and has proved practical and economical in every respect." The "construction of these buildings is on the unit system," he wrote, "and so designed that they can be cut at any mill, the numbers marked and assembled with the greatest rapidity . . . shipped on scows and erected in a very short period of time."[21]

Gould's recreational pursuits, besides painting, included skiing and sailing. Three small commissions relate to skiing. He was for a time a member of the Mountaineers Club, for which he designed two huts, apparently without any charge for his services. One, a small three-room, log frame lodge near Olallie Lake, was designed and built in 1914; it later burned down. The other consisted of improvements to the Meany Hut (1933), located east of Snoqualmie Pass in the Cascade Mountains east of Seattle. Each design is without any pretension but is well suited to its locale and function. In 1916 he designed the first John Muir Memorial Hut, built at the elevation of 10,000 feet on Mt. Rainier. The hut's massive stone walls enclose a single room 9 by 15 feet. Gould's drawing indicates that the roof should be designed to bear a 34 foot snowload! The roof is composed of 2-by-12 boards laid side by side to form a solid mass of timber, each 16 feet long, each carried to the site by two men climbing 4000 feet. Gould, the elegant and urbane architect, understood construction in almost inaccessible areas.[22]

Most upper-middle-class people used their homes on Bainbridge Island in the summer only, but the Goulds lived there all year around until they built a house in Seattle in 1920. After that they migrated to "the country," as Bainbridge Island was then called, for the summer season. In the two and a half years after their marriage, their first children, Carl, Jr. (1916–92), and Anne Westbrook (1917–) were born. Their third child, John Bradford VanWyck Fay Gould, was born in 1925. Their life as a family could be harried. During the summer of 1916, while Carl, Jr., was in diapers and Dorothy was pregnant with Anne, Gould experienced the severe headaches, insomnia, and weight loss that drove him to the sanatorium near Portland. The separation from Dorothy was so painful that he wrote frequent letters alluding to their robust sensual life. He also hoped for better times. "I do know, if there is something that can be corrected, I will be a different person. The one or two times I remember feeling really well gave me an inkling of what one might be able to do if one was not constantly shut down by depression and headache." Illness did not prevent him from appreciating his advantages: "Even if I can't be improved physically, I shouldn't complain as I have had chances and pleasures much greater than the average man." Dorothy's responses attempted encouragement and cheer, but also complained of life without domestic help, a hardship for a pregnant young woman with a baby to care for, who was accustomed to having others do the chores.[23]

When Gould was in reasonably good health he moved at a pace that would have exhausted many men. By 1919 Carl, Jr. and Anne were old enough to exhibit independence, and this trait, combined with Carl's constant activity, could lead to uproarious family scenes. Dorothy described one January evening when Carl rushed home from a Harvard Club meeting to "gobble dinner" before dashing off to see a client. The children ate at a separate table, and too late the parents found "that Carl Jr. had ruined his dinner and Anne's trying to 'salt' his and her food with red pepper." As Gould rose from the table, Carl Jr. insisted that his father operate a Christmas gift from Grand-

mother Annie, a slide projector, then an expensive, bulky piece of equipment. "Carley wanted some picture showing as he calls your magic lantern," Dorothy wrote to Annie, "but had to be bribed with sugar to wait till tomorrow. Then Anne—who is very greedy and a great grabber nowadays—stole the piece from under his nose, and you should have heard the row."[24]

Dorothy was a helpmeet and companion to Carl in ways that allowed him to extend the range of his activity and worry less about the household. Even though work in 1918 was scarce, she wrote to Annie in the cheerful deference she wisely maintained toward her mother-in-law, "We get along very well on the University salary of $133 a month and it is remarkable how much you can do without just as happily as ever." Dorothy probably was not economizing quite as much as her letter suggested, for there was some income from the office. In 1919 she complained about the maid wanting weekends off, compounding the problem of her own free days being consumed by cooking, dishes, and babies, unwelcome diversions taking her time away from Carl. Carl's pace had not slackened; indeed he was "always on the jump," rushing from a university regents' meeting, to an advanced architecture class, to a downtown "committee meeting on the Auditorium War Memorial Plans." Dorothy wished that he would "buy a second hand Dodge" to save most of the thirty to forty-five minutes spent on trolleys and walking from downtown to the university. Absent the Dodge, Dorothy pitched in to help. She taught a morning class of Gould's, then remained in town to cover an early afternoon class while he went to the war memorial meeting.[25]

The Goulds moved closer to Carl's work in 1920 when they built a house at Federal Avenue East and East Lynn Street on Capitol Hill (FIGS. 4.8, 4.9). The house at 1058

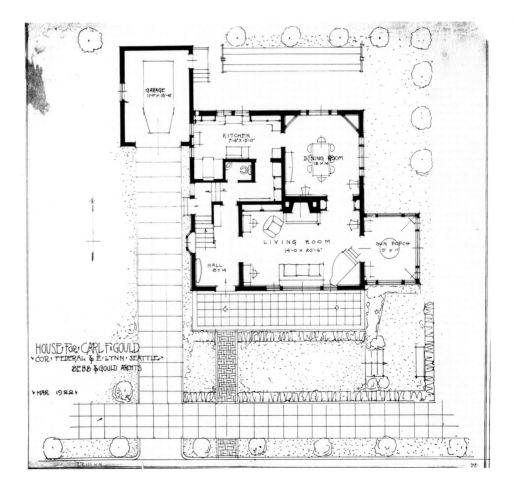

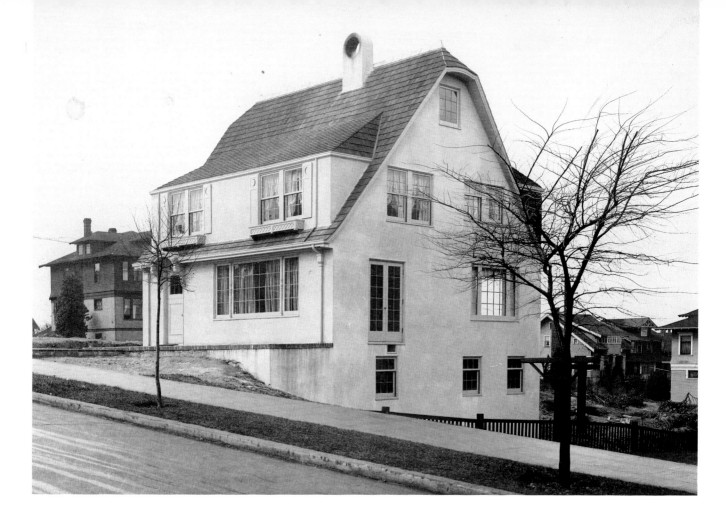

4.9 Gould family house, southeast view.

East Lynn, with its steeply sloping roof, stucco walls, and small double-hung windows, is reminiscent of an English cottage. The windows in the living and dining rooms are generously sized, however, to permit more light in the family and entertaining rooms. The house is economically arranged, with a short hall on the left (west) side leading past the living room, first to a tightly designed box stair, then after two turns, to the kitchen. A front patio and an east-side sun porch appear in the plan but were not constructed, although an anomalous French door on the east side marks the intended access to the porch. The construction drawings, based on Gould's sketches, were a gift from his office staff.[26]

The relatively small house—the living room at 14 feet by 20 feet 6 inches is by far the largest—and the informal design seem incompatible with Carl's background and the Goulds' social position in Seattle. But several considerations intruded. Year-round living on Bainbridge Island required a boat trip of up to an hour each way over Puget Sound. The omission of the patio and sun room suggest a move to town dictated not so much by Carl's affluence as by the necessity of improving access to clients, teaching, and the office. Given what Carl and Dorothy believed they could spend on a house, an informal arrangement was less pretentious, reflecting Carl's sense of fitness and restrained temperament. The rooms were adequate for the parties the Goulds gave at home, as most of their entertaining occurred at their clubs. Carl sited the house at the east end of a rectangular lot, leaving a large side yard with plenty of southern and western exposure for the children's outdoor play. The house and its yard reveal how much Gould relished a private yet abundant family life. About the same time he bought a "nice car," not a second-hand one, but a new automobile to increase his mobility.[27]

The public Gould became increasingly prominent after 1914, as an architect and as a leader in the WSC, the city planning commission, and in related organizations. The state chapter of the American Institute of Architects and its concerns were the hub of much of his activity. As head of the WSC's war memorial committee, he reported regularly in 1919 on the efforts of the Joint Liberty Memorial Committee to develop a civic auditorium at the old Bogue civic center site, Fifth Avenue and Blanchard Street. The plans eventually came to nothing. Similarly frustrating was his 1920 effort as chairman of the committee on community planning to develop a five-acre residential subdivision near Ravenna Park. The owner pledged cooperation with the committee, which had selected the project as the one promising "the greatest likelihood of success." The committee carefully redrew the standard plat in an "attractive and economical fashion" to accommodate thirty-five houses, not the thirty provided by the standard city lot, and designed "an intimate community entrance and ways of approach." The owner received approval of the plat and his financing, but balked at paying the cost of the field drawings, five or six hundred dollars, asking the committee members to take stock in that amount in his company instead. They refused, and the idea expired as a WSC project.[28]

In December 1921 Gould realized a long-standing ambition when the WSC nominating committee recommended him for the presidency. He had run for office before but had occupied no higher position than the executive committee of the eighty-member organization. Once elected, he worked hard at being a thorough and innovative president. After a February 1922 business meeting, he showed some fifty lantern slides to the group, slides that "elicited much interesting comment and it is hoped that the Chapter have many more such enjoyable evenings." He encouraged art education in the schools, competitions among architecture students and draftsmen, and good civic design. All the while he assiduously cultivated the press. During Gould's tenure the WSC worked closely with the Puget Mill Company in developing its Sunrise Addition in the Mt. Baker Park district. The wearying details of an unprofessional conduct case brought in 1923 took a substantial amount of his time.[29]

The social side of the WSC received unprecedented attention. Gould invited wives to the meeting of 23 June 1922, and afterward "all present were taken in machines" to the University of Washington to inspect Bebb & Gould's new Education Hall. Following a stop at the newly completed Roosevelt High School, the caravan went "to the Highlands where two beautiful houses," one by Bebb & Gould, "were inspected. Returning, the machines stopped at the new home of the Chapter President where a pleasant hour was spent in friendly conversation."[30]

Gould's call for a regional architecture stirred the chapter as much as any of his other achievements. Regionalism had not always appealed to Gould. In 1912 he speculated on the meaning for architects of the rapid diffusion of fresh designs: "Almost as soon as a suggestion is offered in New York, it becomes known throughout the country." Similarly, innovations in Italy or Austria soon reached the United States. Thus "all the world is gradually being brought within one radius of ideas. It seems improbable, therefore, that ever again will any locality or country or any section of any country be able to develop a style which can be considered distinctive and peculiar to itself." Here Gould was extending the line laid down by Henry van Brunt in 1893, which he could have read in published form while at Harvard. Van Brunt argued

against adapting, as distinguished from appreciating, the best styles of the past. Following stylistic principles in the abstract, however, could result in a successful, though not distinctively American architecture.[31]

His wrestling with this issue revealed the American influences on Gould's work and thought, as distinguished from those of the Beaux-Arts, although the two cannot be disentangled entirely. While Gould was growing to maturity, eclectic architects were struggling with the question of developing a distinctive American style. Most agreed that styles should link with the past while avoiding archeological slavishness in favor of expressive adaptions. They disagreed on whether the result would produce a single style, a group of styles related to function, a series of regional styles, or no uniquely American style at all.[32]

Ten years later Gould abandoned universalism. Instead he embraced the prospect of an American style, however distant, but much more importantly and immediately, he foresaw a renaissance of regionalism. Now he was drawing, consciously or not, on articles by the critics and analysts Barr Ferree, Edgar V. Seeler, and Arthur Burnett Benton, as well as the California regionalism of Bernard Maybeck, Charles and Henry Greene, and Irving Gill. He first turned to the question of an American style. For him the solution would be discovered neither in the picturesque successionism of Louis Sullivan and Frank Lloyd Wright, nor in the adaptation of European styles. An American style, whatever its ultimate development, would emerge from a peculiarly American set of circumstances as yet unformed. "At the present time we are so overlaid with a confusion of impressions and emotions that we have apparently no dominating one which gives a direction to our thought and from which the architect can obtain positive inspiration." Individualistic Americans persisted in building isolated designs according to personal or corporate whim rather than seeking an ensemble based on a fine example of a type. Cass Gilbert's masterful Woolworth Building, "piercing the air with a vibrant vertical effect, apparently satisfying all the elements which make for beauty," was "an inspiration which one would think would be followed." But no; the nearby new telephone building, expensive but inexpressive, "is made up of a series of superimposed Greek marble temples . . . totally contradicting its magnificent neighbor."[33]

When Gould delivered his first presidential address to the wsc in 1923, he blamed a lack of discerning regionalism on the architect without "deep conviction" and on the client who "rarely if ever" offers "any intelligent reason" for preferring "one type of building to another, the only demand he makes is that it be entirely dissimilar to any building in the vicinity." The question, then, was how to achieve an integrative architectural beauty when there was so little agreement on stylistic "purpose."[34]

He began by asking if the people, history, and climate of the Pacific Northwest were not substantially different from that of California. "Do not our conditions more closely approximate those of Northern Europe, whereas California approximates the conditions of the Mediterranean Basin?" If so, then "the horizontality, the calmness and the massive walls belong to California, while the vibrant verticality, the small extent of wall with large window area are characteristic of us." If clients refused to "bring unity out of chaos, is it not our duty to attempt to do so by conscious agreement?" Architects should act because an individual building, however attractive, "if it does not conform to the conditions of the community in which it is placed it does not

4.10 Carl F. Gould, Miller Hall, sketch of window details, University of Washington, 1921.

contain the fundamental elements of beauty." The lovely Taj Mahal moved to Britain would be "an exotic thing." Every architect should, therefore, "strive to discover or evolve or transport an architectural type which most nearly seems to fit our conditions and accept it as a basic point of departure, and each of us as best we can evolve and apply such a type," until it develops "into a form which perfectly expresses our community, as did the temples of the Egyptians and the Churches of France express the spirit of their communities."[35]

Gould's talk prompted the WSC to set aside a portion of a March meeting for "a very enjoyable and interesting discussion on the merits and suitableness" of California architecture versus "the taller, more vertical, and Tudor type of architecture for this Northern Country." The wide-ranging discussion was in part accompanied by "heckling and side remarks of the members," but concluded in general that the Tudor, with its verticality and lack of eaves and overhangs, was preferable to the Georgian and Colonial styles, provided that a more generous glass area were introduced into the traditional Tudor design. Several years earlier Gould had settled on an expansively windowed Tudor Gothic for the University of Washington campus (FIG. 4.10). It is doubtful, however, whether he intended the search for a regional style to end with the

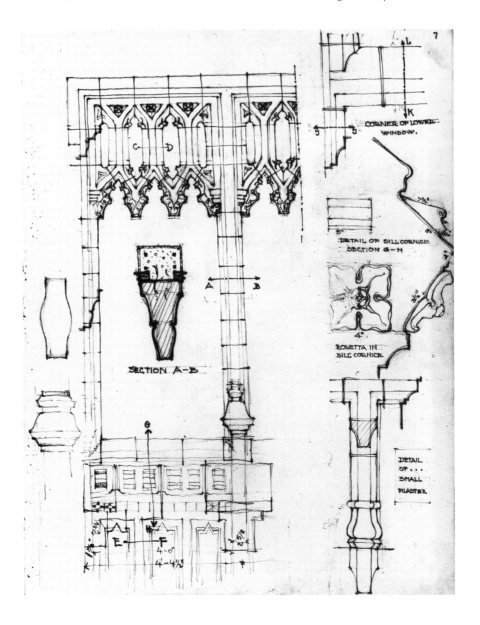

Tudor. He designed only a few houses or noncampus buildings in that style. Topsfield, though a horizontal house, is unabashedly vertical in its window treatment of the south view wall. Gould's house on Capitol Hill is English cottage in feeling but is also vigorously vertical, without wide eaves or overhanging roofs.[36]

After his stint as wsc president, Gould worked on the exhibition committee but failed to stir the old enthusiasm for architectural exhibitions. In 1925 he was named a delegate to the AIA national convention, perhaps because he was willing to attend as part of an eastern trip and to pay his own expenses. He devoted more concern and attention to the problems of planning and zoning, then a hotly debated topic among architects and urban planners. The concern for establishing planning and zoning commissions with broad powers to draw up city plans, hold hearings, and recommend zoning changes to city councils gathered momentum even before the Supreme Court upheld the principle of local land use controls in *Euclid v. Ambler* (1926). As early as 1919 Gould urged the wsc to consider "the impending zoning need," and to secure the distinguished planner Charles H. Cheney to address a meeting composed of representatives of the wsc, the Real Estate Board, the Chamber of Commerce, and the city council. In October Cheney spoke on the subject with a "forceful manner of address" to the chapter and a few guests. The wsc endorsed "a permanent City Plans Commission" and named a committee "to wait upon the Mayor and Council with a request that an ordinance be passed creating such a commission."[37]

Late in the following year Gould, the chairman of the community planning committee, announced a campaign to expand the existing zoning commission to include city planning for Seattle. The effort succeeded in 1924, with Gould active to the end. At a meeting on 3 October, he reminded the wsc that three days later the council was to vote on an ordinance establishing the city planning commission, and that "members should get in touch with the Council and endeavor to have them pass the ordinance."[38]

Gould served on the first city planning commission. He represented the Chamber of Commerce on a "representative" commission composed of nominees from various civic organizations, although the members were appointed by the mayor. He attended the meetings, which were sometimes crowded with petitions to change the existing zoning designations for individual lots or groups of lots, most often from restricted residential zoning to a category permitting apartments or commercial activity. Earlier he had served the chamber as a member of its cleanup campaign. "The papers make us laugh," Dorothy reported to Annie. "They keep quoting interviews with him (imaginary) about *cleanliness*! And you know Carl may *believe* in *cleanliness*, but he is much more likely to advocate beauty and take *cleanliness* for granted!"[39]

The teens and the 1920s saw Gould delve deeply into the professional, social, and civic life of Seattle. He retained his ties with New York—"Seeing N.Y. is like a drink of water in a desert after a couple of years in Seattle"[40]—but he was firmly planted in the Puget Sound city by 1914. In that year he formed an enduring partnership, and in the next year he married. By 1926 he had become established in the wsc, on the planning commission, in the Fine Arts Society, in clubs, and at the University of Washington, where he was both head of the Department of Architecture, and architect to the university.

The size, proportion, beauty, and character of detail must be consistent. —CARL F. GOULD[1]

5 At the Zenith: Campus Work, 1914–1926

GOULD'S MULTIPLE ROLES AT THE UNIVERSITY OF WASHINGTON from 1914 through 1926 epitomized his holistic approach to beauty. As a teacher he inculcated the principles of architecture in the young. As the university planner he projected a classically axial campus, and as the university architect he designed individual buildings to define the plan. Bebb played an early role in each of these undertakings, but Gould's was by far the greater sustained effort.

Gould traced his interest in teaching to the failure of the Bogue plan. After the public rejected the architects' bid for design control of the city, "I wondered what was the use of working for these people. I thought, 'why not try and see what you can do with the youngsters.'" He would capture by indirection what he failed to take by storm, for "the younger mind is more susceptible," can be led outward from architecture, "and you can suggest the beauty of surroundings and make a city beautiful and orderly." The idea of a beautiful city, once it captivated the young, would be realized when the indoctrinated younger "fellow goes down to the city council," and puts "his ideas across." Beauty, without which life was not "worth wasting the time on," was always the ultimate end. "Nature is, of course, beautiful but you can't be always surrounded with natural beauty. We are not going to rest content without our own created beauty."[2]

Gould remembered that he had been asked "to come out here to lecture to students. So I came and organized this department [of architecture]." His statements about the Bogue plan and the invitation were too self-effacing. He already saw architectural education as part of his professional obligation, both to younger practitioners and to the public. During his first year in Seattle he joined the Architectural Club, a group of architects and draftsmen, and became the head of its education committee. He stated that his mission was to impart to the draftsmen, who were already good technicians, the soul of architecture. That soul lay in something more profound than faultless execution; it lay in the "spirit of creative imagination."

Gould advanced the development of architectural creativity in two ways. First he organized an evening class to teach draftsmen the principles of design. He then arranged *esquisse* tests for the draftsmen, examinations based on Ecole des Beaux-Arts

77

practice (FIGS. 5.1, 5.2). The work was sent to San Francisco to be judged by a panel of eminent Beaux-Arts alumni, who followed the manner of judging at the Ecole. Nor did Gould neglect the public. After he joined the WSC and became the chairman of the exhibition committee, the WSC in 1910 held an exhibition of architects' and draftsmen's projects at the Seattle Public Library. Seventeen thousand five hundred people attended the exhibition, providing an opportunity for the public to see and perhaps understand something of the architects' devotion to beauty and good design.[3]

Furthermore, architectural education had become a commonplace among leading universities in the United States by the time the Bogue plan was irretrievably lost. Charles Alden, a local architect, had lectured on his profession to University of Washington students in home economics. In 1912, several months before the defeat of the north end courthouse site, Bebb brought up in a WSC meeting "a subject formerly under active consideration by the Chapter," establishing a "chair of architecture" at the university. Bebb was named chairman of a committee to confer with the board of regents, a committee including David Myers and Gould. The three wrote letters to leading professors of architecture, including John Galen Howard of the University of California, Paul Cret of the University of Pennsylvania, and A.D.F. Hamlin at Columbia University, asking for the professors' reactions to establishing a school of architecture. The committee excerpted their positive comments in its presentation to the board. The thrust of the WSC argument, however, rested on the rapid growth of the Pacific Coast region and the need for well-done buildings to accommodate that growth. With one exception, there was no existing west coast school to train architects

5.1 Carl F. Gould, pavilion, pencil rendered elevation, Ecole des Beaux-Arts, 1900.

5.2 Carl F. Gould, figure dessinée charcoal on paper, Third Medal, Ecole des Beaux-Arts, sketch, 1900–1901.

for the job ahead. The committee referred indirectly to Seattle's needs when it forecast a competition among growing cities to display the best architectural work.[4]

Moving to specifics, the committee advised that while the first year of a student's work would be general, the school would require "the nucleus of an architectural library," including, possibly, casts, photographs, and lantern slides. The second-year course would be specialized, follow the recommendations of the AIA and the practices of established schools of architecture, and be well funded. The WSC pledged its cooperation. It emphasized most strongly the need for "a professional man of recognized ability and with sufficient experience" to found a school. The board reacted favorably but referred the matter to President Thomas F. Kane. Kane wrote to Bebb that the university would pursue the matter vigorously, that together the processes of university review, regents' approval, and funding would take some time, and that Kane would consult with him before reporting to the regents. An architecture school was by no means a novel idea at the university. "Our men have had this item on the calendar or waiting list for five or six years," Kane informed Bebb, "and it will not take them long to make their preliminary estimates and reports for me." As always, Gould was alert to the political dimension of the situation. He told the WSC that an architecture school depended upon legislative funding "and as the University Authorities were susceptible to public opinion he urged that the Chapter members use their influence with the Regents and others in behalf of the movement."[5]

By January 1913 the decisions were made. In that month the regents approved the formation of a new College of Fine Arts, including a Department of Architecture. They appointed Gould as lecturer beginning in the fall of 1914, to head the department. He began teaching a class on "Elements in Architecture and Home Architecture," similar to the "Happy Home" course given in the fall of 1913. He was located, temporarily, in the home economics program, where Alden's lecture had been held. The class met two hours per week, and by the standards of the late twentieth century demanded substantial reading: five books, and articles from *House Beautiful*, *Good Housekeeping*, and *House and Garden*. The students were required to submit a house design based on a Beaux-Arts *concours*, with the location, site, climatic characteristics, construction materials, and interior arrangement clearly presented. Gould came right to the point in his introductory remarks, telling the students that beauty would be the central theme: "The course will increase . . . your powers of appreciating the . . . beauty in your surroundings."[6]

Gould brought exceptional credentials to his new task. He had attended the Ecole des Beaux-Arts, served on the staffs of nationally recognized architectural firms, successfully established himself with Seattle's elite, and demonstrated that he could conduct an independent practice. He was interested in the job, energetic, and ambitious for the university. The multifarious tasks of the chairman of even a small department were probably more demanding than he assumed at the outset, involving as they did curriculum development, student and faculty recruitment, battling with the administration for adequate space, supplies and equipment, and salaries.[7]

Fortunately Gould had several curricular models to follow and chose Columbia's for his basic framework. As developed in 1915, his course structure also was roughly comparable to the program at the University of Pennsylvania and the curriculum at the University of Oregon, fully instituted the year before. By the time he established

his own four-year program of study, Beaux-Arts style education and its loosely structured arrangements were woven into the more restrictive American university organization. Gould accepted this development. Under his presidency the Architectural League of the Pacific Coast had held a symposium on architectural instruction in June 1913, in which the keynote speaker advocated a strong regional system of university-based architectural education, but returning to the Beaux-Arts arrangement of ungraded courses, examinations, ateliers, and competitions. The speaker did not endorse Beaux-Arts design preoccupations, only the Beaux-Arts method. Gould was sympathetic to the idea, but not to the point of walling off architecture from the rest of the curriculum. His integrative bent led him to advocate a "popular course" open to all students, many of whom would take an appreciation of architecture into their business careers.[8]

Gould introduced some elements of Beaux-Arts training into the four-year curriculum, for he believed in their relevance. He insisted that only a practicing architect should head the department because a practitioner was in "daily contact" with real problems, as was the *patron* of an atelier. He presented problems to the students much like the Beaux-Arts *concours*, and sent the projects resulting from programs to the Beaux-Arts Institute of Design in New York for judging. He drafted fellow Seattle architects for individual lectures on special topics, or to teach for a year or more on a part-time basis. In this he was making a virtue of necessity, for he needed people to fill in while he was absent from class for faculty recruiting trips or community activity, and he required temporary teachers to cover entire classes when his faculty recruiting or retention efforts failed. Nevertheless he really believed that practicing architects or an occasional on-campus lecturer who specialized in some related field would bring a greater knowledge of the practical to his students.[9]

Gould organized the design laboratories with project deadlines imitating those of the Ecole. During "charette week," his students were allowed to work late every night to meet deadlines. The marathon session was named for the *charettes*, the carts in which the Beaux-Arts students rushed their projects for judging at the Ecole. Charette week was a time for both students and faculty to "sing and put over a little horseplay to keep the blood circulating during the early morning hours," Gould recalled. This uproarious imitation of the ateliers of Gould's Paris days became possible after 1917, when his former employee Elwell, who became the building superintendent for the university, permitted the activities, and more so a year or two later, when the department moved from behind the Auditorium stage to a temporary building near Denny Hall. The quarters were affectionately called the "shack," and here the students could indulge their penchant for raillery. Their noisy recreation of an atelier accompanied the department in its 1923 move to Education (now Miller) Hall (FIG. 5.3), although not for long. The attic space was well lighted, but it was also "concrete floored, telegraphing the rumpus we like to raise on charette week to our friends, the engineers, below." The engineering students enforced "harsh restrictions" on the hilarity of "charette week" during the remainder of Gould's professorship.[10]

The department's student population began with twelve in 1914–15, and despite fluctuations caused by war and depression rose to fifty-eight in 1924–25. The department did not confer its first bachelor's degree until 1918 because Gould believed it to be so poorly equipped that he encouraged students to take their final two years at an

eastern school. Through 1927 it produced twenty-three graduates, among them Samuel Chamberlain, who made an international reputation as an architectural illustrator, and Walter C. Wurdeman, who went on to receive a master's degree from MIT, return to work in Gould's office, and develop a prominent practice in California after World War II. The male enrollment slump of the First World War forced Gould to seek female students. Usually he discouraged women from enrolling. If they persisted despite him and were superior students, however, he took pride in their work. His attitude was reprehensible from the perspective of gender equality, but was rooted in his patrician upbringing, an environment from which women rarely entered the professions, his experience at the Ecole, which was overwhelmingly male, and his own marriage, in which Dorothy was mother, helpmeet, and companion.[11]

As head of the department Gould knew the joys and sorrows of student and faculty recruitment. He was satisfied with the abilities of his students but not always pleased with their preparation. To combat student provincialism he worked to secure a Fontainebleau Scholarship of $1000 for exceptional students who could travel in Europe, attend summer school at the Fontainebleau American School of Fine Arts, then return to Seattle to finish their program while sharing their experiences with their classmates. The scholarship was a gift from various donors who responded to Gould's entreaties. It began in 1925 and lapsed during the Great Depression. But if student quality was not a problem, quantity was. Gould wrote to a new faculty member in 1923 that "we need a larger number of students. This means talks given to the High Schools and exhibition of drawings sent throughout the State. I shall expect you to cooperate with me in working this matter up."[12]

Attracting faculty posed sometimes insurmountable difficulties, for the pay was low and Seattle was remote from good, well-trained candidates. At first local talent filled the breach. Howard O. Sexsmith of Gould's office became a part-time instructor, interrupted his service for World War I, returned for a time, then left in 1923. Robert F. McClelland replaced Sexsmith, stayed on after the latter's return, then resigned, also in 1923. Replacements were sometimes drawn to the scenic Pacific Northwest but repelled by the salary, one writing in 1923 that "it would cost a large part of $3000 to get my family across the continent." Gould was discouraged by his inability to offer competitive salaries, less than those of good draftsmen who made "considerably over $3000 a year; with holiday bonuses." He persevered, however, and gradually attracted men who would guide the department and mold its students through the 1930s and beyond: Arthur Hermann, Lancelot E. Gowen, a former Seattle resident who wished to return home, Harlan Thomas, and Lionel Pries, whom Gould wooed but who did not arrive until 1928.[13]

In the beginning Gould bemoaned his inadequate facilities and equipment in letters indicating that he was expected to construct a department with blue smoke and mirrors. By 1915 he had reason to hope, for Henry Suzzallo had become president of the university. Aggressive, tough-minded, and zealous, Suzzallo was also a sympathetic man who valued the arts. By the end of 1916 Gould was writing about how "Dr. Suzzallo is doing wonders for this institution and he seems particularly interested in architecture and the teaching of it and I believe that in a few years we should have a very well equipped department." The two men developed a closeness best reflected in their collaboration on the physical development of the campus. Suzzallo helped the department, too. Gould declared in 1924 that "we get the sympathetic support of the administration as Dr. Suzzallo is very much interested in the work we are doing." The department's equipment, he wrote during the next year, had "been materially added to during the past two years. . . . We have ample quarters, a good library of about 650 standard volumes, 3000 half-tone plates and photographs; 1750 lantern slides, and a studio of 72 architectural casts." He went on to praise the administration's "generous budget," including a fund for slides, books, and equipment, and the salary of a full-time librarian.[14]

Teaching provided Gould with his best opportunity to exhibit characteristics of his father's friendliness and his mother's devotion to beauty, which worked to inculcate a love of beauty in the young. He was so sympathetic and engaging that his students, who had at first made Newport Row's appellation "Gouldy" a byword, changed his nickname to "Papa Gould." Probably he was "Papa" to small advanced classes and during charette week. Dorothy found him in 1919 a much more animated lecturer to his large class than she recalled from the Newport Row days. "He talks so much better than when I heard him last about 4 years ago," she wrote to Annie, "quite a lot of humor and ease and no stuttering." Elizabeth Ayer, the first woman graduate in 1921, remembered Gould differently, as "not a gifted teacher" whose classes "were a good place to catch up on sleep." Ayer did credit him with building up his department and with providing "a great many social times," especially the "gatherings at his summer home on the island."[15]

Dorothy's and Ayer's differing views of Gould's teaching may be reconciled in part by Dorothy's devotion to Carl and her effort to be positive and praiseful in her letters

to Annie. Beyond that, Gould may have become bored with his own material over the years, for he changed his courses little once they had matured. He wrote out his lectures, a practice that helped others take over his classes, but one that could have led to the deadly dull habit of reading aloud from the podium, a method requiring more than an occasional witticism to hold the attention of most late adolescents. As his pace accelerated, it was probably more difficult for him to take the time to look over his lectures and reflect on them before class. Reading his manuscript aloud then became necessary to a full presentation. Indeed, his courses were so frozen that he did not change his examination questions. Dorothy, who "frequently" graded his students' papers, "was shocked to find one student invariably copied A-plus papers done by others in previous years." She "demanded that Carl flunk the young man," but "Papa Gould" replied in words revealing his desire to be a friendly father figure, especially to this student. "No, my dear," he told his wife. "He doesn't have a father and he has the talent to recognize good papers; pass him."[16]

Gould's academic superiors acknowledged his guidance of the department with regular promotions. Beginning as a lecturer, he became an assistant professor in 1915. Four years later he was appointed associate professor. He was promoted to professor in 1923 at $1800 per year, a salary that compared favorably with others in the department when his half-time status is considered. In 1925 he achieved the ultimate reward for the head of a young program when the Association of Collegiate Schools of Architecture admitted the department to membership, in effect conferring accreditation upon it. The universities of California and Oregon were then the only other accredited programs on the West Coast.[17] During the years that he established a successful department of architecture, Gould also performed brilliantly as the campus planner and architect.

Bebb & Gould's appointment as campus planners and the firm's unofficial role as university architects opened the door for Gould's greatest architectonic and architectural triumphs. At the time of the formation of Bebb & Gould, he was already teaching at the university. In anticipation of his assumption of full faculty status, acting president Henry Landes in 1913 appointed Gould as one of a committee to reconsider the newly updated Olmsted Brothers campus plan (which was formally published in 1914).[18]

Gould began work near the end of a great era in campus design, when Beaux-Arts ideas of axiality and symmetry held sway. The designs found favor not merely because they paralleled the popular City Beautiful style of remaking the urban world beyond the campus. As Paul Venable Turner has written, the American university enjoyed a golden age of rising status, growing emphasis on research and graduate education, and soaring donations which funded increased academic specialization, expansion and complexity. Old ideas of romanticism and collegial democracy reflected in multipurpose main buildings, or in halls scattered through a sylvan landscape, no longer expressed the new era. Axiality and formality were needed to impose some visual organization and control over these centrifugal institutions. Architects and planners searching the past for models symbolic of the new era rediscovered Thomas Jefferson's classical plan (1817) for the quadrangle of the University of Virginia.[19]

The neoclassical format worked best when a university required a fresh design for

a relocated campus (Columbia University, 1894), or when its authorities were willing to consider sacrificing a few buildings to achieve axiality (Guilford College, 1909). Gould and his committee enjoyed neither luxury. They inherited a design refined from the Olmsted Brothers plan for the Alaska-Yukon-Pacific Exposition of 1909. The exposition grounds occupied the south end of the campus, organized around a north-west-to-southeast axis, the Rainier Vista, designed to focus on the majestic mountain eighty miles away. Those grounds were not blended with the upper campus, where a few buildings already had been built, notably Denny Hall, a stone and brick essay in eclecticism that Gould described as turreted French Renaissance. The revised Olmsted design (commissioned in 1911) concentrated on the vista axis and its subordinate radial axes and traffic circles, but without bringing the north campus into the formal composition of the whole. Indeed, they organized the north part into lozenge-shaped blocks reminiscent of the designs of F. L. Olmsted, Sr., for Riverside, Illinois, and Tacoma, Washington. The Olmsted Brothers plan arrayed buildings along roads rather than around enclosing yards. The library was placed near Fifteenth Avenue Northeast, a poor location away from the center of the campus. The central layout articulated a V-shaped plan. It was awkwardly joined because the throat of the V was not marked with a significant building facing Meany Hall. An entrance from Fifteenth Avenue Northeast to a traffic circle south of the apex, away from the true focus of the campus plan, created further ambiguity. Among other crudities, a major road ran through the middle of what would become the liberal arts quadrangle. The Olmsted Brothers plan did envision replacing the crumbling temporary buildings remaining from the exposition. The Law School, housed in a lath-and-plaster evocation of a Roman temple, was one of a dozen or so "shells which cost a fortune to heat and were constantly demanding more repairs, as their confectionery outsides had a humorous way of sliding off when it rained or blew hard."[20]

Although Gould was not the chairman of the committee, it is evident that his architectural, organizational, and educational ideas directed its work. The committee's nine-point program became the design scheme. It recommended that the central portion of the Olmsted plan be rearranged, that the principle of quadrangles be adopted, that the main entrances be at the north and south on axis with the Rainier Vista geyser basin. It argued that the library should be the pivotal building at the focal point of the campus. Driveways, it recommended, should be outside the central portion. The program called for nine quadrangular groupings and the collegiate Gothic style. The regents should employ an architect to make sketches, the plans to be submitted to the committee and the regents. The program also reserved areas along the Stevens Way ring road for future engineering buildings or other unspecified uses. Following the report of the committee in 1914, the university announced that it required a new master plan and would invite architects for interviews. Gould and his partner submitted their candidacy. In July 1914 the university awarded Bebb & Gould the commission to prepare the master plan.[21]

Gould responded to the problem of an inchoate campus by creating strong axes bisecting a series of quadrangles organized around the sciences, the arts, administration, and extracurricular activities. Gould's schema is best visualized in plan (FIG. 5.4) from a position above the now-demolished Meany Hall at the west edge of the campus. Meany itself is expanded, with a new facade facing Fifteenth Avenue North-

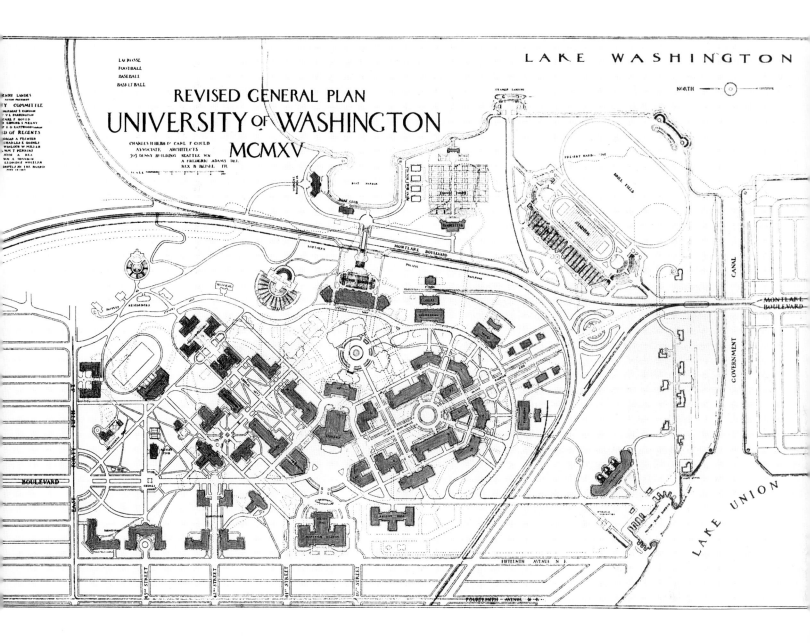

REVISED GENERAL PLAN
UNIVERSITY OF WASHINGTON
MCMXV

CHARLES H BEBB & CARL F GOULD
ASSOCIATE ARCHITECTS
303 DENNY BUILDING SEATTLE WN
A FREDERIC ADAMS DEL
REX B BEISEL JR

LAKE UNION

5.4 Bebb & Gould, revised general plan for the University of Washington, 1915.

east between Northeast Fortieth and Forty-first streets. Meany forms the base of a Y leading across an irregular court to the facade of the proposed new library, where the arms of the Y splay at a 110-degree angle. The southeasterly branch, the Rainier Vista, leads to the science quadrangle, with new buildings bounding and defining the view to the mountain while providing a south end entrance. The northeasterly branch is much more Jeffersonian and Beaux-Arts, terminating in a proposed hall, thus closing a revised liberal arts quadrangle, more contained and traffic-free than in the Olmsted plan. Four other proposed buildings define the quadrangle, two on either side of the axis.

Three additional axes complete the campus organization. One extends the base of the Y through the library, and anchors the irregular Meany-library quadrangle to the eastern side of the campus, down a steep bluff to a boat harbor on Lake Washington. Gould later abandoned this impractical line. Another axis (now Memorial Way) carries broad, leafy University Boulevard (now Seventeenth Avenue Northeast) south into the campus to the Meany-library quad, then farther south to a proposed fisheries-laboratory complex on Lake Union. The third, a cross axis, runs from the

junction of Fifteenth Avenue Northeast and Northeast Forty-second Street to the present Memorial Way. Several subordinate quadrangles to accommodate expansion complete the plan. The entire composition reflects Gould's classical planning orientation, in which a carefully structured composition of elements encourage the observer to view individual buildings for themselves but also as parts of an ordered whole.

What was to be the minor Denny Hall quadrangle, northwest of the liberal arts quadrangle, well expresses Gould's Beaux-Arts classicism. Denny Hall was built on a commanding ridge but left isolated by the A-Y-P Exposition and the subsequent Olmsted plan. Gould carefully arranged the liberal arts quadrangle and painstakingly proportioned its buildings to terminate its cross axis at the facade of Denny Hall. The little quadrangle was not built and, despite axial walkways, the pastoral scene in front of Denny remains. Even so, his solution to the problem of Denny Hall illustrates Gould's skilled integration of disparate, apparently intractable elements into a unified plan.

Beaux-Arts principles, not classicism itself, guided Gould. The well-proportioned quadrangles at Oxford, where Gothic buildings contained the open space, powerfully affected his design. "After visiting the colleges of Oxford," he wrote, "I find I cannot feel more than a sentimental affection for the Harvard yard." Whatever the value of his criticism of the lack of grouping and beauty at Harvard, he was determined to control the proportions between space and buildings at the University of Washington. He chose late English Gothic partly because of the problem of spatial and facade proportions. Neoclassical buildings were unsuited to the expansive quadrangles, because they were expensive to build, their eaves and porticos blocked natural light, and their forms became attenuated on structures tall enough to control the quadrangles. The positive aspects of English Gothic lay in its verticality and its adaptability to concrete and steel construction, with its load-bearing elements concentrated in buttresses rather than spread through walls. Gothic buttresses expressed the wide spans between slender reinforced concrete pillars, and allowed for much larger expanses of glass, so necessary for classrooms and laboratories in the often cloudy Pacific Northwest.[22]

The library and its quadrangle epitomized Gould's theory of collegiate design, which Suzzallo shared. Gould placed the new library at the apex of the Y, at the confluence of the liberal arts and science axes. The site confirmed his belief in the library as "the great center of interest of the entire University, intellectually speaking," with the "power of impressing young minds." The facade of the library then would face Meany Hall auditorium across a space of about 300 feet, or the base of the Y. This axis, together with two irregularly shaped buildings on each flank, formed the administrative quadrangle. Given the future Gothic facades, it was an advantage to Gould's scheme that Meany, oriented to the street grid west of the campus, did not align completely with the library across the quad, for the central campus space could then appear to have grown by accretion, and the flanking buildings could be shaped according to site and use requirements rather than to the inflexible demand of perfect symmetry. For all his interest in axiality Gould followed the Olmsted plan by preserving Stevens Way, a curving drive around most of the campus, designed in part to exploit views of the Cascade Mountains.[23]

The Board of Regents accepted the plan on 19 May 1915. The university retained

Bebb & Gould for every part of the building program through 1926, although the firm was never designated the official architects. If Gould were his usual self on the campus plan committee, he well understood how his cultivated charm and friendliness could lead to some prized commissions in the actual development of the plan. In later years he declared the campus plan commission to be "of such magnitude and potentiality, and having so few pre-determined conditions" that it was "one to be approached with the greatest humility." He remembered that the assignment could not "have been more stimulating." Gould probably approached the plan with less humility and more determination to work hard, on a program "stimulating" partly because it promised so much beyond itself. The plan served the university for fifty years, and its deep imprint remains. Bebb & Gould's assignment of 65 per cent of the profits from the university buildings to Gould recognized his design leadership and his involvement in revising the campus plan.[24]

Henry Suzzallo was the patron of Gould the architect just as much as he was of Gould the teacher and department head. They shared a vision of development for the university through eleven years, through careers so symbiotic that they ended almost at the same time. Their mutual vision rested on a belief in beauty as a positive force in ordinary lives. "People must be made moral and they should be made intellectual," Suzzallo wrote in an archetypical expression of progressive faith and determination, "but intellectuality and morality are doubled in their efficiency when the grace and appreciation of beauty are added." To Suzzallo, his university initially lacked the means for either moral or intellectual uplift. It "disturbed me greatly when I first came. The campus was naturally beautiful but the buildings were ugly." He set about to rectify this disastrous physical environment. Soon after his installation in July 1915, he commissioned the first building under the new plan, of the Gothic design and structural contemporaneity that would set the architectural standard for the next twenty-five years. Bebb & Gould created seventeen campus buildings or additions during the eleven years of Suzzallo's tenure.[25]

Gould approached the design of the Home Economics Building (1915, now Raitt Hall, FIG. 5.5) as four interdependent problems. The structural problem he resolved in favor of fireproofing. He designed in reinforced concrete, with widely spaced piers allowing for large windows and flexibility in the placement of water, gas, and drain services. The building contains three stories and an attic, tall enough to frame the new liberal arts quadrangle, with stairs clearly focusing the entrance but without encumbering the students and faculty who would use the building. The second problem, overall exterior design, had already been settled. Gould used "collegiate Gothic," but a "free interpretation"[26] of the late English style emphasizing the wide, high windows that reinforced concrete framing permitted.

As Gould knew well, however, design was more than a relationship between structure and exterior. With Raitt, he enlisted the aid of the Washington Brick Lime and Sewer Pipe Company of Spokane to develop a fresh range of warm brown brick colors, which became known as the "university mix." His subtle variations of pattern — his favorite was a repeated diamond form — and of tone are most evident to the ground observer on the solid walls of the compact Henry Gallery. Gould had long since abandoned a prejudice from his Beaux-Arts years that "brick work" was "apt

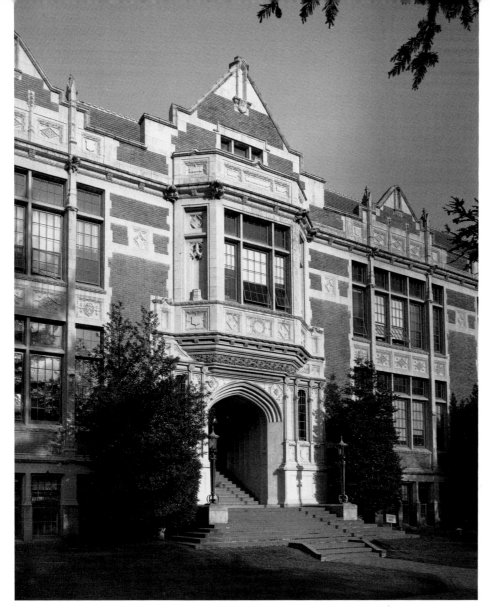

5.5 *Bebb & Gould, Raitt Hall, detail of southeast elevation, University of Washington, 1915.*

5.6 *Bebb & Gould, Savery Hall, southeast elevation, University of Washington, 1917–1920.*

5.7 *Savery Hall, gargoyle of Gould, 1920.*

5.8 *Bebb & Gould, Miller Hall, south view, University of Washington, 1921.*

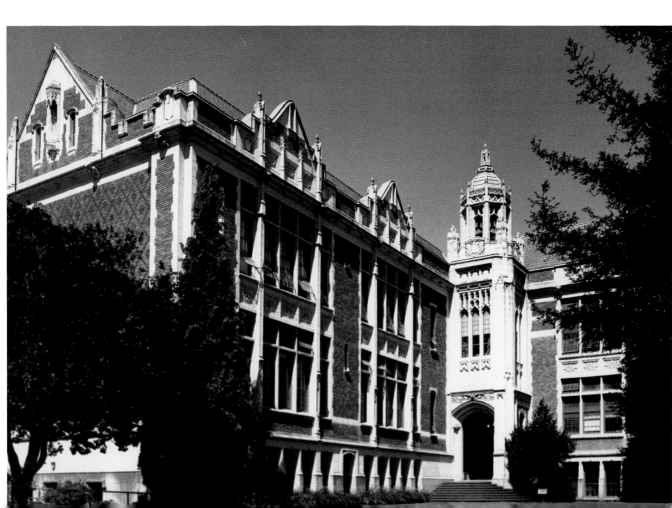

to be insignificant, easily copied by poor designers."[27] The fourth problem was to indicate through design the specific use of the building, and this Gould achieved through human shapes in terra cotta around the cornice, female figures performing domestic duties. The women portrayed are sewing, cooking, carrying a fruit basket, caring for a child, spinning, laundering, sweeping, grinding, and distilling. Each figure is repeated three times around the building, but only along the walls; watchful eagles grace the corners. The only male figure, at the left of the entrance, is a bearded, berobed man holding a model of the liberal arts quadrangle. All the figures were executed from Gould's designs.[28]

Raitt was built at the quadrangle's north corner. The commerce (1916) and philosophy buildings (1917–20), now combined as Savery Hall (FIG. 5.6), followed on the west corner in the same Gothic style. The design details and the brick patterns vary from those of Raitt but are compatible with the earlier building. The terra cotta figures sketched by Gould and executed by Alonzo Victor Lewis reveal the whimsy Gould had shown ever since his Beaux-Arts days, when he drew in a dog to give scale to a competition entry.[29] The figures are not confined to those appropriate to the subject matter taught in each of the now combined halls, but include a wide variety of academic and nonacademic activities, including sports. Most are representative figures but they also include Woodrow Wilson and Gould himself (FIG. 5.7) above the northwest door at the west end. The education building (1921, now Miller Hall, FIG. 5.8) was not planned for teacher training but rather for general instruction. It was here that Gould's own department had its first appropriately designed space on the top floor under skylights. Figures set at the tops of the Gothic buttresses represent history, religion, natural science, the arts, and teaching. Of all Gould's buildings, Miller, at the east corner of the quad across from Raitt, has the most graceful Gothic details (FIG. 5.9).

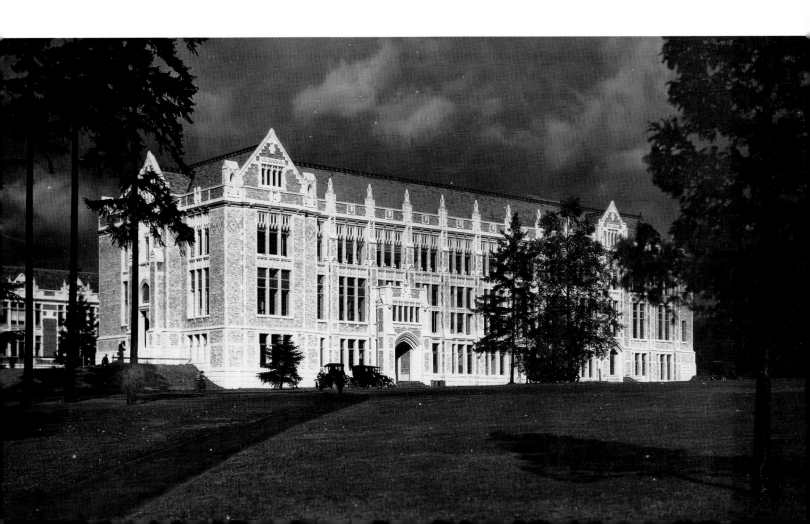

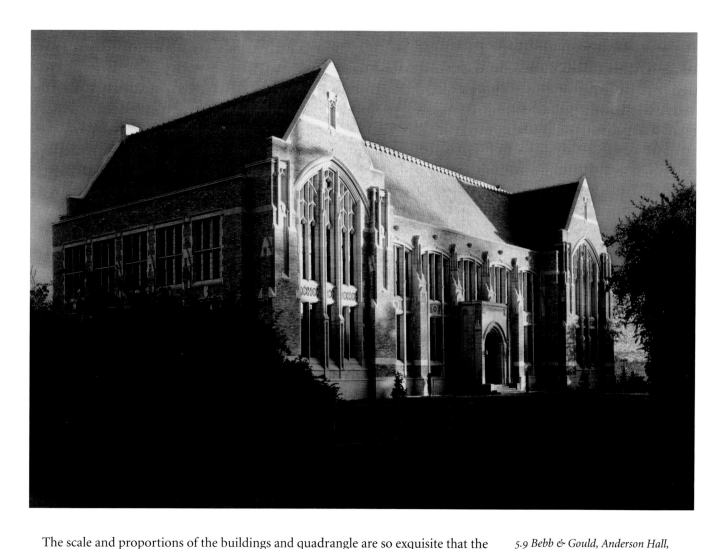

5.9 Bebb & Gould, Anderson Hall,
north view, University of Washington,
1924.

The scale and proportions of the buildings and quadrangle are so exquisite that the whole appears at first glance to be simply a pleasant academic greensward. Gould oversaw the creation of his great ensemble, but at times he was forced to defend his basic design scheme. In late 1915 or early 1916 a member of the university's building and grounds committee, of which Gould was chairman, wished to raise the first floor of the home economics building 6 feet, raise ceiling heights and place the third story in the attic. Gould forestalled such a change by pointing out that it would require similar adjustments in the other buildings, increase costs, force students to climb more stairs, disturb the proportions between building height and length, reduce the lighting and flexibility in the third floor of home economics, and create other practical problems. The incident should have demonstrated to Gould, if he did not already know it, that there are few if any final victories in design battles fought over such a large area as a university campus.[30]

Among other major structures, Gould designed the Women's Gymnasium (1921), the quarters for the school of mines (1921), and the forestry school building (1924). The women's gym, now Hutchinson Hall and no longer used for athletics, is notable for retaining the scale of Gould's earlier buildings despite its great bulk. It contains the elegantly light and simple trusses of his first long-span roof structure. The former gym is located north of the liberal arts quadrangle on the original football field. The other two buildings formed the nucleus of the engineering quadrangle. The mines building (1921, now Roberts Hall), required a three-story space for a rock crusher.

Gould capped the space with a large skylight, then continued the skylight over the laboratories on the top floor. The slender brick buttresses, minimal decoration, and expanses of industrial steel sash set within the buttresses make an appropriate envelope for the no-nonsense discipline taught within. The forestry building (1924, now Anderson Hall), reflects the romance of an outdoor occupation combining practicality with scenic preservation and conservation. Gould's stone entrance details are the most elaborate on the campus except for those of the library. The interior contains two large but carefully detailed and comfortable rooms, the Forestry Club room on the east and the lecture hall on the west (FIG. 5.10). Both have the timber vaulting fitting for the forestry school and for the overall design.

The central library (now Suzzallo Library, 1922–26, 1933–34) is Gould's greatest building on the campus and his finest historicist structure. It embodies his conviction that "all departments of learning must draw upon and focus" on the library; that the library should be "the dominating building," and that it "should express this idea of

5.11 Bebb & Gould, Suzzallo Library, general site plan, University of Washington, 1924.

dominance of our intellectual and spiritual ideals in education" through "appropriate architectural treatment" and "in its physical expression." Early on, then, Gould had decided that the library would be at the apex of his liberal arts and science axes, that it would be functional but elaborate, and that it would be large. Serious discussions of spatial and organizational requirements had begun within Gould's building and grounds committee as early as 1916.[31]

Later Gould and Suzzallo conferred on a preliminary program, and Gould made some sketches, but general ideas of location, bulk, and detailing were insufficient for a final scheme. To give his and Suzzallo's abstractions more concrete form, Gould traveled around the country in 1921 and 1922. He went with Suzzallo to the libraries at Stanford and the University of California at Berkeley. On his own he journeyed to the libraries at Harvard and Yale, and to the public libraries in San Francisco,

Detroit, New York, and Boston. He conferred with head librarians and other archi-
tects whenever he could. He quickly discovered that many universities had outgrown
their libraries during the time between planning and the completion of construction.
A plan "for almost indefinite expansion became one of the essential problems," forc-
ing him to rethink parts of his program.[32]

His plan, as finally developed, called for six distinct but integrated elements, build-
able over time as funds allowed (FIG. 5.11). The facade faced west across the adminis-
trative quadrangle toward Meany Hall. It contained an entrance area as well as two
large reading rooms on the first floor, and a great reading room above. A wing to the
southeast of the facade looked out on the Rainier Vista, the science quad, while its
side paralleled those of the buildings along the quadrangle. The northeast wing per-
formed the same spatial function for the liberal arts quad. Inside the triangle formed
by the facade and wing elements stood a central area composed of two parts. The
western part, closest to the great reading room, was designed to hold the card catalogs
on either side of an axis aisle leading from the reading room doors to the delivery
desks in the eastern part. "This location," Gould wrote, "comes close to the center of
gravity of the entire building." The fifth element, to the east of the receiving desk, was
the stack section, an arrangement permitting ease of access from the stacks to the
reading room and through connecting aisles to the wings. The arrangement appears
dysfunctional in the era of "open stacks," when simply entering many libraries grants
access to all but their sacrosanct collections. But in Gould's time and for decades
afterward, the stacks were closed; only staff and perhaps some faculty and graduate
students were allowed in the stack area. Thus Gould's plan answered well the multiple
demands upon it. The sixth and final element was the graceful tower (FIG. 5.12) rising
above the central section, a tower designed to symbolize the library's purpose.[33]

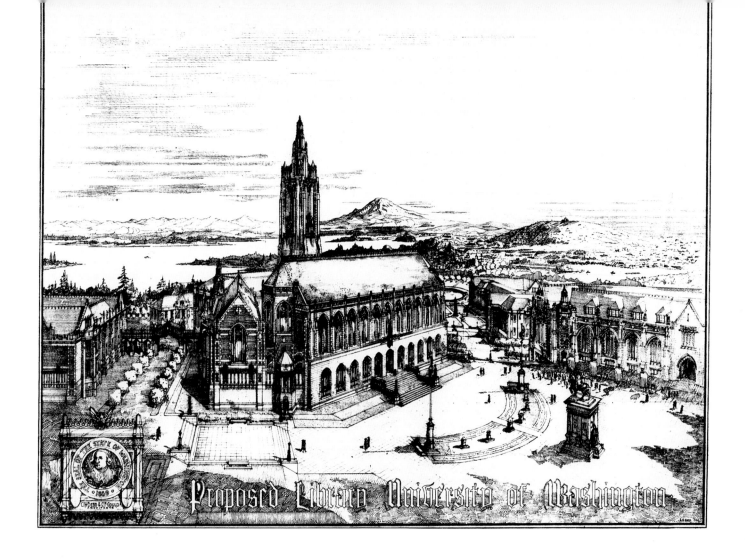

The facade of the library, though dressed in Gothic details, is a Beaux-Arts composition. Gould's early perspective (FIG. 5.13) reveals his immediate indebtedness to McKim, Mead & White's Boston Public Library, and especially to an earlier version of the Boston building published in 1888 before all of its facade details had been resolved. Gould's library displays one fewer bay on each side of the entrance, and the pitch of its roof is steeper, but otherwise it is remarkably similar. The common features of both include a lower story with smaller windows, an upper, higher story with tall windows admitting light to a great reading room extending across the building, and a broad terrace in front. Gould's library also was similar in having three central entrance bays and a vaulted entrance hall flanked by reading rooms. A Beaux-Arts forecourt and equestrian statue recall the proposed formal treatment of Copley Square in front of the Boston Public Library.[34]

Gould added Gothic detail and replaced the terrace with modest entrance stairs and a front railing. The changes obscure his debt to the Boston building but accentuate his adaptation of Gothic and Gothic Revival ecclesiastical architecture. In 1926 he wrote to a prominent Seattle citizen "that probably the new Liverpool Cathedral has been the most vital source of suggestion for the library," although he acknowledged other churches as well as conversations with the eminent gothicists Ralph Adams Cram and Bertram Grosvenor Goodhue. Gould observed Liverpool Cathedral under construction in 1908, and drew "suggestion," but not models, from its doubled windows, powerful buttresses, finials, and tower (FIG. 5.14). It is possible that these later Gothic festoons responded to Suzzallo's desire for an expanded iconography and for

5.13 Bebb & Gould, Suzzallo Library, perspective view of plaza and building, 1924.

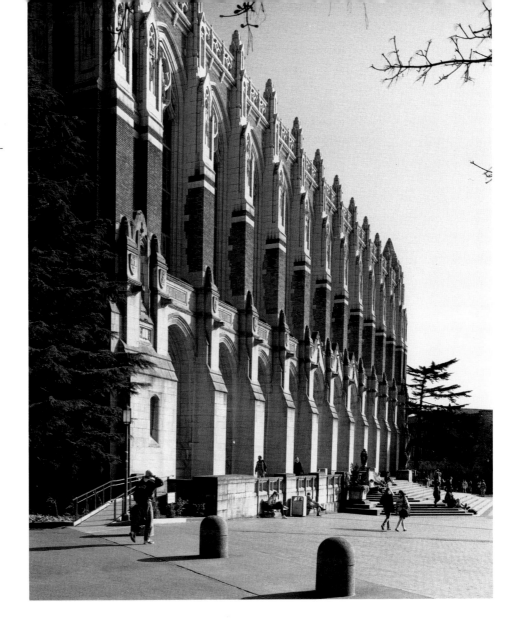

5.14 Suzzallo Library, west view,
1922–27.

5.15 Suzzallo Library, finial above sculpture by Allan Clark.

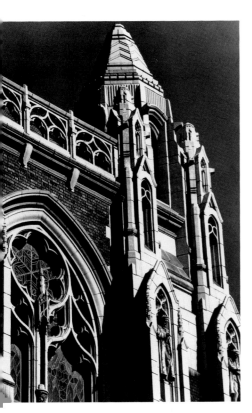

some faculty involvement in decorating the centripetal building on the campus. In November 1923 Suzzallo sent a letter to all faculty members, inviting each of them to submit a list of the eighteen men responsible for "the chief contributions to learning and culture," whose modeled terra cotta statues would rest in niches some 75 feet above grade, ten in the buttresses between the bays, four in the massive buttresses at either end of the facade. A committee consisting of Suzzallo, a regent, and a dean combined most of the faculty's majority selections with others to recognize the chief "occidental" contributors.[35]

The same or another committee selected fourteen university crests to adorn the buttresses at the belt course between the two stories. Eight inscriptions in the belt course describe fields of university study. Three Ruskinian heroic figures above the entrances are an aged, hooded male figure representing *Thought*, a slender, young, ecstatic female figure representing *Inspiration*, and a vigorous young male figure representing *Mastery*. Allan Clark of Tacoma and New York was the sculptor. Gould placed the names of printers over the doors in ironwork. The window glass above was "patterned in the character of watermarks used by early printers." The finials (FIG. 5.15) at each corner of the facade are another illustration of Gould's refusal to allow hard work to overcome lightheartedness. They are not Gothic at all, but are decorated with chevrons in a style later associated with Art Deco.[36]

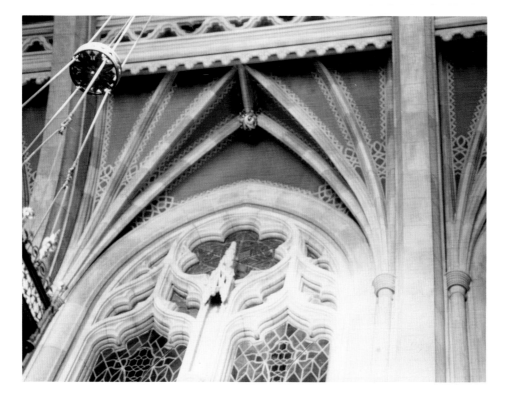

No discussion of Gould's plan and exterior iconography is complete without a reference to the elevations and sketches of his unbuilt carillon tower. Attached columns articulated the tower's corners, while the single-lancet openings in the principal faces were decorated with double-curved details similar to those in the reading room. Its windows rose some 55 feet compared with 36 for the reading room apertures. The tower was unresponsive to functionalist aesthetics, but Gould had in mind an overriding symbolism. Rising 335 feet above grade, the tower "will be the dominant feature of the campus," reinforcing the library's centrality, "and will be seen widely from points outside the campus," a reminder to all viewers of the state's flagship educational institution.[37]

The interior of the constructed central element is its own triumph. On entering, the patron walks by two 5000 square-foot, well-lighted reading rooms, to gracefully curving stairs on either side of the entry. The stairs are designed to preserve the axis of the building for library uses that a central stair would have eliminated (FIG. 5.16). The entry itself, despite the effect of a later addition to the east and stridently bright lighting, retains a simplicity based on Gould's astute handling of proportions and of decorative detail. At the head of the stairs is the former card catalog area, but without the elaborate shafts and vaulting originally planned for it. The area was built only to provide additional restrooms and a connection with a frame crib of temporary stacks that survived into the 1960s. A turn westward brings the patron to the reading room doors, and through them, to the center of Gould's greatest space (FIG. 5.17).[38]

The reading room is a great Gothic hall "240 feet long, 52 feet wide, and 65 feet high to the apex of the ceiling." Gould designed it to seat 700 and to provide shelf space around the walls for 17,000 volumes. He also designed it to inspire reverence. He wrote of "an instinctive attitude of peace and calm in the presence of books," an attitude "that the physical container ought to express" by imparting "the impression

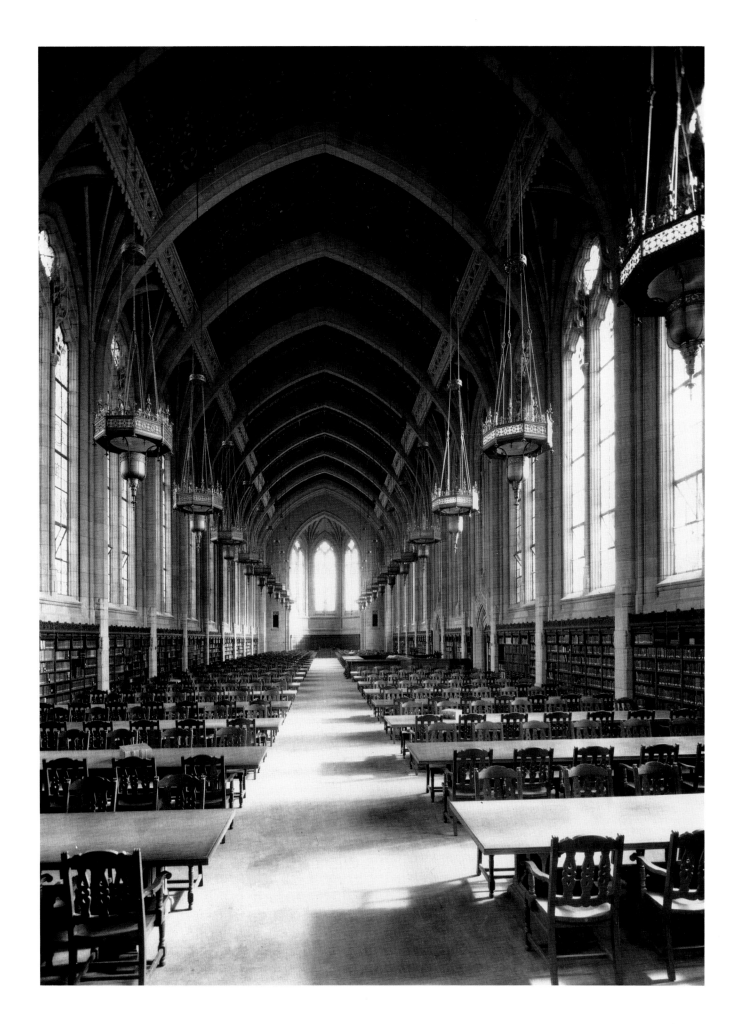

of something higher than the individual" which "aids in detaching the mind from incidental thinking" and prepares it for serious thought and reflection. But the room is not merely big. It is carefully proportioned, with brilliantly colored stencils on canvas dividing the transverse arches of the ceiling. From his student days Gould had worried about the appropriate colors and designs for ceilings. He continued to fret over the effects of his rhythmic repetitions of designs, especially as the scaffolding came down from beneath the great ceiling of the reading room. "A more difficult job was never undertaken," he wrote, for "the color intensities were very difficult to determine," but he was ultimately satisfied that "the color values are good."[39]

The truncated building served well, not only because Gould grasped the library function, but also because he took as much care with all aspects of the work as he did with the ceiling colors. The panes of the bubble glass in the great windows of the reading room diffuse the light. Delicately carved Washington State wildflowers enhance the bookcases. Gould designed the reading room furniture for use as well as for a "unity of impressions," as did other designers and architects of his era, including Frank Lloyd Wright. He struggled with the details of the huge chandeliers. He specified noiseless, compressed cork tile for the flooring because of its "excellent wearing qualities" and because of its "warmth and color essential to the scheme of the room." His draftsmen worked on full-size detail drawings, some as large as 3 by 8 feet. They took off their shoes, then knelt on the sheets to make the drawings. Gould wrote that all the features of the library "have been worked into the design with great care." He could savor the moment when, on 7 July 1926, he guided the regents through the almost-completed building. "The effect on the Board seemed to be one of active silence, giving the air of absolute approval. One could not feel otherwise than triumphant."[40]

Gould's triumph is the greater when his work is compared with another elaborate collegiate Gothic library, the William Rainey Harper Library at the University of Chicago (Shepley, Rutan & Coolidge, 1906–12). Gould may have visited the Harper; certainly he was aware of so prominent a building. Both libraries feature large reading rooms placed longitudinally above the entrance. Both employ tracery and vaulting; they incorporate a rich iconography of coats of arms, emblems, and quotations. Yet Gould's design is superior. Gould conceived a reading room not just larger, but better proportioned and more delicately wrought. His facade is more rhythmic and graceful, and his interior arrangements appear to be more functional.[41]

The Horace C. Henry Art Gallery (1926, FIG. 5.18) was one of five campus buildings executed while the library was under construction. In Gould's eyes the gallery assumed a significance far beyond its size because of Henry's importance to the cultural and commercial life of Seattle, and because Gould organized it into a proposed new building group and approach to the campus. Henry and Gould were well acquainted, as both men were involved in the Seattle Fine Arts Society and had interests in art beyond the society. Henry, a railroad contractor and a developer of the Metropolitan Tract, was wealthy enough to indulge his taste for nineteenth-century European and American paintings. These he displayed first in his Capitol Hill house and later in a gallery addition. His gallery was public as well as private, the only structure in the Pacific Northwest housing a permanent collection accessible to the

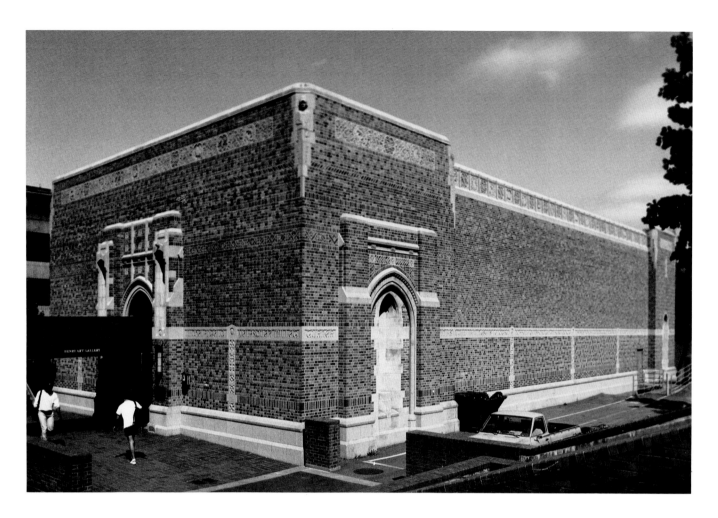

5.18 Bebb & Gould, Horace C. Henry
Gallery, southeast view, University of
Washington, 1926.

public on a regular basis. He wanted the Society to assume the maintenance and display of his collection, but the organization was not strong enough to do so (see CHAPTER SEVEN). With Gould probably serving as mediator, Suzzallo invited Henry to donate to the university his 140 paintings and $100,000 for a small gallery.[42]

At the same time, Gould worked to place the Henry Gallery within a larger context. His conception included the beautification of the city and the campus, the establishment of a new, functional group of buildings, and the creation of a fresh nexus between the campus and the city. In 1923 he revised the central part of the west edge of the campus to include a fine-arts group, with the gallery on the north, an expanded, refurbished Meany Hall in the center, facing a forecourt, and a proposed music building on the south, facing the Henry. Meany was the terminus of a new ceremonial approach to the university, along a double-lane, tree-lined boulevard flanked by academic buildings. The boulevard, running between Northeast Fortieth and Forty-first streets, was later constructed and is now known as Campus Parkway. Gould's plan well expressed Suzzallo's concern for outreach and extension work in Seattle.[43]

Gould explained that the Henry would "eventually be on the main axis of approach to the University from the city on the west and likewise be centrally related to the academic group" by the Meany-library axis (FIG. 5.19). At the same time an art gallery open to the public "as well as the students should be accessible from the city without traversing the campus." The Henry was merely the "first unit" of "a great museum group" with Meany at its "center, or heart. . . . Unless this is comprehended," the

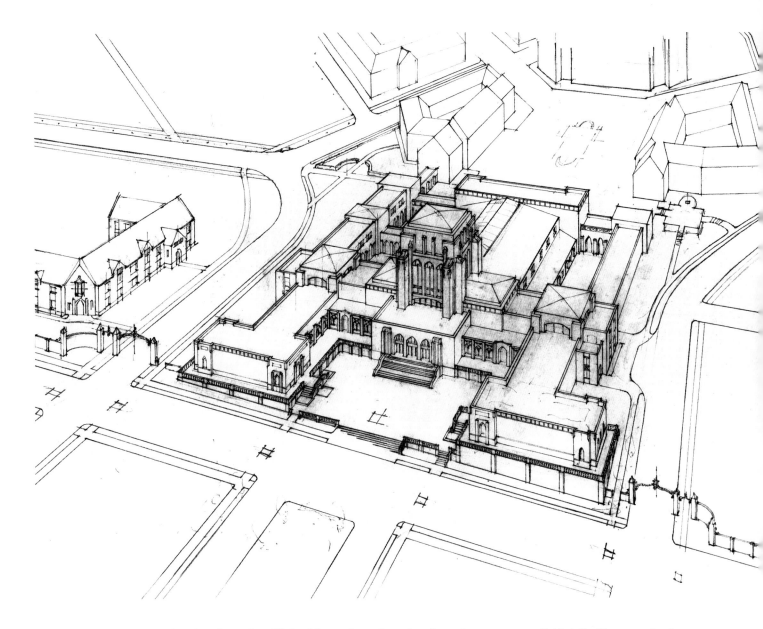

5.19 Bebb & Gould, western development, perspective view from west, University of Washington, 1925.

Henry Gallery "seems isolated and unrelated." Gould may have thought of moving some paintings into Meany or the music building, or both of them, for he wrote of the Henry as the "nucleus of . . . one of the great art galleries of the country."[44]

In exterior plan the Henry is simply a rectangular brick box, a container for the jewels within. Solid, patterned brick walls with wide but shallow buttresses at the four corners announce a recessive Tudor Gothic much influenced by Art Deco, as do the four severe, angular allegorical figures at the upper corners representing the civilizations and arts of Egypt, Classical Greece, medieval Europe, and Asia. The cornice is a frieze of medallions by Dudley Pratt, the sculptor of the figures, while a belt course carries the names of the world's great artists in no discernible order, a collection of names chosen by Suzzallo and the faculty. A single stone-framed doorway, except for a service entrance the sole penetration of the walls, is designed in a much-simplified Gothic manner. As usual with university buildings, Gould worried about the subtle brick colors and other details. "The whole treatment [is] somewhat experimental," he confided to his diary. "Have had trouble getting brick selected properly. . . . Too many light and not enough dark headers." On another occasion he "spent most of morning in correcting F[ull] S[ize] D[etails] on interior trim of Henry Art Gallery—Hath-

away's mouldings too heavy—reduced scale and simplified them." The exterior and interior designs and the plan were so compelling that they received special attention in the *Architectural Forum*.[45]

The Henry would be the first building on the West Coast designed as an art gallery from its inception, another reason why its architect fussed over its details. He divided the 54 by 120-foot interior space into seven galleries, the largest of which is 30 by 50 feet. The entrance is grand if not over-large; it is decorated with quotations chosen, as were the exterior names, by Suzzallo and the faculty. A fountain played at the center of the building and served as a reference point. Gould designed the gallery rooms to be environments for undisturbed viewing. Each has angled corners, an innovation doubling the number of prime mounting areas, and probably depending on Platt's Freer Gallery (Washington D.C., 1923), for its inspiration. All rooms "are hung above the base line with Monks cloth in order that there may be no distracting color element." The skylighted ceilings are proportional to the dimensions of each room, with lighting arranged to avoid glare and retain a constant value "as natural light fades and artificial light comes on." Gould provided for temperature and humidity controls to preserve the paintings. Since Gould's time, the gallery's collection has grown to 3000 objects, but only a relatively few works may be shown on the 5000 square feet of hanging area at any one time. The gallery now mounts shows of national and international importance, all within the building's original spaces.[46]

In the late summer of 1926 Gould could feel great satisfaction with his university work. The Department of Architecture was well launched, having achieved accreditation the year before. The great new library was growing to completion, as was the Henry Gallery. In March 1926, in a move ratifying Gould's conception of the western edge of the central campus, the Board of Regents had agreed that Bebb & Gould should "prepare sketches and necessary studies of the proposed Museum Group to be erected in the future." The regents wanted the new grouping to "properly co-ordinate with the H. C. Henry Art Gallery . . . considered as the first unit of said Group."[47]

There were, however, ominous clouds on Gould's horizon. His euphoria already was tempered by the 1924 gubernatorial election victory of the irascible and self-righteous Roland Hartley, who strove for personal control of state institutions and for their extremely economical operation. Hartley, described as "a man short in both stature and humility; feisty, profane, intelligent but ill-educated," was almost certain to collide with Suzzallo. The university president believed in fiscal responsibility but also in institutional autonomy within the context of accountability to the legislature and the people. Second, Suzzallo, while not politically ambitious in the electoral sense, viewed himself as an "educational statesman" bound to press for increased independence and funding for his institution. Third, Suzzallo had successfully urged an eight-hour day and other concessions for lumber employees during World War I, concessions that rankled Hartley, a lumberman from Everett.[48]

In January 1925 Hartley announced his intention to review all institutional budgets. His political ally, Duncan Dunn, a legislator from Yakima County and a regent of the State College in Pullman, challenged the University of Washington's exclusive use of rentals from the Metropolitan Tract, the state-owned land in downtown Seattle and former campus site. Suzzallo hit back. At an April alumni meeting in Yakima, he

denounced Dunn as "the worst enemy that the University has," thereby broadening the struggle to include the Hartley clique. Hartley maintained that he was leading a fight against interest groups, not against higher education. When the legislature passed the university's increased funding over his veto, however, he instructed the Board of Regents not to spend the money. When the regents defied him, he removed and replaced a sufficient number of them to secure a reversal of the spending decision. In 1926 he removed another regent and appointed yet another crony. The reconstituted board demanded Suzzallo's resignation in October, then dismissed him after he refused.[49]

Until October 1926 Gould rode out the storm, although he was worried about the university's "heck of a time with our Gov. Hartley," whose actions and statements raised the question of "whether Dr. Suzzallo and ourselves will be fired and the whole university cleared out." Twenty-four days after the compliant regents fired Suzzallo, it was Gould's turn. Hartley vilified Gould in a radio address notable for its loose statements. "We find that after a chair of architecture had been endowed by a firm of architects . . . one member of that firm was given this chair at a salary of $1000 a year, for seven and one-half hours of work a week." Hartley correctly asserted that Bebb & Gould had "prepared the design, directed the letting of contracts and supervised the construction of all university buildings," but his implication that the arrangement was somehow illegitimate was unfair. Hartley asserted that Bebb & Gould received "handsome fees" and "$63,432.79 on the Library Building alone," a figure roughly accurate in itself but hardly "handsome" when the breadth of Gould's responsibility is considered.[50]

Immediately after Hartley's speech, Gould received a letter from the chairman of the Board of Regents asking, in effect, for his resignation. A.H.B. Jordan, a friend and former client, was embarrassed to cite a state law providing "that no one connected with our public schools can have any financial dealings with the school district where a profit might occur," then to confess that the law might not cover Gould. "But in any event, it is the same principle," Jordan wrote. He concluded that he "would deeply regret being obliged to take any action in this matter," and suggested that Gould's "relationship with the University . . . be severed." Gould resigned.[51]

Gould wrote little about his decision. His diary entry of 29 October notes only his determination to avoid newspaper "controversy," and his weariness coupled with regret at "giving up my students & teaching." Yet his thinking may be recovered inferentially. Jordan had made it clear that Gould would suffer Suzzallo's fate, dismissal, if he did not resign. He knew that he was losing Bebb & Gould's monopoly on the campus design business, a monopoly that was almost certainly gone whether he stayed or went. Gould could have claimed tenure, but his half-time status, and the lesser regard for tenure then, militated against that course. Had he elected to stand on tenure, he probably would have faced a long, bitter, and expensive legal battle with no guarantee of victory. He hoped for vindication through a recall movement against Hartley, but the recall effort failed to generate much enthusiasm outside Seattle. Not surprisingly, Bebb wrote to Jordan defending the reasonableness of his firm's fees, and a WSC investigation found them modest in relation both to the finished work and to studies for future completion. Those exercises were unavailing, for Gould sustained a heavy blow to his finances and to his career.[52]

5.20 Bebb & Gould, dining hall, east view, Marine Biological Station, Friday Harbor, 1923–24.

At the time, few beyond Hartley and his minions suggested a conflict of interest among Gould's teaching, planning, and architectural work. There is no question that Bebb & Gould profited from the university connection. On the other hand, the firm probably made less money than it would have from comparable institutional or commercial work had it been free to assume other commissions. It is certain that Gould's contributions to the University of Washington led to other commissions for campus planning and building design. They included the Marine Biological Research Station at Friday Harbor on San Juan Island (1923); Washington State Normal School (1926, now Western Washington University) at Bellingham; St. Nicholas School (1925, now part of the Cornish College of the Arts) in Seattle; and the Lakeside School (1930), also in Seattle.

The Marine Biological Station at Friday Harbor occupies a former military reservation acquired by the State of Washington in 1922. The state commissioned Gould to provide a long-range plan for a remote residential community of marine scientists, a group then independent of the University of Washington. He arranged the site with the laboratories close to the water, the source of the scientists' studies, while placing the residences among the trees on the backland. From the water his informal positioning of the laboratories gives the impression of an array of one-story buildings strung along the waterfront. His arrangement, however, nicely complements the rugged foreshore. The low, hipped roofs reinforce the informal siting. The dining hall walls with their expansive windows suggest a seaside holiday retreat (FIG. 5.20). When Ralph D. Anderson designed two new apartments and a new laboratory building for the station in 1962, he found that Gould's apparent casualness was in fact so carefully studied that inserting new buildings into the scheme posed a difficult problem. The group, with Anderson's successful additions, is one of Gould's most widely appreciated projects.

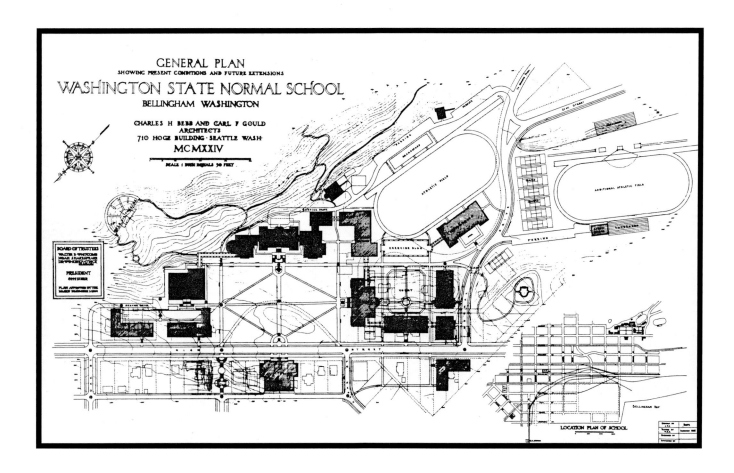

5.21 Bebb & Gould, general plan, Washington State Normal School (Western Washington University), Bellingham, 1924.

In 1924 Bebb & Gould became the campus planner and architect for the Washington State Normal School at Bellingham (FIG. 5.21). Their plan for the long-range development of the campus was well received, and they were commissioned to design the library and the new gymnasium (1928). Both buildings departed from the collegiate Gothic format to blend with the more rugged Richardsonian style of "Old Main," the central building on the campus. The gymnasium is basically a rectangular box, but its arches and tile roof over the entrance reflect the Romanesque Old Main. The library is the more complex building of the two. Again Gould's inspiration was the Boston Public Library perspective of 1888, but the light brick tones and the Romanesque arches and columns at the first floor window blend Richardsonian detail with Renaissance proportions (FIG. 5.22). The single projecting entrance, reminiscent of a Mediterranean chapel, is scaled to the relatively small facade and suggests Gould's belief in the library as a place of secular reverence and retreat. The reading room enjoys excellent daylighting and lush coloring in the ceiling. At the user's level it imparts the sense of a great space surrounded by books.

Gould best described the library during his brief speech at its dedication in April 1928. He explained that the "simplicity and dignity" of the main building "should not be contradicted," but instead "its spirit" should be adapted "to the special requirements" of a library. "The large windows allow ample light to the Main Reading Room." The windows themselves were an integral part of the design, for he gave close attention to the "proportioning of the mass and the relation and size of the window openings," as well as to the subtle details of facade ornament. He denied that any ornament was "an archaeological copy" of the Romanesque, but instead was adapted

5.22 Bebb & Gould, library, north view, Western Washington University, Bellingham, 1925–27.

to "give an inviting impression" through the use of gilding, wrought iron, oak paneling, and terrazzo flooring. The reading room, 150 feet long, 42 feet wide, and 32 feet high, was decorated with "abstract ornament painted directly on the structural concrete beams" to emphasize the structure and form of the room. Gould was nothing if not ecumenical in his search for expressive ornament. "These designs have been suggested by some recently unearthed material found in Southern Mexico and Central America, that Aztec civilization which is still an enigma to the archaeologist."[53]

Speeches and ceremony done, "we lined up in Main reading room to receive congratulations of a large crowd assembled from entire countryside," Gould reminisced to his diary. "The evening sun streamed across the floor & through the large windows. Splendid clouds could be seen ascending. All profuse in praise & no indication of any disapproval. To shake hands with 1500 people interesting, trying experience—infinite variety of the human never before struck me with such force. Young, old, sturdy, feeble, large, small—hard & soft—crusty, susceptible—responsive & dumb passed before us in countless numbers." Then Gould, Dorothy, and his mother-in-law dressed for dinner, followed by an "evening reception until 10 PM. After good stiff cup of coffee drove back in heavy rain & tumbled in bed at 2:45 AM."[54] It was a punishingly long day but a fulfilling one, for Gould had seized the opportunity to educate the public in the principles of good design.

Gould's experience with educational buildings stood him in good stead during the Great Depression, when he gained commissions for new private secondary schools. He began work in 1930 on the St. Nicholas School for Girls on Tenth Avenue East, just

5.23 Bebb & Gould, Bliss and More halls, Lakeside School, 14400 First Avenue Northeast, Seattle, 1930–31.

a block from some of his Federal Avenue houses. His first sketch shows a cozy, Cotswold-style stone building, projecting an image of warmth and security. Evidently his clients preferred a more restrained, severe, classical garb, for the completed building features red brick walls with carefully arranged patterns, Palladian windows, a loggia, and large dormers. In addition to classrooms and offices, the building includes a painstakingly scaled and structurally expressive gymnasium and auditorium.

Before St. Nicholas was completed, Gould began planning for the Lakeside School at a new campus then north of Seattle. His own preparatory school, Phillips Exeter, and the nearby Philips Andover by Bulfinch and by Platt, are the likely models. The Lakeside master plan follows those and other eastern prep schools in its arrangement of Colonial-style, red-brick buildings trimmed in white, with playing fields nearby. A refectory, a dormitory (More Hall), and a classroom building (Bliss Hall) were constructed at the remarkably low cost, even for the depression era, of $150,000. The gymnasium, the headmaster's house, and the other masters' housing were built later. The interior of the refectory hall is one of Gould's most charming spaces, with simple wood trusses overhead. The central classroom building (FIG. 5.23) with its clock tower derived from Bulfinch Hall at Andover (1818–19), crowns the New England composition.[55]

Gould founded and headed the Department of Architecture of the University of Washington for twelve years. Accreditation of the department and its move to permanent quarters were his signal successes. He developed the Y-shaped campus plan, then designed seventeen buildings or additions to buildings during that time. His work still dominates the campus despite the great expansion of the university's facilities on the south end over what was once its golf course, the sprawl of athletic fields, parking areas, and student housing to the east. The abandonment of the collegiate Gothic style in favor of a scattering of remarkably characterless buildings in the central area and along the northeastern section of Stevens Way has not diminished the

force of Gould's accomplishment. Despite his contributions, Governor Hartley and his compliant Board of Regents would not permit so close an associate of Suzzallo to survive either as university architect or as a teacher. A later board re-employed Bebb & Gould, a move vindicating Gould's imaginative yet scrupulously careful efforts. His designs, sometimes in concert with Bebb's connections, led to other well-executed campus commissions. In all, the years from 1914 through 1926 were busy and fulfilling ones for Gould, who reached beyond campus work to design for a wide range of clients.

Not only were the forms of historic architecture valuable through their beauty, but they came to our times freighted with historic associations that every cultivated person was familiar with. —WALTER C. KIDNEY[1]

6 Eclecticism in Commercial Buildings, Houses, and Churches, 1914–1926

FROM 1914 TO 1926 GOULD BECAME A THOROUGHGOING DESIGN eclectic, vigorously exploiting the past while creating little in the modern style. He did not oppose architectural modernism or uphold historicism for its own sake so much as he sought personal security, sound interior and exterior design, and client approval, in a reversion to traditional modes. "Why worry about Modern style," he mused in 1926, "if it expresses underlying principles of architecture?" Eclecticism was a method of achieving his goal of beauty without obtruding anything garish or disconsonant into the urban landscape. Walter C. Kidney, the historian of eclecticism, wrote of the eclectics "taking up forms of proven and mature beauty from the formal and vernacular architectures of the past and adapting them, learnedly but with personal touches, to modern building programs." Kidney believed that familiar forms, "well handled by an architect of talent . . . had a beauty that needed no explanation, no philosophy."[2]

Gould did explain beauty in his speeches, writings, and through his buildings, and he had a philosophy of architecture, even if his clients often did not. He saw himself not as the devotee of a particular school or movement, nor as an exploiter of a stylistic genre who stayed with it until the winds of opinion forced a change. It is more likely that his great success with collegiate Gothic on the University of Washington campus influenced his commitment in the teens and twenties. After 1926 and the loss of the University of Washington commissions, he expressed in other forms the enduring maxims learned at the Ecole des Beaux-Arts. To Gould the essence of architecture was always found in the best solution to the multiple problems of site, landscape, client, and contemporary requirements. His embrace of eclecticism rested upon a commitment to perpetuating the finest expression of western culture. At the same time he did not reject grafting the "residue" of new movements onto the accepted architectural approaches. Where clients were concerned, eclecticism never justified sloppiness or indifference to the project. Gould's almost frantic pace and his attention to detail are attested by his wife and the Bebb & Gould draftsmen. The demands of a busy office and Bebb's declining participation enforced an increasingly rigorous discipline.[3]

6.1 Bebb & Mendel and Bebb & Gould,
Fisher Studio Building, east elevation,
1519 Third Avenue, Seattle, 1913–15.

Upon joining Bebb's office in 1914, Gould modified or carried forward some large projects that he or Mendel had begun. They included the Chittenden Locks ensemble (see CHAPTER THREE), the Fisher Studio Building (1914, FIG. 6.1) at 1519 Second Avenue, the Puget Sound News Company (1915, FIG. 6.2), and the Times Square Building (1915). The Fisher building, begun according to Mendel's design in 1913, had reached the second of eight floors when Gould redrew the upper stories of the street facade and the recital hall on the seventh and eighth floors. He expressed the recital hall on the exterior with a blank wall of terra cotta ornament of Venetian-inspired details. He also redesigned the Times Square Building at Olive Street and Fifth Avenue, begun in 1913 for the *Seattle Times*, the city's leading newspaper. It is Seattle's quintessential Beaux-Arts building (FIG. 6.3). The perfect proportions of terra cotta wall to glass area, the exact horizontal registration, the fine banding, and the deeply incised joints recall the rustication of Renaissance prototypes.[4]

THE · PUGET · SOUND
· NEWS · COMPANY ·

6.2 Bebb & Gould, Puget Sound News
Company, east elevation, 1931 Second
Avenue, Seattle, 1915.

6.3 Bebb & Mendel and Bebb & Gould,
Times Square Building, northeast view,
414 Stewart Street, Seattle, 1913–15.

One of Gould's earliest extensive plans of the Bebb association was a logging camp and its buildings, designed from 1915 to 1917 for the Merrill & Ring Lumber Company. The plan was important both for itself and as the probable origin of a far-reaching scheme to build a camp to harvest spruce lumber for Army aircraft during World War I. The remote Merrill & Ring camp on the Pysht River, located on the Strait of Juan de Fuca (north) coast of the Olympic Peninsula, was then accessible only by steam launch from Port Angeles, some 35 miles to the east. Gould made the trip of 100 miles or more from Seattle to Port Angeles, then went by launch to Pysht to meet with the county school board and select a site for the school. The architect and the board found their locations on high ground, away from the river, where a

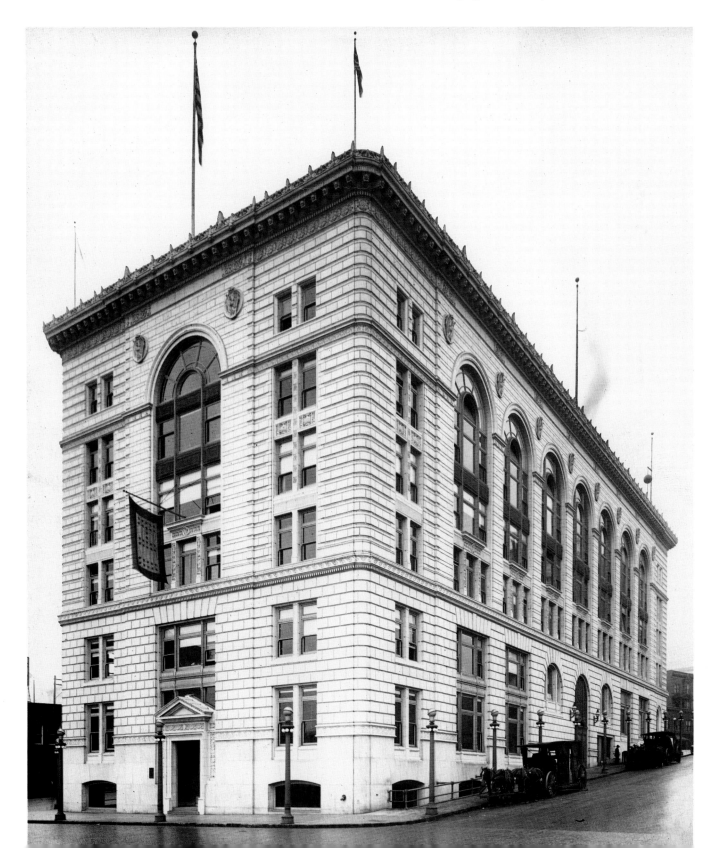

6.4 *Bebb & Gould, lodge, south view, Merrill & Ring Company camp at Pysht, 1917.*

clearing in the forest provided a good play yard. The school, neat and compact, featured two classrooms and a small play hall. The time and effort Gould invested in the school exemplified the kind of personal attention he gave to his Bebb & Gould commissions.[5]

The Merrill & Ring camp was in fact a small town including, besides the school, cottages for about twenty families, a store, machine shops, and bunkhouse railroad cars built to Gould's designs. The guest lodge (FIG. 6.4) was more elaborate, with a fireplace constructed by a mason who came from Seattle. Gould personally attended to matching the task and the craftsman. The company enthusiastically approved the results. "Unit construction lends itself with great advantage to this type of building in point of economy, rapidity, and simplicity of construction," Richard D. Merrill wrote. "The liberal use of glass has proven particularly adapted to this climate," he continued. "We feared at first that this would add considerable to the cost of the building, but I doubt now if it increased the cost to any appreciable extent." The Merrill & Ring Logging Company employees "feel they are well housed, and are contented, which is an important consideration," Merrill concluded.[6]

No direct connection is known, but it is probable that Gould's success with Merrill & Ring's remote Pysht River town was responsible for Bebb & Gould's commission to build a new town for the United States Army at Lake Pleasant, about 14 miles southwest of the mouth of the Pysht. The plan was part of the Army's ill-advised and ill-fated attempt to produce 2,000,000 board feet of spruce lumber a day for the domestic aircraft industry. Warplanes then were built mostly from light, strong, clear spruce. The best sources for the wood were the coastal regions of Oregon and Washington, including the Olympic Peninsula. The demand for spruce outstripped the industry's ability to supply it, a problem exacerbated by labor unrest among the loggers. The Industrial Workers of the World, the militant syndicalist union, was active among the logging crews despite being an object of government surveillance and vigilante action. The IWW, anti-war and anti-corporation, was so disruptive that cutting large quantities of timber on schedule could not be assured.[7]

The Army found a way out of its quandary by organizing a labor force through the Loyal League of Loggers and Lumbermen and organizing the construction of railroads, mills, and a town. The Army's contractor, the New York firm of Siems, Carey, & Kerbaugh (SCK), commissioned Bebb & Gould to plan the new town and its structures, as well as the buildings of the mill. Gould and his partner were in the unusual situation of working for a construction company rather than with one. At first neither this arrangement nor the beginning of design work late in August 1918 were cause for alarm. Both the design for the buildings and for the town itself were in Gould's hands. Bebb was overall manager for his firm. It was a large undertaking, for the site was almost a mile across (FIG. 6.5). Gould arranged the buildings along a pair of streets parallel to Lake Creek, running east to the lake and perpendicular to the road to the mill, about one-half mile south. The streets curved along the contours of the ground and did not meet at right angles. The design was a naturalistic, enlightened company town plan, based in part on the Merrill & Ring precedent. A cluster of significant structures included the hotel (FIG. 6.6), post office, community building, administration building, and some supervisors' housing. To the east, toward the lake, were sites for additional supervisors' quarters, bunk houses, and a dining hall. Bebb & Gould employed as many as eight men to prepare the construction drawings in just two months.[8]

6.5 Bebb & Gould, town plan, Lake Pleasant, 1918.

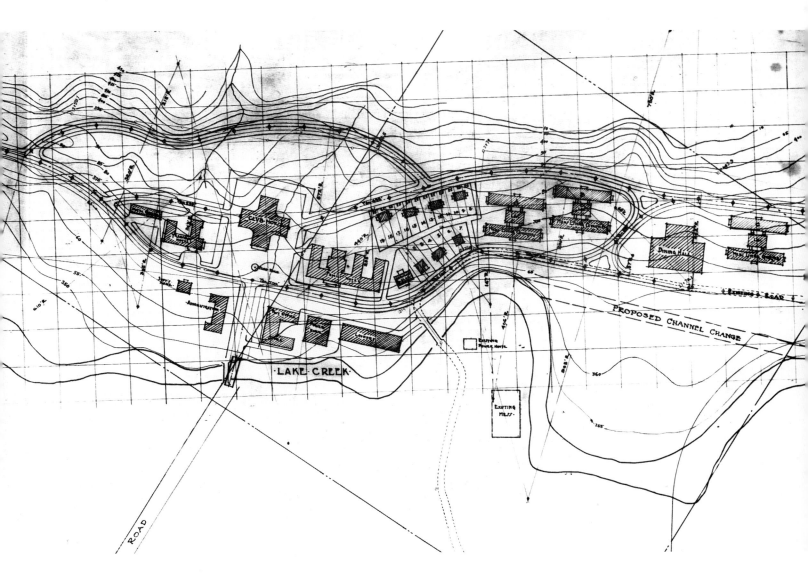

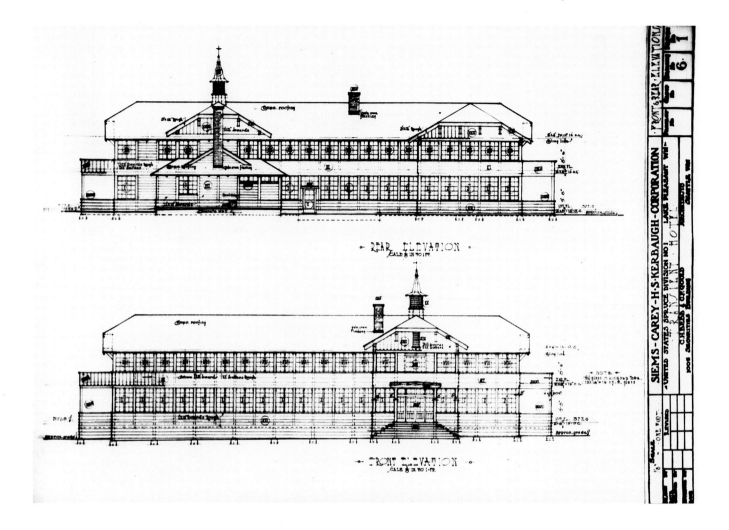

6.6 Hotel, front and rear elevations,
Lake Pleasant.

Gould's planning reflected contemporary English thought about town plans, probably gleaned from books in his library by Raymond Unwin, H. Inigo Triggs, and Thomas H. Mawson. Each addressed the need for beauty in cities and towns. "The curve in street planning is not to be avoided," Triggs wrote, "but rather gladly accepted, when the conditions of the site suggest it," as they did at Lake Pleasant, where on the north the land sloped upward from the meander of Lake Creek. All the authors struggled with the definition of beauty, Unwin regarding it as "a quality that . . . springs from the spirit of the artist infused into the work," words similar to those later used by Gould. Gould, ever the artist, created the Lake Pleasant plan with a central plaza and curved streets. He drew in a curving high street above the town, parallel to the creek. It was such a street as Triggs described, one where "the vista constantly varies" as "features of beauty come into view one after another and form picturesque groups that have a beauty and charm which it does not need an artist to appreciate." The plaza, a planning element that the Englishmen espoused, identifies Lake Pleasant with the era's other advanced plans that placed their towns' community buildings at the center and banished the mills to their margins. The town was intended to be semipermanent and therefore shares the spirit of the substantial plans by Earle S. Draper for the mill towns of Pacolet Mill Village, South Carolina (1919) and Chicopee, Georgia (1925), and the lumber town of Brookings, Oregon, by Bernard Maybeck (1913–14). All these plans emphasized the community over the founding business. In Gould's final plan the community hall assumes the prominent position.[9]

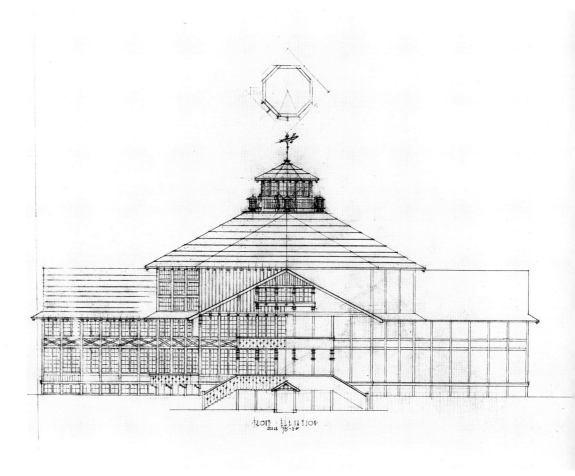

Gould's designs for the individual buildings were at once charming in their detailing and thrilling in their scale and boldness of structure. Both the dining hall and recreation building were 120 feet across, 32 feet to the bottom chord of the trusses, and capped by a glazed lantern (FIG. 6.7). Their details recall the shagginess or rough-hewn qualities of the Adirondack lodges of Gould's days at Saranac Lake and his design for Potter at Greenough, Montana (FIG. 6.8). The dog-eared gables, the curved dormer windows, and, in the industrial buildings, panes of glass set overlapping, like shingles, all contribute to the woodsy ambience. The use of wide expanses of glass between the columns (FIG. 6.9) was borrowed from the Pysht buildings and from Topsfield. The small cottages were stick-framed, departures from the modular system, but lavishly detailed (FIG. 6.10).[10]

Bebb & Gould had to strike a delicate balance between sturdiness and designs permitting rapid construction by relatively unskilled and inexperienced workers. Bebb, the managing partner, may have been involved with the concept, but the partners also engaged Henry Bittman as the structural engineer. Massive, heavy timber trusses spanned 85 feet in the recreation hall and dining hall. The main chords were 12 by 16-inch fir timbers, and the trusses were 12 feet high. The recreation hall roof peaked 45 feet above the floor. The posts and beams were of a modular arrangement to speed construction. So were the glazed areas and the wall panels below them. The great space of the recreation hall, solid yet soaring and airy, would ring to its rafters as thousands of loggers and their women stamped their feet to Saturday night hoe-downs.[11]

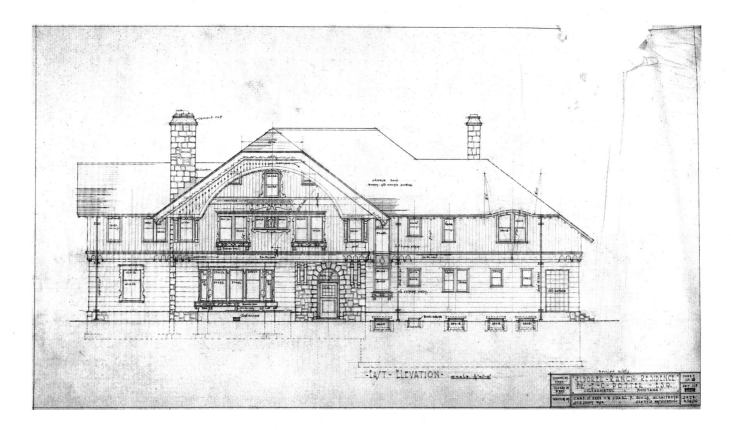

But it would not be. Gould and his force labored over the designs, apparently
assuming that dedication, knowledge, and experience would count for something
with sck. When the contractors completed their estimates, however, their reaction
was swift and shocking. In late October they dismissed Bebb & Gould. "The type of
buildings you are making plans for will entail an expenditure far in excess of the
amount we are ready to spend," William F. Carey declared. There would be no modi-
fication of the plans, and there could be no appeal to a mutual employer. Under the
peculiar arrangement in place, the Army had hired a contractor, which in turn had
hired Bebb & Gould. The architects were fired as they had been hired. Bebb was hurt
but proud of an excellent design accomplished in a timely way. "When you realize the
amount of work completed in two months and the very low cost entailed," he replied
to Carey, "absurdly low from the ordinary commercial standpoint, you will agree that
there was a motive other than the mere question of salary."[12]

As for sck, probably it was clearing timber and laying foundations at Lake Pleasant
in November 1918 when the armistice ended the war and its project. Even without the
armistice, aircraft production suffered from delays, materials shortages, and escalating
costs. Bebb & Gould's peremptory dismissal may have resulted from government
pressure on sck to economize. In any case, the project is one of the most elaborate
unbuilt plans ever conceived for Washington State.[13]

Bebb & Gould garnered one successful wartime project, fireproof shops for the
Boeing Airplane Company, funded by the Navy. Boeing built flying boats in these first
permanent structures at its site. Bebb probably secured the commission because of his
association with William Boeing at least as old as his design for Boeing's house in The
Highlands.[14]

Gould's domestic designs from 1914 to 1926 continued the eclectic pattern. For him,
the beautiful—symmetry, harmony, unity, proportion—as well as matters of site and

116

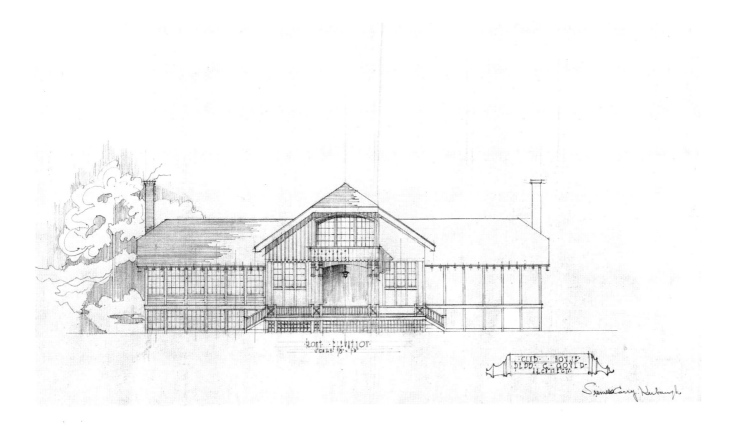

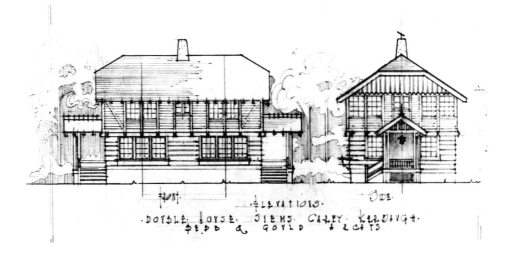

6.9 *Clubhouse, south elevation, Lake Pleasant.*

6.10 *Staff housing, side and gable wall elevations, Lake Pleasant.*

client preference—were foremost. The exterior style of a building counted less than beauty, finish and details. Once he and a client agreed on an interior design he might wrap floor plans in a variety of styles for the client's inspection. Style was relatively unimportant as long as it was graceful and well adapted to the Pacific Northwest, opened important rooms to light, expressed the room arrangement, and met his client's purse and taste. Design, on the other hand, was critical. A well-designed house appealed to the environmentalist in Gould because he believed that it would create a healthy home life. Gould's capabilities embraced the modern, but he was too gregarious, too much a part of his social milieu, either to adopt a carping insularity, or risk the rebel's isolation by pressing a personal style upon his clients.

A selection of Gould's domestic work, built and unbuilt, illustrates his concerns for beauty, good design, site, and client desires. Clients who sought out Gould frequently

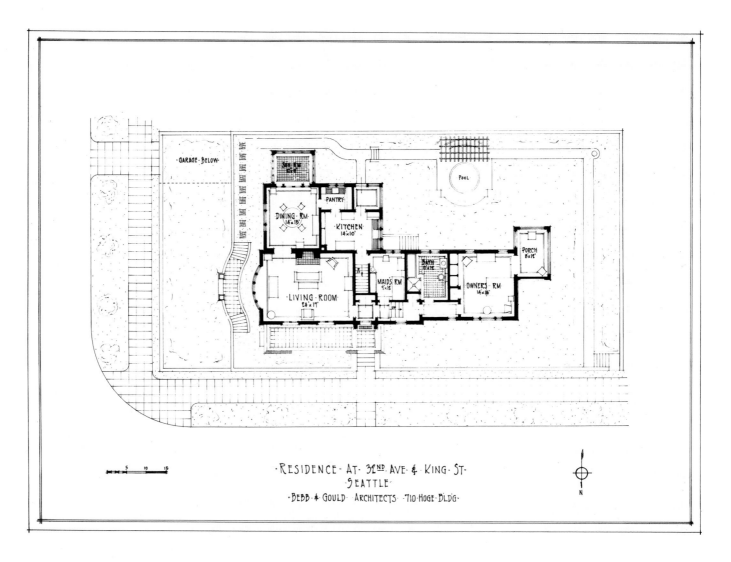

·RESIDENCE· AT· 32ᴺᴰ· AVE· & KING· ST·
·SEATTLE·
·BEBB· & GOULD· ARCHITECTS· 710·HOGE·BLDG·

had the funds and the foresight to purchase magnificently situated lots affording sweeping views of water and mountains. If they selected smaller, more confined lots, they often chose sites sloping toward Lake Washington on the east or Puget Sound on the west. Mrs. J. deClarenze (1914) owned such a lot at 3119 South King Street, a narrow plot bounded by King and Thirty-second Avenue that plunged down a ridge toward Lake Washington. Gould softened the slope with a high wall on three sides of the lot and fill at the east end, to bring the new grade almost level at the front entry walk from King Street. The house plan (FIG. 6.11) is an informal arrangement of family rooms on the east, or view end, and bedrooms without vistas on the west. To compensate for the lack of view, the bedrooms look south upon a carefully arranged patio. The one-story arrangement, with its combination of intimacy and views and separation of functions, creates a villa-like feeling further expressed by stucco walls detailed in a Mediterranean manner, with unframed openings, minimal roof overhangs, and an entry door flush with the wall. The steep roofs covered with wood shingles return the overall design to the Pacific Northwest context.

Gould's house for Mrs. Annie Houlahan (1915), on a flat lot at 2159 East Shelby Street, has a confined view toward Lake Washington's Union Bay. Here Gould created a smaller (36 by 50 feet) version of the Larrabee mansion in Bellingham (see CHAPTER THREE). He began the design work while Daniel Houlahan, the founder of Builder's Brick Company, was still alive, so the house was one of the few Gould did in brick.

6.11 Bebb & Gould, deClarenze residence, ground plan, 3119 South King Street, Seattle, 1914.

6.12 Bebb & Gould, Houlahan residence, northeast view, 2159 East Shelby Street, Seattle, 1915.

6.13 Houlahan residence, plan.

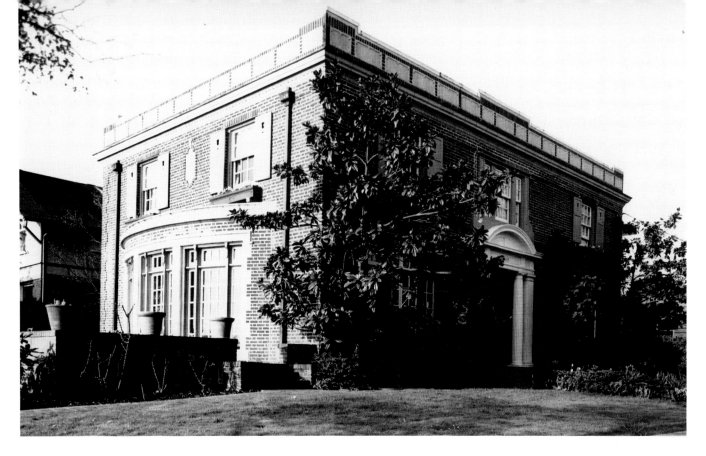

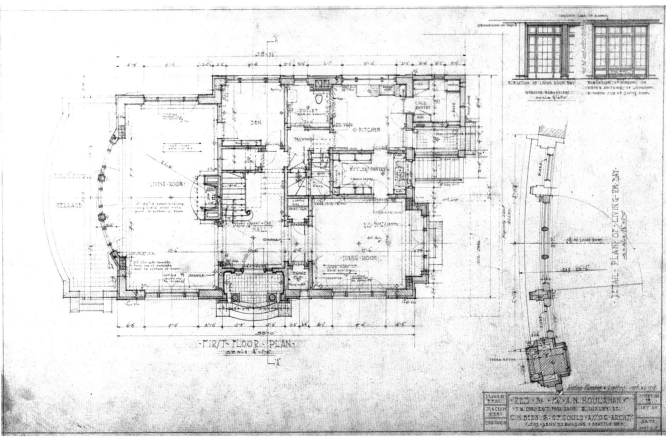

Houlahan died and Gould completed the work for Mrs. Houlahan. The plan is formal in disposition and in the shaping of the main rooms. The neoclassical facades are symmetrically arranged with finely cut stone offsetting the brick (FIGS. 6.12, 6.13). The entry, one of Gould's finest, is painstakingly detailed.

W. M. Winter commissioned Gould in 1917 to design a residence in Everett on another flat lot overlooking water. Winter was an executive in the Everett mill of the Weyerhaeuser Lumber Company. The corner lot at 1631 Grand Avenue overlooks the mill and Port Gardner. Once again, the plan is formally arranged about a center hall. The house is designed to include domestic servants—a stairway and separate chambers exist for the staff. Outside, each elevation is symmetrical, and the wooden window and roof details replicate those on Georgian houses. The garage and chauffeur's quarters are similarly designed as a smoothly integrated whole, well demonstrating the calm consistency typical of Gould's best work.

In 1918 Gould returned to the Federal Avenue area to design an Italianate house at 1051 East Galer Street. The H. J. Fetter house is built on a lot graded level above retaining walls, making it visible but visually and physically isolated from the street (FIGS. 6.14, 6.15). Entry is gained from a pair of steps curving up from the street in a Baroque configuration. The central axis runs from the entry through the house and garden, and ends at a pool and pergola. The garden is classically arranged, with a cross axis. An open porch with a glazed sun porch or sleeping porch above, off the living room on the west, balances the service entry and garage on the east. The arched window heads and stucco walls suggest masonry construction, but in fact the house is wood framed. The Fetter house is almost bare of interior decorative moldings and details, an unusual circumstance in a Gould residence. It is as though the exterior and the finely finished landscaping had exhausted the client's resources.

Farther south, at 939 Federal Avenue East, is a Gould design for Jane Terry (1919). In plan the house is traditional Colonial but its lot shares elements with the Italianate Fetter house (FIG. 6.16). They are differently disposed, however, for this client desired a large service area at the rear of the lot, an area dictated in part by the lack of an alley in which to maneuver automobiles, delivery trucks, or other vehicles. So Gould divided the back yard, giving 40 per cent of it lying between the rear of the house and the lot line to a garage, service drive, clothes drying area, and undifferentiated space. He shifted the formal garden to the axis of the living room, adapting the pool-pergola arrangement of the Fetter garden by dropping the cross axis and reinforcing the main axis with parallel rows of flagstones, which point in toward the pergola when they reach the rear of the pool. He thus developed an ingenious solution to a difficult problem: had he kept the cross axis, its unequal length on either side of the main axis would have emphasized the fact that the axis of the living room, pool, and pergola is off the center of the garden area. Yet he could not have moved the house to align the living room with the true axis of the garden space without obliterating the side-yard and bringing the living room too near the lot line.

This last of Gould's "Colonial" houses tends, like the Winter house, to the Georgian (FIG. 6.17). The elaborate entrance is highly individualized, with its cartouche in the pediment above the door, but it has more in common with Georgian than with either Colonial or Colonial Revival entranceways. The modillions under the eaves also suggest the Georgian. Notable, too, are the extraordinarily narrow but generously glazed windows, set within a well-proportioned and subtly detailed casing. The Terry house illustrates Gould's ability to adapt design motifs and fuse them into a graceful whole.

Of all his residential projects in The Highlands, Gould's most distinguished was "Sunnycrest," for James Hoge (1919). The house was large enough, about 3000 square

*6.14 Bebb & Gould, Fetter residence,
ground plan, 1051 East Galer Street,
Seattle, 1918.*

6.15 Fetter residence, southwest view.

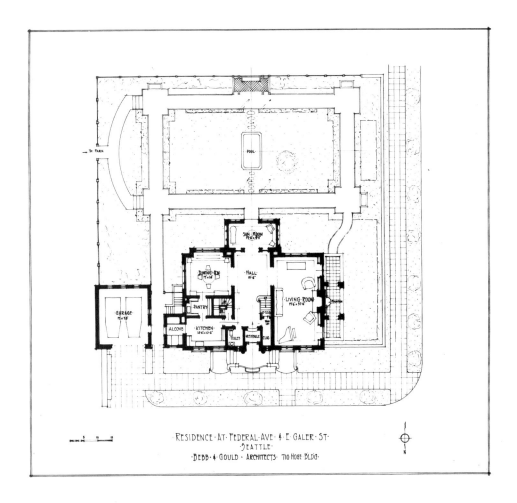

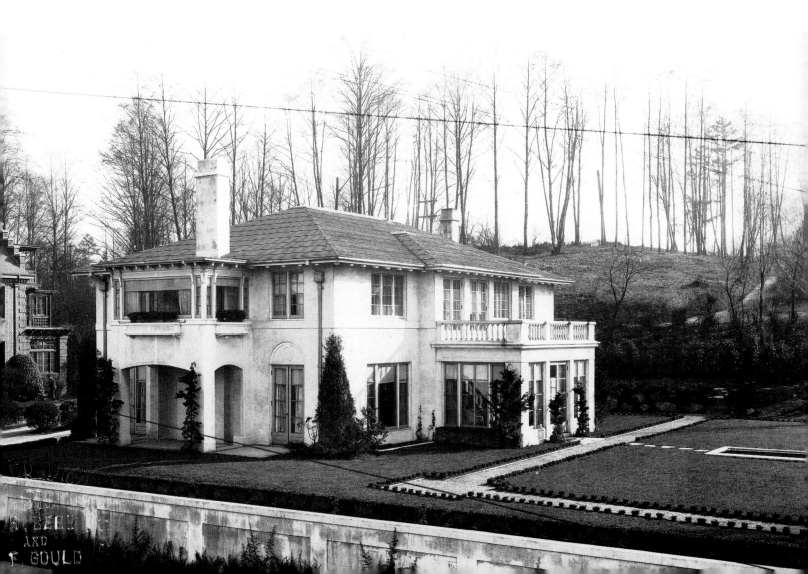

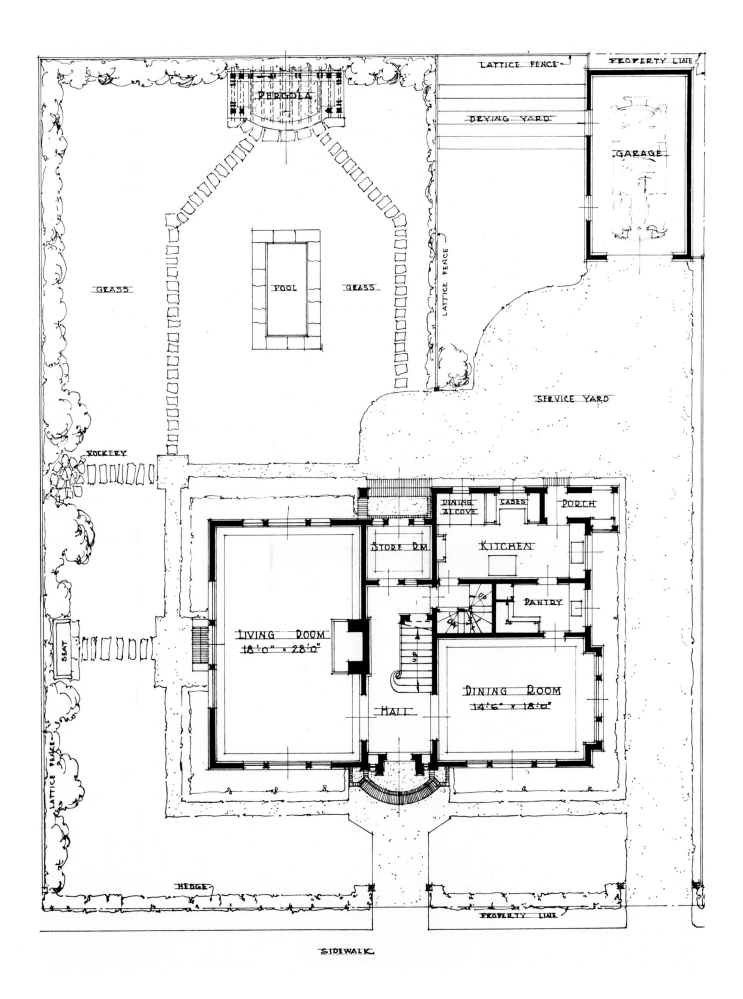

PERGOLA

LATTICE FENCE

PROPERTY LINE

DRYING YARD

GARAGE

GRASS

POOL

GRASS

LATTICE FENCE

SERVICE YARD

ROCKERY

DINING ALCOVE

CASES

PORCH

STORE RM

KITCHEN

SEAT

UP

PANTRY

LIVING ROOM
18'-0" x 28'-0"

UP

DINING ROOM
14'-6" x 18'-0"

HALL

LATTICE FENCE

HEDGE

PROPERTY LINE

SIDEWALK

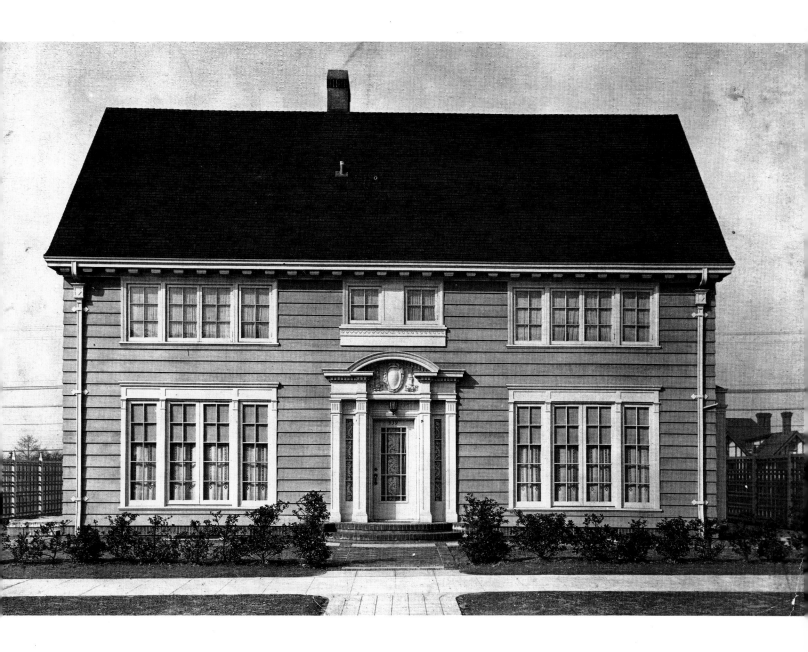

6.16 Bebb & Gould, Terry residence, ground plan, 939 Federal Avenue East, Seattle, 1919.

6.17 Terry residence, east front.

feet on each floor, to give Gould scope for his lavish yet fine detail. Again he benefited from an Olmsted Brothers site plan, which he modified to suit his own conceptions (FIG. 6.18). The lot required extensive concrete retaining walls to permit a grand driveway and adequate level ground for the house. The simple timber, brick, and stucco exterior barely hints at the elegance of the interior. The rooms are arranged along the western view, beginning with the garden room and study at the south and proceeding to the kitchen at the north. All the second-floor bedrooms face the view. The moldings and casings for doors and windows are freely derived from historical models but are original shapes. The materials used—parquet oak floors, marble fireplace fronts, ceramic tiles, gold leaf ceilings—are exquisitely handled but never vulgarly opulent. Gould also designed some of the decorations of the Hoges' housewarming and grand ball held on the tennis courts.

Commissions for representative later houses resulted from Gould's connections within the academic and business communities, including his activity in the Chamber of Commerce. In 1922, David Whitcomb, the president of a real estate development company, retained him to design a great country estate on his property near Ed-

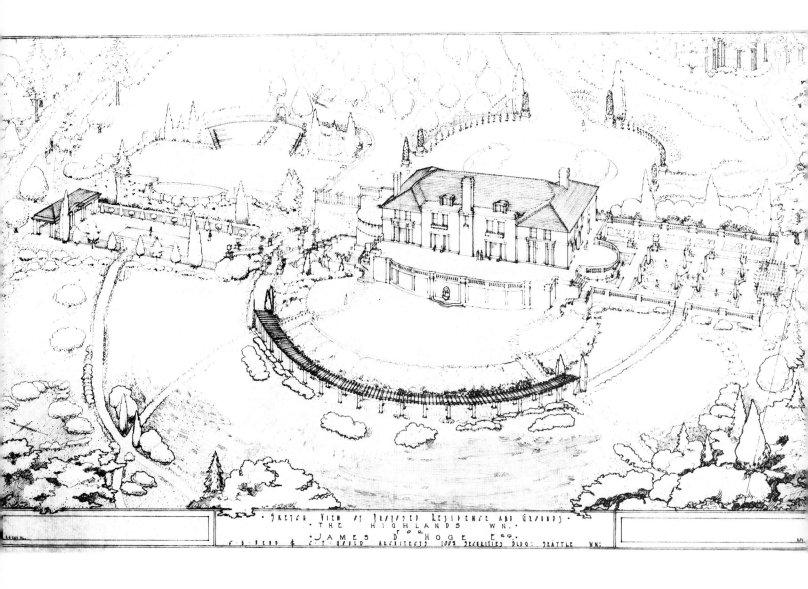

monds, in Snohomish County north of Seattle. It was not built, although Harlan Thomas designed a strikingly similar house which was later constructed on the same site. Gould planned the twenty-five-room mansion so that each major living space projected beyond the mass of the building. He may have been modeling the Whitcomb project after a pre-Renaissance French stone manor house, with vast roofs covering projecting gables, bays, dormers, and chimneys. Gould's concern for views toward water and mountains may be seen in the labeled arrows pointing from the living room and library toward the objectives. The house is so large by Pacific Northwest standards that it compares with mansions near Cleveland and Detroit.[15]

The founder of the Bon Marché department store, Arthur Nordoff, commissioned Gould for his house in the Washington Park district in 1923. The site at 540 Thirty-sixth Avenue East slopes down at both the south and east toward Lake Washington. Difficult grades from the street required giving most of the forecourt over to the driveway (FIG. 6.19). Both plan and elevations are informal. Gould earlier sketched a red brick house but he ultimately chose stucco, one of his favorite materials.

For M. Lyle Spencer, dean of the School of Journalism, Gould designed a Tudor house on a small lot at 3400 East Laurelhurst Drive Northeast, overlooking Lake Washington (1924). Its dark brick cladding and interior informality suggest that it was the

6.18 Bebb & Gould, Hoge residence, bird's-eye view of site development, The Highlands, Seattle, 1919–22.

6.19 Bebb & Gould, Nordoff residence, west front, 540 Thirty-sixth Avenue East, Seattle, 1923.

design precursor of the larger Krauss house of 1926. Soon after the Spencer commission, H. H. Judson, a title company vice-president, retained Gould to design a large, lot-filling house in the Madrona district at 230 Thirty-sixth Avenue East (1924). He used an angled plan to take advantage of the sweeping mountain views from Mt. Baker on the north to Mt. Rainier.

Gould's commercial projects were far fewer than his residential designs, but they were as stylistically diverse. For the Pacific Telephone and Telegraph Company he designed a new central building downtown at 1204 Third Avenue (1920, two top floors 1926, FIG. 6.20). The building comprises a classic scheme of base, shaft, and capital, with terra cotta decoration around relatively open bays on the first two floors. Above them rises a shaft of brick in which relieving arches above the windows and rusticated quoins are the principal decoration. The top two floors are clad in terra cotta, but an elaborate terra cotta cornice was removed after the 1965 earthquake. The composition has the air not so much of a commercial building, but of an elegant apartment house on Park Avenue in New York City. The regional telephone company's satisfaction with Gould's work led to commissions for at least eight more buildings in Seattle and other Washington cities (see CHAPTER EIGHT).[16]

6.20 *Bebb & Gould, Pacific Telephone & Telegraph Co. (now U.S. West), west view, 1204 Third Avenue, Seattle, 1922–26.*

6.21 *Bebb & Gould, Chicago Tribune Competition, Honorable Mention, 1922.*

6.22 *Bebb & Gould, Skinner residence garage, west view, 726 Thirteenth Avenue East, Seattle, 1912.*

Gould's next major role would be subordinate but significant, the local representative of the architect of the Olympic Hotel. The Olympic project began in 1922, when the Community Hotel Corporation, composed of leading local investors, proposed to build a first-class hostelry, one better than any existing in Seattle. The corporation invited George B. Post and Sons of New York to design the hotel, and the Post firm named Gould as the architects' local representative. Not for nothing had Gould maintained his New York and Beaux-Arts connections; J. Otis Post had been his roommate in their Paris days. Gould was not responsible for the design, which was modified

Renaissance on the exterior and Baroque decoration of the interior public areas. His job was nevertheless significant, for he attended to a myriad of design details, including the brickwork. The local corporation opted for the cheaper university mix, but Gould held out for a buff color even though he had created the university mix. Buff brick followed "the general tendency of modern buildings toward lighter colors," was harmonious with nearby buildings, and would produce a "beautiful effect." When the hotel opened in 1924 to a city-wide celebration, 3000 business and social leaders dined and danced the night away in the grand ballroom. Gould was proud of the Olympic. "Personally I think it is a gem," he wrote to J. Otis Post near the end of his account of the grand opening. "It has a very interesting variety in form, not to speak of the charm and beauty of the proportion of detail."[17]

Concurrently with the Olympic Hotel project, Gould immersed himself in the 1922 Chicago Tribune tower competition. He seized the opportunity to test his mettle against an international field of 281 entrants, and was rewarded with an honorable mention. His design used Gothic elements at the entrance, around the windows, and especially in the tower capping the office shaft (FIG. 6.21). In its gothicism his effort resembled the winning design by Hood and Howells, but it was a much more recessive and cleaner Gothic. The tower is strikingly similar to the one he proposed for the University of Washington library (see FIG. 5.12). Entering the competition required a major allocation of his firm's talent, as the more than 100 sketches for the project attest.[18]

As a member of the first mature generation to be liberated by the automobile, Gould took a keen interest in the architectural problem of the motor car. Clients gave him numerous opportunities to address the problems of selling, servicing, and garaging automobiles. His solutions to those problems affirm his conviction that he was a modernist designer who created buildings appropriate to new uses and technologies. He designed graceful garages for many economically important Seattle families, including Skinner (FIG. 6.22), Blethen, Rhodes, Cobb, and Treat. He created a style both spare and elegant for showrooms to display Packard automobiles (1919; Olive Street and Boren Avenue), and White autos (1922; Pike Street and Twelfth Avenue). About the same time he designed a similar building for Northwest Motors (1919). The showrooms were essentially plate-glass palaces with elaborate, glazed terra cotta entrances suggesting the sophistication of the potential customer, the elegant cars within, and the experience of operating an automobile. Terra cotta cornices tied the

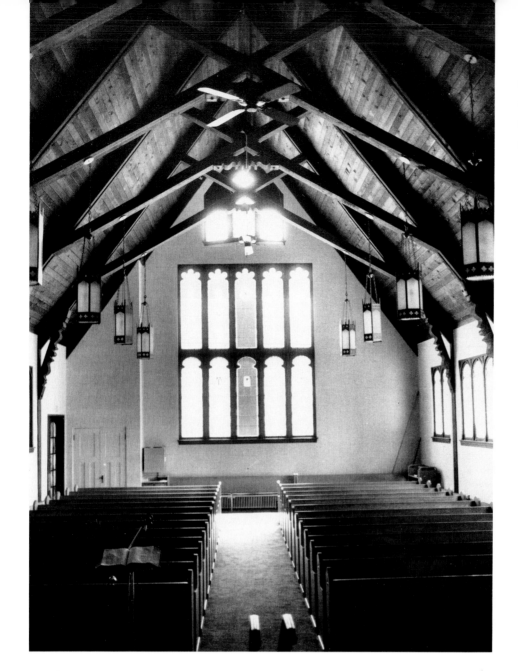

showrooms to the service sections, which were, like the show areas, commodious and expressive. The Packard showroom and service building survives as a Honda dealership, a testimony to the functionalism and adaptability of Gould's designs.

Church architecture challenged Gould to accomplish some of his best work. Perhaps through Bebb, the firm obtained three projects, two churches and a large-scale planning scheme, from the Pacific Synod of the United Lutheran Church. The survivor among them, Trinity Lutheran Church in Everett (1924), is largely intact. A tight budget required restraint in materials, but the interior of the stuccoed building is warmly finished. Ample light streams through Gothic windows to illuminate the plain nave (FIG. 6.23). Timber scissor-trusses span the worship space, and its ceiling is boarded, an arrangement common in many parish churches of the time.[19]

The simplicity of the wood detailing in the church contrasts dramatically with the lavish forms in a small office building for the Weyerhaeuser Lumber Company in Everett (1923). The timber giant commissioned the building for its new "Mill 6" at the north end of town. Gould made the wood resplendent in forms and textures recalling the riotous variety of California Victorian architecture, but he maintained restraint in

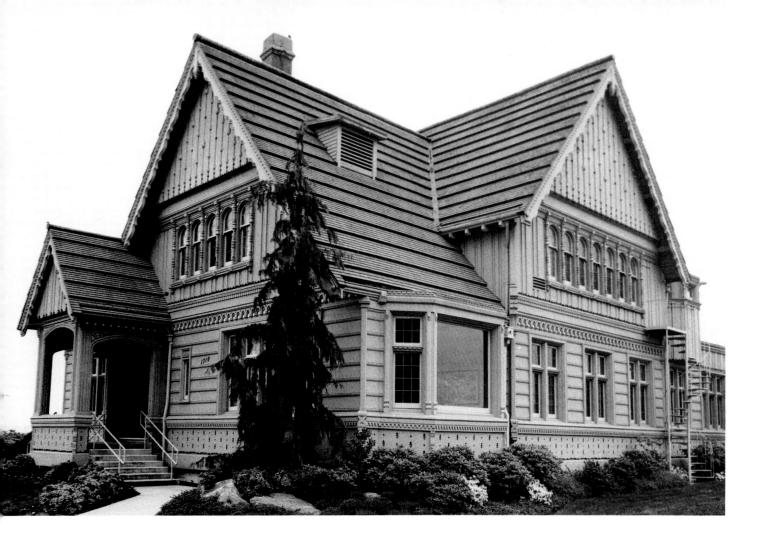

6.24 *Bebb & Gould, Weyerhaeuser Company office building (now Chamber of Commerce), waterfront, Everett, 1923.*

roof forms and massing (FIG. 6.24). The interior, largely preserved in its original state, has an elegance of layout and detailing befitting an executive office. The building lacks a dominant style, and therefore is an exercise in eclecticism, but its form and proportions are graceful and disciplined.[20]

One of Gould's best designs in Romanesque was an unbuilt project in Aberdeen, Washington, for Hayes and Hayes Bankers (1924, FIG. 6.25). The scheme, his first using Romanesque motifs, is revealed in several carefully rendered and well-preserved design drawings. The facade contains a tall, arched entrance flanked by much smaller double windows. Belt courses, and decorative windows high above the first-floor double windows, lend balance and symmetry to the facade. The composition is Sullivanesque but more lavishly decorated than the small midwestern banks that Sullivan designed in the declining years of his practice. The plan of the banking floor is simple but clear in its functional-spatial allocations. Gould planned skylights for the central public space. Unfortunately, the bankers failed before the project could be built.[21]

The years from 1914 to 1926 witnessed Gould's maturation as an eclectic architect. He developed Gothic expressions for collegiate, commercial, religious, and residential structures because the Gothic was flexible and could be adapted to the Pacific Northwest environment. Those surroundings required height for views, together with narrow eaves and large window openings for light. He did not always design in Gothic if client tastes ran to other formulas. His own ahistorical Topsfield, his Seattle house, and the elegant Hoge house in The Highlands were stylistically individual,

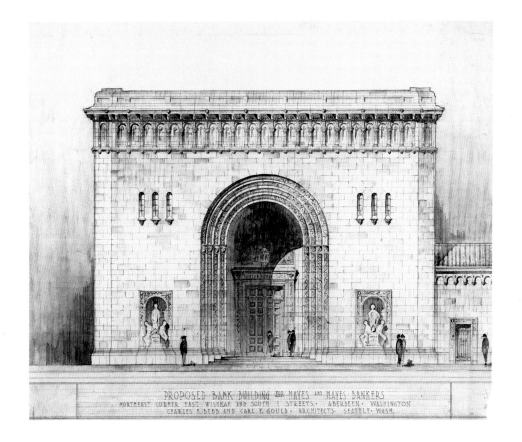

PROPOSED BANK BUILDING FOR HAYES AND HAYES BANKERS
NORTHEAST CORNER EAST WISHKAH AND SOUTH I STREETS · ABERDEEN · WASHINGTON
CHARLES H. BEBB AND CARL F. GOULD · ARCHITECTS · SEATTLE · WASH.

but all were tempered to regional conditions. The Terry house, the last of his Colonial-Georgian expressions, is both a regional adaptation—note the large glazed areas—and a modern concept in its incorporation of the auto in the site plan.[22] Finally, eclecticism did not rule out the contemporary, as Gould's successful designs for auto showroom-service buildings revealed. His genial, undogmatic attitude would stand him in good stead during the final twelve years of his practice.

6.25 *Bebb & Gould, Hayes and Hayes bank building (proposed), front elevation, Aberdeen,* 1924.

You architects are, above all, the guardians of beauty. —HENRY SUZZALLO[1]

7 Domestic Life, Late Houses, and Civic Involvement, 1926–1936

WHEN GOULD RESIGNED FROM THE UNIVERSITY OF WASHINGTON and the Board of Regents hired others to plan and design, Bebb & Gould suffered a great financial loss. In 1927 the firm's net income peaked at $40,000. It was a princely sum at the time, but the partners achieved it largely on the strength of payments for past work. The next year the net revenue plunged to $14,000. It exceeded that amount only twice through 1937, reaching five figures in but three of those years.[2] The declining office practice allowed Gould more time for family, civic, and professional activity, even though he continued to pay careful attention to the relatively few commissions he garnered.

The Goulds remained at their Capitol Hill English cottage-style home. With Carl, Jr., and Anne growing into their teenage years and John VanWyck's birth in November 1925, there could be no serious thought of a more lavish house or even of adding the front porch and sun porch Gould had drawn into the original plans. As the children grew, the dinner scenes of barely controlled chaos at Topsfield gave way to formal settings, at least when the Goulds entertained. The gatherings of relatives and friends were almost Victorian in their ritual. Gould met guests in a fresh collar and a trim suit with a vest. Visiting children and young adults were expected to be clothed to match, in what they called the "party dress" mode, and to greet "Mr. Gould" with a handshake. He served wine to the adults before the meal, limiting himself to one glass. A maid prepared dinner and served at table under Dorothy's direction.[3]

Dinner time was so central to Gould that he designed the dinner table. It featured a recessed bowl at its center, which Dorothy sometimes used to hold flowers or tropical fish. A silver coffee and tea service concluded each meal. Neither the dimensions of the house nor Gould's interest in sociability permitted the Victorian convention of single-sex or strictly adult conversation groups, but otherwise these entertainments appeared to be survivals of nineteenth-century practices in Gould's family, practices involving the more elaborate settings in the much larger houses of his childhood and youth.

Dorothy stood always at the center of Gould's adoration (FIG. 7.1). Their sensual life remained vigorous, in contrast to their outward reserve. Carl's explicit letters to

Dorothy and Dorothy's confidences to her female relatives leave no doubt of their fervent sexuality. Despite their active love life, public or familial displays of affection, such as hugging their children, occurred rarely. Dorothy was not a large woman at 5 feet 6 inches, but her presence was formidable. She had a purposeful manner of walking or doing the simplest chores. Before leaving home she carefully groomed herself, dressed in the best clothes according to the latest fashion, embellishing all with finer jewelry than Carl could, perhaps, afford. She dominated her children, directing their activities toward the acquisition of culture, educational attainment, and polished decorum.[4]

Dorothy moved in Seattle's elite social circles, and within them she was aggressively active. Her name appeared frequently in the social pages, where she was mentioned as

7.2 *Carl F. Gould, cartoon for* SOYP
(Socks Outside Your Pants club), 1923.

having poured tea or hosted small gatherings, especially for the ladies' auxiliary of the Fine Arts Society. A polished hostess, she enjoyed cultivating her social connections, an activity that probably helped Carl to gain some commissions. Gould told the twentieth anniversary celebration of the founding the Department of Architecture that "to her help my subsequent success, if it can be considered such, is attributed." She was intelligent although not above embellishing stories for personal advantage. She wrote with a flair, and in the 1930s gathered and organized a collection of Pacific Northwest lore into a book. She was the perfect foil for her husband's career.[5]

As the older children grew, riding became an important family pastime. The pageantry of horse shows and their fine uniforms appealed to Gould's formality. His favorite venue was the Olympic Riding and Driving Club, of which he was a trustee. In 1926 he designed the Olympic's new clubhouse.[6]

Skiing was another recreation Gould shared with his children, taking them by train to the slopes at Hyak, near Snoqualmie Pass in the Cascades. At other times he joined with some sixty male friends, among them Seattle's and Tacoma's most illustrious early mountaineers, in annual outings to Mt. Rainier. They made up a colorful troop, calling themselves the SOYP (Socks Outside Your Pants) because of their winter skiing and climbing garb (FIG. 7.2). Gould's friend and client David Whitcomb was "Chief SOYP" and Gould's tribal name, in keeping with the Northwest Coast Native motifs the group adopted, was "Tyee Tokalo." During summers Gould took the family sailing in the San Juan Islands north of Seattle. In the 1930s, with office work at a low ebb, he relaxed during Bainbridge Island summers by conducting art classes for the gaggle of children who lived around Topsfield.[7]

Gould's house designs in the years after 1925 continued in his eclectic tradition but with some tilt toward the modern. Houses designed on the Colonial plan were sparer, lacking traditional details. There were few new calls for grand Renaissance Revival houses, and the handful of Renaissance elevations he rendered show stripped, planar facades. Other houses were less formal and more irregular, with exteriors derived from the rural Continental tradition, but with flowing floor plans in the modern mode. Of fifteen new residential designs after 1925, only five were constructed. With the exception of the great unbuilt project for William Boeing, none was explicitly modern; however, some were among Gould's most innovative work. The projects generally were more modest, especially after 1930 when the Great Depression tempered his clients' means. As always, the competition continued, with skilled traditionalist Arthur Loveless and modernist William Bain garnering their share of the available business.[8]

The Keith Fisken house at 1401 Thirty-ninth Avenue East (1928, FIG. 7.3) is the only house with a traditional **H**-shaped floor plan built from a Gould design in the decade after 1925. It embodies well-proportioned rooms and neatly ordered elevations. The elevations are plain to the point of severity, without Colonial details such as dentils and elaborately molded door frames. The interiors lack Gould's usual fine finishes.

The informally arranged Continental-style manor house continued to be popular into the late 1920s. Gould's design for Arthur J. Krauss at 128 Lake Washington Boulevard East (1926) is a fine example of the type. It rests on an unusually well-situated if difficult building lot that affords panoramic views, but shears away from the boule-

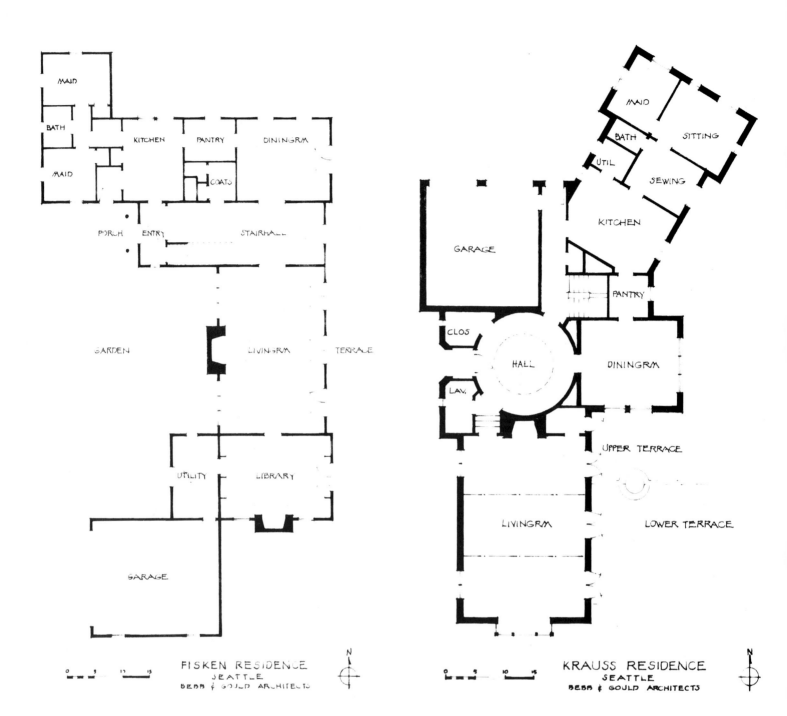

FISKEN RESIDENCE
SEATTLE
BEBB & GOULD ARCHITECTS

KRAUSS RESIDENCE
SEATTLE
BEBB & GOULD ARCHITECTS

vard down to the western shore of the lake. Assisted by Olmsted Brothers, Gould carved out a level area for the house. He captured a stunning view of Mt. Rainier by angling the north wing toward the mountain (FIG. 7.4). At the center, or knuckle, he placed a cylindrical entry and stairwell accessible from all the living areas. Directly ahead of the hall is a modest-sized dining room made more expansive by large windows on three sides, and made intimate by a low, beamed ceiling.[9]

To the right of the stair hall is an insignificant doorway leading to the living room. The small opening sets a deliberate surprise for the visitor as one emerges into a baronial space (FIG. 7.5). The living room is fitted up like a great study, with a beamed ceiling soaring two stories above the floor. Great French doors open upon a patio from which stairs and landings lead to the lakefront. The private rooms in the north wing are more finely scaled, in keeping with their inclination to intimacy. The whole is

7.3 Bebb & Gould, Fisken residence, main floor plan, 1401 Thirty-ninth Avenue East, Seattle, 1928.

7.4 Bebb & Gould, Krauss residence, main floor plan, 128 Lake Washington Boulevard East, Seattle, 1926.

7.5 Krauss residence, living room, interior view to north.

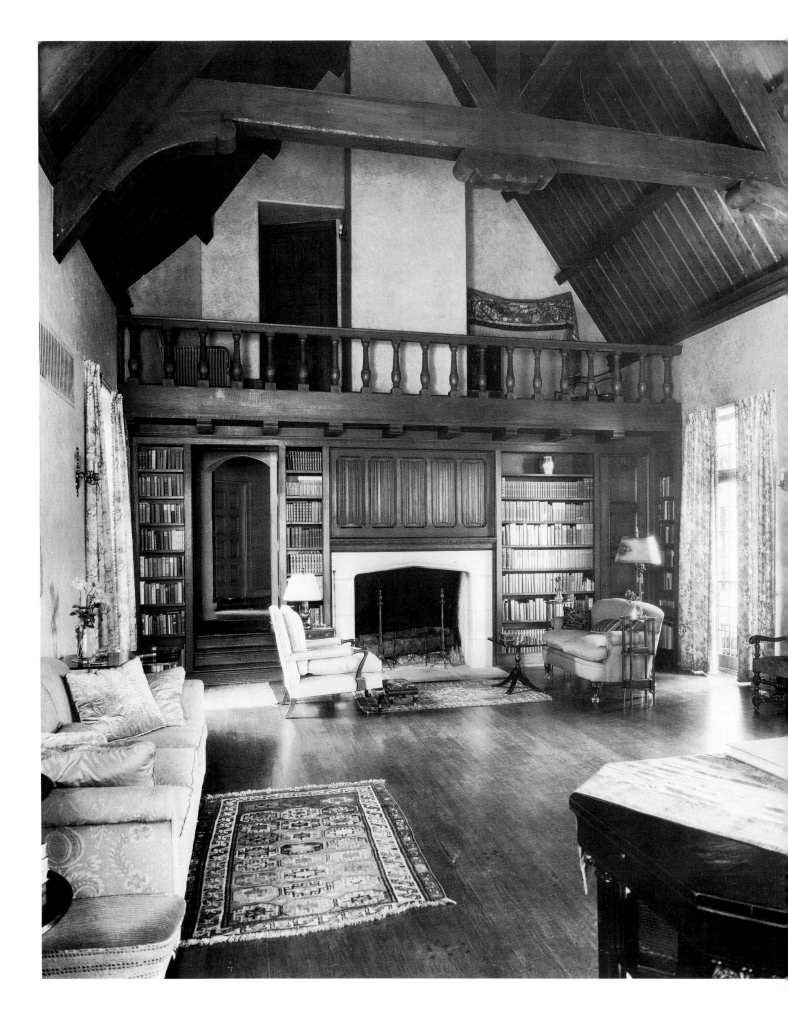

contained in brick walls and steeply sloping roofs, with the three stories on the lake side presenting a rather loosely organized elevation.

A similar picturesque, vaguely Tudor style home (1929) belonged to S. S. Magofinn, a Canadian timber baron. He was an acquaintance of R. D. Merrill of Merrill & Ring Lumber, and probably of Bebb as well. It is likely that Gould secured the Magofinn commission through one or both of them. In designing the Magofinn house, Gould followed his own inclinations toward regional expression as well as the popular interest in picturesque-Tudoresque designs in the later 1920s. Unlike many fanciful, so-called "storybook" Tudors with rooms too small and plans that were inconvenient at best, Gould's designs featured well-proportioned rooms, good flow, and easy livability.

The Magofinn house in West Vancouver, British Columbia, illustrates Gould's fidelity to the principles of design. Magofinn's lot is similar to the Krauss plot, and therefore it is not surprising that his solutions were related. The site is an extraordinarily fine setting on the north side of English Bay, opposite the Spanish Banks. The land plunges down to the bay, requiring a steep drive and retaining walls. The house is compact, with three stories on the water side and two facing the land. The Magofinn plan follows the Krauss with its round stairwell at the angle, from which all areas are accessible. There is a view of the entire bay from every principal room.

Gould's last large executed design is a cottage (1931) on Bainbridge Island. The sprawling house is no more a cottage in its dimensions than the famous cottages at Newport, for the living room alone measures 44 by 28 feet. The client and her husband wanted a large house for themselves and their four children. Gould supplied a functional, modern, freely organized floor plan combined with rustic-romantic styling, to both of which Walter Wurdeman made significant contributions. Arne Campbell remembered that Wurdeman took over the job soon after Gould assigned him to assist with it. Wurdeman was handsome, well traveled, and cultured, and the client "probably fell for that stuff."[10]

7.6 *Bebb & Gould, residence, west view of living room, 2532 Upper Farms Road, Bainbridge Island, 1932.*

7.7 *Residence, west view detail.*

7.8 *Residence, east view of living and dining rooms.*

The site is on a rise at the south end of the island, with views east to Seattle and down Puget Sound to Mt. Rainier. From the grounds the structure appears to be a compound of buildings, with each important function contained in a distinct architectural form. In places it is as tall as a conventional two-story house, yet it clings to the earth because the eaves sweep low in the manner of the western Stick style. The exterior is as diverse as the room functions. The living room is built of random-patterned brick and of board siding so thick and broad that the boards have nearly heroic dimensions. The roof is covered with especially thick and long shakes (FIG. 7.6). The adult sleeping quarters connect to the main house through a breezeway. A sod roof covers them (FIG. 7.7). The breakfast and dining room is an ell off the kitchen on the east side of the house, in a conservatory large enough to seat sixteen people (FIG. 7.8). Three ellipses cut in the slab floor at the side walls expose bare earth and allow for planting and training six grapevines up and inside the glazed panels, to filter the light and offer fresh grapes in season.

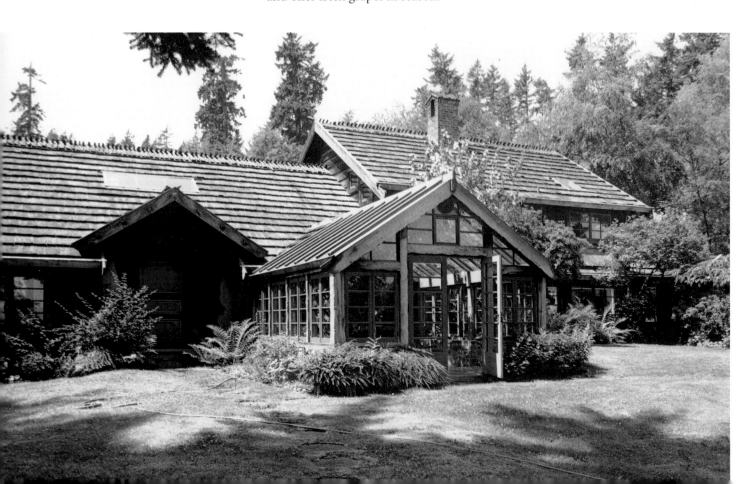

The visual centerpiece of the cottage is the living room, really a great room that could also serve as a banquet dining hall. Its interior wood carving is as finely detailed as its dimensions are magnificent. Unemployed shipwrights carved posts, banisters, beams, and panels to create the ambience of a Norwegian farmhouse. A massive traditional corner hearth reinforces the feeling and embodies the idea of a family center. The built-in cabinets are finished in remarkably fine "rosemaling," a style of painted decoration used in traditional Norwegian furnishings. Yet there is a studied ambiguity about much of the design. With its swooping eaves, pitched roof, and wood interior, the room could derive from a Northwest Coast Native lodge. The windows on the east, overlooking Seattle, and on the west are panels of horizontal rectangles. This change from glazed squares was just coming into vogue in the 1930s and probably is traceable to Wurdeman. The horizontal glazing is unusual in a rustic house but thoroughly compatible with the overall design. The picture window on the south end frames Mt. Rainier.

Outside, the house blends with the site. Inside, it is a study in the integration of craft, art, and architecture that was the fullest realization of Gould's dream of beauty. If there is a defect in Gould's scheme, it is the relatively dark interiors—the price paid for the overhanging eaves. Had Gould published the project instead of keeping it confidential as the owner wished, it could have influenced other architects.

7.9 Bebb & Gould, Boeing residence, proposed ground plan, Innis Arden, Seattle, 1930.

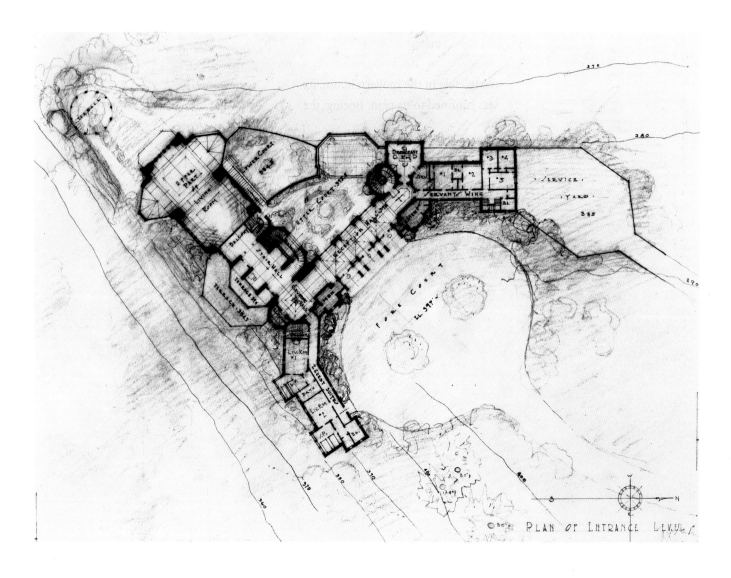

PLAN OF ENTRANCE LEVEL

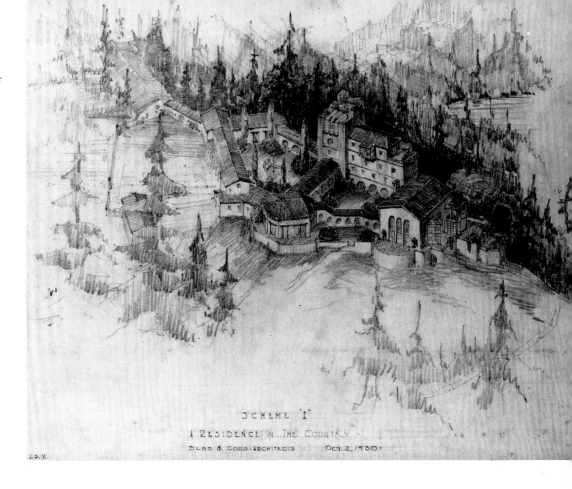

7.10 *Boeing residence, bird's-eye view of mansion, scheme I (Oct. 1930), John S. Villesvik, delineator.*

7.11 *Boeing residence, interior view of library (Aug. 1931), Walter Wurdeman, delineator.*

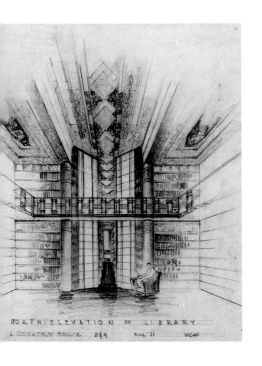

Gould's grandest composition of the era is in the elevations and perspectives of his unbuilt second house for William Boeing. The Boeing house was his only residence completely in the modern idiom, for the modernism of the Bainbridge Island cottage was confined to its plan. Boeing, then living in a large home of Bebb & Mendel design, asked Gould to prepare plans for a great house to be sited on his extensive landholding immediately north of The Highlands. A former logger and later the president of the airplane manufacturing company bearing his name, he was wealthy and more than a little eccentric. The program for the new mansion was expansive and ever changing, as the sixteen separate schemes reveal.

Gould progressed toward a design that was utterly unconventional, and certainly would have been the most costly residential project in his œuvre. Wurdeman, then completing his contribution to the Bainbridge Island cottage, was his primary assistant, although others in the office made drawings too. Wurdeman's interior views and elevations (FIG. 7.9) are remarkable for their sheer invention. They are dreamy compositions that appear to be Hollywood-inspired, with grand scale and muscular detailing, much like the heroic sculpture of the time. Whether Gould showed these sketches to Boeing is conjectural. If he did, Boeing did not reject them out of hand, because later schemes are indebted to earlier designs. The dream project was not built because of the falling fortunes of Boeing, who became embroiled in a bitter controversy with the federal government. Nevertheless the project reveals Gould's versatility, his persistent search for an ideal design, and his determination to find the correct solution for a client (FIGS. 7.10, 7.11).[11]

With his commissions declining, Gould had more time to devote to his professional organization, the WSC. Through 1936 he was appointed to various committees, in-

cluding those on education and institute affairs, and was from time to time a delegate to the national convention of the AIA. In 1931 he served on the committee to arrange for the WSC's contribution of $100 toward the expenses of Frank Lloyd Wright's lecture and exhibition in Seattle, part of Wright's tour of the Pacific Northwest. Wright's tour "did much to create interest in architecture in Seattle." The next year the education committee sponsored a conference between the WSC and representatives of the Washington State Art Instructors' Association on the subject of closer cooperation in developing architectural appreciation and draftsmanship in the high schools.[12]

The Great Depression crippled architecture as badly as it did any other profession. As early as December 1930 the WSC minutes referred to architects sitting "smugly in our jobless offices," and by 1934 Gould was lobbying the Washington State Congressional delegation to have large federal government commissions handled locally. He argued that dispensing the work instead of having it done in the Treasury Department would spread jobs, encourage regional innovation, spur the use of local materials, and avoid the pitfalls of architectural sameness and ignorance of local conditions. The matter was important to the WSC, for as its president remarked in 1935: "Public building seems to be the Architect's only hope."[13]

Gould served on the city planning commission in several capacities, including the chairmanship of the airport committee in 1927. The same year he presented to the parks committee a new design for a city light standard with endorsements from the WSC and the Fine Arts Society. The commission accepted his idea, "preferable to others that have been considered," and thanked him for his "service in presenting this design." Examples of his standard, shorn of all globes save the single one at the top of the shaft, still survive on some downtown streets. He continued on the commission until 1931, when the "representative" system of selected organizations nominating a member subject to the mayor's confirmation was dropped in favor of a commission consisting of ex-officio members and direct mayoral appointments.[14]

Given his long-term association with William Boeing and his involvement in airports from the planning perspective, Gould's continuing interest in Boeing Field is not surprising. In 1928 he coordinated the design and placement of a memorial plaque to Boeing, a plaque now located outside the Boeing Field passenger terminal. Once again he chose Dudley Pratt to be the sculptor. The same year he sketched a boulevard linking the field with downtown, a plan recognizing the airport as an integral part of Seattle's transportation network. Airport planning was a live issue at the time, so perhaps he proposed the scheme in connection with his planning commission duties.[15]

In 1929 Gould tested his thinking about airports in an open competition sponsored by the Lehigh Portland Cement Company. His scheme suggests, as with Boeing Field, a broad boulevard link from the airport. The terminal building and control tower are modern concrete structures, but the overall design remains rooted in the symmetry and axiality of the Beaux-Arts. It is difficult to disagree with the jury's comment that Gould's converging runways are not "planned to the best advantage" for the safe operation of a busy airport with airplanes crossing the point of intersection. On the other hand, his perspective does anticipate the need for parallel runways, an aspect not developed in most of the other competitions.[16]

On at least two occasions Gould spoke on the subject of city planning. He deliv-

7.12 Carl F. Gould, watercolor land-
scape, ca. 1933.

ered "Value of Aesthetics in City Planning" to the Pacific Northwest Conference on City and Regional Planning at the Olympic Hotel in December 1928. The speech was a conventional discussion of the aesthetic implications of streets, waterways, street furniture, architectural forms, and color. "Our cities are not orderly," he said, but he held out hope that from "this chaos . . . order is gradually coming." In 1934 he spoke, perhaps to the Monday Club, on "City Planning and Government." He discussed major urban planning activity, the background of zoning, and the virtual halt to developments during the Great Depression. He urged continuing urban and regional planning in "this period of quiet in our commercial progress" in order that new growth would flow into the proper channels when prosperity returned. He discerned "renewed hope for not only efficient machinery being set up for the study and preparation of a city plan but for its orderly and proper execution over a long period of time."[17]

In the decade after 1926 he worked privately and through professional and civic organizations to promote beauty in art and architecture. He organized the Pochet Club in 1928 under the auspices of the Fine Arts Society as a private, voluntary atelier-style study group. Successor to the Seattle Architectural Club, the organization focused on the artistic problems of architecture, with Gould serving as the "patron" who proposed and graded the members' projects. An artist himself, he sympathized with the often unrecognized, difficult, and lonely labors of contemporary artists. When the local landscape painter Paul Gustin left for an eighteen-month sojourn in Europe, Gould acted as his financial trustee and agent. Several of Gustin's paintings in the Gould family collection probably represent compensation for Gould's efforts. He also befriended Allan Clark, the sculptor of the heroic figures above the entrances of the University of Washington library.[18]

In 1930 Gould resumed watercolor painting. His subjects included seascapes painted during a cruise of the San Juan Islands (FIG. 7.12), flowers, and landscapes on Bainbridge Island or in the area mountains. He encouraged the whole family to paint as a recreational activity. In 1935 his quest for a unifying arts organization led him to propose that the Chamber of Commerce become a "cultural clearing house" with the purpose of synchronizing schedules so that arts groups' programs would not overlap.[19]

In 1936 he packed John off to camp and took Dorothy, Carl Jr., and Anne to the American School of Fine Arts, a summer school at Fontainebleau. He organized the journey despite the parlous state of his finances (see CHAPTER NINE). The school was founded in 1923 at the urging of older Beaux-Arts students "to provide younger generations with a brief but durable contact with traditional French values." The Goulds sailed on the *Normandie*, socializing with "friends from the east" bound for a garden club gathering in Paris, to which Dorothy was also a delegate. The *Normandie* made such a rapid crossing that the family toured England before going to France. At Fontainebleau they found a school diminished by the world-wide economic depression and changes in architectural taste, but still under the leadership of the influential Jacques Carlu, a student of the great Laloux. Carl studied sculpture, Dorothy studied fresco painting, and the children took courses in architecture and decorative design. "During visits to Paris," Carl returned to "his old stamping ground, the Ecole des Beaux-Arts." Summer school over, the family toured Belgium, Holland, Germany,

Sweden, and Scandinavia before returning on the *Queen Mary*.[20]

Gould's greatest investment of time and effort in the cause of art was in the Fine Arts Society, which he had served as president from 1912 to 1916. The Society had drifted from 1923 through 1926 because of a lack of vision and direction. Dorothy remembered the time as "the dreadful era," but the Society still claimed 523 members in good standing early in 1926. Gould, relieved of his university duties and their time pressures, ran for the presidency and was elected. He at once set about revitalizing the organization. He negotiated with Horace C. Henry for the use of the Henry house and gallery after Henry's paintings were removed to the gallery at the University of Washington. The Society occupied the house in April 1927, and once there expanded its art classes, lectures, exhibits and other programs. Dorothy and others founded the Junior Fine Arts as a branch of the Society, to educate women about crafts and the fine arts in history. Carl rejuvenated the Society's social functions, leading a later director mistakenly to conclude that during his presidency "the organization was essentially social in its outlook." Gould's emphasis on social activities, his penchant for gregariousness aside, was always to strengthen the group. Near the end of his presidency, in December 1928, the organization realized his dream of art reaching the community when it changed its name to the Art Institute of Seattle.[21]

Despite his achievements Gould's presidency was far from easy or uniformly enjoyable. Rebuilding an effective administration was a difficult task. A well-respected curator in whose hiring he invested thought, time, and energy proved to be capable but offensively brusque. He led the move to terminate her despite the enthusiasm she kindled among several members of the Society. When she resigned before receiving official notice of her removal, the board accepted her resignation.[22]

An event more difficult for Gould to handle was the brouhaha over the division between traditionalists and modernists in painting and sculpture. In 1928 the leading regional modernists refused to exhibit for the traditional Northwest Annual exhibition at the Henry house. Instead they organized an independent salon without a jury, and with prizes chosen by popular vote. The next year two categories, conservative and modern, were established, but most artists refused to have their work so pigeon-holed and mounted the independent show once more. A later Northwest Annual with one jury finally healed the breach between artists, and between them and the Art Institute.[23]

During his presidency Gould brought the Art Institute to a recognition of the need for a building designed for shows, permanent displays, and other activities. In 1928 he invited Richard E. Fuller, a wealthy geologist and collector, to join the board of the Society. Fuller served as vice president under Gould in 1929, and was elected president in 1930. The Art Institute became the touchstone of Fuller's civic life. In 1928 he donated $1000 as the seed of a much-needed endowment fund. In October 1931 he publicly announced his gift of $250,000, a huge sum at the time, for a new art museum building. Gould was named the architect of the new museum resulting in part from his efforts.[24]

During the decade after 1925, Gould concentrated his labors on relatively few domestic projects, not an uncommon experience for architects. He embraced looser, less formal plans, and in the Fisken house wrapped a traditional plan in a stripped exte-

rior. But exteriors, too, became less rigidly organized. The walls of the Bainbridge Island cottage are pierced to incorporate marvelous views, while the varied exterior materials suggest the differentiation of interior spaces, and the spaces themselves are radically untraditional. The unbuilt Boeing project marks Gould's final embrace of the modern in domestic architecture. Beyond his work and his conservative family life, Gould's interests lay in civic pursuits. His dedicated service to the WSC, the city planning commission, and especially to the Fine Arts Society, resulted in solid achievement. As always, he was frustrated in his efforts to achieve a comprehensive arts organization or a high level of interorganizational cooperation, but he was able to record some cooperative successes, including the adoption of his new street-lighting design. For all his domestic design and civic activity, however, his great projects during those years involved commercial and public buildings.

To be released from the enormous accumulation of the baggage of traditional form immediately gives architecture wings and freedom for flight! —CARL F. GOULD[1]

8 Modern Architecture, 1926–1938

ARCHITECTURAL MODERNISM, CONSIDERED AS A BROAD reaction against traditional forms, had been gathering momentum since the late nineteenth century. Gould, always open to the possibilities of any mode, did not object to the modern. Superb execution of a project according to Beaux-Arts principles mattered more to him than style as long as the building envelope was expressive, fit the overall program, and met the client's wishes. For these reasons several of his buildings were stylistically ahistorical, as the lockmasters' houses at the Chittenden Locks, his own Topsfield, and the project designs for Lake Pleasant attest. When the client accepted the departure, he abandoned traditional floor plans, as in the great Osgood project of 1911 and the Bainbridge Island cottage of twenty years later (see CHAPTER SEVEN).[2]

Modernism meshed well with Gould's commitment to regionalism. Modernism's large window spaces, its glazed and rounded corners, its almost stark simplicity, its celebration of recessive ornament, and its vestigial capping of vertical elements all admitted light. The absence of heavy columns or pilasters and the abolition of cornice overhangs virtually eliminated structural shadowing on the many overcast Pacific Northwest days. The modern challenged, too. Gould wrote that it required an architect to "produce abstract forms . . . which are at once suitable and have permanent aesthetic values, without the prop of traditional norms to fall back on." The architect left with no way to disguise his shortcomings "must command, to the minutest detail, the relationship of all of his forms—which requires a far greater aptitude and aesthetic awareness."[3] No longer could architects take refuge behind decorative detail.

Gould's designs in the modern style were a personal adaptation of Art Deco, in which, over time, the blocky shapes of Art Deco blended with the rounded, flowing, streamlined Art Moderne. The zigzags and chevrons of Art Deco remained in the later buildings, usually attached to entrances or the surviving rectangular elements of the envelope. Because his residential clients were almost unanimously uninterested in domestic adaptations of the modern (with the notable exception of the unorthodox William Boeing), the style made its first appearance in Gould's commercial, memor-

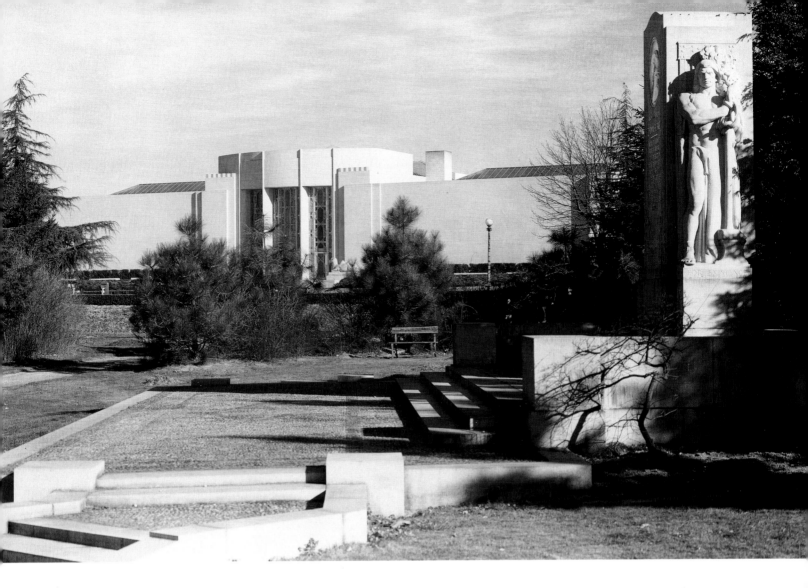

8.1 Bebb & Gould, view of Burke
Memorial (1926–30) and Seattle Art
Museum (1931–33).

8.2 Bebb & Gould, Burke mausoleum,
Washelli Cemetery, Seattle, 1927.

ial, and institutional projects. Modern style was the architectural fashion in the late
1920s and early 1930s for those clients who wished to present an image of modernity
to customers, patients, or prospective tenants. The Pacific Telephone and Telegraph
Company, for example, insisted on buildings overtly modern.

None of this implies a smooth transition from traditional styles to the modern.
Programs involving individual or group remembrance, achievement, and exclusivity
mixed the styles intriguingly. Gould's first foray into Art Moderne occurred in 1926
(completed 1930) with the monument to Thomas Burke, a leading Seattle citizen,
which is located in Volunteer Park a short distance southwest of the Seattle Art
Museum (FIG. 8.1). The organizational scheme is neoclassical, resembling several
designs by McKim, Mead & White, but the figures by H. A. MacNeil are Art Moderne.
The monument looks to the design future, and Burke's friends were futurist in their
acceptance of it. The Volunteer Park commemoration stands in contrast to the Burke
mausoleum (1927) in the Washelli Cemetery (FIG. 8.2). There Gould developed a
thoroughly neoclassical composition, with stark white marble Doric columns and
entablature.[4]

Gould's cultivation of the Seattle establishment culminated in his being selected
architect for the prestigious Rainier Club's addition (1926). The exterior emulates
the original brick Flemish style by Kirtland Cutter (1904), and the prominent door
on Fourth Avenue derives from rococo sources. Inside, however, another scheme
prevails. Gould's designs for the interior of the addition—and in 1929 for the older

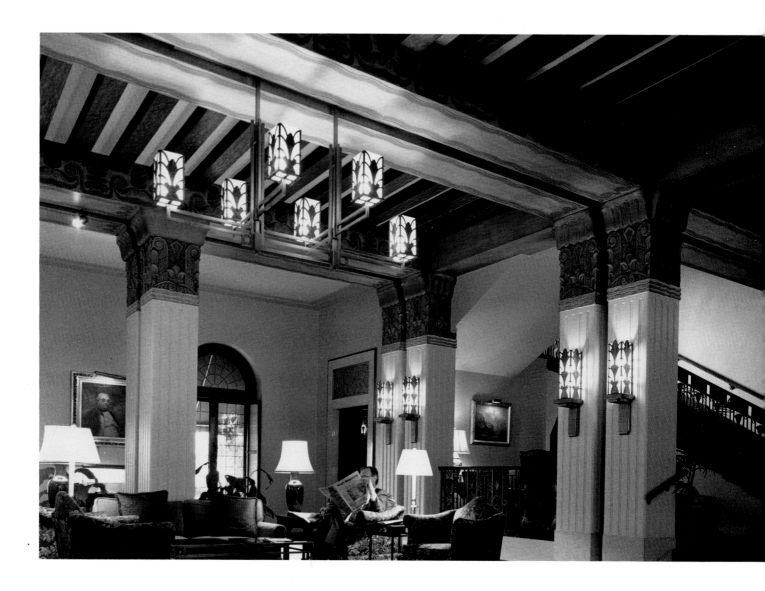

northern section—represent his first opus in Moderne decor. He decorated the entrance lobby and grand stair hall with vigorously shaped, gilded, and painted wood details (FIG. 8.3). His deft handling of the forms compares favorably with those in Albertson, Wilson & Richardson's Northern Life Tower (1928) and in John Graham's Exchange Building (1930). The Rainier Club interiors were Gould's prelude to commercial and institutional work embodying modern motifs.[5]

Gould's first essay in commercial modernism came in 1928 with an unbuilt project for Associated Business Properties, whose president David Whitcomb was a good friend. He drew several perspectives of two proposed buildings. One, for a building of some twenty stories (FIG. 8.4), contains a parking garage, a new feature demonstrating Gould's and his client's awareness of the requirements of the automobile. Although the main entrance is of overpowering size, it is free of neoclassical detailing. String courses break the upward flow of the office floors, but the recessed windows and spandrels, the absence of projections, and the stepped-back top floor with its squared-off finials above the corner windows, all suggest a spare rendition of Art Moderne.

Gould designed his first constructed building combining Art Deco style with Art Moderne (1928) for Pacific Telephone and Telegraph in Longview, Washington (FIG.

8.3 Bebb & Gould, Rainier Club, interior view, 820 Fourth Avenue, Seattle, 1926–29.

8.4 Bebb & Gould, Associated Business Properties (proposed), Seattle, 1928.

8.5). This compact three-story structure, designed to house switchgear, contains his most elaborate Art Deco embellishments, but they are framed in the simple wall planes typical of Art Moderne (FIG. 8.6). Decorative motifs aside, the building is a severely contained and controlled box, clearly a departure from Gould's telephone company building in Seattle (see CHAPTER SIX). There are no projecting cornices, pilasters, or other classical features. The Longview project is not only Gould's first built modern structure, it is one of the earliest Pacific Northwest buildings in the style, and is contemporary with such better-known examples as the Northern Life Tower (1928) by Albertson, Wilson & Richardson, the Olympic Tower (1929) by Henry Bittman, and the Great Northern Building (1928) by Robert C. Reamer. The Longview project should have placed Gould among the architectural avant-garde in the region if not nationally, though its size and location in a small city were against him. Had Gould written up his achievement it might have received some notice, but he did not. The man who published his institutional designs without hesitation was too circumspect toward private clients to exploit them in return for recognition.

In 1929 Gould designed a telephone company building in Yakima in the same vein of design as the Longview structure. The next year marked his move into the company of modernist architects. In 1930 he designed the United States Marine Hospital (now the Pacific Medical Center), a merchant marine facility, at 1131 Fourteenth

8.5 *Bebb & Gould, Pacific Telephone &
Telegraph Co. (now U.S. West), north-
east view, Mississippi Street and Van-
dercook Way, Longview, 1928.*

8.6 *Pacific Telephone & Telegraph Co.,
detail, Longview.*

Avenue South (FIG. 8.7). The structure is essentially a twelve-story exercise, set off by seven-story wings, crowned at the center by an almost windowless section of mechanical apparatus rising another four floors, all clad in Art Moderne brick and terra cotta. What could have been a pastiche in the hands of a lesser architect is a unified structure in Gould's. To achieve unity Gould employed three devices. First and most obvious is the banding of shades of orange brick and uniform window size. Second, the brick at the corners of the lower section are not rounded but laid chamfered, so they achieve an Art Moderne expression without a streamlining effect, which would have clashed with the series of rectangles above. Third, rising from the entrance are five strictly decorative and slightly protruding piers, the two flanking columns halting above the deep insets, the center three continuing to the very top of the mechanical section, with chevrons enhancing their verticality (FIG. 8.8). Thus Gould used subtle effects of color, size, and detail to unify a building without capitulating to mere structural articulation or design fads.

Gould's analysis of his design reveals that he not only had set aside the vocabulary of classicism at Marine View, but had also abandoned the modern expression of classical forms, the base, shaft, and capital. "In our hospital design I have no longer considered that we are obtaining unity, that quality which good design will always exhibit, by voids and solids, base, shaft & cap or cornice. Nor do we consider the preponderance of vertical or horizontal. I look up[on] our design as a well proportioned package or series of parallelopipeds bound together as if by sturdy rope carried in two directions [a reference to the horizontal window bands and brick verticals] & thereby erect a sense of unity." Gould admitted that his arrangement was "experimental & remains to be seen if it has working basis for future design." Hugh S. Cumming, the surgeon general, thought so. He praised the "splendid piece of architecture," and declared that he had seen no other hospital "either here or abroad which is more satisfactory both from an architectural and professional standpoint." Later the building was nominated a Seattle historic landmark.[6]

But there is more to the work. The project expanded to realize the master plan, a campus of residential buildings south of the hospital. The hospital came in at $300,000 under budget, leaving funds to go forward with the small townhouses for staff and nurses' residences. Each townhouse doorway is individually decorated, each townhouse is a design delight, and together they create a sense of care-giving and peaceful simplicity (FIG. 8.9).[7]

The Marine Hospital is notable, too, as a study of Gould's exertions to overcome the economic stagnation in his profession by garnering government work. When the federal government's plan to build became known, Gould went by rail to Washington in October 1930 and attempted to secure the contract. There he discovered that at least two other Seattle architects, John Graham and Harlan Thomas, were also after the job. "It's a lone hand I am playing against much odds & no help from Bebb unfortunately," he wrote to Dorothy, but he promised to do "every possible thing" for Bebb & Gould. He lined up influential references and saw all the right people. The best he could report to Dorothy on 11 November was that "we have not been discarded yet." The break came two days later when Ferry K. Heath, Assistant Secretary of the Treasury, called early in the morning to ask Gould "if it were not possible to get together with Graham." Gould hesitated. Then Graham came "to see me in a humble mood"

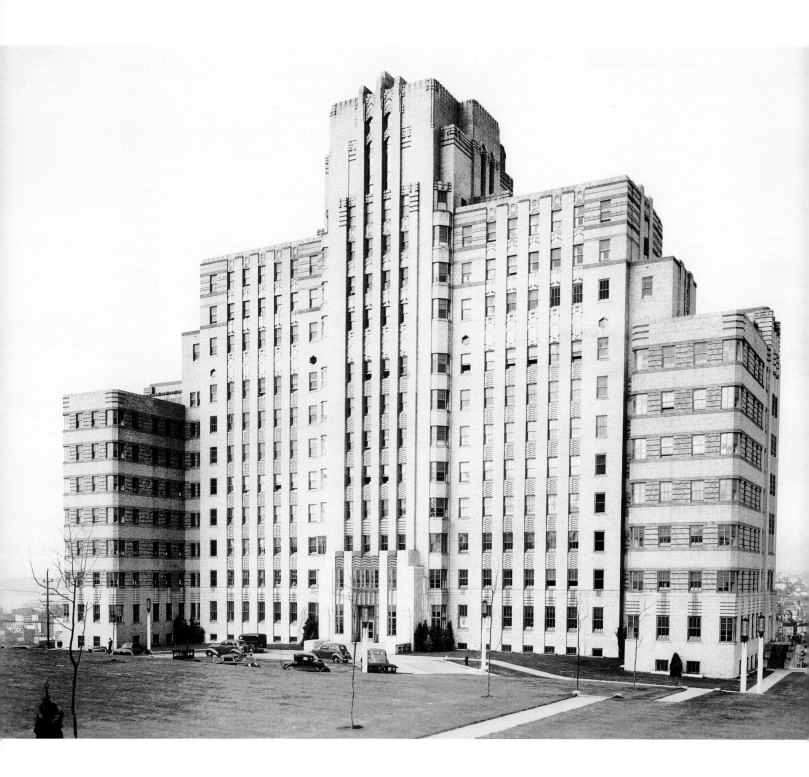

and the two agreed to collaborate, sealing their pact with a drink. The contract was to be split evenly, but Graham was to be listed as the associated architect, and "I am to take command of the design. Mail comes to our office."[8]

Gould confided to Dorothy that if "we can put this through expeditiously we ought to make something out of it." The Hoover administration wanted quick work because the hospital was part of its emergency public works program, which perhaps explains its desire to split the contract between two active offices. In any event Gould moved the work forward with astonishing rapidity, even considering that neither his nor his associate's office was overwhelmed with work during the depression years of 1930 and 1931. Back in Seattle, he began the design process the day after Thanksgiving and with-

8.7 Bebb & Gould, U.S. Marine Hospital (now Pacific Medical Center), south view, 1200 Twelfth Avenue South, Seattle, 1930–32.

8.8 *U.S. Marine Hospital, exterior, detail of tower.*

8.9 *U.S. Marine Hospital, nurses' housing, south elevation detail, 1931–32.*

in three weeks had completed the schematic drawings. With them in hand, Gould and Graham left on 26 December for the national capital. They met with Cumming, Warren Wetmore, the supervising architect, Andrew Mellon, Secretary of the Treasury, and "chatted with Pres. Hoover" and others. Early in January 1931 the federal officials approved the documents and tendered Gould's payment. By 10 May Graham's office had prepared the contract documents with the collaboration of two Bebb & Gould employees who were working there, and they were ready for bid. By July the contract for the tower was let. The residences were bid and awarded before the year's end. All the work was completed in less than two years from its inception, a remarkable achievement in any time.[9]

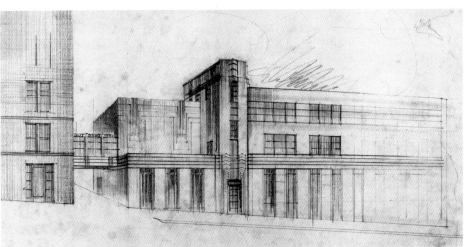

In 1932 Gould carried minimalism further for an unrealized medical-dental office (FIG. 8.10). His perspective shows a severely modern building with sheer walls and sharply incised window openings. There is slight Art Deco decoration at the cornice line but none elsewhere, and the simplest entrance. Gould's final health-care project brought the modern, minimalist approach nearly to its ultimate expression. His 1933 design for the X-ray facility of the Tumor Institute of Swedish Hospital presents a facade that is almost industrial in its simplicity (FIG. 8.11). He created the building to contain and direct the beam of a new General Electric X-ray generator. Because massive concrete walls were the most cost-effective container of X-rays, Gould designed 36-inch-thick slabs around the generator room. Except along the facade, the building has few windows. Therefore Gould employed the modern device of horizontal banding to provide scale and relief on the massive walls. In this building, as in his previous medical designs, Gould demonstrated his versatility in handling what were, for him, new and complex problems, and delivered solutions wrapped in effective contemporary compositions.

Gould's most difficult modern project, and his most superb modern design, is the original Seattle Art Museum (FIG. 8.12) located in Volunteer Park. This stunning building is an achievement compounded of so many elements that they should first be considered separately. The first was Gould's extensive knowledge of museum requirements. Second, the donors Richard Fuller, his mother Margaret E. MacTavish Fuller and their friend the painter Kenneth Callahan wanted a popular museum "to educate the layman," one free of designs associated "with the past and established dead traditions."[10] Third, Walter Wurdeman, a first-rate designer in the modern idiom, had recently joined Bebb & Gould. Fourth, the project consultant came out in favor of a modern conception. Fifth, budget constraints imposed a disciplined approach.

Finally, the museum's magnificent location dictated an impressive building, whatever its style and dimensions. The Art Institute had pledged to build a museum in Volunteer Park on Capitol Hill. The proposed site was a rise overlooking a formal garden and a reservoir, and commanding, at successively greater distances to the west, views of downtown, Puget Sound, and the Olympic Mountains. The setting called for a structure of fine proportions and large dimensions. Once built, the museum building would become the property of the city, which agreed to assume its maintenance, although the Art Institute would continue to own the contents.[11]

Gould's knowledge of museums reached back to the Louvre, the gallery areas of the Lenox, New York's Metropolitan Museum, and the Brooklyn Museum. During his 1930 visits to Washington D.C. and New York, and his 1931 return to Washington, he examined a number of museums and spoke with the author and critic Fiske Kimball, then the director of the Philadelphia Museum of Art. He conferred with Lionel Pries, the newly appointed head of the Seattle Art Institute and "an absolute advocate of the modern movement," while both were in New York. Gould's studies were more thorough and painstaking than his forays to libraries years before. Indeed, Gould believed that Fuller postponed the announcement of his gift for a year pending Gould's full report on his inspection of museums.[12] His task was all the more demanding because no thoroughly modern example of an art museum existed anywhere. Worse yet, an art museum has little in common with other building types. It requires large and flexible spaces for the display of paintings, sculpture, and other objects; areas for storage and exhibit preparation, a library and other rooms for students and scholars to work with collections in storage; a lecture hall and classrooms; and the best contemporary systems of lighting and environmental control.

The Henry Gallery, advanced as it was, could be of little help, for it is simply a gallery, not a multiple-function museum. The Henry, moreover, is Gothic in spirit despite a blocky shape and ornament reflecting Art Deco. Building the Henry forced Gould to grapple with light and air quality and to supply sophisticated control systems, but the associated mechanical problems, while important, did not represent the range, scale, and complexity of those confronting a museum architect. His first reaction in the face of these diverse requirements outside the scope of his direct experience was a retreat into certitude.

The design development drawings for the museum are unique among those in the Gould collection for their precise dating.[13] They reveal the design sequence from the most atavistic early efforts to the ultimate, modern solution. In August 1931 Gould

prepared a series of small sketches made with a wide, soft pencil and derived from older museum designs. One, safely traditional and uninspiring, appears to be a diminutive version of the Brooklyn Museum (FIG. 8.13), with a colonnade, a rotunda, wings, courts, and galleries supported by freestanding columns. Such interior columns break up space, limit viewer circulation, are distracting, and are therefore poor vehicles for the display of art objects. Fortunately, Gould did not rest with his own designs but asked others to try their hands, as he usually did, at least in his later practice. Some of the resulting schemes were more stylish than Gould's, banishing the old-fashioned rotunda, for example, or confining the colonnade to the principal facade. But all relied on Classical or Neoclassical models, whether the Agora in Athens, the works of Palladio, the National Gallery by John Russell Pope, or the Buffalo and Akron museums by Edward Green (FIG. 8.14).

All the sketches wrestled with two related problems: how to announce the entrance, and how to differentiate the space within. The sketched interiors typically are composed of large and small gallery areas, with no indication of how problems of lighting and air quality would be solved, nor of how the limited hierarchy of spaces could bend to the demands of varied exhibitions. The entrance posed a difficulty, for a sin-

8.12 Bebb & Gould, Seattle Art Museum, west front, Volunteer Park, Seattle, 1931–33.

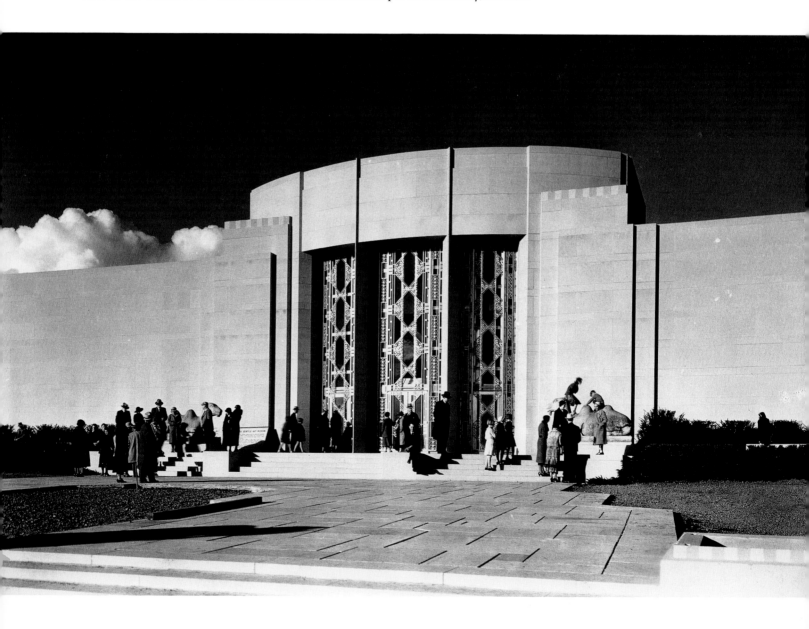

8.13 Bebb & Gould, pencil sketch of plan, probably by Gould, Seattle Art Museum, August 1931.

8.14 Seattle Art Museum, sketch of west elevation, September 1931.

gle door could seem to dwindle visually to mousehole proportions in a two-story, 200-foot facade. A massive portico might seem acceptable in the perspective of a small sketch, but when constructed would appear forbiddingly monumental to the flesh-and-blood patron. Gould's initial sketch conveniently dissolves below the floor of his great portico without so much as suggesting the tall flight of stairs necessary to provide an adequate approach and base for his massive museum. The patron who climbed those absent stairs might have been giddy less from anticipated contemplation of the treasures within, than from oxygen deprivation induced by a scamper up them. In retrospect one scheme stands out (FIG. 8.15), because it is the forerunner of the final entrance solution and also because it is from another hand than Gould's.

The next designs, dated 1 October, are from the brilliant, stagy Walter Wurdeman. Gould probably chose Wurdeman's elevation either because he assigned the problem to him with a firm request for a solution, or because he picked the Wurdeman effort from among a group of competitive solutions. In this instance it

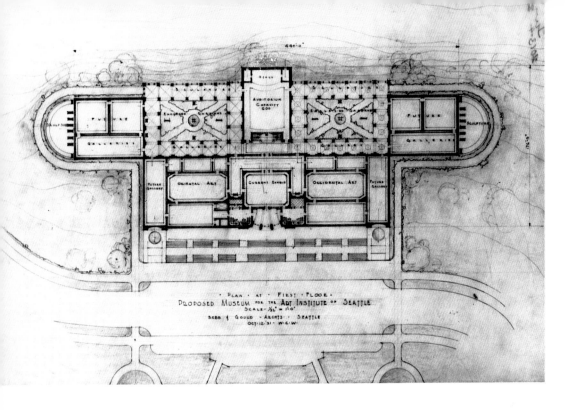

*8.15 Seattle Art Museum, sketch of
ground plan, Walter Wurdeman, delin-
eator, October 1931.*

*8.16 Seattle Art Museum, proposed west
elevation, Wurdeman, delineator, Octo-
ber 1931.*

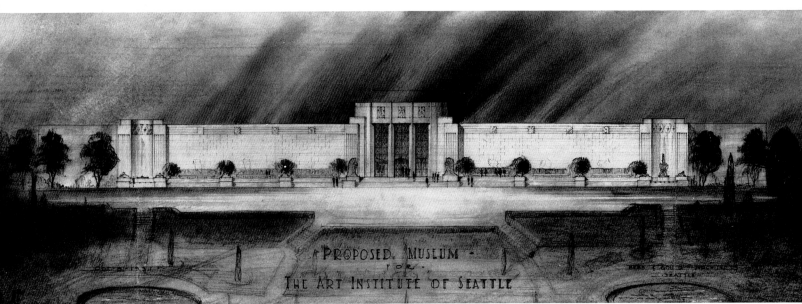

appears that Gould first held a competition in the office, from which the various
"classical" solutions emerged. Then he chose Wurdeman to pursue a design based
on the one anomalous sketch in the group, an ahistorical elevation probably from
Wurdeman's hand. It is possible, however, that Fuller and Kenneth Callahan, friend
of the Fullers and of Gould, prevailed on the architect to abandon classicism in
favor of a modern museum.[14]

Wurdeman's design loosely followed a thesis project he had completed for his Uni-
versity of Washington architecture degree, a temple with a bowed front containing
doors separated by prismatic columns, and clad in stone with bands of alternating
height. Wurdeman's drawings for the museum are without historical embellishment
(FIG. 8.16). The facade is marked by insets at the wings, the only interruption of the
surface save for the entrance itself. The entrance soars above the second story, its three
bays marked by slender prisms—the pure geometry of modernism.

The design would be refined and simplified as well as vastly reduced in scale, its Art Deco motifs and windowed walls giving way to the greater rounding, fluting, and smoothness of Art Moderne. But the fundamentals were fixed. As Fuller expressed it, the design "followed no established precedent, although—to the best of our ability—Mr. Carl Gould and I have endeavored to profit by the advantages and disadvantages which we observed in other museums. The attempt to achieve permanent beauty principally by refinement of shape and proportion, with only a restrained use of accessory ornamentation, has greatly emphasized the necessity of perfect workmanship."[15]

The solution of interior problems, however, came more slowly. A 1 October sketch leads the visitor from a tight foyer through a single doorway to the largest central gallery. Only this room has a skylight, a radical change in program from the Henry Gallery, where all rooms have skylights. There were other indications that no focused design program existed. For example, the lower floor contained galleries and a lecture hall, leaving only about 1000 square feet—a ridiculously small area—for storage. Sections drawn through the central gallery show provisions for electric lighting, a demonstration that Gould was insisting on up-to-date mechanical arrangements. But smooth lighting without glare or hot spots would be of little benefit unless thoughtfully integrated into an interior design worthy of the facade and of the collections.

Either Gould or Fuller, or both of them, realized that they were beyond their depth and recognized the need for an expert consultant who would advise them about staff space, mechanical systems, and the range of display media. To obtain this information, Fuller retained Laurence Vail Coleman, director of the American Association of Museums. Coleman's report arrived in early October; in it was a program for designing a museum for a city somewhat larger than Seattle. Gould's next scheme, dated 9 October 1931, responded to Coleman's report with changes in all areas of the plans. The lower floor gained substantially more storage. A space for an art school, Gould's continuing ambition, was removed, but children's galleries were included. The entrance, still with three doors, was contained in a prominently projecting and curved element, a form that endured through the remaining revisions. The foyer, ungainly in its dimensions (17 feet wide, 35 feet high) was more a slot than a room. But the new plan has a generous three doors leading to a central gallery identified for "current exhibits." Acting as Gould's pencil, Wurdeman had helped to transform a traditional design into a modern concept.[16]

Yet much remained to be done. Wurdeman's exterior scheme was busy, with a sort of Mayan decoration superseding the windows. Inside, the galleries required more work because there was no hierarchy of exhibition spaces suitable for displaying a variety of art objects. In any case, the projected building was vastly beyond the means of the Art Institute. The drawings were sufficiently well advanced by the end of 1931 for Bebb & Gould to estimate the costs, which were "well over" the amount of Fuller's gift. Worse, no funds had come in to match the gift; indeed, economic conditions were so serious that one trustee, a banker, resigned in embarrassment when he could not fulfill his pledge. A year earlier, ten patrons had each mustered $1000 to support the Art Institute, but such generosity was not to be repeated. At their meeting of 12 January 1932 the trustees acknowledged that donations were no longer expected, and that the plans would have to be revised.[17]

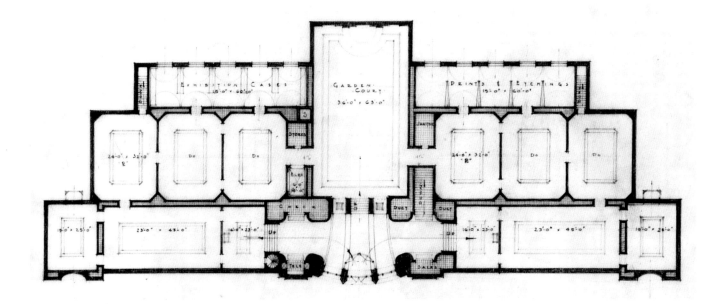

Gould's drawings dated 23 January 1932 reflect the radically reduced scope of the project as well as his latest thinking about the interior. He removed the second floor, shortened the facade, and shaped the gallery spaces into a tightly organized, inverted T, with the central gallery forming the leg, long galleries at either side of the entrance making the top crossbar, and smaller galleries behind, flanking the central gallery and making a second, shorter crossbar (FIG. 8.17). The new scheme brought the facade and interior spaces together in an expressive whole. The entrance marks the access to the central gallery, now labeled a sculpture court. The smooth facades reflect the long galleries at either side of the entrance, while the fluted ellipses at each end of the facade suggest the small gallery spaces beyond. The three galleries flanking the central court responded to a fresh suggestion from Callahan. The rooms adopt the angled corners of the Henry, an innovation providing four added areas in each room to display objects. Most important for the exterior effect, Gould raised the galleries 4 feet above the entrance level, giving the impression from the outside of a much taller building and permitting a properly scaled interior entrance (FIG. 8.18).[18]

The January drawings broke decisively with tradition, and with most of the earlier schemes. Traditional picture galleries were laid out like Renaissance palaces, in a series of rooms through which viewers moved, then retraced their steps to the point of entry. In contrast, these new plans allowed for a variety of pathways adaptable to the requirements of various exhibits. Section drawings reveal a great skylight over the central gallery and in the side galleries, with skylights and troughs for indirect lighting in the ceilings (FIG. 8.19). Grille decorations much like those in the final design appeared at the entrance door and the windows above them. From these schemes Wurdeman rushed through a complete set of plans, elevations, and sections, which the trustees approved on 9 February. Several new features appeared in this set of drawings. The foyer advanced from a clumsy assemblage of columns and angled wall planes to a simply arranged room without columns, with smoothly curved corners, and with niches in the walls for secondary uses—telephones, sales, checking, and stairways. A rear (east) elevation showed windows with their upper corners clipped or angled.[19]

8.17 Seattle Art Museum, approved plan, Wurdeman, delineator, January 1932.

8.18 Seattle Art Museum, foyer, 1933.

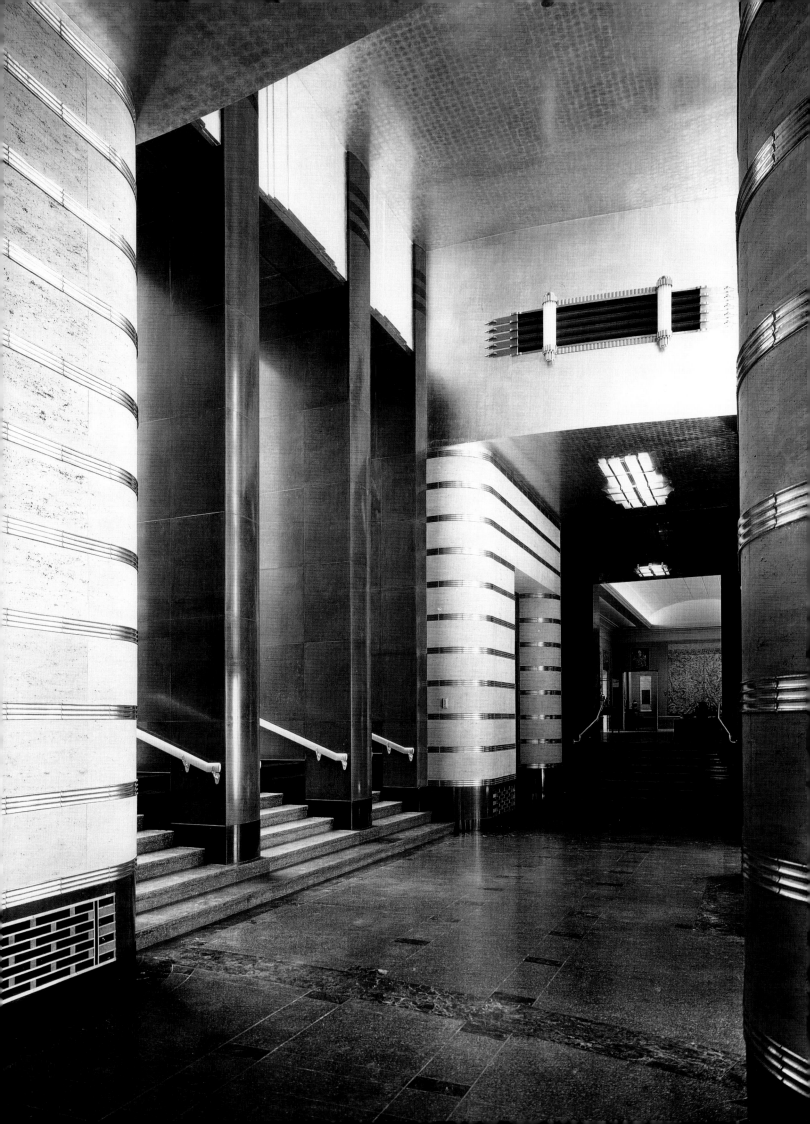

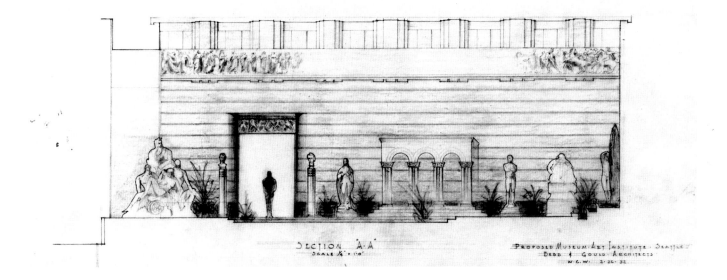

SECTION "A-A"
SCALE 1/4" = 1'0"

PROPOSED MUSEUM·ART·INSTITUTE·SEATTLE
DODD & GOULD·ARCHITECTS
W·C·W· 2·26·32

The process of refining the design into a complete architectural statement continued rapidly. Interior studies dated 25 February 1932 and initialed by Wurdeman established Gould's universal motif of four stepping planes, a design appearing on columns, the frieze for the central gallery, on ceilings, and over portals. Plans dated 27 February gave most of the attention to the lower floor. They settled the location of the stairway and elevator, the spacing of the windows in the library and offices, and the provision for ventilation ducts. New systems and materials included Masonite flooring, improved General Electric lighting, and humidity and ventilation controls. With these refinements in place the work continued straight into the construction documents, a final surge of activity testifying to Gould's mastery and his staff's competence. In just six weeks they completed the drawings and specifications and sent them out to bid. Two weeks later bids came in from four contractors, all four below the estimated cost.[20]

The museum opened in July 1933 with great fanfare, with the police on hand to control a crowd estimated at between 20,000 and 25,000. Inside, an exhibit featured the work of the regionalist Paul Gustin. It was a fitting tribute to Gustin, who had volunteered much of his time to the Art Institute. The national attention was also a tribute to Gould, one which Fuller recognized in words reflecting a cost-conscious era. "The building," Fuller wrote, "is a logical expression of contemporary architecture. As testimony to the careful study of the problem, the final cost of the building coincides almost precisely with the amount of the gift." Although Gould later felt called upon to defend his modest profit ($2300 out of a total project cost of about $210,000), he was well pleased with his handiwork. On Independence Day 1932, he wrote Anne a letter revealing his pride in the building, his regard for the site, and his love and aspirations for his daughter. "Dick [Fuller] is going to get two huge Chinese camels for the terrace, lying down, and it will be a grand place to see the Olympic mountains from. Some day maybe you will take your youngsters up there and it will be so beautiful you will not mind saying your Dad was the architect and inside will be all the loveliest things that can be got, and maybe you will become an artist and something of yours will be exhibited there."[21]

Coleman confirmed Gould's judgment many years later. In 1950 he wrote of the

8.20 *Seattle Art Museum, garden court, 1933.*

"art museums at Seattle and Portland," as the "recognized forerunners" of the coming changes in museum design. He noted the Seattle Art Museum's excellent use of floor space, a matter on which he had advised Fuller and the board. Of 53,000 square feet, the plan devoted 33 per cent to exhibits and 14 per cent to storage, areas much larger than in most other museums. Gould's work compares closely in square footage and cost to Pietro Belluschi's Museum of Art in Portland, but the styles are radically dissimilar. Belluschi used red brick with limestone trim and banding on a boxy building. His design dispensed with skylights and their maintenance problems in favor of light monitors, but lost the advantages of a heightened sense of interior spaciousness and natural illumination. Twenty-two years later Martha Kingsbury judged the Seattle Art Museum to be "a particularly suave example" of the modern style. Kingsbury praised it because of the clarity of its surfaces, and because its decoration and rounded elements "soften any potential harshness without destroying the streamlined flow of the basic forms." (FIG. 8.20)[22]

Gould's last project was a final essay in modernism, the University of Washington's Penthouse Theatre (1938), for which he supplied the finished drawings. The Penthouse was the first theater in the United States built as a circus or arena theater, bet-

ter known in this country as theater in the round. The concept, not Gould's, was the product of a collaboration between Glenn Hughes and John Conway of the university's Department of Drama. Conway sketched a slightly oval design encircled by a hallway. Hughes insisted on an intimate setting to maintain audience involvement in the productions, so Conway limited the seats to 172. Auxiliary rooms are tucked into niches in the oval or placed across the hallway (FIG. 8.21). Because the Penthouse Theatre was a low-budget Works Progress Administration (WPA) project, the exterior was finished in 5/8-inch plywood and coated with white fireproofing. The exterior design is reminiscent, on a small scale, of the Seattle Art Museum, although Conway's inspiration may have been the published drawings of Norman Bel Geddes, Walter Gropius, and others.[23]

Gould accepted the overall scheme although he made some changes in detail. One reason he warmed to the building was its advanced wooden construction. His interest in contemporary wood interiors stemmed from his promotional work for Pacific Forest Industries, a result of which was his 1938 article in *Architect and Engineer* presenting Douglas fir plywood as a contemporary finishing material. The most daring aspect of the Penthouse's interior design is the glue-laminated wooden arches spanning the auditorium. The eight arches spring from the inside walls to a compression ring above the stage, eliminating interior posts. Sergius Sergev of the engineering school designed the arches to be built up from 20-foot Douglas fir boards. The unusual construction system—only some 100 buildings in the country employed it then—and its smooth exterior appealed to Gould despite his colleagues' displeasure. The WSC protested the intrusion of the building into the university's master plan and complained "that, judged as 'modern' architecture, it is frankly bad in design." Whatever the WSC's contemporary judgment, the theater is thoroughly modernist because it is white, fully expresses its interior form, and is utterly devoid of decoration. By

8.21 *Bebb & Gould with Glenn Hughes and John Conway for planning concept and Sergius Sergev for structural design, Penthouse Theatre, south view on relocated site (1992), University of Washington, 1930. Boyle/Wagoner were the restoration architects.*

1990 the Penthouse Theatre had become so well regarded that the university decided to move the structure to a new site rather than demolish it.[24]

Within a decade Gould emerged as a remarkable modern architect whose great triumph, the Seattle Art Museum, is arguably the first modern building of its kind in the United States. All the while he turned his hand to other complex modern structures such as the U.S. Marine Hospital, and to other projects in other design idioms. He was proud of his work but never considered it more exceptional than any other part of his oeuvre. Gould's modesty, or more accurately, his hurried, distracted indifference to notoriety, has obscured these fine achievements.

Life is just full of beautiful things and in order to perceive them one must be beautiful within. —CARL F. GOULD[1]

9 The Great Depression and a Life in Architecture

THE GREAT DEPRESSION OVERSHADOWED THE LAST YEARS OF Gould's life. He had always gone after business, but his correspondence of the 1930s swelled with direct requests for jobs, and with earnest appeals to former clients to write letters to new prospects on his behalf. "We are still making every effort to get the U.S. Hospital to be built shortly on Beacon Hill," he wrote to Suzzallo in 1930. John C. Higgins of the New York law firm of Sullivan & Cromwell, for whom Gould designed a family cemetery monument, wrote in support of this effort that "Mr. Gould has the well-deserved reputation of being one of the finest architects in the country from the artistic standpoint." His friend and client Valentine H. May praised his work, "uniformly of a high character," in support of a successful effort to win the design contract for a new federal building at Longview.[2]

The Great Depression heightened an already keen competitive situation, for there were few private commissions to be had. One of the best, the Edmond Meany Hotel (1931, now the Meany Tower Hotel) near the University of Washington, went to Robert C. Reamer, who designed a stunning and innovative tower structure. Nor were past client relationships any assurance for the future. Bebb & Gould's "best client" was snatched "out from under our noses," Gould told Suzzallo. "The competitive spirit is growing stronger every day and . . . whether to advise my boy Carl to follow in on a professional basis I don't know." Harlan Thomas, Gould's successor at the University of Washington, was attempting to relocate the Department of Architecture from the liberal arts quadrangle to the west side of the campus, where Gould had planned a museum and fine arts group. The revision dismayed him. "The world does no longer seem to admit the professional view point," he wrote. "They are willing to pay for bricks but not ideas."[3]

Fortunately Gould returned to the campus with the setting of Governor Roland Hartley's political star. He took more personal satisfaction than economic security from a Board of Regents' resolution in July 1934 naming Bebb & Gould the "supervisory architects" for all university buildings. The regents gave Bebb & Gould "final authority" over all "plans and designs," the firm's fee to be paid from "architect fees for each particular building," but construction was limited in the 1930s. Moreover

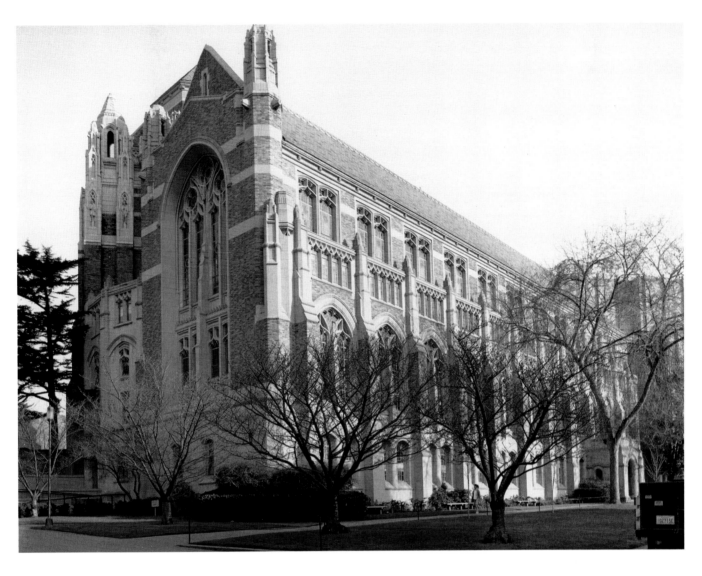

9.1 *Bebb & Gould, Suzzallo Library, south wing, southwest view, University of Washington, 1933–34.*

the 30 per cent or more of total project cost, granted by the Public Works Administration (PWA) of Franklin D. Roosevelt's New Deal, meant that the entire project came under the scrutiny of PWA attorneys, inspectors, and auditors. These functionaries required so many reports and approvals that costs increased, from double or more on superintending construction to "more than ten times" beyond the usual state project, on the awarding of contracts and on business administration. Still, the supervisory fee of 1.5 per cent probably covered the costs, and it helped to keep the office open during lean times.[4]

The university work allowed Bebb some fresh involvement in the firm's management. The older partner had "helped in advice on contracts & drew up the recent one in which we are consulting archts for several bldgs at the U. being done by other archts." But it was a limited involvement. "Bebb's condition has been such for a number of years during which he has withdrawn from active work in the office," Gould wrote in his diary. "Nor has he been able to bring new work." For his part, Gould assisted with some buildings and designed a swimming pool addition to the men's gymnasium (1934), the chemistry building (1936), and the completion phase of the social sciences building on the liberal arts quadrangle (Smith Hall, 1938).[5]

Gould's great campus design of these years was the restrained but complementary south addition to his beloved library (1933–34, FIG. 9.1). His facile development of the

Gothic design as well as his handling of interior spaces created a structure well adapted to its purposes: to form the visual transition to the science quadrangle (the Rainier Vista area), and significantly to expand the library's space and uses in a graceful manner. The wing is functionally distinct from the earlier building, containing intermediate floor levels and only two important spaces, the natural sciences reading room and the Charles W. Smith Pacific Northwest Room (FIG. 9.2). Its south elevation utilizes the traditional Gothic interior nave arrangement of aisle windows, triforium openings and nave windows. The whole is set upon a windowed foundation story, making a four-story elevation with the top story set back slightly. The result is an invented Gothic couched in tradition but suited to modern function. The details are scaled to the elevations of the wing yet distinct from and subordinate to those of the magnificent main facade.

The great west window of the Smith Room fills the space with light. A complex iconography of crests, seals, and totem motifs on the west wall and medallions in the south windows relates mostly to the history of the Pacific Northwest. The dark fir paneling and furnishings suggest quiet, study, and contemplation, as do the recessed carrels in the south wall. Across the room and above shelving, Paul Gustin's and John T. Jacobsen's frescoes depicting the exploration and development of the Pacific Northwest complete the staging of a room designed to house regional collections.[6]

Gould supervised and created more than individual buildings, for his total effort involved the greater development of his campus plan. The work required "a great deal of special study for departmental needs." As part of the program he redesigned the "Fine Arts Grouping" on the west edge of the campus. The group became a spare neogothic ensemble linking the Henry Gallery, a redesigned Meany Hall, and a new twin of the Henry on the south.

In 1938 Gould recalled the progressive development of campus plant materials, beginning with the rose gardens of the A-Y-P Exposition. Republican though he was,

he appreciated the Democratic Roosevelt administration's WPA program of paying "unskilled relief labor" to develop the campus in accord with the master plan. WPA labor "not only gives employment relief, but will make for the creation of permanent values, and round out the design" through terracing, planting, and walkway construction. Both students and visitors "can begin to realize that what appeared to be isolated elements, such as terraces; architectural accents such as turrets and oriel projections; niches with and without their sculpture; and the pool on Rainier Vista, are not isolated elements but a part of an entity." Gould did not object in theory to a mixture of modern and historical styles but in practice, excepting the Penthouse Theatre, he maintained Tudor Gothic as the campus design staple.[7]

In these later years Gould's office staff was small but lively, responding to his kindly, patient supervision. Sometimes he would sketch out a design conception and ask the draftsmen to refine it in overlay tracings. He might provide the sketchiest outline of an idea; then the draftsmen would flesh out the plans and elevations for his critique. Or he might announce an intra-office design competition, with more or less guidance from the mentor himself. He followed the last approach with the design for the Everett, Washington Public Library (1933). Draftsman John Villesvik remembered that all four employees began designing one morning, using a rough plan developed by Gould. The draftsmen searched for the appropriate style and form of expression until Gould interrupted their work with the announcement, about midafternoon, that he was satisfied with one of the designs. It was Villesvik's scheme (FIG. 9.3), featuring brick set in horizontal bands, a then-current style having its origin in the Dutch architecture of the early 1920s. Villesvik became the job captain and the others turned to the task, lending a hand at perfecting the design. It was an egalitarian, collegial effort in a remarkably challenging but supportive work environment.[8]

As the designing progressed Gould would critique the work just as he would in an atelier, commenting and drawing proposed changes over a draftsman's work. The

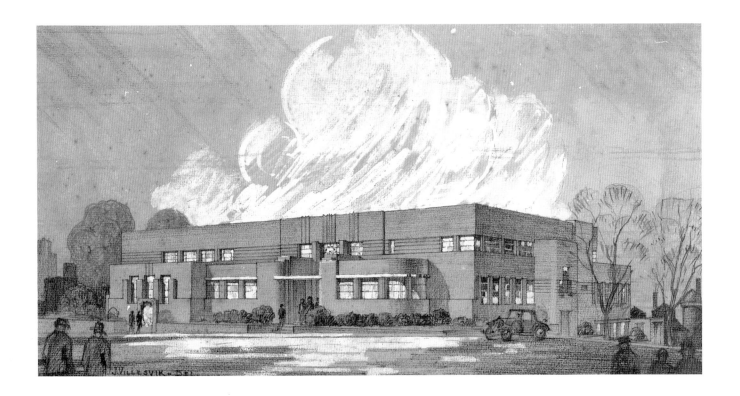

design did not advance until the draftsman and his lean, kindly mentor agreed on its appropriateness. When both were satisfied, Gould would remark "that won't hurt our reputation," adding a check mark and a "G." The check resembled a "V" so the staff called his mark of approval a "VG." No job was complete, however, until detailed drawings and specifications were finished. Should inspiration fail, the design library and an extensive clipping file were available for reference.[9]

As commissions dwindled—there were two in 1937—it became more difficult for Gould to maintain his accustomed life style. The 1936 trip to Fontainebleau, a trip his children fondly remembered, appears in retrospect to have been Gould's final attempt to keep up patrician appearances. In 1931 he resigned from the Architectural League of New York, and later perhaps from some Seattle clubs, a bitter reality for a man accustomed to the genteel camaraderie of associational life. By February 1938 he had to write a cautionary note to Anne about her Easter vacation plans involving an expense of $75 to $100. "We are skidding close to the wind financially," he confessed, reciting a litany of woes including labor problems and uncertain future commissions. He hoped to have the money later "but for possibly 10 days or two weeks it will have to be deferred—what an aggravating Dad."[10]

Gould kept busy despite the lack of work. He remained active in the Seattle Art Museum, the name adopted by the art institute on the opening of his new building, although Fuller gathered the effective leadership into his own hands. He maintained his membership and near hyperactivity in the WSC of the AIA. The national body elected him to a fellowship, its highest honor, in 1934. In 1936 he was named the technical advisor to the Oregon State Capitol Commission, a demanding and thankless task for which he was paid $2000 and expenses. In the late 1930s he supported increased fees for designs for buildings sponsored by the PWA, and opposed any unionization of architects or their office forces. During the summer of 1938 the social critic and urbanist Lewis Mumford visited Seattle. Gould could not schedule a meeting with the WSC, but he did assist in arranging for Mumford to address the Chamber of Commerce, and for a conference with the mayor. He organized the local exhibits for the 1938 show of the Architectural League of New York, at which the Seattle Art Museum won an honorable mention. Ever the unifier, he promoted a joint meeting with the Oregon AIA chapter, held in November 1938 at the newly opened Timberline Lodge on Mt. Hood. Gould was by then too ill to attend, but he managed a congratulatory telegram.[11]

Gould's health and his fortunes declined, but his family life went on. Anne was clearly his favorite, but in 1934 he noted with satisfaction that Carl, Jr., at eighteen was a freshman in the University of Washington Department of Architecture, had pledged the Delta Kappa Epsilon fraternity, and "seems thoroughly launched." John was "at Bush School, a bright dynamic kid—10th birthday Saturday." (Carl, after graduating from Yale in 1939, followed his father's profession.) Gould's last diary entry, written at home on 18 April 1937, recorded family plans. Anne was to go to her mother's college "& specialize in Landscape Archt.—or other eastern school." Gould may have been expressing some advance misgivings, for Anne did not warm to Vassar, where she stayed only one year. Then she attended the Cambridge School of Design and the University of Washington, and later became a patron of the arts in Seattle. John was

"to go to Groton where he has been admitted—just finished his exams successfully."[12] John, subsequently a Princeton graduate, worked as a wood products engineer.

Gould then turned to the scene around him. "John stretched out in front of open fire reading the 'funnies'. Carl taking a warm bath after his two days working on boat. Dorothy preparing breakfast for tomorrow. Anne not returned yet from skiing." Recording these domestic scenes seemed less to comfort him than to remind him of their precarious financial foundation. "Times are difficult," he wrote, "just how to make ends meet & what we have ahead of us is perhaps more uncertain than any time in my career."[13]

The Gould household savored a literary triumph in 1938 when Dorothy's *Beyond the Shining Mountains: 36 Northwest Adventures* appeared. Binfords & Mort, a Portland, Oregon press, published the heavily illustrated young adult book based on stories and legends which Dorothy had heard as a child. Dorothy worked hard at gathering information and photographs about Natives, early explorers and settlers, and about riveting events such as the gold rush to the Yukon Territory and Alaska. She wrote clearly and crisply, using a rich vocabulary that in no way condescended to her youthful audience. Her section on the Northwestern frontier included an account of George Bush, the African American settler whose generosity was legendary among his white compatriots. Her husband's influence was apparent in such statements as: "With lavish gestures, each of the coast towns grew, disregarding natural advantages more beautiful than Naples and Geneva combined."[14]

No one development, not even a publishing event, could lift the cloud of the Great Depression hanging over the household. Gould's spending habits exacerbated the difficult situation. The Fontainebleau excursion, for example, was culturally priceless but financially demanding at a time when he had already begun to borrow against the bond portfolio that was his inheritance. In six of the nine years after 1928 he drew more from his firm than he earned. His loans and overdrafts totaled $11,482.62 at his death, a substantial sum worth about twelve times its amount in the depreciated currency of the late twentieth century. It did not help that much of the Gould family fortune was in New York City real estate, a notorious financial nonperformer during the 1930s.[15]

Worse, Gould had for many years operated an office to which Bebb contributed little. Yet the older man reported five-figure incomes from 1930 through 1937, except for 1932 and 1935. As early as 1930 Gould wrote to Suzzallo that "Dear old Charlie is getting a little the worse for wear" and could not work with his accustomed "vital energy." In 1934 Gould noted in his diary that "Mr. Bebb comes to the office in the morning, transacts very little business and leaves at noon. He has lost his original vigor & I am afraid is becoming an old man." In 1936 Bebb broke his arm and could scarcely sign his name. Gould's frustration and personal depression with his office circumstances deepened, yet even within the family, Dorothy remembered, "he never lost his temper or ever said anything angry." Dorothy, who detested Bebb, believed that the office situation contributed to Gould's declining health and his bouts of headaches and insomnia. She insisted that her husband had wanted to dissolve the association at least from July 1938, but that Bebb had demanded an impossibly large payment as the price of dissolution.[16]

Dorothy believed that her husband tolerated Bebb's poor performance because Carl

was so patient and forbearing. Doubtless his sympathy and generosity explain in part his reluctance to force a showdown with Bebb, but they are just as certainly not the whole story. He owed a lot to Bebb, who agreed to an association when Bebb was an established practitioner and Gould a comparative newcomer to Seattle. Nor could he be sure that his cherished personal reputation would survive a break with Bebb, a break almost certain to cause comment among the architectural community and its clients. Charlie Bebb enjoyed many fast friendships. "Charlie 79 had a grand party with all the young folks—cocktails etc.," Gould wrote to Anne in 1935. "I wonder when I get 79 if I will have so many appreciative friends."[17]

On 4 January 1939 Carl Gould died from complications of renal failure, worn down by the accumulated frustrations of ill health and financial distress. He was sixty-five. The obituaries praised him. One mentioned his "many beautiful buildings," his "constant effort to beautify his city and his State," and the "tremendous energy" he "displayed in many and varied forms of civic activity." Another declared that his buildings "testified to his ability" and "brought him national fame." Still another lauded the "foremost part" he took "in every plan looking to the betterment and beautification of the city."[18]

The contemporary comments captured some of their subject, but part of Gould eluded them. All his life he set extraordinary store by gregariousness, friendliness, and public acceptance. Much of his civic effort, therefore, went into strengthening local and regional organizations dedicated to advancing his ideals of professionalism and beauty, such as the wsc and the Seattle Art Museum. All that happened long ago, however, and now Gould's name is scarcely associated with either. He is remembered as the Seattle Art Museum's architect and is memorialized in its Gould Room (1955), but his efforts to preserve and expand its predecessor organizations are forgotten. Little remains of his larger vision of a populist arts organization. His drive for a broad program to promote public education, studio classes, lectures, and the exhibition of contemporary work ended, ironically, when the Seattle Art Museum occupied the building he designed. Richard Fuller did not share Gould's vision, but preferred to concentrate on the collection, and on presenting traditional exhibits. The Northwest Annual Exhibition of Contemporary Art died out. Similarly, art education in the public schools, another of Gould's passions, has withered to the point of nonexistence. So has his ideal of cooperative interaction among all members of the arts community.

Gould's desire to ingratiate himself with Seattle's elite also explains his failure to design much contemporary architecture. His Osgood project of 1911 and his final, uncompleted Wheaton College (Massachusetts) project of 1937 or 1938 bracket his career in contemporary design. Both are axial and in that sense classical, but the articulation and massing of both is beautifully functional.[19]

Only a larger population than Seattle's or one more susceptible to contemporary influences during Gould's prime, would have supported a career devoted to avant garde architectural inventions. Gould showed little interest in cultivating a larger market. "Unfortunately," he wrote to Annie in 1929, resisting her urgings to return to New York, "the profession of Architecture requires a locus or a fixed establishment." He preferred to find his clients among the solid middle class and the economic upper echelon of a regional metropolis, where his patrician education and Eastern Seaboard

connections gained him rapid acceptance. Seattle's elite, though progressive commercially, was generally uninterested in avant garde domestic architecture. Only a few mavericks such as William Boeing, who was daring and innovative in the mold of Frank Lloyd Wright's early clients, opted for the modern. Most of Gould's clients preferred tasteful adaptations of traditional styles, sensitive to their needs and to a Pacific Northwest of cool temperatures and often overcast skies. Gould responded with the generous windows, shallow eaves, careful orientation to stunning views, and the painstaking finish work characteristic of the regional architecture he advocated, but his design envelopes were almost always traditional. He was known as he wished to be known, then, as a masterful society architect. His reputation was similar to those of Howard Van Doren Shaw in Chicago and John F. Staub in Houston, who were well regarded in their lifetimes but who have been largely ignored by posterity.[20]

Yet Gould was not entirely happy with his reputation, which rested on the approval of provincial clients who rarely allowed his imagination a free rein. His domestic architecture, though skilled, did not so much influence as reflect the imitative elite culture of his social peers. He may from time to time have made bold suggestions, only to be reminded of the canons of good taste as his clients understood them. In 1931 he wrote that the Pacific Northwest "is a curious place" but becoming more cosmopolitan with an influx of migrants from other parts of the country. Still, he complained to a friend in the East, the "intention of our clients seems always to do an outstanding thing but so often through various associations and causes [they] are drawn back to do the second rate thing which is somewhat disconcerting for the Architect."[21]

Gould had another reason to lament his situation when residential construction rebounded in the late 1930s. Despite his essays in modern styles, Gould was part of the "established architectural community," in which some of the most "progressive" work was Andrew Willatsen's. Willatsen, a WSC colleague, designed in the Prairie style, scarcely an innovation by the 1930s. Residential clients desiring the modern sought out younger architects such as Gould's talented student Paul Thiry (1904–93), the winner of the Fontainebleau scholarship in 1927. Thiry built his own house, an arresting essay in European modernism, in the Washington Park area in 1936. Gould's skilled adaptations of traditional styles to contemporary requirements appeared dated, while Thiry's advanced work garnered new commissions. Other young men designing in modern styles included Gould's protegée John T. Jacobsen and John R. Sproule.[22]

Gould's institutional and commercial architecture is better known than his domestic work, and is relatively released from provincial bonds. It stands as a reminder of the cultural literacy and valuable artistic currency of earlier times in architecture. Among many others, the Times Square Building, the structures at the Chittenden Locks, the Pacific Medical Center, and the Seattle Art Museum in Volunteer Park survive essentially intact. They represent differing styles and building types, but each is individual, cleanly designed, original, beautiful in Gould's understanding of the term, and fully adapted to its purpose.

Gould's best-known legacy remains the campus of the University of Washington, for which he designed the basic plan and twenty-eight buildings, or forty-six if additions and supervision are counted. His name is inscribed in an architectural hall of fame at the university, and the brooding, brutalist Carl F. Gould Hall was named for

him when it opened in 1972. Gould Hall houses the College of Architecture and Urban Planning, a descendant of the department Gould founded in 1914. The college is now separated into the departments of Architecture and Planning, Landscape Architecture, Urban Design and Planning, and Building Construction, which together embrace the range of studies offered at the Ecole des Beaux-Arts during Gould's student days, save for interior design.[23]

His institutional works best demonstrate Gould's genius for creating superb spaces. The university's Hutchinson Hall, a former gymnasium, the club and lecture rooms in Anderson Hall, and the Smith Room in the south addition to the Suzzallo Library all are fine interiors, meticulously finished in accordance with their purposes. The soaring, varicolored reading room of the Suzzallo, the most sumptuous of them all, is the great room of Seattle. But any large space is visible only if it is well lighted; Gould's concern for ample daylighting is revealed in these rooms as well as in the library of the present Western Washington University and the garden court of the Seattle Art Museum. He justified a modified Tudor Gothic for the University of Washington campus because its large glazed areas let in light.

Gould used contemporary materials well. The concrete at the Chittenden Locks, the slender steel framing of the buildings at the University of Washington, the steel spans in his gymnasiums, his ingenious post-and-panel construction system first developed at Topsfield, all were incisive. He did not, however, accept the transcendental quality of materials, any more than he believed in constructivist functionalism or the unity of function and form. He believed that a building should express its function, as the Suzzallo Library is so evidently an academic library, and equally evidently the linchpin of the campus plan. But style was not at the bidding of function. For Gould, style involved an exterior appropriate to function, but also a symbolism re-

9.4 Bebb & Gould, Arts quadrangle, University of Washington, 1915–ca. 1950. Art and music buildings by Whitehouse & Church, Gowan Hall by A. H. Albertson.

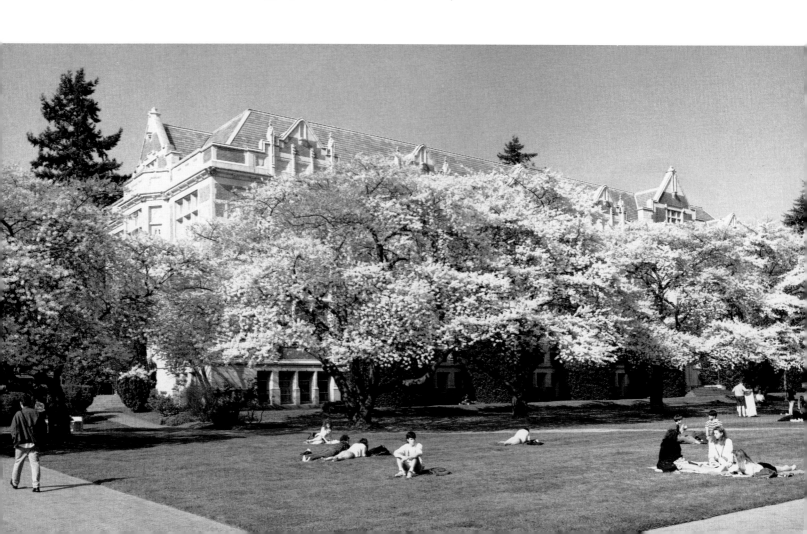

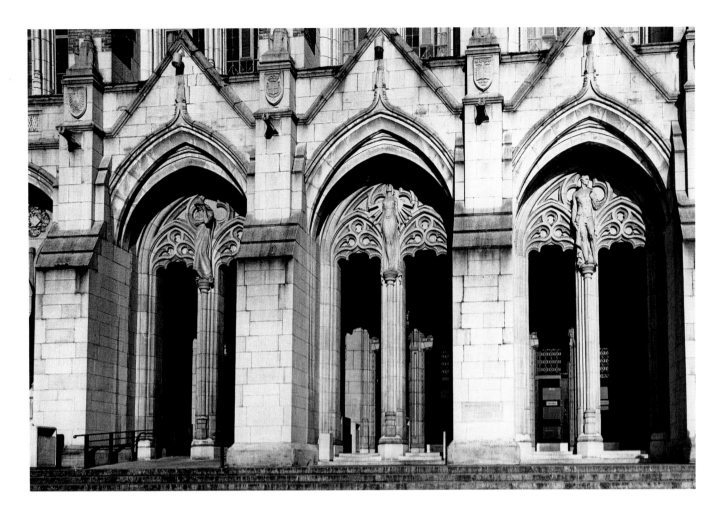

9.5 Bebb & Gould, Suzzallo Library, entry detail, figures by Allan Clark, University of Washington, 1927.

lated to use, to Western history, myth, and traditions, and to cultural aspiration. The social context of a building as well as its function determined its style.

Of Gould's university architecture and plan, much remains, and they are maintained as he designed them. Although development plans are not usually considered effective for more than a generation, his basic Y-shaped plan continues to be a point of reference. The plan is incomplete in a few of its elements, and is diminished by some recent buildings, but its essential features remain. The great central yard, bounded on the east by Gould's library and once so full of potential, is now defined and defiled by crude architecture on the north and west and a paltry rendition of Gothic on the south. Three tall, boxy, brick shafts in the yard are no substitute for Gould's unbuilt library tower. Such flawed constructions serve only to force attention toward the library, where the beauty that architecture once attained stands forth magnificently. The Henry Gallery, planned as part of an arts triad, remains in isolation at the western entrance to the campus, its role in a balanced classical approach unfulfilled. (A major addition to the Henry Gallery is planned for 1996.)

Perhaps in the future Gould's vision of a campus bounded by buildings related to adjacent streets and structures will be realized. For now, the sylvan campus rather than a future campus-urban demands attention. The Liberal Arts quadrangle, under a full moon in April with the cherry blossoms glowing, is a spellbinding sight (FIG. 9.4). It is captivating because it is preserved in Gould's exquisite proportions, but its appeal is the enchantment of ensemble. Gould would have wished for his buildings to be individually appreciated as well.

Grant Hildebrand, in 1980 the architecture and design critic of the *Seattle Times*, understood as much when he wrote that Gould was "an eclectic" but "also adept," an architect of "clear monumental entries; the art of getting from outside to inside is celebrated." Gould, he wrote, "worked at a high level of quality" to design buildings that "reward continued examination." Hildebrand confessed to "a feeling now that the modern movement threw away too much, that the qualities valued by Gould's generation are important to our environment."[24] Hildebrand's comments are valid, but how many of the users of Gould's buildings pause to consider his didactic iconography, or reflectively prepare themselves to participate in the activities within (FIG. 9.5)? Generations of moderns have taught them that a building is good for getting into and out of the weather, but not something that usually repays extended exterior study. Still, Gould's buildings ought to be preserved for the reasons that Hildebrand gave.

It is important above all to preserve the quality of Gould that has mostly faded from memory, his spirit. He remained unfailingly genial and friendly. He took the time to show young relatives the wonders of nature, to tell them about the stars, and about birds and plants. Occasionally he revealed his despair to Dorothy or a close friend, but he refused for years to yield to the triple blows of the Great Depression, poor health, and his disappointment in an unproductive partner. In 1934 he sent a postcard to Anne, one featuring a photograph of rails on the Burlington railroad converging on a vanishing point somewhere between Chicago and St. Paul. It was not a happy year for Gould, yet he scribbled out a cheerful, imaginative message for his adolescent daughter. "Don't you think it's fun to wonder what goes on just beyond the vanishing point, just over the top of the world and beyond. Keep wondering all your life long & if you do its fun to live."[25] Carl Gould kept his determination, and his wonder.

9.6 Gould family Christmas card, 1936.

Catalogue of Extant Buildings
by Carl F. Gould, Huntington & Gould,
and Bebb & Gould

Dates are approximately between beginning and completion. All locations cited are in the state of Washington, unless otherwise noted.

R. D. Merrill mansion, 1909
919 Harvard Avenue East, Seattle
Charles A. Platt
Gould was local architect

W. C. Squire apartments, 1909
Thirteenth Avenue & Jefferson Street, Seattle
Huntington & Gould

Marshall Bond residence, 1910
1230 Federal Avenue East, Seattle
Huntington & Gould

F. H. Brownell residence, 1910
1137 Harvard Avenue East, Seattle
Carl Gould
Remodeled 1914 by Bebb & Gould

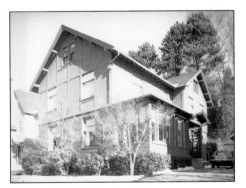
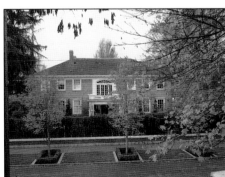

William Peachey residence, 1910
2250 Upper Farms Road, Bainbridge Island
Carl Gould

F. H. Osgood residence, 1910
Ojai, CA
Carl Gould

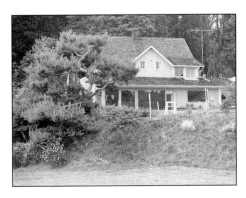

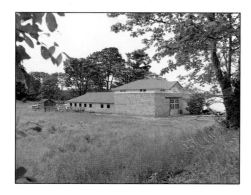

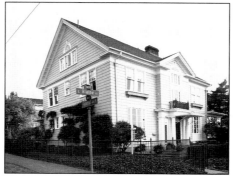

Cow barn, 1911
The Country Club, Bainbridge Island
Carl Gould

Thomas Dovey residence, 1911
1017 East Blaine Street, Seattle
Huntington & Gould

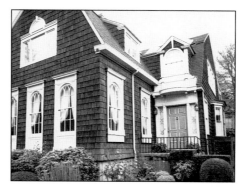

Maj. J. Cavanaugh residence, 1912
Prosser
Carl Gould
Owner attached to Army Corps of Engineers
Believed to be extant

Dr. Bruce Elmore residence, 1912
1604 Federal Avenue East, Seattle
Carl Gould
Remodeled 1918 by Bebb & Gould

W. S. Peachey residence, 1912
1055 East Prospect Street, Seattle
Carl Gould

D. E. Skinner garage, 1912
726 Thirteenth Avenue, Seattle
Carl Gould
Addition. Residence by Sabin

C. F. White residence, 1912
The Highlands, Seattle
Carl Gould
Addition for Bullitt 1924

William E. Boeing residence, 1913
The Highlands, Seattle
Bebb & Mendel, Bebb, and Bebb & Gould
Completed 1915. Details by Gould

Lawrence Bogle residence, 1913
1118 Federal Avenue East, Seattle
Carl Gould
Remodeled 1916 by Bebb & Gould

E. B. Downing residence, 1913
17525 Tenth Avenue NW, Seattle
Carl Gould

A. L. Glover residence, 1913
1206 NE Sixty-first Street, Seattle
Carl Gould

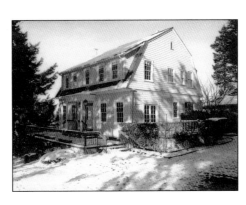

C. B. Blethen residence, 1914
500 West Comstock Street, Seattle
Bebb & Gould
Landscape additions

Joseph Daniels residence, 1914
5511 Seventeenth Avenue NE, Seattle
Bebb & Gould

J. D. deClarenze residence, 1914
3119 South King Street, Seattle
Bebb & Gould

Aubrey Gould residence, 1914
Great Neck, NY
Bebb & Gould

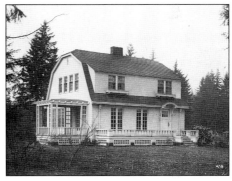

Carl Gould residence, "Topsfield," 1914
2380 Upper Farms Road, Bainbridge Island
Carl Gould

Otto Hanson residence, 1914
2000 Beans Bight Road, Bainbridge Island
Carl Gould

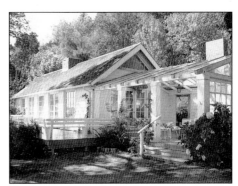

Mrs. C. X. Larrabee residence, 1914
405 Fieldston Road, Bellingham
Carl Gould, Bebb & Gould

L. E. Marple residence, 1914
3809 Fortieth Avenue South, Seattle
Carl Gould

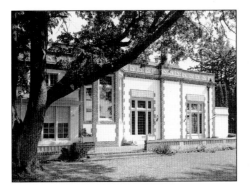

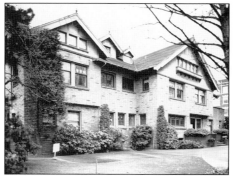

Alex McEwan residence, 1914
The Country Club, Bainbridge Island
Carl Gould
Addition 1919 by Bebb & Gould

H. L. Treat garage, 1914
1 West Highland Drive, Seattle
Bebb & Gould
Addition. Residence by Bebb & Mendel

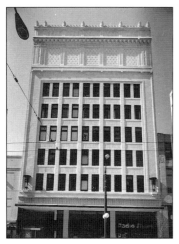

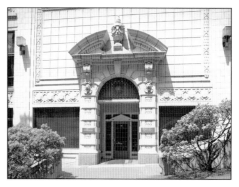

Fisher Studio Building, 1914
1519 Third Avenue, Seattle
Bebb & Gould
Begun by Bebb & Mendel 1913

Puget Sound Mill Co., 1914
75 Seneca Street, Seattle
Bebb & Gould
Part of Watermark Tower

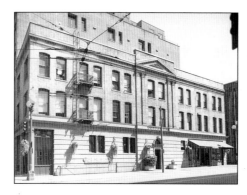

Puget Sound Mill Co., 1914
106 South Jackson, Seattle
Bebb & Gould
Original by Bebb & Mendel

Times Square Building, 1914
414 Stewart Street, Seattle
Bebb & Gould
Begun by Bebb & Mendel

YWCA, 1914
NE corner of Forest & Maple Streets,
Bellingham
Carl Gould
Now Cyrus Gates Apartments

John B. Agen residence, 1915
645 NW One-hundred-thirty-seventh Street,
Seattle
Bebb & Gould
Remodeled 1931 and 1934

F. H. Brownell summer house, 1915
The Country Club, Bainbridge Island
Carl Gould
Remodeled 1924 and 1931 by Bebb & Gould

Henry Field residence, 1915
The Highlands, Seattle
Bebb & Gould
Photo not available

A. L. Glover cabin, 1915
Agate Point Rd. & Mariner Dr.,
Bainbridge Island
Bebb & Gould

Annie Houlahan residence, 1915
2159 East Shelby Street, Seattle
Bebb & Gould

Wm. McEwan residence, 1915
The Country Club, Bainbridge Island
Carl Gould
Addition 1919, Bebb & Gould

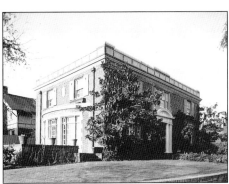

C. D. Stimson residence, 1915
405 West Highland Drive, Seattle
Bebb & Gould
Remodel. Original by Bebb & Mendel

Harvey Wilbur residence, 1915
434 Thirty-fifth Avenue, Seattle
Bebb & Gould

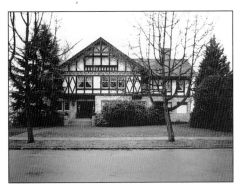

American News Co. warehouse and office, 1915
1931 Second Avenue, Seattle
Bebb & Gould
Now Terminal Sales Annex Building

Home Economics Building, 1915
University of Washington, Seattle
Bebb & Gould
Now Raitt Hall

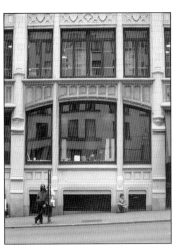

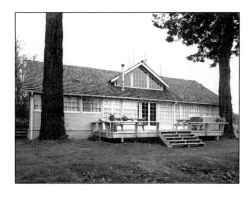

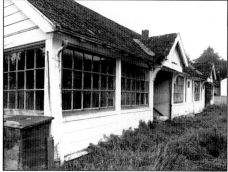

Merrill & Ring Lumber Co., 1915
Guest house, Pysht
Bebb & Gould

Merrill & Ring Lumber Co., 1915
Shop buildings, Pysht
Bebb & Gould

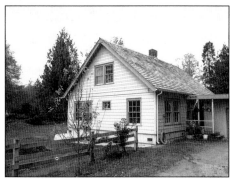

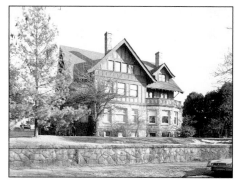

Merrill & Ring Lumber Co., 1915
Supervisor's cottage, Pysht
Bebb & Gould

C. H. Cobb residence, 1916
1409 East Aloha, Seattle
Bebb & Gould
Remodel. Original by Bebb & Mendel

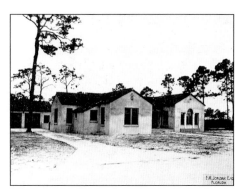

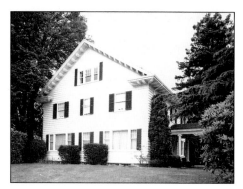

F. M. Jordan residence, 1916
Orlando, FL
Bebb & Gould

W. M. Winter residence, 1916
1631 Grand Avenue, Everett
Bebb & Gould

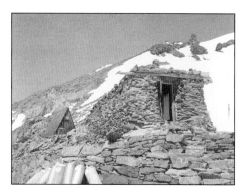

Hoge Building, 1914 thru 1928
701 Second Avenue, Seattle
Bebb & Gould
Original by Bebb & Mendel

Muir Memorial (Guides') Hut, 1916
Mount Rainier
Bebb & Gould
Donated by Geo. Wright and friends

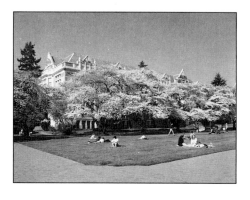

Philosophy Hall, 1916
University of Washington, Seattle
Bebb & Gould
West part of Savery Hall

U.S. Government (Hiram M. Chittenden)
 Locks, 1916
3015 Northwest Fifty-fourth Street, Seattle
Carl Gould, Bebb & Gould

U.S. Immigration Building, 1916
1300 Western Avenue, Seattle
Bebb & Gould

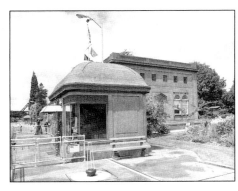

Washington State Capitol campus,
 1916–26
Olympia
Wilder & White
Bebb was local architect

John Hewitt residence, 1917
1649 Federal Avenue East, Seattle
Bebb & Gould
Remodel. Original by Elsworth Storey

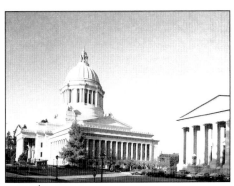
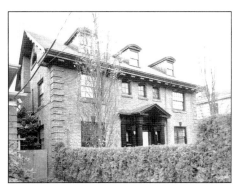

Cahalan & Callahan Building, 1917
Yakima Avenue and Fourth Street,
Yakima
Bebb & Gould
New office building

Caretaker's house, 1917
The Country Club, Bainbridge Island
Bebb & Gould

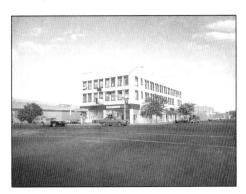
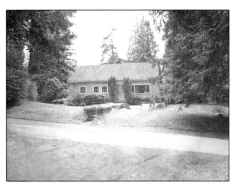

Corona Hotel, 1917
616 Second Avenue, Seattle
Bebb & Gould
Remodel. Original by Bebb & Mendel

Wintonia Hotel, 1917
Minor Avenue and Pike Street, Seattle
Remodel. Original by Bebb & Mendel

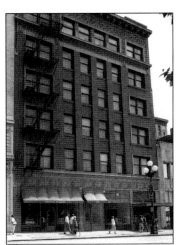
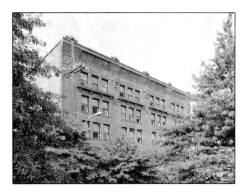

H. J. Fetter residence, 1918
1051 East Galer Street, Seattle
Bebb & Gould

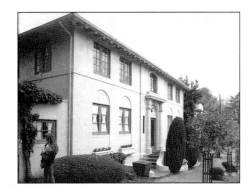

J. H. deVeuve residence, 1918
The Highlands, Seattle
Bebb & Gould
Remodel. Original by Bebb & Mendel
Photo not available

The Boeing Company, 1918
Duwamish River, Seattle
Bebb & Gould
Two buildings for U.S. Navy

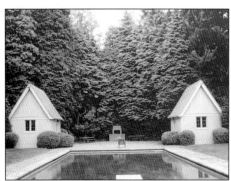

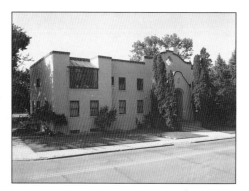

Community swimming pool, 1918
The Highlands, Seattle
Bebb & Gould

Ellensburg Hospital, 1918
Poplar and Third Streets, Ellensburg
Bebb & Gould

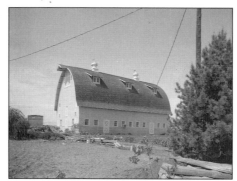

Gatzert Fountain, 1918
University of Washington, Seattle
Bebb & Gould

F. Waterhouse farm buildings, 1918
Wapato
Bebb & Gould

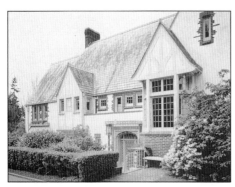

James Hoge residence, 1919
The Highlands, Seattle
Bebb & Gould

Frank McDermott residence, 1919
21 Highland Drive, Seattle
Bebb & Gould
Remodel. Original by Bebb & Mendel

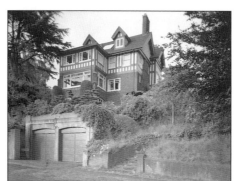

Jane Terry residence, 1919
939 Federal Avenue East, Seattle
Bebb & Gould

T. Wolfe residence, 1919
717 West Galer Street, Seattle
Bebb & Gould
Remodel. Original by Bebb & Mendel

St. Barnabas Mission, 1919
1932 Federal Avenue East, Seattle
Bebb & Gould
For H. H. Gowan

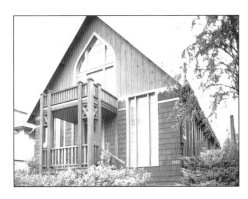

Northwest Motors, Inc., 1919
1115 Olive Way, Seattle
Bebb & Gould

Virginia Mason Clinic, 1919
Terry Avenue & Spring Street, Seattle
Bebb & Gould
And several later additions

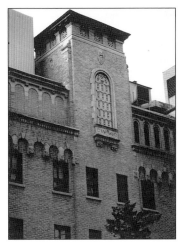

Carl Gould residence, 1920
1058 East Lynn Street, Seattle
Bebb & Gould

Men's University Club, 1920 and 1926
1004 Boren Street, Seattle
Bebb & Gould
Remodel

Commerce Hall, 1920
University of Washington, Seattle
Bebb & Gould
Now east part of Savery Hall

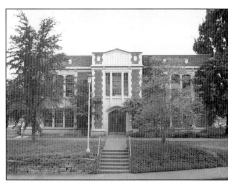

Harris Hydraulics Laboratory, 1920
University of Washington, Seattle
Bebb & Gould

Polson Logging Co. office, 1920
Eighth & Levee Streets, Hoquiam
Bebb & Gould

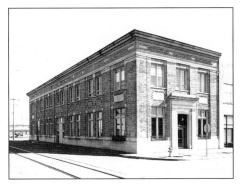

Stadium, 1920
University of Washington, Seattle
Bebb & Gould
First phase, now altered
Photo not available

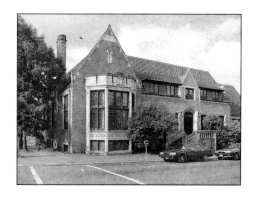

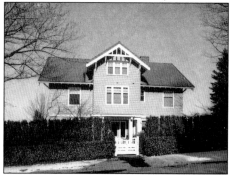

YMCA at University of Washington, 1920
1435 NE Forty-third Street, Seattle
Bebb & Gould
Now Egleston Hall

E. S. McCord residence, 1921
1802 Seventeenth Avenue East, Seattle
Bebb & Gould
Remodel

Education Hall, 1921
University of Washington, Seattle
Bebb & Gould
Now Miller Hall

Pacific Telephone & Telegraph Co., 1921
1200 Third Avenue, Seattle
Bebb & Gould

Roberts Hall, 1921
University of Washington, Seattle
Bebb & Gould

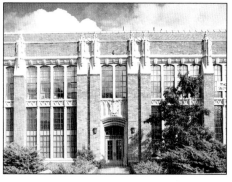

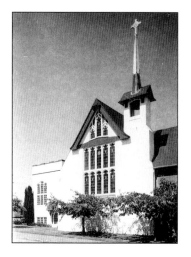

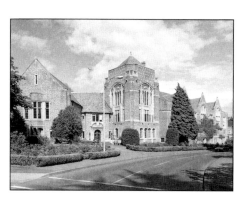

Trinity Lutheran Church, 1921
Twenty-fourth & Lombard Streets, Everett
Bebb & Gould

Women's Gymnasium, 1921
University of Washington, Seattle
Bebb & Gould
Now Hutchinson Hall

Broussais Beck, 1922
Candy Cane Lane NE, Seattle
Bebb & Gould
Neighborhood plan

E. S. Grammer residence, 1922
1251 Federal Avenue East, Seattle
Bebb & Gould
New garage & pergola. Remodel house

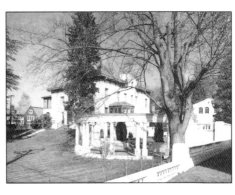

Olympic Hotel, 1922
University Street & Fourth Avenue, Seattle
George B. Post
Bebb & Gould, local architect

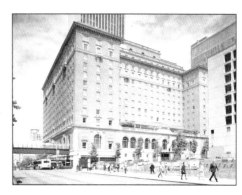

Delta Chi fraternity house, 1922
4651 Nineteenth Avenue NE, Seattle
Bebb & Gould

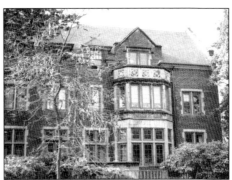

Delta Delta Delta sorority house, 1922
4527 Twenty-first Avenue NE, Seattle
Bebb & Gould

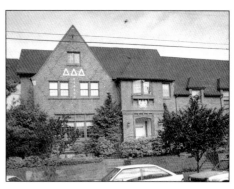

White Auto Co., 1922
NE corner Pike Street & Twelfth Avenue,
 Seattle
Bebb & Gould

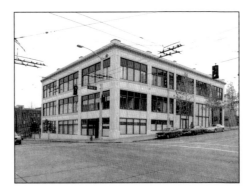

R. P. Greer residence, 1923
1052 East Galer Street, Seattle
Bebb & Gould
Remodel. Garden plan

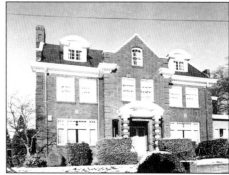

Arthur Nordoff residence, 1923
540 Thirty-sixth Avenue East, Seattle
Bebb & Gould

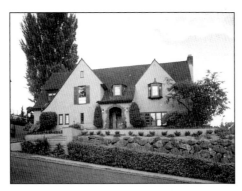

W. L. Rhodes garage and garden, 1923
1005 Belmont Place East, Seattle
Bebb & Gould
Addition

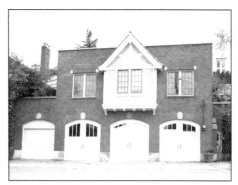

Everett General Hospital, 1923
Colby Avenue & Thirteenth Street, Everett
Bebb & Gould
Stevenson and Porter, consulting architects

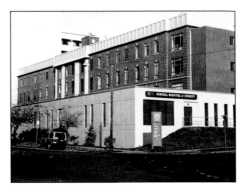

McChesney family mausoleum, 1923
Evergreen Cemetery, Everett
Bebb & Gould
Located near flagpole

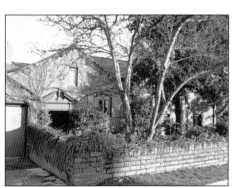

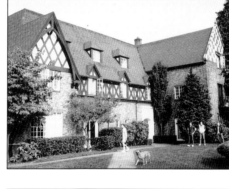

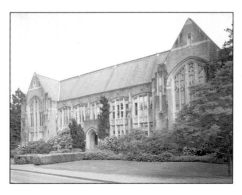

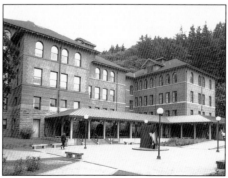

Marine Biological Station, 1923
Friday Harbor
Bebb & Gould
Laboratories and dining hall

Weyerhaeuser Company office, 1923
Waterfront, Everett
Bebb & Gould
Now Chamber of Commerce

Scott Bullitt residence, 1924
The Highlands, Seattle
Bebb & Gould
Remodel. Original by Carl Gould

H. H. Judson residence, 1924
230 Thirty-sixth Avenue East, Seattle
Bebb & Gould

M. L. Spencer residence, 1924
3400 East Laurelhurst Dr. NE, Seattle
Bebb & Gould

Alpha Delta Phi fraternity house, 1924
2110 NE Forty-seventh Street, Seattle
Bebb & Gould

Anderson Hall, 1924
University of Washington, Seattle.
Bebb & Gould

Campus Plan and remodel Old Main, 1924
Western WA University, Bellingham
Bebb & Gould

Central Library, 1924
University of Washington, Seattle
Bebb & Gould
Now Suzzallo Library

Henry memorial benches, 1924
University of Washington
Bebb & Gould

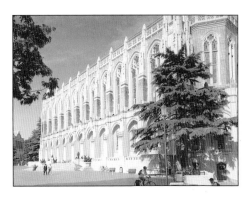

Psi Upsilon fraternity house, 1924
1818 NE Forty-seventh Street, Seattle
Bebb & Gould

Roberts Hall addition, 1924
University of Washington, Seattle
Bebb & Gould

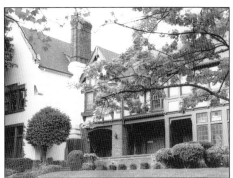 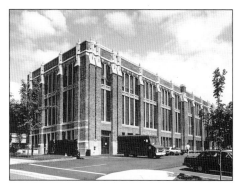

The Uplands gateway, 1924
Seward Park Ave. South & South Orcas St.,
Seattle
Bebb & Gould

H. F. Alexander residence, 1925
613 West Lee Street, Seattle
Bebb & Gould
Remodel. Original by Bebb & Mendel

 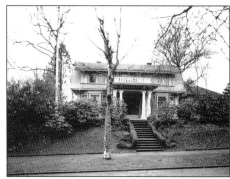

Alex McEwan garage, 1925
1055 East Prospect Street, Seattle
Bebb & Gould
Addition. Residence by Carl Gould

W. A. Streigleder residence, 1925
8321 Thirty-second Avenue West, Seattle
Bebb & Gould
Remodel

Mrs. C. F. White residence, 1925
1245 Federal Avenue East, Seattle
Bebb & Gould
Remodel

St. Nicholas School, 1925
Tenth Avenue East and East Galer Street,
 Seattle
Bebb & Gould
Now Cornish College of the Arts

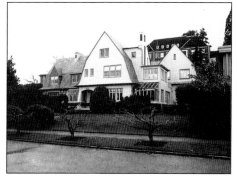

Mons. Prefontaine Fountain, 1925
Second Avenue & Yesler Way, Seattle
Bebb & Gould
From Carl Gould 1913 design

Reginald Parson garage, 1926
618 West Highland, Seattle
Bebb & Gould
Addition. Residence by Somervell

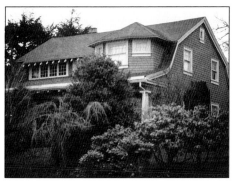

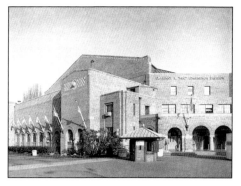

C. S. Willis residence, 1926
416 West Comstock Street, Seattle
Bebb & Gould
Remodel

Athletic pavilion, 1926
University of Washington, Seattle
Bebb & Gould
Now Hec Edmundson Pavilion

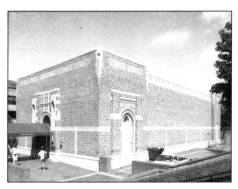

Horace C. Henry Art Gallery, 1926
University of Washington, Seattle
Bebb & Gould

Pacific Telephone & Telegraph Co., 1926
1200 Third Avenue, Seattle
Bebb & Gould
Top two stories added to 1920 design

Pacific Telephone & Telegraph Co., 1926
1708 East Pike Street, Seattle
Bebb & Gould

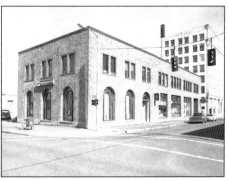

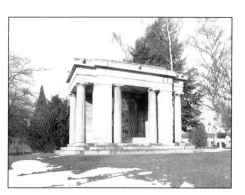

Aberdeen World building, 1926
Market & I Streets, Aberdeen
Bebb & Gould

Burke family mausoleum, 1927
Washelli Cemetery, Seattle
Bebb & Gould

Central Library, 1927
Western WA University, Bellingham
Bebb & Gould

Men's Gymnasium, 1927
Western WA University, Bellingham
Bebb & Gould

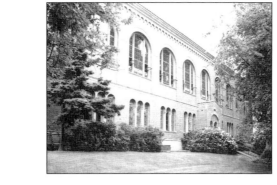 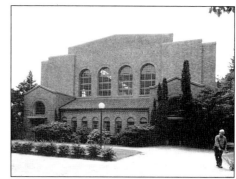

Olympic Hotel, 1927
110 West First Street, Port Angeles
Bebb & Gould

Keith Fisken residence, 1928
1401 Thirty-ninth Avenue East, Seattle
Bebb & Gould

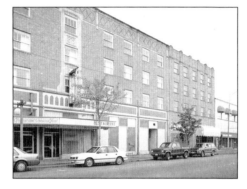

S. S. Magofinn residence, 1928
Near Marine Drive, Vancouver, BC
Bebb & Gould

Thomas Burke Memorial, 1928
Volunteer Park, Seattle
Bebb & Gould
H. A. MacNeil, sculptor. Completed 1930.

Pacific Telephone & Telegraph Co., 1928
Mississippi Street and Vendercook Way,
 Longview
Bebb & Gould

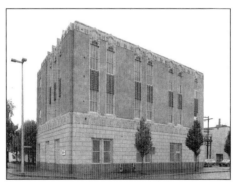

Pacific Telephone & Telegraph Co., 1929
212 West Yakima Avenue, Yakima
Bebb & Gould

The Rainier Club, 1929
820 Fourth Avenue, Seattle
Bebb & Gould
South end addition to original by K. Cutter

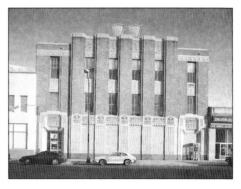

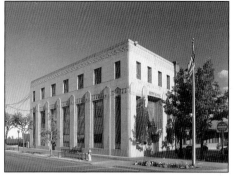

J. C. Baillargeon garden and garage, 1930
The Highlands, Seattle
Bebb & Gould

Ellensburg National Bank, 1930
Fifth and Pine Streets, Ellensburg
Bebb & Gould

J. C. Higgins monument, 1930
Washelli Cemetery
Bebb & Gould

Kelleher family headstones, 1930
Lakeview Cemetery: south side, Seattle
Bebb & Gould

Pacific Telephone & Telegraph Co., 1930
North Pearl & West Pine, Centralia
Bebb & Gould

Pacific Telephone & Telegraph Co., 1930
119 East Seventh Avenue, Olympia
Bebb & Gould
Addition 1936

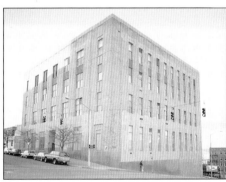

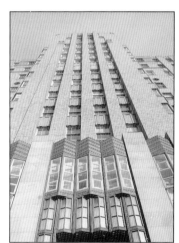

Pacific Telephone & Telegraph Co., 1930
757 Fawcett Avenue, Tacoma
Bebb & Gould

U.S. Marine Hospital, 1930 and 1931
1200 Twelfth Avenue South, Seattle
Bebb & Gould and John Graham, Sr.
Now Pacific Medical Center

F. R. Greene residence, 1930
The Highlands, Seattle
Bebb & Gould
Large remodel

The Lakeside School, 1931
14050 First Avenue North, Seattle
Bebb & Gould
More and Bliss Halls

Memorial Gateway, 1931
University of Washington, Seattle
Bebb & Gould

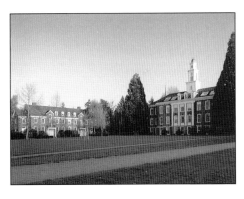

U.S. Post Office, 1931
1603 Larch Street, Longview
Bebb & Gould and John Graham, Sr.

Residence, 1932
2532 Upper Farms Road, Bainbridge Island
Bebb & Gould
Addition by W. Wurdeman, 1933

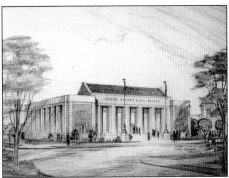

Refectory, 1932
The Lakeside School
14050 First Avenue North, Seattle
Bebb & Gould

Headmaster's house
The Lakeside School
Bebb & Gould

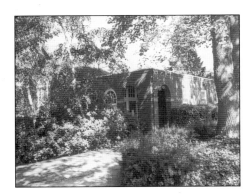

Seattle Art Museum, 1932
Volunteer Park, Seattle
Bebb & Gould

Everett Library, 1933
2702 Hoyt Avenue, Everett
Bebb & Gould
D. Pratt, sculptor; T. Jacobsen, muralist
1992 restoration by Cardwell/Thomas

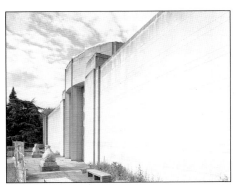

Tumor Institute, 1933
Swedish Hospital, Minor Avenue, Seattle
Bebb & Gould

Chemistry Building, 1934
University of Washington, Seattle
Bebb & Gould
With John Graham, Sr. Now Bagley Hall

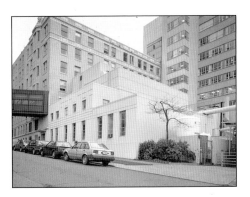

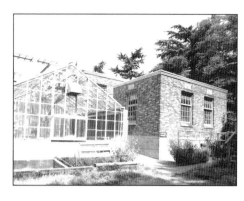

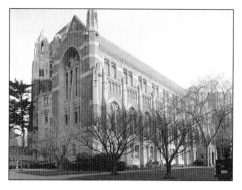

Greenhouses and classroom building, 1934
University of Washington, Seattle
Bebb & Gould

Suzzallo Library, south addition, 1934
University of Washington, Seattle
Bebb & Gould
Murals by P. Gustin

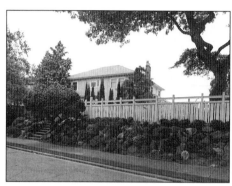

Swimming pavilion, 1934
University of Washington, Seattle
Bebb & Gould

R. J. Venables residence, 1935
2724 Mt. St. Helens Place South, Seattle
Bebb & Gould

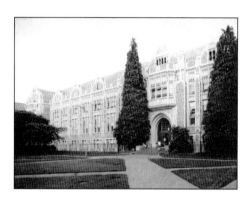

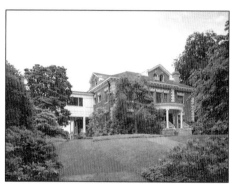

Smith Hall, 1936
University of Washington
Bebb & Gould

Paul Steig (Walker-Ames) residence, 1937
808 Thirty-sixth Avenue East, Seattle
Bebb & Gould
Porte-cochère. Original by Bebb & Mendel

Hoge Building Annex, 1937
711 Second Avenue, Seattle
Bebb & Gould

Penthouse Theatre, 1938
University of Washington, Seattle
Bebb & Gould with Hughes, Conway, Sergev
Relocated to north edge of campus, 1991

Abbreviations Used in the
Notes and Bibliography

AGH PAPERS Anne Gould Hauberg Papers, Accession 2991–3, Manuscripts and University Archives, University of Washington Libraries

CFG COLLECTION, CFG JR. Carl F. Gould Collection in the possession of the heirs of Carl F. Gould, Jr.

CFG COLLECTION, MUA Carl F. Gould Collection by accession number, Manuscripts and University Archives, University of Washington Libraries

CFG COLLECTION, SC Carl F. Gould Collection, Special Collections and Preservation Division, University of Washington Libraries

GF PAPERS Gould Family Papers, Accession 3516, Manuscripts and University Archives, University of Washington Libraries

MUA Manuscripts and University Archives, University of Washington Libraries

PBE *Pacific Builder and Engineer*

P-I *Seattle Post Intelligencer*

PNQ *Pacific Northwest Quarterly*

SAM PAPERS Seattle Art Museum Papers, Accession 2636, Manuscripts and University Archives, University of Washington Libraries

SC Special Collections and Preservation Division, University of Washington Libraries

TC *Town Crier* [Seattle]

UTS ARCHIVES Union Theological Seminary Archives, Burke Library, New York City

WA *Washington Alumnus* [University of Washington]

WSC, AIA Records of the Washington State Chapter of the American Institute of Architects, Accession 1334–2, –3, Manuscripts and University Archives, University of Washington Libraries

NOTES

CHAPTER 1 Architect and Civic Leader

1. Gould, "Report to the Board of Trustees of the Art Institute of Seattle," 17 April 1926, CFG COLLECTION, CFG JR.

2. Donald Leslie Johnson, "Frank Lloyd Wright in the Northwest: The Show, 1931," PNQ 78(July 1987): 100–106. Gould notes of a conversation with Bebb, 15 March 1938, CFG COLLECTION, CFG JR. Gould, "Eyes to See, Ability to See," talk delivered about 1936 or 1937, CFG COLLECTION, CFG JR.

3. Denise Scott-Brown, untitled commentary in *Oppositions* 8(Spring 1977): 165–66.

4. A.D.F. Hamlin, "The Battle of Styles," *Architectural Record* 1(31 March 1892): 265–75. Gould [to Anne, daughter], 2 October 1938, Box 3/10, AGH PAPERS.

5. For the Barnes quotation, see University of Washington Libraries, *Library Directions* 2(Spring 1991): 3.

6. For the trips, see *Harvard College Class of 1898: Twenty-Fifth Anniversary Report, 1898–1923* (privately printed), 217.

7. An unattributed newspaper photograph dated only "December 1938" shows Gould in a hospital bed, conferring with Victor Jones and J. Lister Holmes about their design for the Washington Pavillion. CFG COLLECTION, CFG JR.

8. For an example of how Gould's Department of Architecture was remembered, see Meredith L. Clausen, "Paul Thiry: The Emergence of Modernism in Northwest Architecture," PNQ 75(July 1984): 129–30. Anne Gould Hauberg's statement is from one of many informal interviews conducted by T. William Booth since 1985.

CHAPTER 2 The Preparatory Years, 1873–1908

1. To Anne [daughter], n.d., AGH PAPERS.

2. "Gould, Charles Judson," 8–9; and "Gould, Mrs. Annie (Westbrook)," 11–12, in *Encyclopedia of Biography of New York* (hereafter *Bio. N.Y.*), page proofs in CFG COLLECTION, CFG JR. For Charles' retirement, see Clarence B. Bagley, "Carl Frelinghuysen Gould," *History of King County Washington* 2(Chicago: S. J. Clarke Publishing Company, 1929), 631. For incidental biographical information not cited to printed or manuscript sources, the authors are indebted to the recollections of Carl F. Gould, Jr. and Anne Gould Hauberg, shared with T. William Booth at various times during the preparation of this study.

3. "Gould, Carl Frelinghuysen," *Bio. N.Y.*, 14.

4. Ibid.

5. Ibid., and also see "Gould, Mrs. Annie (Westbrook)," 11.

6. U.S. Department of the Interior, Census Office, *Statistics of the Population of the United States at the Tenth Census (June 1, 1880)*: 1(Washington, D.C.: USGPO, 1880), 453; and *Compendium of the Eleventh Census: 1890* (Washington, D.C.: USGPO, 1897), 111.

7. Norval White, *New York: A Physical History* (New York: Atheneum, 1987), 56–61; and Robert A. M. Stern, Gregory Gilmartin, and John Montague Massengale, *New York 1900: Metropolitan Architecture and Urbanism, 1890–1915* (New York: Rizzoli International Publications, 1983), 12, 315.

8. "Gould, Mrs. Annie (Westbrook)," *Bio. N.Y.*, 12; and Dorothy Fay Gould, interview by Carl F. Gould, Jr., "Carl & Mother re Dad's Cars, etc," February 1975, CFG COLLECTION, Box 1, Acc. 3273–6, MUA.

9. Stern, *New York 1900*, 307–10, 315–17, 321. Paul R. Baker, *Richard Morris Hunt* (Cambridge: MIT Press, 1980), 93–100, 219–25, 274–88; and Sarah Bradford Landau, "Richard Morris Hunt: Architectural Innovator and Father of a 'Distinctive' American School," in *The Architecture of Richard Morris Hunt*, ed. Susan R. Stein (Chicago: University of Chicago Press, 1986), 49–50, 55–58, 71–72.

10. For the Statue of Liberty, see Baker, *Hunt*, 314–23; and Bernard A. Weisberger, *Statue of Liberty: The First Hundred Years* (New York: American Heritage, 1985).

11. Baker, *Hunt,* 181–85; and Landau, "Hunt," 68–70. A search of the Wilberforce Eames Papers, the papers of the Board of Trust Administration, Lenox Library, and the Lenox Library, Superintendent George H. Moore Correspondence at the Rare Books and Manuscripts Division, New York Public Library, uncovered no letters from Annie or Charles Gould. Eames was the Lenox librarian. The admissions register of the Lenox was closed at the time of Wilson's investigation in 1991.

12. Leland M. Roth, *McKim, Mead & White, Architects* (New York: Harper & Row, 1983), 87–90, 145–47, 158–65.

13. Bruce Kelly, Gail Travis Guillet, and Mary Ellen W. Hern, eds., *Art of the Olmsted Landscape* (New York: New York City Landmarks Preservation Commission, 1981); and Henry Hope Reed and Sophia Duckworth, *Central Park: A History and Guide* (New York: Clarkson N. Potter, 1967).

14. Stern, *New York 1900,* 11, 170–73.

15. "Gould, Charles Judson," *Bio. N.Y.,* 10 (quotation); and "Gould, Mrs. Annie (Westbrook)," ibid., 13.

16. For quotation, see letter of A. Tufts, "To Whom it May Concern," n.d., and also the letter of G. R. White, "To Whom it May Concern," n.d., file 9846, Harvard University Archives, Lamont Library.

17. Records of Classes 1887–1909, p. 161, File UA III, 15.75.10, Harvard University Archives, Lamont Library.

18. For camera development see Carl W. Anderson, *George Eastman* (Boston: Houghton Mifflin Company, 1930), 41–89.

19. The watercolors are in the CFG COLLECTION, CFG JR.

20. Standard on the Beaux-Arts is Arthur Drexler, ed., *The Architecture of the Ecole des Beaux-Arts* (New York: Museum of Modern Art, 1977). For discrimination against foreigners, see Sara Holmes Boutelle, *Julia Morgan, Architect* (New York: Abbeville Press, 1988), 27; and Mark Alan Hewitt, *The Architect and the American Country House, 1890–1940* (New Haven: Yale University Press, 1990), 32.

21. Gould was at this time nearing twenty-five; thus his first name will be used subsequently only in the interest of clarity or variation. "Gould, Mrs. Annie (Westbrook)," *Bio. N.Y.,* 12 (quotation). Family information not otherwise cited is from Anne Gould Hauberg, informal interviews by T. William Booth. For Burnham, see Thomas S. Hines, *Burnham of Chicago: Architect and Planner* (New York: Oxford University Press, 1974), 3–15.

22. For the age of the onset of stuttering, see Marcel E. Wingate, *Stuttering: Theory and Treatment* (New York: Irvington Publishers, 1976), 94, 97, 100. The extensive writing on stuttering includes Oliver Bloodstein, *A Handbook on Stuttering,* 3rd ed. (Chicago: National Easter Seal Society, 1981); Judith Cooper, ed., *Research Needs in Stuttering: Roadblocks and Future Directions* (Rockville, Md.: American Speech-Language-Hearing Association, 1990); and Marcel E. Wingate, *The Structure of Stuttering: A Psycholinguistic Analysis* (New York: Springer-Verlag, 1988). Dominick A. Barbara, in *The Psychodynamics of Stuttering* (Springfield, Ill.: Charles C. Thomas, 1982), paints an unflattering portrait of the stutterer, but his discussion of the family background of stutterers, 10–14, is suggestive. Gerald Jones's *Stuttering: The Disorder of Many Theories* (New York: Farrar, Straus and Giroux, 1977), is an engaging memoir by a former stutterer. Clorinda Lincoln, Gould's niece, confirmed family stories of Gould's upbringing in an interview by T. William Booth, 19 April 1993.

23. See an 1898 photograph of Gould in Box 15, folder Photos Family—especially ancestors of CFG, AGH PAPERS.

24. The influence of the Ecole on leading American architects is in Baker, *Hunt,* 26–62: James F. O'Gorman, *H. H. Richardson: Architectural Forms for an American Society* (Chicago: University of Chicago Press, 1987), 11–15, 39, 47, 57–58, 64, 67; Charles Moore, *The Life and Times of Charles Follen McKim* (Boston: Houghton Mifflin Company, 1929), 24–34; Kenneth H. Cardwell, *Bernard Maybeck: Artisan, Architect, Artist* (Santa Barbara: Peregrine Smith, 1977), 17–19, 38–39, 43, 117; and Robert C. Twombly, *Louis Sullivan: His Life and Work* (New York: Viking Penguin, 1986), 56–76, 184, 262, 348, 419. Ernest Flagg, "The Ecole Des Beaux-Arts," *Architectural Record* 3(January–March 1894); 302–13; 3(April–June 1894): 419–28; and 4(July–September 1894): 38–43. See also Flagg's "Influence of the French School on Architecture in the United States," *Architectural Record* 4(October–December 1894): 211–28.

25. Richard Chafee, "The Teaching of Architecture at the Ecole des Beaux-Arts," in Drexler, ed., 61–81.

26. Ibid., 81–82, 86, 87–88, 97–107. For matters of style see ibid., 62–63; Mardges Bacon, *Ernest Flagg: Beaux-Arts Architect and Urban Reformer* (Cambridge: MIT Press, 1986), 17–32, 42–48; David Van Zanten, "Architectural Composition at the Ecole des Beaux-Arts from Charles Percier to Charles Garnier," in Drexler, ed., 231; and Neil Levine, "The Romantic Idea of Architectural Legibility: Henri Labrouste and the Neo-Grec," ibid., 332–416.

27. Chafee, "Teaching of Architecture at the Ecole des Beaux-Arts," in Drexler, ed., 82–83.

28. Ibid., 82; and Boutelle, *Julia Morgan,* 29–30. Flagg notes that it was possible to delay selecting an atelier; "Ecole Des Beaux-Arts" 3(April–June 1894): 422.

29. Chafee, "Teaching of Architecture at the Ecole des Beaux-Arts," in Drexler, ed., 82–86; and Boutelle, *Julia Morgan,* 28–29, 31–39.

30. Chafee, "Teaching of Architecture at the Ecole des Beaux-Arts," in Drexler, ed., 88–93.

31. William H. Jordy, *American Buildings and Their Architects: Progressive and Academic Ideals at the Turn of the Century* (Garden City, N.Y.: Doubleday & Company, 1972), 279.

32. Gould listed the standings in a sketchbook, CFG COLLECTION, CFG JR. His entry in *Records of the Class of 1898, Second Report,* Harvard University, 1907, Harvard University Archives, Lamont Library, lists standings of fourteenth and fifth respectively. Gould's contributions to class records must be used with caution, but they are relied upon for incidental biographical information not specifically cited below when Gould's statements do not conflict with what is known about the outlines of his career from other sources.

33. "Victor Laloux," in Drexler, ed., 459–63. For the photograph, see Chafee, "Teaching of Architecture at the Ecole des Beaux-Arts," ibid., 90. For "creative genius" quotation see Arthur Brown, Jr., in "Hommage à Laloux: De Ses Elèves Americains," *Pencil Points* 18(October 1937): 628. For the importance of the Laloux atelier to Americans, see also Hewitt, *The Architect and the American Country House,* 34.

34. Quoted in Chafee, "Teaching of Architecture at the Ecole des Beaux-Arts," in Drexler, ed., 94. For quotation about Laloux's beliefs, see Brown, "Hommage à Laloux," 628; and for quotation about Laloux's method of criticism, see Chafee, 90.

35. Only the watercolors survive in the CFG COLLECTION, CFG JR.

36. Gould, "Campus 'Functionalism,'" paper read to the Monday Club, 25 November 1935, CFG COLLECTION, CFG JR. in which he mentions the trips.

37. First medal and first mention, CFG COLLECTION, SC.

38. For the mathematics requirement, see Chafee, "Teaching of Architecture at the Ecole des Beaux-Arts," in Drexler, ed., 83, and for the age limit, ibid., 85. For the meaning of the diploma, see Bacon, *Ernest Flagg,* 33–34. For Gould's failure to pass the mathematics examination, see *Records of the Class of 1898, Second Report.*

39. David H. Pinkney, *Napoleon III and the Rebuilding of Paris* (Princeton: Princeton University Press, 1958), is standard on its subject. See also Jean Bastié, "Paris: Baroque Elegance and Agglomeration," in H. Wentworth Eldredge, ed., *World Capitals: Toward Guided Urbanization* (Garden City, N.Y.: Anchor Doubleday, 1975), 58; Norma Evenson, *Paris: A Century of Change, 1878–1978* (New Haven: Yale University Press, 1979), 10–20, 39; and Donald J. Olsen, *The City As a Work of Art* (New Haven: Yale University Press, 1986), 35–37, 210–34.

40. For facades, see Evenson, *Paris,* 143–47; for the Metro, ibid., 106–107; and for building regulation modifications, Olsen, *The City As a Work of Art,* 267. Gould to "Dear Mama," 10 October 1899, CFG COLLECTION, CFG JR.

41. For public health, see Evenson, *Paris,* 50, 208–11 (quotation, 209); and for population, Bastié, "Paris," 61.

42. Gould to "Dearest Mama," 28 January 1902, CFG COLLECTION, CFG JR.

43. For the variety behind the boulevards, see Howard Sallman, *Haussman: Paris Transformed* (New York: George Braziller, 1971), 114, 115. The surviving portion of Gould's design library is in SC.

44. These observations rest on an examination of sketchbooks in the CFG COLLECTION, CFG JR. For Petraraia and Gamberaia, see Norman P. Newton, *Design on the Land: The Development of Landscape Architecture* (Cambridge: Belknap Press of Harvard University Press, 1971), 58–59, 114–19.

45. Gould to "Dearest Mama," 5 April 1901 ("an architect's training"); 28 January 1902 ("it is the"); and 15 November 1901 ("composition decoratif"), CFG COLLECTION, CFG JR.

46. For the Society of Beaux-Arts Architects, see Bacon, *Ernest Flagg,* 50–52. For the inclusion of Gordon Allen in some travels, see *Harvard College, Class of 1898: Twenty-Fifth Anniversary Report, 1898–1923* (privately printed, 1923), 216.

47. *Harvard College Class of 1898: Quindecennial Report* (June 1913), 130. Roth, *McKim, Mead & White,* 245. See also Richard Guy Wilson, *McKim, Mead & White, Architects* (New York: Rizzoli International Publications, 1983). Gould is not listed in the notebook "List of People Who Have Worked for McKim, Mead & White," Acc. 1986.001.00001, or mentioned in other materials from the firm in the Division of Drawings and Archives, Avery Architectural and Fine Arts Library, Columbia University.

48. *Harvard College Class of 1898: Quindecennial Report,* 130. McKim, Mead & White, *The Architecture of McKim, Mead & White in Photographs, Plans and Elevations* (New York: Dover Publications, 1990), pls. 85–91; Lorraine B. Diehl, *The Late, Great Pennsylvania Station* (New York: American Heritage, 1985), especially 112–13; and "Gould, Carl Frelinghuysen," *Bio. N.Y.,* 14.

49. No record of Gould's appeal to Bennett survives, but it is a more likely event than Bennett's seeking out Gould. For first quotation, see Bennett to Gould, 20 May [1905], CFG COLLECTION, CFG JR. For Gould's arrival, see Gould to "Dearest Mama," 4 June 1905, ibid. See Joan E. Draper, *Edward H. Bennett: Architect and City Planner, 1874–1954* (Chicago: Art Institute of Chicago, 1982), for Bennett's education (pp. 7–8) and for his early work with Burnham (pp. 8–13). Polk's involvement is detailed in Richard W. Longstreth, *On the Edge of the World: Four Architects in San Francisco at the Turn of the Century* (Cambridge: MIT Press, 1983), 299–301. For Burnham's exposition and city planning activities, see Hines, *Burnham,* 73–196. For Burnham's plan in the context of San Francisco's development, see Judd Kahn, *Imperial San Francisco: Politics and Planning in an American City, 1897–1906* (Lincoln: University of Nebraska Press, 1979), especially 1–4, 57–127, 177–216. For Gould quotation, see Gould to "Dearest Mama," 24 August 1905, CFG COLLECTION, CFG JR.

50. Daniel H. Burnham, assisted by Edward H. Bennett, *Report on a Plan for San Francisco: Presented to the Mayor and the Board of Supervisors by the Association for the Improvement and Adornment of San Francisco* (San Francisco: City of San Francisco, 1906), "Market Street Termination and Approach to Twin Peaks," and others opposite p. 88; and "The Athenaeum: Showing Vista to the Sea" and others opposite p. 168. Gould's work is acknowledged on p. 211. For Gould's friendship with Bennett, see Dorothy Fay Gould, untitled interview by Carl F. Gould, Jr., February 1975, CFG COLLECTION, Box 1, Acc. 3273–6, MUA; and E. H. Bennett to Gould, 18 March 1914, Municipal League, Seattle, Buildings and Grounds Committee, Box 1, folder General Correspondence 1912–14, Acc. 3746, MUA. For Gould's friendship with Polk, see Gould to Polk, [illegible] 1919, CFG COLLECTION, CFG JR.

51. Gould, "What Is the Architect Doing toward Solving the Problems Now Before Him?" *PBE* 10(14 December 1912): 439. For Burnham's San Francisco buildings through 1905, see Hines, *Burnham,* 378, 380, 381.

52. For Bennett, see n. 49. For Polk's education, itinerancy, and personality, see Longstreth, *On the Edge of the World,* 51–56, 89–96, and 299. The Burnham diary does not mention Gould during two Burnham visits to San Francisco, 30 April–11 May 1905, and 9 September–18 September 1905, although there are references to Polk, Bennett, and others; for example, the entry of 15 September. Burnham, D.H., Diaries, 1895–1912, microfilm roll 2, D.H. Burnham Collection, Ryerson and Burnham Archives, Art Institute of Chicago. No letters to or from Gould survive in the Burnham Collection or in the E. H. Bennett Collection at the Art Institute. The Edward H. Bennett Diaries in the possession of Edward H. Bennett, Jr., Lake Forest, Ill., begin in 1906. Through 1910 they do not mention Gould.

53. In order of quotations: Gould to "Dearest Mama," 4 June 1905; 13 July 1905; and 19 July 1905, CFG COLLECTION, CFG JR.

54. Dorothy Fay Gould mixed elements of the 1905 trip with Gould's 1908 trip in her interview by Carl F. Gould, Jr., "Carl and Mother, Feb. 6, 1975 re: Dad," CFG PAPERS, Box 1, Acc. 3273–6, MUA.

55. "George B. Post Staff List and Pay Ledger, A-Z, 1875–1918," Department of Prints, Photographs and Architecture, New-York Historical Society. For quotation, see "Gould, Carl Frelinghuysen," *Bio. NY,* 14. Henry-Russell Hitchcock and William Seale, *Temples of Democracy: The State Capitols of the USA* (New York: Harcourt Brace Jovanovich, 1976), 242.

56. For Blair, see Gould sketchbook, and for Carpenter, see listing of Beaux-Arts architects, CFG COLLECTION, CFG JR. For the Confederate memorial, see *American Architect* 99(15 March 1911): pls. 5–9.

57. *The Program of a Competition for the Selection of an Architect and the Procuring of a General Plan for the Union Theological Seminary in the City of New York* (New York, 1906), 3, folder (Morningside Heights) Material Concerning Building of new UTS Site, Collection 2.3.D, Union Theological Seminary Archives, Burke Library (hereafter as UTS ARCHIVES). Information about Blair and Carpenter is derived from miscellaneous sources in the CFG COLLECTION, CFG JR.

58. Gould's plans are in CFG COLLECTION, SC. Small reproductions of the winning design are in Collection 2.3.D, UTS ARCHIVES. For all prizewinning entries, see Adin Bennett Lacey, ed., *American Competitions, 1907* (Philadelphia: T Square Club: 1907), especially Gould's entry, pls. 51a, 51b. William Morgan, *The Almighty Wall: The Architecture of Henry Vaughn* (Cambridge: MIT Press, 1983).

59. "Preliminary suggestions for the Committee as to the Development of the New Union Theological Seminary Site," typewritten, n.d., Collection 2.3.D, UTS ARCHIVES. For Gould's implication, see *Records of the Class of 1898, Second Report.*

60. Harvey H. Kaiser, *Great Camps of the Adirondacks* (Boston: David R. Godine, 1982), 130. For quotation, see *Harvard College Class of 1898: 1923*, 216.

61. Erik H. Erikson, *Identity: Youth and Crisis* (New York: W. W. Norton & Company, 1968), 143, 156–59.

62. *Harvard College Class of 1898, 1923*, 216 (first quotation); Gould lecture notes, about 1915, CFG COLLECTION, CFG JR. (second quotation).

CHAPTER 3 Community Involvement and Residential Style, 1909–1914

1. Alvar Aalto, statement to T. William Booth, 1963.

2. See the maps of population distribution in Janice L. Reiff, *Urbanization and the Social Structure: Seattle, Washington, 1852–1910,* (Ann Arbor, Mich.: University Microfilms International, 1981), 216, 218, 219; and see the map in William H. Wilson, *The City Beautiful Movement* (Baltimore: Johns Hopkins University Press, 1989), 152. For views of Seattle neighborhoods about the time Gould arrived, see photographs of Queen Anne Hill, First Hill, and Brooklyn in Roger Sale, *Seattle: Past to Present* (Seattle: University of Washington Press, 1976), following p. 12; and William H. Wilson, "The Seattle Park System and the Ideal of the City Beautiful," in Daniel Schaffer, ed., *Two Centuries of American Planning* (Baltimore: Johns Hopkins University Press, 1988), 125. For the regrades, see Arthur H. Dimock, "Preparing the Groundwork for a City: The Regrading of Seattle, Washington," *Transactions of the American Society of Civil Engineers* 92(1928): 717–33.

3. For Seattle's climate and topography, see Sale, *Seattle,* 3–6.

4. For the impact of the railroads and the gold rush, see Sale, *Seattle,* 50–93; Norbert MacDonald, *Distant Neighbors: A Comparative History of Seattle & Vancouver* (Lincoln: University of Nebraska Press, 1987), 21–25, 33–42, 44–53; and Murray Morgan, *Skid Road: An Informal Portrait of Seattle,* rev. ed. (New York: Viking Press, 1962), 159–68. Local color is captured in Morgan, *Skid Road,* 116–58. For the value of goods see Janice Reiff Webster, "Seattle: The First Fifty-Five Years: A Study in Urban Growth" (Master's thesis, University of Washington, 1973), 73. For the lumbering dispersion, see Reiff, "Urbanization and the Social Structure," 170. For economic and social background, see Richard C. Berner, *Seattle, 1900–1920: From Boomtown, Urban Turbulence, to Restoration* (Seattle: Charles Press, 1991), 3–106.

5. For elite organizations and neighborhoods, see Reiff, "Urbanization and the Social Structure," 169, 193–94, 199–200, 213. For the work of Howells & Stokes, see John Mead Howells to Gould, 30 January 1909, CFG COLLECTION, CFG JR.; and Neal O. Hines, *Denny's Knoll: A History of the Metropolitan Tract of the University of Washington* (Seattle: University of Washington Press, 1980), 64–107, and the photographs of the Cobb and White-Henry-Stewart buildings following p. 338. For construction values, see "Graph of Building Activity 1903–1914," *PBE* 19(23 January 1915): 40. Most architects in Seattle began as engineers, for example, Charles H. Bebb, Henry Bittman, John Graham, and David

Myers. Others were builders who simply declared themselves architects, for example, Beezer Brothers.

6. Terrence M. Cole, "Promoting the Pacific Rim: The Alaska-Yukon-Pacific Exposition of 1909," *Alaska History* 6(Spring 1991): 18–34; George A. Frykman, "The Alaska-Yukon-Pacific Exposition, 1909," *PNQ* 53(July 1962): 89–99; and Norman J. Johnston, "The Olmsted Brothers and the Alaska-Yukon-Pacific Exposition: 'Eternal Loveliness,'" *PNQ* 75(April 1984): 56–61. Joan Draper, "The Ecole des Beaux-Arts and the Architectural Profession in the United States: The Case of John Galen Howard," in Spiro Kostof, ed., *The Architect: Chapters in the History of the Profession* (New York: Oxford University Press, 1977), 209–344.

7. Alexander Miller to Charles J. Gould, 21 April 1909, CFG COLLECTION, CFG JR., mentions the letter. Over the years Gould built up a client network of lumber merchants and executives, including the McEwans, Arthur Krauss, Walter Nettleton, Valentine May, and William Boeing.

8. For the Monday Club, see Monday Club, Acc. 1641, 1491—1497–12, MUA. For first quotation, see undated typescript by J.P.D. Llwyd, Box 1/1; and for second quotation, see Robert B. Walkinshaw to Charles E. Martin, 5 May 1933, Box 1/3, ibid. An example of carelessness in detail is Gould's speech of 1931 or 1932, "L'Ecole National et Superieure des Beaux-Arts, Paris," CFG COLLECTION, CFG JR.; while the 1919 talk "The Future of the Architect" is confused and poorly organized, WSC, AIA, "Minutes, 1915–1919," 8 January 1919, 3:65–69, Box 5, AIA. For Gould's organizations, see Carl B. Bagley, "Carl Frelinghuysen Gould," *History of King County, Washington*, vol. 2 (Chicago: S. J. Clarke, 1929), 633.

9. Erikson, *Identity: Youth and Crisis* (New York: W. W. Norton, 1968) 158–61, argues that the individual's final identity, achieved at the end of adolescence, may incorporate and subordinate previous identification with parents and others. Gould had at last successfully constructed his own identity even though the personalities of his parents played a large role in the final result. In 1910 Gould wrote that his appreciation of beauty "came only by chance through my mother." See "Architectural League of the Pacific Coast," *PBE* 16(15 November 1913): 302. For quotation, see Gould to "Dearest Mother," 21 October 1929, CFG COLLECTION, CFG JR.

10. WSC, AIA "Minutes, 1922," 27 January 1923, 6:43–44, Box 5. It is arguable that thoughts expressed in 1923 should not be attributed to Gould in 1908. He had, however, made a similar statement in 1919, though in a less polished manner. His letters, articles, and designs from and after 1909, when he was thirty-five, indicate a matured consistency of his idea of the beautiful.

11. Ibid., 44–45.

12. Gould's library contained books discussing beauty in an urban context, including Thomas H. Mawson, *Civic Art: Studies in Town Planning, Parks, Boulevards, and Open Spaces* (London: B. T. Batsford, 1911), 32; H. Inigo Triggs, *Town Planning: Past, Present, and Possible* (London: Methuen & Co., 1909), 217–18; and Raymond Unwin, *Town Planning in Practice: An Introduction to the Art of Designing Cities and Suburbs* (London: T. Fisher Unwin, 1913), 4, 9–14.

13. Donald Leslie Johnson, "Frank Lloyd Wright in the Northwest: The Show, 1931" *PNQ* 78 (July 1987): 100–102, 106.

14. W. R. B. Willcox, "Modern Architecture and How Determined: Effects of Historical Precedents, the Fancy of Clients' and Architects' Attitude," *PBE* 14(16 November 1912): 397–98; and Don Genasci, "Walter Willcox—the Relation of Architecture to Society," in Genasci and David Shelman, *W. R. B. Willcox (1869–1947): His Architectural and Educational Theory* (Eugene: Department of Architecture, University of Oregon, 1980), 1–18.

15. "A dissertation on the Influences of precedent upon Archi design," a response to W. R. B. Willcox, CFG COLLECTION, CFG JR.

16. For the church, see CFG COLLECTION, SC. For Huntington's career, see Susan Boyle, "Landmark Nomination Form: The Lake Union Power Plants" (Seattle: City of Seattle, Department of Community Development, Office of Urban Conservation, 1987), 8, 14–15; and "Daniel Huntington," *PBE* 22(27 October 1916): 12.

17. Gould's lengthy undated statement in CFG COLLECTION, CFG JR., recounts his unsatisfactory initial relationship with Squire.

18. Keith Morgan, *Charles A. Platt: The Artist as Architect* (Cambridge: MIT Press, 1985), 244.

19. Lecture notes, n.d., CFG COLLECTION, CFG JR. Marcus Vitruvius Pollio, *Vitruvius: The Ten*

Books on Architecture, trans. Morris Hicky Morgan (1914; reprint, New York: Dover Publications, 1960), 16, 181–82.

20. Gould, "What is the Architect Doing toward Solving the Problems Now Before Him," PBE 10 (14 December 1912): 439. There was no typical bungalow; see Gustav Stickley, *Craftsman Homes: Architecture and the Furnishings of the American Arts and Crafts Movement* (1909: New York: Dover Publications, 1979). For Shaw, see Vincent J. Scully, Jr., *The Shingle Style and the Stick Style: Architectural Theory and Design from Richardson to the Origins of Wright,* rev. ed. (New Haven: Yale University Press, 1971), 1–18, 39–43, 87–88, and Figs. 6, 8, 20, 51.

21. For the Derby house, see Harold Kirker, *The Architecture of Charles Bulfinch* (Cambridge: Harvard University Press, 1969), 125–27.

22. Job files, CFG COLLECTION, CFG JR.; and *A.I.A.—Small House Service Bureau of the U.S.A., Inc., Houses* (New York: Architectural League, 1925). Files of *Bungalow Magazine* are in the Seattle Public Library.

23. Material on Storey includes Victor Steinbrueck, *Seattle Cityscape* (Seattle: University of Washington Press, 1962), 160; "Seattle's Storey Cottages," *Pacific Architect and Builder* 66 (June 1960): 21–24; Larry Brown, "At Home with Ellsworth Storey," *Pacific* [magazine of the *Seattle Times* and *Seattle Post-Intelligencer*] (15 September 1985): 22–24; Darrell Glover, "Storey's Homes Distinctive," *Seattle Post-Intelligencer* (hereafter P-I), 23 January 1972: D9; Nancy Knapp, "The Houses That Storey Built," *Puget Soundings* (May 1968): 16–17, 18; and Romi Richmond, "Ellsworth Storey of Seattle," *ARCADE* 6 (February/March 1983): 4–5. These discussions are uniformly positive. Knapp, for example, praises Storey's small windows for assuring privacy but overlooks the fact that draperies over large windows would have achieved the same effect while admitting light at times that privacy was not desired.

24. Sources in n. 23, and the Storey folder in the Architects' Reference File, SC. See also Jeffrey Karl Ochsner, ed., *Shaping Seattle Architecture: A Historical Guide to the Architects* (Seattle: University of Washington Press, 1994), "Ellsworth Storey," by Grant Hildebrand, 102–7.

25. For the church, see Steinbrueck, *Seattle Cityscape*, 180, and for the park, ibid., 137. See also the Storey folder, n. 24; and *Times* and P.I, 2 Nov. 1986, p. B11.

26. Mark Alan Hewitt, *The Architect and the American Country House, 1890–1940* (New Haven: Yale University Press, 1990), 10–14; and Morgan, *Platt,* 78–79.

27. For quotation, see Clive Aslet, *The American Country House* (New Haven: Yale University Press, 1990), v. See also Mark Girouard, *The Victorian Country House* (New Haven: Yale University Press, 1990).

28. Hewitt, *The Architect and the American Country House,* 153–56.

29. For The Country Club, see Thomas Minor Pelly, *Restoration Point and Country Club* (Seattle: Lowman & Hanford Co., 1931), 41. Valentine May, a fellow resident at the University Club, was the likely intermediary for the barn.

30. Hewitt, *The Architect and the American Country House,* 115 (first quotation); and 116 (second quotation).

31. Gould was influenced by Grace Tabor, *The Landscape Gardening Book* (Philadelphia: Winston & Co., 1911), which was in his library. Ashael Curtis photographs of the Alexander McEwan house (Nos. 34955–60 and 35122–29), the William McEwan house (No. 35120–21), and the Brownell house (No. 35176–84) are in the A. Curtis Collection, Washington State Historical Museum, Olympia. For floral embellishment, see Hewitt, *The Architect and the American Country House,* 176. See also Louise N. Johnson, "An Island Home Near Seattle," *House Beautiful* 46 (July 1919): 26–28.

32. For the Pratt house, see Randell L. Makinson, *Greene & Greene: Architecture as Fine Art* (Salt Lake City: Peregrine Smith, 1977), 168–73, especially the plan on p. 168.

33. T. William Booth has examined the original Olmsted plan in the possession of later owners of the White property, and Gould's plans for the same property. For The Highlands, see Lawrence Bogle, A. Scott Bullitt, Caspar W. Clarke, and Hamilton C. Rolfe, eds., "The Highlands" (1931), a looseleaf notebook in SC. A historical sketch is on p. 31. See also Lawrence Kreisman, *The Stimson Legacy: Architecture in the Urban West* (Seattle: Willows Press, 1992), 97–120.

34. Edith Wharton, *Italian Villas and Their Gardens* (New York: Century Co., 1910), 12. For Wharton's gardening, see Richard R. B. Lewis, *Edith Wharton: A Biography* (New York: Harper & Row, 1975), 448, 476.

35. For Gould's move, see *PBE* 14(13 July 1912): 41. Except where otherwise noted, information on Gould's staff is from the CFG COLLECTION, CFG JR.

36. White to Gould, 2 October 1912; and Gould to White, 3 October, 1912, CFG COLLECTION, CFG JR.

37. "Washington State Capitol Commission and Its Jury," *PBE* 12(14 October 1911): 213. The associated architects were Willcox & Sayward, Huntington & Gould, and Charles Alden. See also Norman J. Johnston, *Washington's Audacious State Capitol and Its Builders* (Seattle: University of Washington Press, 1988), 20–30. Gould was involved in a third government project, a campus plan for the University of Washington; see Chapter Five.

38. Gould, "Early Use of Architectural Concrete at Government Locks, Ballard," *Architect and Engineer* 104(February 1931): 54–55. Robert E. Ficken, "Seattle's 'Ditch': The Corps of Engineers and the Lake Washington Ship Canal," *PNQ* 77(January 1986): 11–20. See also Reyner Banham, *A Concrete Atlantis: U.S. Industrial Building and European Modern Architecture, 1900–1925* (Cambridge: MIT Press, 1986).

39. Quoted from Gould, "Early Use of Architectural Concrete at Government Locks, Ballard": 55. For United States precedents, see Peter Collins, *Concrete: The Vision of a New Architecture: A Study of Auguste Perret and His Precursors* (New York: Horizon Press, 1959), 61–64, 81, 86, 90, 141–42, 146.

40. Anne H. Calhoun, *A Seattle Heritage: The Fine Arts Society* (Seattle: Lowman & Hanford Co., 1942), 13–28 (quotation, 18–19). See also exhibit catalogs, Box 37/51, SAM PAPERS.

41. Gould, "What Art Means to a City," *TC* 10(8 November 1915), 11. Calhoun, *Seattle Heritage*, 28–30, 43, 45, 99.

42. Calhoun, *Seattle Heritage*, 31–46. For quotation, see "Minutes, Oct. 1, 1910-June 27, 1917," 8 September 1914, p. 119 (quotation), Box 34, SAM PAPERS.

43. WSC, AIA, "Minutes, 1894–1910," 13 December 1895 (membership) 1:2–3; 12 June, 15 October 1906 (Alaska-Yukon-Pacific Exposition) 1:100, 106; 12 December 1907 (building department) 1:124; 19 December 1907 (civic center committee) 1:125; and 19 December 1907 (paper) 1:126; Box 5, AIA RECORDS.

44. Wilson, *City Beautiful Movement*, for example, 126–46.

45. WSC, AIA, "Minutes 1894–1910," 15 January 1909, 1:148. Gould joined during June, ibid., 10 June 1909, p. 154. Virgil G. Bogue, *Plan of Seattle: Report of the Municipal Plans Commission Submitting Report of Virgil G. Bogue, Engineer, 1911* (Seattle: Lowman & Hanford Co., 1911), 9 (quotation), 11. Except as cited, this discussion of the Bogue plan is drawn from Wilson, *City Beautiful Movement*, 213–33.

46. For the conference committee, see *P-I*, 2 Dec. 1909. *Municipal League News*, 20 January 1912; and *Times*, 14 Feb. 1912.

47. For quotation, see Gould, "Town Planning: Illustrated talk to be given at Trinity Church, 3 January 1913," CFG COLLECTION, CFG JR. The fountain was slightly altered in 1989. For the City Beautiful movement's dual commitment to aesthetics and private enterprise, see Wilson, *City Beautiful Movement*, 78–95, 296–98; and Daniel M. Bluestone, *Constructing Chicago* (New Haven: Yale University Press, 1991), 185–98.

48. WSC, AIA, "Minutes, 1910–1914," 10 April 1912, 2:108; and 2 October 1912, 2:135. For the Commercial Club gathering, see *Municipal League News*, 19 October 1912; *Times* 30 Oct. 1912; and *P-I*, 4 Nov. 1912.

49. *P-I*, 1 Nov. 1912 (quotation); 2 Nov. 1912; and 3 Nov. 1912.

50. WSC, AIA, "Minutes, 1894–1910," 10 June 1909, 1:154; 11 October 1909, 1:157; and 13 December 1909, 1:175–77. For the Public Library, see ibid., "Minutes, 1910–1914," 12 May 1910, 2:21. For the convention, see ibid., 29 November 1911, 2:82. For quotation, ibid., 2:120. For professional concerns, see ibid., 2 March 1910, 2:10; 13 June 1910, 2:25; 12 May 1910, 2:20; 7 June 1911, 2:58; and 2 November 1910, 2:33, Box 5, AIA RECORDS.

51. Gould, "New Building Ordinance of the City of Seattle," *PBE* 16(20 December 1913): 393.

CHAPTER 4 Partnership and Marriage, 1914–1926

1. Gould, "Campus 'Functionalism,'" delivered to the Monday Club, 25 November 1935, CFG COLLECTION, CFG JR.

2. Gould diary, 1 November 1934, CFG COLLECTION, CFG JR.

3. Bagley, *History of Seattle*, 3:114, 117–18; Jeffrey K. Ochsner and Dennis A. Andersen, "Adler and Sullivan's Seattle Opera House Project," *Journal of the Society of Architectural Historians* 48(September 1989): 121–23; and Lawrence Kreisman, *The Stimson Legacy: Architecture in the Urban West* (Seattle: Willows Press, 1992), 91.

4. Ochsner and Andersen, "Seattle Opera House," and Robert Twombly, "Beyond Chicago: Louis Sullivan in the American West," *Pacific Historical Review* 54(November 1985): 419. See also Gould, notes of a conversation with Bebb, 15 March 1938, CFG COLLECTION, CFG JR.

5. For the breakup of Bebb & Mendel and the firm's exposition awards, see *Pacific Builder and Engineer* (17 January 1914): 32. For the houses, see Bebb & Mendel, *The Work of Bebb & Mendel, Architects, 1906* (Seattle, 1906); and *Seattle Architecturally* (Seattle, 1902), in SC.

6. WSC, AIA, "Minutes, 1894–1910," meeting of 1 December 1909, 1:166.

7. Articles of association "draft," undated [1914], CFG COLLECTION, CFG JR.

8. Bebb held license number 10, Gould number 61, CFG COLLECTION, CFG JR.

9. This paragraph rests on examination of office files, CFG COLLECTION, CFG JR.; Gould drawings, sketches, perspectives, and plans, SC; and E. A. Campbell, interview by T. William Booth, 10 January 1989.

10. See n. 9 and John S. Villesvik, telephone interview by T. William Booth, 19 June 1985.

11. Office files, CFG COLLECTION, CFG JR.

12. Ibid. For Bebb's donation, see "Gifts," 20 April 1922, CFG COLLECTION, CFG JR.

13. A breakdown of the partners' share of net income after all expenses were paid illustrates their changing fortunes and shares of the work. Figures for 1921 and earlier years are not available.

Bebb & Gould: Net Income to Partners, 1922–1938

Year	Bebb	Per cent	Gould	Per cent	TOTAL
1922	$13,400	51	$13,000	49	$26,400
1923	15,400	51	14,800	49	30,200
1924	15,000	53	13,200	47	28,200
1925	14,300	54	12,400	46	26,600
1926	19,500	56	15,400	44	34,900
1927	22,200	55	18,400	45	40,600
1928	6,900	49	7,100	51	14,000
1929	8,800	43	11,600	57	20,400
1930	3,400	41	4,900	59	8,300
1931	6,300	33	12,700	67	19,000
1932	800	33	1,600	67	2,400
1933	2,400	33	4,900	67	7,300
1934	1,800	33	3,600	67	5,400
1935	800	35	1,500	65	2,300
1936	4,300	33	8,600	67	12,900
1937	2,000	30	4,000	70	6,000
1938	2,647	30	5,923	60	8,822

In 1924 Gould received $1800 from the university for his half-time position as professor and head of the Department of Architecture; CFG COLLECTION, CFG JR. A graph prepared by T. William Booth, based on the job files, CFG COLLECTION, CFG JR., and in the possession of the authors, represents the projects secured by each man through the life of the partnership. For quotation, see Dorothy Gould to "My dear Momma," n.d. [1918 from internal evidence], Box 1, untitled folder, GF PAPERS.

14. For a discussion of population and relative economic stagnation, see Roger Sale, *Seattle: Past to Present* (Seattle: University of Washington Press, 1976), 136–41.

15. TC 7 (15 June 1912): 6; and, for quotations, Dorothy Fay to Mrs. Edward Palmer (Muriel) York, 20 February 1915, CFG COLLECTION, CFG JR.

16. For quotations, Dorothy Fay to Mrs. York, 20 February 1915, CFG COLLECTION, CFG JR.; Dorothy (Mrs. A. Scott) Bullitt, conversation with T. William Booth, 8 February 1989; and later statements, Dorothy Fay Gould, interview by Carl F. Gould, Jr., February 1975, "Carl and Mother re Dad's Cars, etc.," CFG COLLECTION, Box 1, Acc. 3272–6, MUA.

17. Dorothy Fay to Mrs. York, 20 February 1915, CFG COLLECTION, CFG JR.

18. For the bungalow in Seattle, see Rob Anglin, "Briefing Paper on Bungalows in Seattle" (Seattle: City of Seattle, Department of Community Development, Office of Urban Conservation, 1982).

19. For the price of the lot, see job files, CFG COLLECTION, CFG JR. Scenes from the deck of Topsfield are in Gould's sketchbooks, ibid. Dorothy described the system in a letter to Richardson Wright, 24 July 1919, ibid.

20. Dorothy Fay [Gould] to Richardson Wright, 24 July 1919, CFG COLLECTION, CFG JR.

21. Gould to Newton D. Baker, 14 May 1917; and to Egerton Swartwout, 26 May 1917, CFG COLLECTION, CFG JR.

22. Gould applied for membership in 1913 and continued his membership for less than five years. The 1914 log cabin cost $2500. The Muir hut, now called the Guides' hut, apparently was a joint project of the Mountaineers and the National Park Service, CFG COLLECTION, CFG JR., and Ellen Gage, National Park Service, conversation with T. William Booth, Longmire, Washington, 1989.

23. The quoted letters are from a group, mostly undated, but written between late August and early October 1916, CFG COLLECTION, CFG JR.

24. Dorothy Gould to "My dear Mother," 13 January 1919, Box 1, untitled folder, GF PAPERS.

25. Dorothy Gould to "My dear Momma," n.d.; and "Dot" to [Annie], n.d. [probably 1919], ibid.

26. For the gift, E. A. Campbell interview by T. William Booth, 10 January 1989.

27. Dorothy Fay Gould interview, "Dad's Cars."

28. For the war memorial, see WSC, AIA, "Minutes, 1915–1919," meeting of 24 January 1919, 3:121–22; meeting of 4 March 1919, 3:162–63; "Minutes, 1920," meeting of 9 December 1920, 4:47; and Gould, "Report of Civic Design Committee on War Memorial," 20 December 1918, CFG COLLECTION, CFG JR. For the subdivision, see WSC, AIA, twenty-sixth annual meeting, 5 February 1921, Appendix O, "Report of the Committee on Community Planning," 4:139–40.

29. For Gould's nomination, see WSC, AIA, "Minutes, 1921," meeting of 9 December 1921, 5:51. For membership see "Minutes, 1922," 6:2–3. For Gould's running for office, see "Minutes, 1910–1914," meeting of 5 November 1913, 2:189. For slides, see "Minutes, 1922," meeting of 9 February 1922, 6:7. For art education, see ibid. For competitions, see "Minutes, 1923," meeting of 1 March 1923, 7:12. For civic design, see "Minutes, 1923," meeting of 12 January 1924, 7:57. For the press, see "Minutes, 1922," meeting of 27 January 1923, 6:50–51. For the Sunrise Addition, see "Minutes, 1923," meeting of 6 December 1923, 7:56. For the unprofessional conduct case, see Box 14/2.

30. WSC, AIA, "Minutes, 1922," 6:13.

31. Gould, "What Is the Architect Doing Toward Solving the Problems Now Before Him," PBE 10(14 December 1912): 439. For Van Brunt, see David F. Burg, *Chicago's White City of 1893* (Lexington; University Press of Kentucky, 1976), 260–61; and William A. Coles, ed., *Architecture and Society: Selected Essays of Henry Van Brunt* (Cambridge: Belknap Press of Harvard University Press, 1969), 319–27.

32. Richard W. Longstreth, "Academic Eclecticism in American Architecture," *Winterthur Portfolio: A Journal of American Material Culture* 17(Spring 1982): 55–82.

33. WSC, AIA, "Minutes, 1922," meeting of 27 January 1922, 6:46. For the articles, see Longstreth, "Academic Eclecticism," 74–77; and for California architecture, Esther McCoy, *Five California Architects* (New York: Reinhold Publishing Corporation, 1960).

34. WSC, AIA, "Minutes, 1922," meeting of 27 January 1923, 6:46.

35. Ibid., 46–47.

36. WSC, AIA, "Minutes, 1923," meeting of 1 March 1923, 7:13.

37. For the exhibition committee, see WSC, AIA, "Minutes, 1924–1925," meeting of 7 January 1926, 8:150, 153. For *Euclid v. Ambler*, see the standard Mel Scott, *American City Planning Since 1890* (Berkeley: University of California Press, 1969), 237–40. For zoning, see WSC, AIA, "Minutes, 1915–1919," meeting of 26 August 1919, 3:138. For Cheney's address and the endorsement, see WSC, AIA, meeting of 3 October 1919, 3: 141–42.

38. For the expansion campaign, see WSC, AIA, "Minutes, 1920," meeting of 4 November 1920, 3:45. For quotation, see ibid., "Minutes, 1924–25," meeting of 3 October 1924, 8:56. For the success, see ibid., meeting of 9–10 January 1925, 8:27.

39. For Gould's membership, see ibid., meeting of 9–10 January 1925, 8:27. For Gould's commission work, see E. L. Gaines to Gould, 14 December 1926, CFG COLLECTION, 5/13; and 5/16, Acc. 3273–5, MUA. For the cleanliness campaign, "Dot" to [Annie], n.d., Box 1, untitled folder, GF PAPERS.

40. Dorothy Gould to "My dear Mother," 13 January 1919, ibid. Gould all but rejected a return to New York in his letter to "Dearest Mother," 21 October 1929, CFG COLLECTION, CFG JR.

CHAPTER 5 At the Zenith: Campus Work, 1914–1926

1. Gould lecture notes, n.d., CFG COLLECTION, CFG JR.

2. Gould notes for Architecture 1 lecture, 14 December 1926, quoted in Norman J. Johnston, *Architectural Education at the University of Washington: The Gould Years* (Seattle: College of Architecture and Urban Planning, University of Washington, 1987), 5. Johnston relied mostly upon the material in the CFG COLLECTION, Acc. 3273–2, MUA.

3. Gould lecture notes, 21 September 1914, CFG COLLECTION, CFG JR. For the number of attendees, see WSC, AIA, "Minutes, 1910-1914," meeting of 12 May 1910, 2:20. For quotation see Gould's contribution to "Discussion" in "Architectural League of the Pacific Coast," *PBE* 16(23 August 1913): 100; and for the San Francisco competitions, ibid., 103. The students objected to the impracticality of some of the competitions and to the quality of the criticism, Ellis F. Lawrence to Gould, 1 November 1915; and Gould to Clarence Zantzinger, 3 December 1915, CFG COLLECTION, CFG JR.

4. Johnston, *Architectural Education*, 1–2. For first quotation, see WSC, AIA, "Minutes, 1910–1914," meeting of 6 March 1912, 2:102. For the presentation, see WSC, AIA, council meeting of 31 May 1912, 2:117.

5. WSC, AIA, council meeting of 31 May 1912, 2:117–18. Kane to Bebb, 6 June 1912, and other materials appended to the record of this meeting. For Gould quotation, see ibid., regular meeting of 5 June 1912.

6. Johnston, *Architectural Education*, 3. For quotation see Gould lecture and syllabus, n.d.[1913 from internal evidence], CFG COLLECTION, CFG JR.

7. Johnston, *Architectural Education*, does not cite any documents revealing why the regents chose Gould to head the department, and the authors know of none.

8. Warren C. Perry, "Teaching of Architecture on the Pacific Coast," *PBE* 16(23 August 1913): 97–99; and Gould's contribution to "Discussion," ibid., 100.

9. Johnston, *Architectural Education*, 18–20, 21, 25, 28–29.

10. Ibid. For quotation, see p. 48. For the moves, see p. 45.

11. Ibid., 38–39, 41, 47. For Chamberlain, see Chamberlain to Dorothy Gould, 9 May 1964, CFG COLLECTION, CFG JR. For Wurdeman, see Henry F. Withey and Elsie Rathburn Withey, *Biographical Dictionary of American Architects (Deceased)* (facsimile ed., Los Angeles: Hennessey & Ingalls, Inc., 1970), 674; and Adolf K. Placzek, ed., *Macmillan Encyclopedia of Architects* (New York: Free Press, 1982), 4:161. Elizabeth Ayer, who eventually established her own successful practice, was one of the university's best-known woman graduates; see Johnston, *Architectural Education*, 41, and Ayer (Edwin) Family Collection, Acc. 2020–2, –3, Boxes 1/1, 4/34, and 5/various folders, MUA. For Gould's eagerness to attract women during wartime, see Gould to Elizabeth Ayer, 9 September 1918; and 20 September 1918, CFG COLLECTION, CFG JR.

12. Johnston, *Architectural Education*, 38, 39. For quotation, see Gould to Lancelot Gowen, 1924, p. 36.

13. John V. Van Pelt to Gould, 12 June 1923, quoted in ibid., 29; and Gould to Suzzallo, 13 July 1923, quoted in ibid., 30. See also 27–37, 56.

14. Ibid., 43, n. 33; 36; and 47.

15. For the later nickname, "Gould, Carl Frelinghuysen," *Encyclopedia of Biography of New York*, 15. Dorothy to "my dear Mother," 13 January 1919, Box 1, untitled folder, GF PAPERS; and, for Ayer, see Ayer to Johnston, 27 February 1987, Vertical File 3981, MUA.

16. *Seattle Times,* 1 Mar. 1972, p. F1.

17. For salary, see Suzzallo to Gould, 28 May 1924, CFG COLLECTION, CFG JR. For accreditation, see Johnston, *Architectural Education,* 24, and p. 57 n. 19. The accreditation followed frustrating rejections during 1923 and 1924. See Clarence A. Martin to Gould, 5 April 1924; and Gould to D. Knickerbocker Boyd, 18 July 1924, CFG COLLECTION, CFG JR. For Walter R. B. Willcox's rejection of Beaux-Arts training at the University of Oregon, see David Shelman, "Freedom and Responsibility—the Educational Philosophy of Walter Willcox," in Don Genasci and Shelman, *W. R. B. Willcox (1869–1947): His Architectural and Educational Theory* (Eugene: Department of Architecture, University of Oregon, 1980), 19–33.

18. For some light on the formation of Bebb & Gould, see Arne Campbell to Carl F. Gould, Jr., 9 June 1982, CFG COLLECTION, CFG JR. The activities of the partners in relation to the University of Washington must be mostly conjectural in the absence of detailed documentation in boxes 19 and 20, U.W. Regents Records, Acc. 78–103, MUA. It is probable that Bebb was pursuing the planning or architect's commission at the time of the formation of Bebb & Gould.

19. Paul Venable Turner, *Campus: An American Planning Tradition* (Cambridge: MIT Press, 1984), 163–213; and for Gould's plan, 212–13.

20. Turner, *Campus,* 178–79, 206–207. Johnston, *Architectural Education,* 4. For quotation, see *TC* 9 (28 November 1914): 7. The university was well aware of the problem with the Exposition buildings; see "The President's Address," WA 8 (October 1914): 10. For Gould's characterization of Denny, see his "Architectural Character for the New Campus Buildings," to the President and Board of Regents, 21 January 1916, CFG COLLECTION, CFG JR. For a discussion of all university plans up to its publication date, see John Paul Jones, *The University of Washington Campus Plans, 1861–1940* (Seattle: University of Washington, 1940).

21. A summary of the committee report is in CFG COLLECTION, CFG JR. For problems with dating Gould's plan, see n. 18. The faculty and Board of Regents adopted the plan in June 1915, "Greater Washington," WA 8(August 1915): 11.

22. For quotation, see Gould to Darwin Meisenest, 25 February 1920, Box 35/8, Edmond S. Meany Papers, Acc. 106–70–12, MUA. For Gould's justification of the Gothic, see Gould, "Architectural Character for the New Campus Buildings," n. 20 above; and Gould, "The American University and Its Library Problem," *Architectural Forum* 44(June 1926): Pt. 2, 361.

23. For the regents' acceptance, see "University of Washington Plan," *PBE* 20 (24 July 1915): 33. For quotations, see Gould, "The Ultimate Library," WA 14(March 1922): 7; and Gould diary, 1 September 1926, CFG COLLECTION, CFG JR.

24. For quotations, see Gould, "Campus 'Functionalism,'" paper delivered to the Monday Club, 25 November 1935, CFG COLLECTION, CFG JR. For Gould's percentage, see "Office Financial Statements," CFG COLLECTION, CFG JR.

25. Suzzallo to H. C. Henry, 18 December 1918, File 111, Archives of the Museum of History and Industry, Seattle.

26. Gould, "Campus 'Functionalism,'" The count of stories includes a daylight story below the visual first floor.

27. Gould sketchbook, 1903, pp. 16, 17, CFG COLLECTION, CFG JR.

28. Sketches in CFG COLLECTION, SC.

29. Ibid.

30. Gould to Building and Grounds Committee, 15 January 1916, Box 51/1, U.W. Regents, Acc. 78–103, MUA. Disagreements within the committee led Suzzallo to disband it, see Gould to Gabriel Ferrand, 19 April 1921, CFG COLLECTION, CFG JR.

31. Gould, "The American University and Its Library Problem," 361, 366; and "The Ultimate Library," 7. Building and grounds committee, "Minutes," 17 January 1916, CFG COLLECTION, CFG JR.

32. Bebb to A. H. B. Jordan, 26 May 1926, Box 1/15, U.W. Regents, Acc. 78–103, MUA; and, for quotation, see Gould, "The American University and Its Library Problem," 361–62. See also Gould, "The Ultimate Library," 6.

33. Gould, "The American University and Its Library Problem," 363.

34. Leland M. Roth, *McKim, Mead & White, Architects* (New York: Harper & Row, 1983), 120.

35. For decorations and related decisions, see Suzzallo to the faculty, 23 November 1923 and

accompanying documents, Box 127/4, U.W. Regents, Acc. 71–34, MUA. See also Harry C. Bauer, "A Dominant Architectural Role," *WA* 41(Winter 1951): 9–10, 26; Gould, "The American University and Its Library Problem," 364; and "The New Library Now in Use," *WA* 18(February 1927):9. For quotation, see Gould to Joshua Green, 21 June 1926, CFG COLLECTION, CFG JR. Photographs of the Liverpool Cathedral are in J. Mordaunt Crook, *The Dilemma of Style: Architectural Ideas from the Picturesque to the Post-Modern* (Chicago: University of Chicago Press, 1987), 157; and George H. Cook, *The English Cathedral Through the Centuries* (London: Phoenix House, 1957), frontispiece. A discussion with plan is in Cook, 337–40.

36. For quotation, see Gould, "The Value and Function of Aesthetics in Library Design," paper to be delivered, possibly to the Monday Club, 15 March 1929, CFG COLLECTION, CFG JR. For the use of chevrons in Art Deco, see Frank Scarlett and Marjorie Townley, *Arts Décoratifs: A Personal Recollection of the Paris Exhibition* (New York: St. Martin's Press, 1975), 67, 92, 96–97.

37. For quotation, see Gould, "The Ultimate Library," 7. See also Gould, "The American University and Its Library Problem," 361, 365.

38. For the design limits on the card catalog area, see Bebb to Jordan, 26 May 1926, n. 32.

39. For the dimensions, see Gould, "The American University and Its Library Problem," 365. For "an instinctive attitude" quotation, see Gould diary, 27 August 1926, CFG COLLECTION, CFG JR. For "the impression of" quotation, see Gould diary, 1 September 1926. For "A more difficult" quotation, see Gould diary, 15 July 1926. See also Gould, "The New Library Now in Use," *WA* 18(February 1927): 4; and William E. Henry, ibid. For Gould on colors, see sketchbook, Bologna, 22 May 1903, CFG COLLECTION, CFG JR.

40. Campbell to Gould, Jr. (see n. 18 above). For "unity of impressions" and "have been worked" quotations, see Gould, "The New Library Now in Use," 9. For the "excellent" and "warmth" quotations, see "Pacific Northwest Now Boasts One of the Finest University Library Buildings of the World," *PBE* 33(7 May 1927): 30. For "The effect on" quotation, see Gould diary, 7 July 1926, CFG COLLECTION, CFG JR. See also Gould diary, 27 August 1926, ibid. For prevailing ideas of interior unity, see Leland Roth, *A Concise History of American Architecture* (New York: Harper & Row, 1979), 197–98, 208.

41. For the Harper, see Jean F. Block, *The Uses of Gothic: Planning and Building the Campus of the University of Chicago, 1892–1932* (Chicago: University of Chicago Press, 1983), 95–108.

42. For a complete discussion of Henry and his gallery, see Joseph N. Newland, ed., *Henry Art Gallery* (Seattle: Henry Gallery Association, 1986).

43. "Birds-Eye Perspective View of Campus, University of Washington, 5 November 1923," CFG COLLECTION, CFG JR. For the gallery, see Gould, "Horace C. Henry Gallery of the Fine Arts," *WA* 18(March 1927); 1–2. For Suzzallo's concerns, see Suzzallo to Gould, 2 February 1916, and other correspondence in Box 34/18, SAM PAPERS.

44. Gould, "Horace C. Henry Gallery," 2.

45. Gould diary, 7 September and, for quotation, 21 September 1926, CFG COLLECTION, CFG JR. For recognition of the Henry, see Lorimer Rich, "Planning Art Museums," *Architectural Forum* 47(December 1927): 591–92.

46. Gould, "Horace C. Henry Gallery," 2. For the Freer, see the floor plan in Morgan, *Charles A. Platt: The Artist as Architect* (Cambridge: MIT Press, 1985), 167.

47. Memorandum of Agreement, 23 March 1926, Box 28/13, U.W. Regents Records, Acc. 78–103, MUA.

48. For first quotation, see Johnston, *Architectural Education*, 52 (as in n. 2). For second quotation, see Charles M. Gates, *The First Century at the University of Washington, 1861–1961* (Seattle: University of Washington Press, 1961), 166.

49. Gates, *The First Century,* 167–70. For quotation, see "Duncan Isn't Done," *WA* 16(May 1925): 5.

50. Gould to Allan Clark, 18 January 1926, CFG COLLECTION, CFG JR. For Hartley's speech, see *Seattle Times,* 29 Oct. 1926, p. 1.

51. Jordan to Gould, 25 October 1926, copied in entry of 29 October 1926, Gould diary, CFG COLLECTION, CFG JR. For Gould's resignation, see *Seattle Times,* 1 Nov. 1926, p. 1.

52. WSC, AIA, "Minutes, 1926–27," 6:114, 115, 117. Bebb to Jordan, 26 May 1926, n. 32. For quotation, see Gould diary, CFG COLLECTION, CFG JR. For Gould and the recall, see Gould to Edward P. York, 30 November 1926, CFC COLLECTION, CFG JR.

53. Gould, "Library Building—Bellingham Normal School: Its Architecture," CFG COLLECTION, CFG JR.

54. Gould diary, 5 April 1928, CFG COLLECTION, CFG JR.

55. Bid list, *PBE* 36(15 February 1930), 28. See also Harold Kirker, *The Architecture of Charles Bulfinch* (Cambridge: Harvard University Press, 1969), 320, and Morgan, *Platt*, 183–94.

CHAPTER 6 Eclecticism in Commercial Buildings, Houses, and Churches, 1914–1926

1. Walter C. Kidney, *The Architecture of Choice: Eclecticism in America, 1880–1930* (New York: George Braziller, 1974), 2.

2. For first quotation, see Gould notes from a conference of the Associated Schools of Architecture, 26 May 1926, CFG COLLECTION, CFG JR. For the second quotation, see Kidney, *The Architecture of Choice*, 1.

3. Gould, "A dissertation on influences of precedent upon Archi. design," CFG COLLECTION, CFG JR. See also *PBE* 14 (16 November 1912), 397. For a discussion of historicist ideas in architecture, see J. Mordaunt Crook, *The Dilemma of Style: Architectural Ideas from the Picturesque to the Post-Modern* (Chicago: University of Chicago Press, 1987), especially the discussion of the problems of style, 98–132; and of eclecticism, 161–92.

4. T. William Booth, "Seattle in Search of Symbolic Expression: The Architecture of Bebb and Gould," in *Impressions of Imagination: Terra Cotta Seattle*, ed. Lydia Aldredge (Seattle: Allied Arts, 1986): 19–24.

5. CFG COLLECTION, SC; and CFG COLLECTION, CFG JR.

6. CFG COLLECTION, CFG JR. For quotations, see R. D. Merrill to Bebb & Gould, 4 June 1917, ibid.

7. Bryce P. Disque, *History of Spruce Production Division—U.S. Army & Spruce Production Division* (Portland, Oregon: 1920); and Gail H. Evans and T. Allan Comp, *Historic Resource Study for Olympic National Park, 1983* (Washington, D.C.: Department of the Interior, National Park Service, Pacific Northwest Region, Cultural Resources Division, 1983). See also T. William Booth, "Design for a Lumber Town by Bebb and Gould, Architects: A World War I Project in Washington's Wilderness," *PNQ* 82(October 1991): 132–39.

8. Disque, *History of Spruce Production Division*, iii, 19. See also Robert L. Tyler, *Rebels of the Woods: The I.W.W. in the Pacific Northwest* (Eugene: University of Oregon Press, 1967), 85–111: and Paul J. Martin, *Port Angeles, Washington: A History* (Port Angeles: City of Port Angeles, 1983), vol. 1, 51. SCK retained Bebb & Gould for the cost of the work plus a fee of 75 per cent of the cost. Bebb received a fee of $750 per month. Henry Bittman was structural consultant at the rate of $1.75 per hour. Bebb first spoke with SCK representatives on 16 June and went to Lake Pleasant the next day. Designing for the railroad and townsite began immediately, but the site for the mill was not determined until after 26 July. The total fee for Bebb & Gould amounted to about $3000. Bebb to SCK, 27 September 1918, CFG COLLECTION, CFG JR.

9. Thomas H. Mawson, *Civic Art: Studies in Town Planning, Parks, Boulevards, and Open Spaces* (London: B. T. Batsford, 1911); H. Inigo Triggs, *Town Planning: Past, Present, and Possible* (London: Methuen & Co., 1909), 217; and Raymond Unwin, *Town Planning in Practice: An Introduction to the Art of Designing Cities and Suburbs* (London: T. Fisher Unwin, 1913), 9. See also John S. Garner, ed., *The Company Town: Architecture and Society in the Early Industrial Age* (New York: Oxford University Press, 1992), especially Margaret Crawford, "Earle S. Draper and the Company Town in the American South," 139–72; and Leland M. Roth, "Company Towns in the Western United States," 173–205.

10. Harvey H. Kaiser, *Great Camps of the Adirondaks* (Boston: David R. Godine, 1982), 132.

11. See nn. 8, 10. See also job files, CFG COLLECTION, CFG JR.

12. SCK to Bebb, 25 October 1918; and Bebb to SCK, 30 October 1918, GOULD COLLECTION, CFG JR.

13. Alfred F. Hurley, *Billy Mitchell: Crusader for Air Power* (Bloomington: Indiana University Press, 1975), 32–33; John B. Rae, *Climb to Greatness: The American Aircraft Industry, 1920–1960* (Cambridge: MIT Press, 1968), 1–3; and George Soule, *Prosperity Decade: From War to Depression,*

1917–1929 (New York: Harper & Row, 1968; New York: Holt, Rinehart and Winston, 1947), 41–42.

14. U.S. Navy, Order no. 3407, entered on drawing dated November 1918. CFG COLLECTION, SC.

15. For example, see W. Hawkins Ferry, *The Legacy of Albert Kahn* (Detroit: Wayne State University Press, 1970), 106.

16. The buildings include Seattle East Office, Nineteenth Avenue and Pike Street (1926), Bremerton (1927; demolished), Longview (1928), Yakima (1929), Tacoma (1930), Olympia (1930), Centralia (1930), and Olympia (1936).

17. For the buff brick, see Gould to Chairman, Building Committee, Community Hotel Corporation of Seattle, 4 September 1923; for "personally" quotation, Gould to Post, 8 December 1924, CFG COLLECTION, CFG JR.

18. Chicago Tribune, *The International Competition for a New Administration Building* (Chicago, 1922), Plate 73. For additional information see T. William Booth, "Literary and Journalistic Towers: Seattle and Chicago, 1922," ARCADE 9(December 1989/January 1990):16–17, 24–25. An unattributed clipping in the CFG COLLECTION, CFG JR., assigns seventh place to Bebb & Gould.

19. The University Lutheran Chapel (1926) was demolished. The site plan was for a seminary. Other religious buildings Gould designed were the St. Barnabas Mission Church (Episcopal), 1932 Federal Avenue East (1920), and a Presbyterian church in Mt. Vernon (demolished). CFG COLLECTION, CFG JR.

20. Ibid.

21. Ibid.

22. From 1914 through 1925 Bebb & Gould designed seventy-two domestic projects, including remodels. Twenty-seven of the thirty-eight house projects were constructed, seven in The Highlands, and four at The Country Club on Bainbridge Island.

CHAPTER 7 Domestic Life, Late Houses, and Civic Involvement, 1926–1936

1. *Architect and Engineer* 69 (May 1922): 49.

2. See Chapter Four, n. 13.

3. Silvia Roberts Jones, niece of Dorothy Fay Gould, interview by T. William Booth, 5 February 1991.

4. Ibid. Gould to Dorothy, 4 January 1931, CFG COLLECTION, CFG JR. Dorothy's extravagance is detailed in bills from Frederick & Nelson and The Bon Marché, CFG COLLECTION, CFG JR.

5. Jones interview, 5 February 1991. *TC* 26(11 April 1931): 8. For quotation, see Gould, talk at the celebration of the twentieth anniversary of the founding of the University of Washington's Department of Architecture (1934), CFG COLLECTION, CFG JR. For Dorothy's literary activities, see Gould diary, 18 April 1937, CFG COLLECTION, CFG JR.

6. A club program for a horse show on 25–26 May 1928 lists Gould as a trustee and member of the show committee, CFG COLLECTION, CFG JR. For the clubhouse, see job files, CFG COLLECTION, CFG JR.

7. *The Book of SOYP* (Seattle, 1936) is a privately printed chronicle of the annual outings, beginning with 1919. For art classes, see Gould diary, 29 August 1931, CFG COLLECTION, CFG JR.; and Mary Willis Randlett, conversation with T. William Booth, 17 January 1992.

8. Victor Steinbrueck, *Seattle Cityscape* (Seattle: University of Washington Press, 1962), 161. See also Thomas Veith, "An Analysis of the Work of Arthur Loveless with an Emphasis on Human Aesthetic Responses" (Master's thesis, University of Washington, 1991).

9. The Krauss house is now the residence of the Canadian consul in Seattle. The design is similar to other projects of Gould's and to the work of a contemporary whose life was remarkably parallel to his own, Ellis Lawrence of Portland, Oregon. For Lawrence, see Michael Shellenberger, ed., *Harmony in Diversity: The Architecture and Teaching of Ellis Lawrence* (Eugene: University of Oregon Press, 1989).

10. E. A. Campbell, interview by T. William Booth, 10 January 1989. For Wurdeman's visits to this client, see John Park to Gould, 10 February 1931, CFG COLLECTION, CFG JR. All references to the original ownership of the house are removed at the request of the present owners.

11. Job files, CFG COLLECTION, CFG JR. For Boeing's problems, see Harold Mansfield, *Vision: A Saga of the Sky* (New York: Duell, Sloan and Pearce, 1956), 107, 108.

12. For education, see WSC, AIA, "Minutes, 1934–1935," meeting of 19 January 1935, 15:29; for institute affairs, see ibid., "Minutes, 1928–1929," 10:128; and for delegate, ibid., meeting of 7 July 1928, 10:11. For Frank Lloyd Wright, see "Minutes, 1931," meeting of 5 February 1931, 12:16; and for quotation, ibid., meeting of 22 October 1931, 12:67. For Wright's visit to Seattle, see Donald Leslie Johnson, "Frank Lloyd Wright in the Northwest: The Show, 1931," PNQ 78(July 1987): 104. For the meeting, see WSC, AIA, "Minutes, 1932," meeting of 20 February 1932, 13:7–8.

13. For first quotation, see WSC, AIA, "Minutes, 1930," 11:135. For Gould, see ibid., "Minutes, 1934–1935," meeting of 1 November 1934, 15:27; and his brief, ibid., 80–85. For second quotation, see ibid., "Minutes 1934–35," 15:32.

14. For the airport committee, see minutes, meeting of 27 July 1927, Box 5/23, CFG COLLECTION, Acc. 3273–5, MUA. For the quotation about the light standards, see minutes, meeting of 6 June 1927, Box 5/25, ibid. See also CFG COLLECTION, SC. For the planning commission, see WSC, AIA, "Minutes, 1931," 12:73–74.

15. CFG COLLECTION, CFG JR. Mel Scott, *American City Planning Since 1890* (Berkeley: University of California Press, 1969), 190.

16. Lehigh Portland Cement Company, *American Airport Designs* (New York, 1930), 75.

17. WSC, AIA, *Monthy Bulletin* 8(December 1928), in "Minutes, 1928–1929," 10:17; and "City Planning and Government," Box 6/1, CFG COLLECTION, Acc. 3273–5, MUA.

18. For the Pochet Club, see Acc. 3747, Box 1/folder General Correspondence 1929–30; and Box 1/folder Miscellany, MUA. Dorothy promoted Gustin in a lengthy fine arts column published under her byline, attributed to the *Seattle Star,* early in 1922, CFG COLLECTION, CFG JR. Direct evidence for Gould's activities on Gustin's behalf, other than information from Carl F. Gould, Jr., is lacking. Gould's sympathy for artists is evident in his letter to Gustin, 2 March 1925. Gould refers to Gustin's European journey in a 20 April 1925 letter. Among several letters to Clark, see 20 April 1925, all in CFG COLLECTION, CFG JR.

19. For quotation, see *Argus* 42(28 September 1935): 4.

20. WSC, AIA, "Minutes, 1936," meeting of 5 November 1936, 16:116; Gould diary, 18 April 1937; and Gould to Paul Bacon, 28 October 1936, both in CFG COLLECTION, CFG JR. For the school, see Isabelle Gournay, "Architecture at the Fontainebleau School of Fine Arts, 1923–1939," *Journal of the Society of Architectural Historians* 45(September 1986): 270–85 (quotation, 271).

21. For a general discussion of the society, the museum, and artistic developments, see Richard C. Berner, *Seattle in the 20th Century: Seattle 1921–1940: From Boom to Bust* (Seattle: Charles Press, 1992), 251–56. For first quotation, see copy of Anne Calhoun, *A Seattle Heritage: The Fine Arts Society* (Seattle: Lowman & Hanford Co., 1942), notation on 102, now in the possession of T. William Booth. For membership, see minutes of quarterly meeting, 14 January 1926, Box 34/3, SAM PAPERS. For the Henry house, see President's Report, 17 April 1928, Box 1/3, SAM PAPERS; Calhoun, *Seattle Heritage,* 79; and Gould diary, 15 November 1927, CFG COLLECTION, CFG JR. For the Junior Fine Arts, see Calhoun, *Seattle Heritage* 76, 81; and for Dorothy's role, see her marginal notation on 76. For the social rejuvenation, see Calhoun, *Seattle Heritage,* 77, 81–82. For second quotation, John Davis Hatch to [identity unknown], probably 1931, Box 31/1, SAM PAPERS. For the name change, see Gould, note of 19 December 1928, Box 31/2, SAM PAPERS; For Gould's belief, see Mrs. Farley D. McLouth to Laurence Vail Coleman, 23 February 1928, Box 35/1, SAM PAPERS.

22. For the termination, see Box 31/4, SAM PAPERS. See also Box 35/6; and Box 1/1, CFG COLLECTION, Acc. 3273–4, MUA.

23. For the Northwest Annual, see Calhoun, *Seattle Heritage,* 88.

24. For Gould's insistence on a museum, see McLouth to Coleman, n. 21. For Fuller's first appearance on the board, see Calhoun, *Seattle Heritage,* 103. For Fuller's $1000 donation, see Gould to Board of Directors, Seattle Fine Arts Society, 28 July 1928, Box 35/8, SAM PAPERS. For Fuller's gift of $250,000, see "Fuller Donation," *Town Crier* 26(3 October 1931): 11; and a preliminary announcement signed by Fuller and his mother, minutes of the board of directors, 1 October 1931, SAM archives, Seattle Art Museum.

CHAPTER 8 Modern Architecture, 1926–1938

1. Paper on "Modernism," probably prepared for the Monday Club, n.d., CFG COLLECTION, CFG JR.

2. For modernism in its relation to regionalism, see Martha Kingsbury, *Art of the Thirties: The Pacific Northwest* (Seattle: Henry Art Gallery and University of Washington Press, 1972), 13, 21.

3. Gould "Modernism," CGF COLLECTION, CGF JR.

4. A much-copied neoclassical base is McKim's, for the Shaw Memorial, Boston (completed 1897).

5. The club's account of the addition is in [Walt Crowley], *The Rainier Club, 1888–1988* (Seattle, 1988), 39–42.

6. Gould diary, 16 February 1931, CFG COLLECTION, CFG JR. Cumming to Bebb & Gould and John Graham, 20 January 1933, CFG COLLECTION, CFG JR. For the landmark nomination prepared by T. William Booth, see the files of the Seattle Historic Landmark Board, Office of Urban Conservation. "U.S. Marine Hospital, Seattle, Wash.," *American Architect* 147(November 1935): 29–31, 33.

7. Gould diary, 31 August 1931, CFG COLLECTION, CFG JR; and "U.S. Marine Hospital, Seattle, Wash.," 33.

8. Gould to Dorothy, 3 November 1930; 11 November 1930 [misdated 1931]; and 13 November 1930, CFG COLLECTION, CFG JR. For "I am" quotation, see Gould diary, 16 February 1931, CFG COLLECTION, CFG JR. Gould and Graham agreed that Graham would lead the next public job, which was the Longview Post Office; E. A. Campbell, interview by T. William Booth, 10 January 1989.

9. Gould to Dorothy, 13 November 1930, CFG COLLECTION, CFG JR. Gould diary, 16 February 1931, CFG COLLECTION, CFG JR.

10. For the first quotation, see Kenneth Callahan, "Utopian Museum," TC 26(7 October 1931): 14; for the second quotation, his article "Future Museum," TC 26(5 December 1931): 34. Callahan, a regular contributor to TC, wrote several items about the museum, for example "A New Art Institute," 26(28 March 1931): 15. For a review of SAM, see Laura Leanne Burns, "The Architectural Development of the Seattle Art Museum: A Historical Perspective," M.A. thesis, University of Washington, 1983.

11. Ordinance 61998, copy, passed by the city council 7 December 1931, Box 31/2, SAM PAPERS.

12. For quotation, see Gould to Dorothy, 16 December 1931, CFG COLLECTION, CFG JR. For Gould's belief, see letter to Dorothy, 5 November 1930, CFG COLLECTION, CFG JR.

13. CFG COLLECTION, SC.

14. For a detailed discussion of the design development of the museum, see T. William Booth, "The Man, the Moment, and the Museum," [Seattle] *Weekly* (20–26 November 1986): 30–35, 38–41. Board decisions may be followed in the minutes in the archives of the Seattle Art Museum.

15. Fuller, "Annual Report to the Board of Trustees, 1932–1933," in *Annual Report of the Art Institute of Seattle, 1932–1933* (Seattle, 1933).

16. For Coleman's being retained, see "Annual Report of the President," in *Annual Report of the Art Institute of Seattle, 1930–1931* (Seattle, 1931), 31. See also Burns, "The Architectural Development of the Seattle Art Museum," 19, 20, 25.

17. Box 31/4, SAM PAPERS. For the resignation, see "Annual Report of the President," *in Annual Report, 1930–1931*, 12.

18. Callahan, "Future Museum," 35.

19. Minutes of trustees' meeting, 9 February 1932, SAM PAPERS. Gould's clipped corners and the detailing of his grilles bear a striking resemblance to features on John Graham's Exchange Building (1930), located in the same block as Gould's office in the Hoge Building. The Freer Gallery was another precedent. See Lorimer Rich, "Planning Art Museums," *Architectural Forum* 47(December 1927): 558. See also Richard F. Bach, "Modern Museum—Plan & Functions," *Architectural Record* 62(December 1927): 475. For other sources for the grilles and additional decorations, see *Encyclopédie des Arts Décoratifs et Industriels Moderns au XXième Siècle* (reprint ed., New York: Garland Publishing Co., 1977), 2: pl. 63; and 3: pl. 16.

20. For costs and bids, see Box 2/1–5, CFG COLLECTION, Acc. 3273–4, MUA.

21. Fuller, "Annual Report to the Board of Trustees, 1932–33." For Gould's defense of his profit,

see Gould to "Dear Dick," 16 August 1935, Box 1, folder General Correspondence 1935, SAM PAPERS; and for letter to Anne, Box 3/1, AGH PAPERS. For the crowd, see Burns, "The Architectural Development of the Seattle Art Museum," 39. For an example of national attention, see *Boston Evening Transcript*, 12 July 1933, clipping in CFG COLLECTION, CFG JR.

22. Laurence Vail Coleman, *Museum Buildings* (Washington, D.C.: American Association of Museums, 1950), 3, 5, 35, 57, 98. Kingsbury, *Art of the Thirties*, 21. See also Burns, "The Architectural Development of the Seattle Art Museum," 39–40.

23. Candace Jean Kern, "The Penthouse Theatre," edited by Susan Boyle, in *The Penthouse Theatre Relocation Study* (Seattle: Boyle-Wagoner Architects, 1989), 2–12. A copy is in the office of the campus architect, University of Washington.

24. Ibid. Gould, "Portfolio of Architectural Plates of Douglas Fir Plywood Paneling," *Architect and Engineer* 134 (September 1938): 45–53. See also Jaroslav Andel, Stephen Bann, Hal Foster, et al., *Art into Life* (New York: Rizzoli, 1990). For the WSC's criticism, see *University of Washington Daily*, 4 Nov. 1938, clipping in CFG COLLECTION, CFG JR.

CHAPTER 9 The Great Depression and a Life in Architecture

1. Gould to Anne, n.d., Box 3/14, AGH PAPERS.

2. Gould to Suzzallo, 18 June 1930, Box 37/8, Henry Suzzallo Papers, Acc. 48–70–76; Higgins to Ferry K. Heath, 13 November 1930, Box 5/9, CFG COLLECTION, Acc. 3273–5; and May to Ferry K. Heath, 24 December 1930, Box 75/22, Merrill & Ring Lumber Company Papers, Acc. 726, all in MUA. William H. Mullins demonstrates in *The Depression and the Urban West Coast, 1929–1933: Los Angeles, San Francisco, Seattle, and Portland* (Bloomington: Indiana University Press, 1991) that the economic depression was at least as serious in Seattle and the other cities he studies as it was elsewhere. See the statement of his thesis, 7–13.

3. Gould to Suzzallo, 18 June 1930, Box 37/8, Henry Suzzallo Papers, Acc. 48–70–76, MUA. For the hotel, see Victor Steinbrueck, *Seattle Cityscape* (Seattle: University of Washington Press, 1962), 90.

4. Resolution of 28 July 1934, Box 3/29, U.W. Regents Records, Acc. 78–103, MUA. For PWA problems, see John Paul Jones, office memorandum, 27 January 1937, CFG COLLECTION, CFG JR.

5. For quotations see Gould diary, 1 November 1934; and for buildings, see Gould diary, 18 April 1937, CFG COLLECTION, CFG JR. See also job files, CFG COLLECTION, CFG JR.

6. Bauer, "A Dominant Architectural Role," WA 41(Winter 1951): 10, 26.

7. For the campus plan revision, see Gould diary, 1 November 1934, CFG COLLECTION, CFG JR. For the PWA, see Gould, "The Campus of a Thousand Years," 8 March 1938, CFG COLLECTION, CFG JR.

8. Villesvik, telephone interview by Booth, 28 June 1985. For restoration and addition to Everett library, see Heidi Landecker, "Depression Modern," *Architecture* (December 1992): 54–57.

9. Villesvik, telephone interview by Booth, 28 June 1985.

10. Gould to "Dearest Anne,"— February 1938, Box 3/8, AGH PAPERS.

11. For Gould's activity, see Box 2/General Correspondence 1937, F-G, SAM PAPERS. For Fuller's control, see Sue Ann Kendall, "50 Years," *Pacific* [magazine of the *Seattle Times* and *Seattle Post-Intelligencer*] (26 June 1983): 17. For the fellowship award, see WSC, AIA, "Minutes, 1934–1935," meeting of 6 September 1934, 15:16. For the Oregon competition, see Box 6/10, 24, CFG COLLECTION, Acc. 3273–5, MUA; Roi L. Martin, "The Oregon Competition in Retrospect: Minutes of Jury Show Unusual Deliberations," *Architect and Engineer* 127(November 1936): 11–36; and Walter H. Thomas, "Oregon State Capitol Competition: Some Remarks Concerning Its Results," *Pencil Points* 17(July 1936): 353–74. Complete documentation of the competition is in the Oregon State Archives, Salem. For the PWA, "Minutes, 1937," meeting of 19 June 1937, 17:28; and for unionization, WSC, AIA, meeting of 1 April 1937, 17:28. For Mumford, see "Minutes, 1938," vol. 18, Report of the Committee on Civic Design and Planning, 28 January 1939, 1. For the Architectural League exhibit, see "Minutes, 1938," meeting of 8 April 1938, 18:16; and board meeting of 20 April 1938, 18:109. For the Oregon meeting, see meeting of 6 November 1938, 18:29; and 18:155.

12. Gould diary, 18 April 1937, CFG COLLECTION, CFG JR.

13. Ibid.

14. For quotation, see ibid., 205.

15. For borrowing, see Gould to Dorothy, 7 November 1930, CFG COLLECTION, CFG JR. For debts, see Canadian Bank of Commerce, copy of creditor's claim, n.d., CFG COLLECTION, CFG JR. For real estate, see Lemuel Skidmore to Gould, n.d. [ca. March 1934]; and Aubrey V. Gould to Gould, 8 April 1937, both in CFG COLLECTION, CFG JR. For Gould family finances, see Box 1, GF PAPERS.

16. Gould to Suzzallo, 18 June 1930, Box 37/8, Henry Suzzallo Papers. Gould diary, 1 November 1934, CFG COLLECTION, CFG JR. For Bebb's arm, see Bebb to Gould, 7 April 1936, CFG COLLECTION, CFG JR. "Carl & Mother re Dad's Cars, etc.," February 1975, Box 1, Dorothy Fay Gould, interview by Carl F. Gould, Jr., CFG COLLECTION, Acc. 3273-6, MUA. For Dorothy's beliefs, see her letters to "Dear Robert," 11 December 1938, and to "My Dear Robert," 30 December 1938, Box 1, GF PAPERS.

17. 12 April 1935, Box 3/3, AGH PAPERS.

18. WSC, AIA, *Monthly Bulletin* (January 1939): 3, in "Minutes, 1939," 19:233; *Argus* 46(7 January 1939): 3; and *P-I* 5 Jan. 1939, p. 1. Gould was diagnosed as having nephritis, a general condition rather than a specific ailment, for which he had been hospitalized since mid-October 1938. Alex Oxholm to Bebb and Gould, 28 October 1938; and J. C. Flippin to Dorothy Gould, 28 December 1938, both in CFG COLLECTION, CFG JR.

19. For the Wheaton College competition, see *Architectural Forum* 65(July 1936): 2–11; and 69(August 1938): 143–58; Talbot F. Hamlin, "Competitions," *Pencil Points* 19(September 1938): 551–63; and James D. Kornwolf, ed., *Modernism in America 1937–1941: A Catalog and Exhibition of Four Architectural Competitions* (Williamsburg, Virginia: College of William and Mary, 1985), 23–40.

20. For Wright's clients, see Leonard K. Eaton, *Two Chicago Architects and Their Clients: Frank Lloyd Wright and Howard Van Doren Shaw* (Cambridge: MIT Press, 1969), 67–133; for Shaw, see ibid., 137–236. For Staub, see Howard Barnstone, *The Architecture of John F. Staub: Houston and the South* (Austin: University of Texas Press, 1979).

21. Gould to Tom Fransioli, 9 November 1931, CFG COLLECTION, CFG JR.

22. Meredith L. Clausen, "Paul Thiry: The Emergence of Modernism in Northwest Architecture," PNQ 75(July 1984): quotations, 132 n. 9, and 129. See Steinbrueck, *Seattle Cityscape*, for a sketch of a Willatsen house, 161, and sketches of Thiry, Sproule, and Jacobsen houses, 163. Thiry lived his last years in Gould's Dovey residence and made some incongruous alterations inside and an addition on the west side.

23. *Times*, 1 Mar. 1972, p. F1; and *Times* and *P-I*, 2 Nov. 1986, p. B11.

24. *Times,* 11 May 1980, p. F14.

25. Sylvia Jones, interview by T. William Booth, 5 February 1991. Gould to Anne, 14 May 1934, Box 3/2, AGH PAPERS.

BIBLIOGRAPHY

Manuscript Sources

The indispensable source for a study of Carl F. Gould is the material in the possession of his son Carl F. Gould, Jr., at the time of the latter's death in 1992. This uninventoried collection, gathered in many cardboard boxes, contains the personal correspondence of Carl Gould and his wife Dorothy Wheaton Fay Gould. The Gould family systematically saved Carl's correspondence from his student days in Paris, while Gould made copies of many personal letters after his permanent move to Seattle in 1908. Dorothy preserved most of Carl's letters to her. Dorothy's correspondence is less full but includes letters saved by Carl or other family members, or copies made by her, from the time of her engagement to Carl in 1914 until after his death in 1939. Some letters from Gould family members contain family news or refer to the family's declining fortunes during the Great Depression. Other related items are Gould's watercolors, sketchbooks, lecture notes, and a diary that he kept intermittently in journal form. We refer to all of this material as the "CFG COLLECTION, CFG JR." Carl, Jr., also possessed much office correspondence of a professional nature, the office files, and a group of files organized by commission, the job files.

The Manuscripts and University Archives, University of Washington Libraries, house many important papers. Chief among them are the Carl F. Gould collections, including papers related to his academic career at the University of Washington and to his public service. A third collection consists of Dorothy Gould's interviews by Carl, Jr., and other taped material. Dorothy's recollections of her husband are not always accurate or precise but are revealing of both of them. The Gould Family Papers are described by their title. The Anne Gould Hauberg Papers show that Carl was a concerned, loving, and protective parent. The Seattle Art Museum Papers are important to understanding the development of Gould's museum design. The Records of the Regents of the University of Washington and the Henry Suzzallo Papers help in the understanding of Gould's relationships with the university. The papers of the Monday Club, the Municipal League, the Pochet Club, and the Records of the Washington State Chapter, American Institute of Architects, especially the latter, throw light on Gould's career. The Ayer (Edwin) Family Collection illuminates the life of one of Gould's students, Elizabeth Ayer, while Vertical File 3981 contains Miss Ayer's reminiscence of Carl. The Merrill & Ring Lumber Company Papers include a few useful items.

The Special Collections and Preservation Division houses a large, carefully arranged collection of Gould's drawings, elevations, sketches, and other graphic materials, as well as a folder in the Architects' Reference File concerning Gould's celebrated contemporary Ellsworth Storey. Elsewhere in Seattle, the archives of the Seattle Art Museum supplement the museum papers at the university archives. The archives of the Museum of History and Industry include a valuable Henry Suzzallo letter. Various interviews by T. William Booth, including those with E. A. Campbell and John S. Villesvik, are in the authors' possession.

Gould's course records are in the Harvard University Archives at Harvard's Lamont Library, Cambridge, Massachusetts. Of the New York City archives potentially containing information about Gould, two yielded a little: the George B. Post Staff List and Pay Ledger, in the Department of Prints, Photographs and Architecture, New-York Historical Society, and Collection 2.3.D, concerning the new campus of the Union Theological Seminary, in the archives of that institution.

Books, Chapters in Books, Encyclopedia Articles, and Other Studies

A.I.A.—*Small House Service Bureau of the U.S.A., Inc., Houses.* New York: Architectural League, 1925.
Aldredge, Lydia, ed. *Impressions of Imagination: Terra Cotta Seattle.* Seattle: Allied Arts, 1986.
Andel, Janoslav, Stephen Bann, Hal Foster, Selim O. Kahn Magomedov, Christina Lodder, Anatole
 Senkevich, Jr., Anatolii Stringalev, and Owen Smith. *Art into Life.* New York: Rizzoli, 1990.
Anderson, Carl W. *George Eastman.* Boston: Houghton Mifflin, 1930.
Anglin, Rob. "Briefing Paper on Bungalows in Seattle." Seattle: City of Seattle, Department of Com-

munity Development, Office of Urban Conservation, 1982.

Annual Report of the Art Institute of Seattle, 1930–1931. Seattle, 1931.

Aslet, Clive. *The American Country House.* New Haven: Yale University Press, 1990.

Bacon, Mardges. *Ernest Flagg: Beaux-Arts Architect and Urban Reformer.* Cambridge: MIT Press, 1986.

Bagley, Clarence B. "Carl Frelinghuysen Gould." In *History of King County Washington.* Vol. 2. Chicago: S. J. Clarke Publishing Company, 1929.

————. *History of King County Washington.* Vol. 2. Chicago: S. J. Clarke Publishing Company, 1929.

————. *History of Seattle from the Earliest Settlement to the Present Time.* Vol. 3. Chicago: S. J. Clarke Publishing Company, 1916.

Baker, Paul R. *Richard Morris Hunt.* Cambridge: MIT Press, 1980.

Banham, Reyner: *A Concrete Atlantis: U.S. Industrial Building and European Modern Architecture, 1900–1925.* Cambridge: MIT Press, 1986.

Barbara, Dominick A. *The Psychodynamics of Stuttering.* Springfield, Ill.: Charles C. Thomas, 1982.

Barnstone, Howard. *The Architecture of John F. Staub: Houston and the South.* Austin: University of Texas Press, 1979.

Bastié, Jean. "Paris: Baroque Elegance and Agglomeration." In *World Capitals: Toward Guided Urbanization,* edited by H. Wentworth Eldredge. Garden City, N.Y.: Anchor Doubleday, 1975.

Bebb & Mendel. *Seattle Architecturally.* Seattle, 1902.

————. *The Work of Bebb & Mendel, Architects.* Seattle, 1906.

Berner, Richard C. *Seattle in the 20th Century.* Vol. 1, *Seattle, 1900–1920: From Boomtown, Urban Turbulence, to Restoration.* Seattle: Charles Press, 1991. Vol. 2, *Seattle, 1921–1940: From Boom to Bust.* Seattle: Charles Press, 1992.

Block, Jean F. *The Uses of Gothic: Planning and Building the Campus of the University of Chicago, 1892–1932.* Chicago: University of Chicago Press, 1983.

Bloodstein, Oliver. *A Handbook on Stuttering.* 3d ed. Chicago: National Easter Seal Society, 1981.

Bluestone, Daniel M. *Constructing Chicago.* New Haven: Yale University Press, 1991.

Bogle, Lawrence, A. Scott Bullitt, Caspar W. Clarke, and Hamilton C. Rolfe, eds. "The Highlands." Seattle, 1931.

Bogue, Virgil G. *Plan of Seattle: Report of the Municipal Plans Commission Submitting Report of Virgil G. Bogue, Engineer, 1911.* Seattle: Lowman & Hanford Co., 1911.

The Book of SOYP. Seattle, 1936 (privately published).

Booth, T. William. "Seattle in Search of Symbolic Expression: The Architecture of Bebb and Gould." In *Impressions of Imagination: Terra Cotta Seattle,* edited by Lydia Aldredge. Seattle: Allied Arts, 1986.

Boutelle, Sara Holmes. *Julia Morgan, Architect.* New York: Abbeville Press, 1988.

Boyle, Susan. "Landmark Nomination Form: The Lake Union Power Plants." Seattle: City of Seattle, Department of Community Development, Office of Urban Conservation, 1987.

————, ed. *The Penthouse Theatre Relocation Study.* Seattle: Boyle-Wagoner Architects, 1989.

Burg, David F. *Chicago's White City of 1893.* Lexington: University Press of Kentucky, 1976.

Burnham, Daniel H., assisted by Edward H. Bennett. *Report on a Plan for San Francisco: Presented to the Mayor and the Board of Supervisors by the Association for the Improvement and Adornment of San Francisco.* San Francisco: City of San Francisco, 1906.

Burns, Laura Leanne. "The Architectural Development of the Seattle Art Museum: A Historical Perspective." Master's thesis, University of Washington, 1983.

Calhoun, Anne H. *A Seattle Heritage: The Fine Arts Society.* Seattle: Lowman & Hanford Co., 1942.

Cardwell, Kenneth H. *Bernard Maybeck: Artisan, Architect, Artist.* Santa Barbara: Peregrine Smith, 1977.

Chicago Tribune. *The International Competition for a New Administration Building.* Chicago: 1922.

Chafee, Richard. "The Teaching of Architecture at the Ecole des Beaux-Arts." In *Architecture of the Ecole des Beaux-Arts,* edited by Arthur Drexler. New York: Museum of Modern Art, 1977.

Coleman, Lawrence Vail. *Museum Buildings.* Washington, D.C.: American Association of Museums, 1950.

Coles, William, ed. *Architecture and Society: Selected Essays of Henry Van Brunt.* Cambridge: Belknap Press of Harvard University Press, 1969.

Collins, Peter. *Concrete: The Vision of a New Architecture: A Study of Auguste Perret and His Precursors.* New York: Horizon Press, 1959.

Cook, George H. *The English Cathedral Through the Centuries.* London: Phoenix House, 1957.

Cooper, Judith, ed. *Research Needs in Stuttering: Roadblocks and Future Directions.,* Rockville, Md.: American Speech-Language-Hearing Association, 1990.

Crawford, Margaret. "Earle S. Draper and the Company Town in the American South." In *The Company Town: Architecture and Society in the Early Industrial Age,* edited by John S. Garner. New York: Oxford University Press, 1992.

Crook, J. Mordaunt. *The Dilemma of Style: Architectural Ideas from the Picturesque to the Post-Modern.* Chicago: University of Chicago Press, 1987.

[Crowley, Walt]. *The Rainier Club, 1888–1988.* Seattle, 1988.

Diehl, Lorraine B. *The Late, Great Pennsylvania Station.* New York: American Heritage, 1985.

Disque, Bryce P. *History of Spruce Production Division—U.S. Army & Spruce Production Division.* Portland, Oregon, 1920.

Draper, Joan E. *Edward H. Bennett: Architect and City Planner, 1874–1954.* Chicago: Art Institute of Chicago, 1982.

———. "The Ecole des Beaux-Arts and the Architectural Profession in the United States: The Case of John Galen Howard." In *The Architect: Chapters in the History of the Profession,* edited by Spiro Kostof. New York: Oxford University Press, 1977.

Drexler, Arthur, ed. *The Architecture of the Ecole des Beaux-Arts.* New York: Museum of Modern Art, 1977.

Eaton, Leonard K. *Two Chicago Architects and Their Clients: Frank Lloyd Wright and Howard Van Doren Shaw.* Cambridge: MIT Press, 1969.

Eldredge, H. Wentworth, ed. *World Capitals: Toward Guided Urbanization.* Garden City, N.Y.: Anchor Doubleday, 1975.

Encyclopédie des Arts Décoratifs et Industriels Modernes au XXième Siècle. Vols. 2, 3. Reprint. New York: Garland, 1977.

Erikson, Erik H. *Identity: Youth and Crisis.* New York: W.W. Norton & Company, 1968.

Evans, Gail H., and T. Allan Comp. *Historic Resource Study for Olympic National Park, 1983.* Washington, D.C.: Department of the Interior, National Park Service, Pacific Northwest Region, Cultural Resources Division, 1983.

Evenson, Norma. *Paris: A Century of Change, 1878–1978.* New Haven: Yale University Press, 1986.

Ferry, W. Hawkins. *The Legacy of Albert Kahn.* Detroit: Wayne State University Press, 1970.

Garner, John S., ed. *The Company Town: Architecture and Society in the Early Industrial Age.* New York: Oxford University Press, 1992.

Gates, Charles M. *The First Century at the University of Washington, 1861–1961.* Seattle: University of Washington Press, 1961.

Genasci, Don. "Walter Willcox—the Relation of Architecture to Society," in Don Genasci and David Shelman, *W.R.B. Willcox (1869–1947): His Architectural and Educational Theory.* Eugene: Department of Architecture, University of Oregon, 1980.

———, and David Shelman. *W.R.B. Willcox (1869–1947): His Architectural and Educational Theory.* Eugene: Department of Architecture, University of Oregon, 1980.

Girouard, Mark. *The Victorian Country House.* New Haven: Yale University Press, 1990.

"Gould, Carl Frelinghuysen" In *Encyclopedia of Biography of New York.* Page proofs.

"Gould, Charles Judson." In *Encyclopedia of Biography of New York.* Page proofs.

"Gould, Mrs. Annie (Westbrook)." In *Encyclopedia of Biography of New York.* Page proofs.

Harvard College Class of 1898: Quindecennial Report. Cambridge, 1913.

Harvard College Class of 1898: Twenty-Fifth Anniversary Report, 1898–1923. Cambridge: Privately printed, 1923.

Hewitt, Mark Alan. *The Architect and the American Country House, 1890–1940.* New Haven: Yale University Press, 1990.

Hines, Neal O. *Denny's Knoll: A History of the Metropolitan Tract of the University of Washington.* Seattle: University of Washington Press, 1980.

Hines, Thomas S. *Burnham of Chicago: Architect and Planner.* New York: Oxford University Press, 1974.

Hitchcock, Henry-Russell, and William Seale. *Temples of Democracy: The State Capitols of the USA.* New York: Harcourt Brace Jovanovich, 1976.

Hurley, Alfred F. *Billy Mitchell: Crusader for Air Power.* Bloomington: Indiana University Press, 1975.

Johnston, Norman J. *Architectural Education at the University of Washington: The Gould Years.* Seattle: College of Architecture and Urban Planning, University of Washington, 1987.

_____ *Washington's Audacious State Capitol and Its Builders.* Seattle: University of Washington Press, 1988.

Jonas, Gerald. *Stuttering: The Disorder of Many Theories.* New York: Farrar, Straus and Giroux, 1977.

Jones, John Paul. *The University of Washington Campus Plans, 1861–1940.* Seattle: University of Washington, 1940.

Jordy, William H. *American Buildings and their Architects: Progressive and Academic Ideals at the Turn of the Century.* Garden City, N.Y.: Doubleday & Company, 1972.

Kahn, Judd. *Imperial San Francisco: Politics and Planning in an American City, 1897–1906.* Lincoln: University of Nebraska Press, 1979.

Kaiser, Harvey H. *Great Camps of the Adirondacks.* Boston: David R. Godine, 1982.

Kelly, Bruce, Gail Travis Guillet, and Mary Ellen W. Hearn, eds. *Art of the Olmsted Landscape.* New York: New York City Landmarks Preservation Commission, 1981.

Kern, Candace Jean. "The Penthouse Theatre." In *The Penthouse Theatre Relocation Study*, edited by Susan Boyle. Seattle: Boyle-Wagoner Architects, 1989.

Kidney, Walter C. *The Architecture of Choice: Eclecticism in America, 1880–1930.* New York: George Braziller, 1974.

Kingsbury, Martha. *Art of the Thirties: The Pacific Northwest.* Seattle: Henry Art Gallery and University of Washington Press, 1972.

Kirker, Harold. *The Architecture of Charles Bulfinch.* Cambridge: Harvard University Press, 1969.

Kornwolf, James D., ed. *Modernism in America, 1937–1941: A Catalog and Exhibition of Four Architectural Competitions.* Williamsburg: College of William and Mary, 1985.

Kostof, Spiro, ed. *The Architect: Chapters in the History of the Profession.* New York: Oxford University Press, 1977.

Kreisman, Lawrence. *The Stimson Legacy: Architecture in the Urban West.* Seattle: Willows Press, 1992.

Lacey, Adin Bennett, ed. *American Competitions, 1907.* Philadelphia: T Square Club, 1907.

Landau, Sarah Bradford. "Richard Morris Hunt: Architectural Innovator and Father of a 'Distinctive' American School." In *The Architecture of Richard Morris Hunt,* edited by Susan R. Stein. Chicago: University of Chicago Press, 1986.

Lehigh Portland Cement Company. *American Airport Designs.* New York, 1930.

Levine, Neil. "The Romantic Idea of Architectural Legibility: Henri Labrouste and the Neo-Grec." In *Architecture of the Ecole des Beaux-Arts,* edited by Arthur Drexler. New York: Museum of Modern Art, 1977.

Lewis, Richard R. B. *Edith Wharton: A Biography.* New York: Harper & Row, 1975.

Longstreth, Richard W. *On the Edge of the World: Four Architects in San Francisco at the Turn of the Century.* Cambridge, MIT Press, 1983.

McCoy, Esther. *Five California Architects.* New York: Reinhold Publishing Corporation, 1960.

MacDonald, Norbert. *Distant Neighbors: A Comparative History of Seattle & Vancouver.* Lincoln: University of Nebraska Press, 1987.

McKim, Mead & White. *The Architecture of McKim, Mead & White in Photographs, Plans and Elevations.* New York: Dover Publications, 1990.

Makinson, Randell L. *Greene & Greene: Architecture as Fine Art.* Salt Lake City: Peregrine Smith, 1977.

Mansfield, Harold. *Vision: A Saga of the Sky.* New York: Duell, Sloan and Pearce, 1956.

Martin, Paul J. *Port Angeles, Washington: A History.* Vol. 1. Port Angeles: City of Port Angeles, 1983.

Mawson, Thomas H. *Civic Art: Studies in Town Planning, Parks, Boulevards, and Open Spaces.* London: B.T. Batsford, 1911.

Moore, Charles. *The Life and Times of Charles Follen McKim.* Boston: Houghton Mifflin Company, 1929.

Morgan, Keith. *Charles A. Platt: The Artist as Architect.* Cambridge: MIT Press, 1985.

Morgan, Murray. *Skid Road: An Informal Portrait of Seattle.* rev. ed. New York: Viking Press, 1962.

Morgan, William. *The Almighty Wall: The Architecture of Henry Vaughn.* Cambridge: MIT Press, 1983.

Mullins, William H. *The Depression and the Urban West Coast, 1929–1933: Los Angeles, San Francisco, Seattle, and Portland.* Bloomington: Indiana University Press, 1991.

Newland, Joseph N., ed. *Henry Art Gallery.* Seattle: Henry Gallery Association, 1986.

Newton, Norman P. *Design on the Land: The Development of Landscape Architecture.* Cambridge: Belknap Press of Harvard University Press, 1971.

O'Gorman, James F. *H. H. Richardson: Architectural Forms for an American Society.* Chicago: University of Chicago Press 1987.

Ochsner, Jeffrey Karl, ed. *Shaping Seattle Architecture: A Historical Guide to the Architects.* Seattle: University of Washington Press, 1994.

Olsen, Donald J. *The City As a Work of Art.* New Haven: Yale University Press, 1986.

Pelly, Thomas Minor. *Restoration Point and Country Club.* Seattle: Lowman & Hanford Co., 1931.

Pinkney, David H. *Napoleon III and the Rebuilding of Paris.* Princeton: Princeton University Press, 1958.

Placzek, Adolf K., ed. *Macmillan Encyclopedia of Architects.* New York: Free Press, 1982.

Pollio, Marcus Vitruvius. *Vitruvius: The Ten Books on Architecture.* Translated by Morris Hicky Morgan. New York: Dover Publications, 1960.

Rae, John B. *Climb to Greatness: The American Aircraft Industry, 1920–1960.* Cambridge: MIT Press, 1968.

Reed, Henry Hope, and Sophia Duckworth. *Central Park: History and Guide.* New York: Clarkson N. Potter, 1967.

Reiff, Janice L. *Urbanization and the Social Structure: Seattle, Washington, 1852–1910.* Ann Arbor, Mich.: University Microfilms International, 1981.

Roth, Leland M. *A Concise History of American Architecture.* New York: Harper & Row, 1979.

_____ . "Company Towns in the Western United States." In *The Company Town: Architecture and Society in the Early Industrial Age,* edited by John S. Garner. New York: Oxford University Press, 1992.

_____ . *McKim, Mead & White, Architects.* New York: Harper & Row, 1983.

Sale, Roger. *Seattle: Past to Present.* Seattle: University of Washington Press, 1976.

Sallman, Howard. *Haussman: Paris Transformed.* New York: George Braziller, 1971.

Scarlett, Frank, and Marjorie Townley. *Arts Décoratifs: A Personal Recollection of the Paris Exhibition.* New York: St. Martin's Press, 1975.

Scott, Mel. *American City Planning Since 1890.* Berkeley: University of California Press, 1969.

Schaffer, Daniel, ed. *Two Centuries of American Planning.* Baltimore: Johns Hopkins University Press, 1988.

Scully, Vincent, Jr. *The Shingle Style and the Stick Style: Architectural Theory and Design from Richardson to the Origins of Wright.* rev. ed. New Haven: Yale University Press, 1971.

Shellenberger, Michael, ed. *Harmony in Diversity: The Architecture and Teaching of Ellis Lawrence.* Eugene: University of Oregon Press, 1989.

Shelman, David. "Freedom and Responsibility—the Educational Philosophy of Walter Willcox." In *W.R.B. Willcox (1869–1947): His Architectural and Educational Theory,* by Don Genasci and David Shelman. Eugene: Department of Architecture, University of Oregon, 1980.

Soule, George. *Prosperity Decade: From War to Depression, 1917–1929.* New York: Harper & Row, 1968: New York: Holt, Rinehart and Winston, 1947.

Stein, Susan R., ed. *The Architecture of Richard Morris Hunt.* Chicago: University of Chicago Press, 1986.

Steinbrueck, Victor. *Seattle Cityscape.* Seattle: University of Washington Press, 1962.

Stern, Robert A. M., Gregory Gilmartin, and John Montague Massengale. *New York 1900: Metropolitan Architecture and Urbanism, 1890–1915.* New York. Rizzoli International Publications, 1983.

Stickley, Gustav. *Craftsman Homes: Architecture and the Furnishings of the American Arts and Crafts Movement.* New York: Dover Publications, 1979.

Tabor, Grace. *The Landscape Gardening Book.* Philadelphia: Winston & Co., 1911.

Triggs, H. Inigo. *Town Planning: Past, Present and Possible.* London: Methuen & Co., 1909.

Turner, Paul Venable. *Campus: An American Planning Tradition.* Cambridge: MIT Press, 1984.

Twombly, Robert C. *Louis Sullivan: His Life and Work.* New York: Viking Penguin, 1986.

Tyler, Robert L. *Rebels of the Woods: The I.W.W. in the Pacific Northwest.* Eugene: University of Oregon Press, 1967.

Union Theological Seminary. *The Program of a Competition for the Selection of an Architect and the Procuring of a General Plan for the Union Theological Seminary in the City of New York.* New York, 1906.

U.S. Department of the Interior, Census Office. *Compendium of the Eleventh Census: 1890.* Washington, D.C.: GPO, 1897.

―――― . *Statistics of the Population of the United States at the Tenth Census (June 1, 1880).* Washington, D.C.: GPO, 1880.

Unwin, Raymond. *Town Planning in Practice: An Introduction to the Art of Designing Cities and Suburbs.* London: T. Fisher Unwin, 1913.

Van Zanten, David. "Architectural Composition at the Ecole des Beaux-Arts from Charles Percier to Charles Garnier." In *Architecture of the Ecole des Beaux-Arts,* edited by Arthur Drexler. New York: Museum of Modern Art, 1977.

Veith, Thomas. "An Analysis of the Work of Arthur Loveless with an Emphasis on Human Aesthetic Responses." Master's thesis, University of Washington, 1991.

"Victor Laloux." In *Architecture of the Ecole des Beaux-Arts,* edited by Arthur Drexler. New York: Museum of Modern Art, 1977.

Webster, Janice Reiff. "Seattle: The First Fifty-Five Years: A Study in Urban Growth." Master's thesis, University of Washington, 1973.

Weisberger, Bernard A. *Statue of Liberty: The First Hundred Years.* New York: American Heritage 1985.

Wharton, Edith. *Italian Villas and Their Gardens.* New York: Century Co., 1910.

White, Norval. *New York: Physical History.* New York: Atheneum, 1987.

Wilson, Richard Guy. *McKim, Mead & White, Architects.* New York: Rizzoli International Publications, 1983.

Wilson, William H. *The City Beautiful Movement.* Baltimore: Johns Hopkins University Press, 1989.

―――― . "The Seattle Park System and the Ideal of the City Beautiful." In *Two Centuries of American Planning,* edited by Daniel Schaffer. Baltimore: Johns Hopkins University Press, 1988.

Wingate, Marcel E. *The Structure of Stuttering: A Psycholinguistic Analysis.* New York: Springer-Verlag, 1988.

―――― . *Stuttering: Theory and Treatment.* New York: Irvington Publishers, 1976.

Withey, Henry F., and Elsie Rathburn Withey, eds. *Biographical Dictionary of American Architects (Deceased).* Facsimile ed. Los Angeles: Hennessey & Ingalls, 1970.

Articles

American Architect. 99(15 March 1911): pls. 5–9.

"Achitectural League of the Pacific Coast." *PBE* 16(15 November 1913): 301–2.

Bach, Richard F. "Modern Museum—Plan & Functions." *Architectural Record* 62(December 1927): 457–69.

Bauer, Harry C. "A Dominant Architectural Role." *WA* 41(Winter 1951): 9–10, 26.

Booth, T. William. "Design for a Lumber Town by Bebb & Gould, Architects: A World War I Project in Washington's Wilderness." *PNQ* 82(October 1991): 132–39.

―――― . "Literary and Journalistic Towers: Seattle and Chicago, 1922." *ARCADE* 9(December 1989/January 1990): 16–17, 24–25.

―――― . "The Man, the Moment, and the Museum." [Seattle] *Weekly* 20–26 November 1986; 30–35, 38–41.

Brown, Arthur, Jr., "Hommage à Laloux: De Ses Elèves Americains." *Pencil Points* 18(October 1937): 621–30.

Brown, Larry. "At Home with Ellsworth Storey." *Pacific* [magazine of the *Seattle Times* and *Seattle Post-Intelligencer*] (15 September 1985): 22–24.

Callahan, Kenneth. "A New Art Institute." *TC* 26(28 March 1931): 15.

―――― . "Future Museum." *TC* 26(5 December 1931): 34.

―――― . "Utopian Museum." *TC* 26(7 October 1931): 14.

Clausen, Meredith L. "Paul Thiry: The Emergence of Modernism in Northwest Architecture." *PNQ* 75(July 1984): 128–39.

Cole, Terrence M. "Promoting the Pacific Rim: The Alaska-Yukon-Pacific Exposition of 1909." *Alaska History* 6(Spring 1991): 18–34.

Dimock, Arthur H. "Preparing the Groundwork for a City: The Regrading of Seattle, Washington." *Transactions of the American Society of Civil Engineers* 92(1928): 717–34.

Ficken, Robert E. "Seattle's 'Ditch': The Corps of Engineers and the Lake Washington Ship Canal." *PNQ* 77(January 1986): 11–20.

Flagg, Ernest. "The Ecole Des Beaux-Arts." *Architectural Record.* 3(January–March 1894): 302–13; 3(April–June 1894): 419–28; and 4(July–September 1894): 38–43.

_____ . "Influence of the French School on Architecture in the United States." *Architectural Record* 4(October–December 1894): 211–28.

Frykman, George A. "The Alaska-Yukon-Pacific Exposition, 1909," *PNQ* 53(July 1962): 89–99.

Glover, Darrell. "Storey's Homes Distinctive." *Seattle Post-Intelligencer* (23 January 1972): D9.

Gould, Carl F., "The American University and Its Library Problem." *Architectural Forum* 44(June 1926): Pt. 2, pp. 361–66.

_____ . "Early Use of Architectural Concrete at Government Locks, Ballard." *Architect and Engineer* 104(February 1931): 54–55.

_____ . "Horace C. Henry Gallery of the Fine Arts." *WA* 18(March 1927): 1–2.

_____ . "New Building Ordinance of the City of Seattle." *PBE* 16(20 December 1913): 393.

_____ . "The New Library Now in Use." *WA* 18(February 1927): 4, 9.

_____ . "Portfolio of Architectural Plates of Douglas Fir Plywood Paneling." *Architect and Engineer* 134(September 1938): 45–53.

_____ . "The Ultimate Library." *WA* 14(November 1922): 6–7.

_____ . "What Art Means to a City." *TC* 10(8 November 1915): 11.

_____ . "What Is the Architect Doing Toward Solving the Problems Now Before Him?" *PBE* 10(14 December 1912): 439–40.

Gournay, Isabelle. "Architecture at the Fontainebleau School of Fine Arts, 1923–1939." *Journal of the Society of Architectural Historians* 45(September 1986): 270–85.

Hamlin, A.D.F., "The Battle of Styles." *Architectural Record* 1(31 March 1892): 265–75.

Hamlin, Talbot F. "Competitions." *Pencil Points* 19(September 1938): 551–65.

Henry, William E. "The New Library Now in Use." *WA* 18(February 1927): 4, 9.

Johnson, Donald Leslie. "Frank Lloyd Wright in the Northwest: The Show, 1931." *PNQ* 78(July 1987): 100–106.

Johnson, Louise N. "An Island Home Near Seattle." *House Beautiful* 46(July 1919): 26–28.

Johnston, Norman J. "The Olmsted Brothers and the Alaska-Yukon-Pacific Exposition: 'Eternal Loveliness.'" *PNQ* 75(April 1984): 50–61.

Kendall, Sue Ann. "50 Years." *Pacific* [magazine of the *Seattle Times* and *Seattle Post-Intelligencer*] (26 June 1983): 16–19.

Knapp, Nancy. "The Houses that Storey Built." *Puget Soundings* (May 1968): 16–17, 19.

Landecker, Heidi. "Depression Modern: Everett Public Library." *Architecture* (December 1992): 54–57.

Longstreth, Richard W. "Academic Eclecticism in American Architecture." *Winterthur Portfolio: A Journal of American Material Culture* 17(Spring 1982): 55–82.

Martin, Roi L. "The Oregon Competition in Retrospect: Minutes of Jury Show Unusual Deliberations." *Architect and Engineer* 127(November 1936): 11–36.

Ochsner, Jeffrey K., and Dennis A. Andersen. "Adler and Sullivan's Seattle Opera House Project." *Journal of the Society of Architectural Historians* 48(September 1989): 223–31.

"Pacific Northwest Now Boasts One of the Finest University Library Buildings of the World." *PBE* 33(7 May 1927): 29–31.

Perry, Warren C. "Teaching of Architecture on the Pacific Coast." *PBE* 16(23 August 1913): 97–103.

Rich, Lorimer. "Planning Art Museums." *Architectural Forum* 47(December 1927): 553–600.

Richmond, Romi. "Ellsworth Storey of Seattle." *ARCADE* 6(February/March 1983): 4–5.

Scott-Brown, Denise, untitled commentary. *Oppositions* 8(Spring 1977): 165–66.

Steinbrueck, Victor. "Seattle's Storey Cottages." *Pacific Architect and Builder* 66(June 1960): 21-24.

Thomas, Walter H. "Oregon State Capitol Competition: Some Remarks Concerning Its Results." *Pencil Points* 17(July 1936): 353–57.

Twombly, Robert. "Beyond Chicago: Louis Sullivan in the American West." *Pacific Historical Review* 54(November 1985): 405–38.

"U.S Marine Hospital, Seattle, Wash." *American Architect* 147(November 1935): 29–33.

University of Washington Libraries. *Library Directions* 2(Spring 1991): 3.

"Washington State Capitol Commission and Its Jury." *PBE* 12(14 October 1911): 213.

Willcox, W.R.B. "Modern Architecture and How Determined: Effects of Historic Precedents, the Fancy of Clients' and Architects' Attitude." *PBE* 14(16 November 1912): 397–98.

Picture Credits

Gould Collection, CFG JR.: 1.1, 1.3, 2.1, 2.2, 2.3, 2.4, 2.5, 2.6, 2.7, 2.8, 2.9, 2.10, 2.11, 2.12, 2.13, 2.14, 2.15, 3.6, 3.8, 3.12, 3.17, 3.18, 4.2, 4.3, 4.4, 4.5, 4.9, 4.10, 5.1, 5.4, 5.8, 5.10, 5.19, 5.20, 5.21, 6.2, 6.3, 6.15, 6.17, 6.21, 6.22, 7.1, 7.2, 7.9, 7.10, 7.11, 7.12, 8.4, 8.7, 8.14, 8.16, 9.3, 9.6

Special Collections Division, University of Washington Libraries: 1.2, 3.13, 3.15, 3.16, 3.19, 4.8, 5.2, 5.3, 5.9, 5.11, 5.12, 5.13, 5.17, 6.5, 6.6, 6.7, 6.8, 6.9, 6.10, 6.11, 6.13, 6.14, 6.16, 6.18, 6.25, 8.10, 8.11, 8.13, 8.15, 8.17, 8.19

T. William Booth: 3.1, 3.2, 3.3, 3.4, 3.5, 3.7, 3.9, 3.10, 3.11, 3.14, 4.1, 4.6, 4.7, 5.5, 5.6, 5.7, 5.14, 5.15, 5.16, 5.18, 5.22, 5.23, 6.1, 6.4, 6.12, 6.19, 6.20, 6.23, 6.24, 7.3, 7.4, 7.5, 7.6, 7.7, 7.8, 8.1, 8.3, 8.5, 8.6, 8.8, 8.9, 8.21, 9.1, 9.2, 9.4, 9.5

Seattle Art Museum Archives: 8.2, 8.12, 8.18, 8.20

Daniel H. Burnham, *Report on a Plan for San Francisco* (San Francisco: City of San Francisco, 1906): 2.16

Adin Bennett Lacey, ed., *American Competitions, 1907* (Philadelphia: T Square Club, 1907): 2.17

INDEX

Italic numbers refer to pages with illustrations. Buildings are in Seattle unless otherwise indicated.

The authors and the publisher are grateful for the generous contributions of the following to the publication fund for this book:

Anonymous
Henry David and Patricia Gowen
 Aitken
Ralph Anderson
Manson and Frances Backus
Fred Bassetti
Mr. and Mrs. Alan F. Black
David C. Black
Harrison W. Blair
Prentice Bloedel
Priscilla Collins
Harriett Crosby
Jean Burch Falls
Elizabeth and Alexander Fisken
Evelyn W. Foster
Anne Parsons Frame
Jacquetta Freeman
Laura B. Gowen
Aubrey Van Wyck Gould, MD
Mrs. Carl F. Gould, Jr.
Frederick D. N. Gould
Mr. and Mrs. John V. Gould
Kim Van Wyck Gould
Alice Gould Hanscam
Marshall and Helen Hatch
Anne Gould Hauberg
John H. Hauberg
Sue Bradford Hauberg
Henry Gallery Association
Katy Homans and Patterson Sims
Lakeside School
Annette Ingham Lobb
Alan Liddle

Wendell H. Lovett
Dorothy C. Malone
Prof. Joseph L. McCarthy
Lynda and James Morford
Charles E. Odegaard
Olson/Sundberg Architects, Inc.
Mr. and Mrs. Philip S. Padelford
Nathaniel and Fay Hauberg Page
Virginia W. Patty
Andrew and Marianna Price
Anne Grosvenor Robinson
John S. and Mary M. Robinson
Leila A. Russell
Simpson Reed Fund
Kayla Skinner
Samuel and Althea Stroum
Roland Terry
Prudence L. Trudgian
University of Washington
 President's Office
Walter and Jean Walkinshaw
Marillyn B. Watson
Annette B. Weyerhaeuser
Bagley and Virginia Wright
Mr. and Mrs. David C. Wyman